Eastman Johnson

Painting America

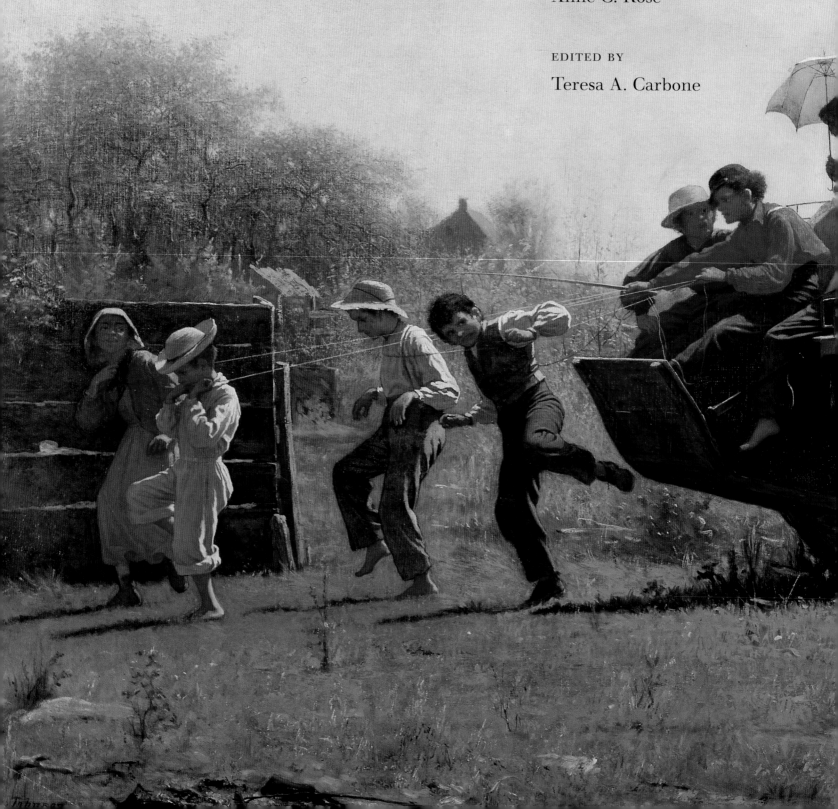

Eastman Johnson

Teresa A. Carbone
Patricia Hills

WITH CONTRIBUTIONS BY
Jane Weiss
Sarah Burns
Anne C. Rose

EDITED BY
Teresa A. Carbone

Painting America

Brooklyn Museum of Art
IN ASSOCIATION WITH
Rizzoli International Publications

This publication was produced in conjunction with the exhibition *Eastman Johnson: Painting America* at the Brooklyn Museum of Art, New York.

The exhibition is made possible by The Henry Luce Foundation, Inc., and Gilder Foundation. Additional support is provided by Richard and Jane Manoogian Foundation, Mr. and Mrs. John S. Tamagni, and Blair W. Effron.

Support for the catalogue was also provided through the generosity of Furthermore, the Publication Program of the J. M. Kaplan Fund, as well as a publications endowment created by the Iris and B. Gerald Cantor Foundation and The Andrew W. Mellon Foundation.

This publication was prepared by the Brooklyn Museum of Art.
James Leggio, Head of Publications
Joanna Ekman, Editor
Abby Sider, Assistant Editor

For Rizzoli International Publications
Christopher Lyon, Senior Editor
Laura Kleger, Editorial Assistant

EXHIBITION ITINERARY

Brooklyn Museum of Art, New York
October 29, 1999–February 6, 2000

San Diego Museum of Art
February 26–May 21, 2000

Seattle Art Museum
June 8–September 10, 2000

First published in the United States of America in 1999 by
Rizzoli International Publications, Inc.
300 Park Avenue South
New York, New York 10010

LIBRARY OF CONGRESS CATALOGING-IN-PUBLICATION DATA
Carbone, Teresa A.
 Eastman Johnson: painting America / by Teresa A. Carbone and Patricia Hills; with contributions by Jane Weiss, Sarah Burns, Anne C. Rose; edited by Teresa A. Carbone.
 p. cm.
 Catalog of the exhibition held at the Brooklyn Museum of Art, Oct. 29, 1999 to Feb. 6, 2000; San Diego Museum of Art, Feb. 26 to May 21, 2000; and Seattle Art Museum, June 8 to Sept. 10, 2000.
 Includes bibliographical references and index.
 ISBN 0-8478-2214-1.—ISBN 0-87273-138-3 (pbk.)
 1. Johnson, Eastman, 1824–1906 Exhibitions. I. Johnson, Eastman, 1824–1906. II. Hills, Patricia. III. Brooklyn Museum of Art. IV. San Diego Museum of Art. V. Seattle Art Museum. VI. Title.
 ND237.J7A4 1999
 759.13—dc21 99-14456
 CIP

Designed by Katy Homans
Printed in Italy

PHOTOGRAPH CREDITS
Photographs of works of art reproduced in this volume have been provided in most cases by the owners or custodians of the works, identified in the captions. The following list applies to photographs for which an additional acknowledgment is due: Fig. 2 David Mathews, © President and Fellows of Harvard College, Harvard University; Figs. 8, 11, 16, No. 66 Colin Harvie; Fig. 30 Brooklyn Museum of Art, Conservation Department; Figs. 32, 33, 55 © Collection of The New-York Historical Society; Fig. 43 The Cleveland Museum of Art, Hinman B. Hurlbut Collection, 355.1915; Figs. 51, 100 Archives of Patricia Hills; Fig. 81 Melville Mclean; Fig. 85 Michael Agee; Fig. 86 Clem Fiori; Fig. 96 Erik Gould; Fig. 101 Hillel Burger; Nos. 7, 8, 14, 46, 55 Will Brown; Nos. 15, 49 Dean Beasom; No. 25 Hugh Tifft; No. 32 Rick Patrick; No. 57 Jim Strong, Inc., New York; No. 64 Ed Brandon; No. 94 E. Irving Blomstrann.

Front cover: Detail, *A Ride for Liberty—The Fugitive Slaves*, circa 1862 (No. 74)
Back cover: *Catching the Bee*, 1872 (No. 90)
Title page: Detail, *The Old Stage Coach*, 1871 (No. 86)

Contents

Foreword

Nearly sixty years after the first Eastman Johnson retrospective exhibition was organized here, the Brooklyn Museum of Art is proud to present *Eastman Johnson: Painting America*, a major reassessment of this celebrated nineteenth-century American painter. As we move into the next century, this exhibition continues and extends the Museum's widely acknowledged reputation for seminal monographic exhibitions in the field of American painting.

In organizing *Eastman Johnson: Painting America*, we are indebted to numerous and exceedingly generous lenders, public and private, for their commitment to Johnson's art and to this project. We particularly thank those descendants of the artist who have allowed us to introduce several beautiful but little-known pictures to the public.

The exhibition would not have been possible without the major funding provided at an early stage by The Henry Luce Foundation, Inc., and we are grateful to its chair, Henry Luce III, and to Ellen Holtzman, Program Director for the Arts, for their advice and encouragement. We also deeply appreciate the generosity of Richard Gilder and Gilder Foundation. Our thanks also go to Richard and Jane Manoogian Foundation, Mr. and Mrs. John S. Tamagni, and Blair W. Effron. It also is a pleasure to acknowledge, once again, the generosity of Furthermore, the Publication Program of the J. M. Kaplan Fund, for its support of the exhibition catalogue. This volume was also supported by a publications endowment created by the Iris and B. Gerald Cantor Foundation and The Andrew W. Mellon Foundation.

This exhibition has been brought about through the scholarship and dedication of a distinguished curatorial team. Teresa A. Carbone, our Associate Curator of American Painting and Sculpture, organized the exhibition with Patricia Hills, Professor of Art History, Boston University. We acknowledge a particular debt to Dr. Hills for generously sharing her insight and expertise, and allowing us access to the copious Eastman Johnson catalogue raisonné files that she has carefully compiled for three decades. In addition, Eastman Johnson scholarship was enriched by the stimulating contributions to the catalogue of Sarah Burns, Professor, School of Fine Arts, Indiana University; Anne C. Rose, Associate Professor of History and Religious Studies, Pennsylvania State University; and Jane Weiss, Adjunct Assistant Professor of Literature, Hunter College. We are grateful for their collaboration.

My thanks, as always, go to the excellent staff of the Brooklyn Museum of Art, who implemented this exhibition and catalogue with characteristic skill, energy, and dedication. Special acknowledgment is owed Linda Ferber, Chief Curator and Andrew W. Mellon Curator of American Art, for her sure-handed guidance of the Museum's programs in American art and of this exhibition in all of its phases.

I am indebted to my colleagues Steven L. Brezzo, at the San Diego Museum of Art, and Mimi Gardner Gates, at the Seattle Art Museum, and their respective staffs, for presenting *Eastman Johnson: Painting America* in their communities, thus expanding the audience for this great American painter and for the pivotal historical moment in which he worked. We also wish to acknowledge Ann and Tom Barwick, for their support of the American art program at the Seattle Art Museum.

For the ongoing support of the Museum's Trustees, we extend special gratitude to Robert S. Rubin and every member of our Board. Without the confidence and active engagement of our Trustees, it would not be possible to initiate and maintain such a high level of exhibition and publication programming as is exemplified by *Eastman Johnson: Painting America*.

Arnold L. Lehman
Director

Preface
and
Acknowledgments

Eastman Johnson: Painting America builds on the seminal work of the great historian of American art and former Brooklyn Museum of Art curator John I. H. Baur. In his foreword to the catalogue of the first retrospective exhibition of Johnson's art, held at the Museum in 1940, Baur remarked that the name Eastman Johnson "evokes perhaps the recollection of one or two pictures . . . or quite possibly it evokes no memory at all." Baur's stated purpose was "to discover whether in fact Eakins, Homer and Ryder were the only real painters of a much maligned era." The 1940 retrospective was a landmark achievement in the field and an important event for the Museum's collection of American art. Baur's contact with the artist's granddaughter Gwendolyn O. L. Conkling resulted in her gift to the Museum of two great works, *A Ride for Liberty—The Fugitive Slaves* and *Not at Home*, in celebration of the exhibition.

Favor and attention remained focused, nevertheless, on the more famous trio for decades. As critics sought to identify the precursors of modernist aesthetics, few were interested in Johnson's technical prowess or his dedication to the narrative of his own era. Not until 1972 was Johnson reintroduced to a more receptive public in an exhibition at the Whitney Museum of American Art—for which Patricia Hills's catalogue provided an expanded study of the development of the painter's style and subjects.

The tenor of our own moment allows a still broader approach to the work of Eastman Johnson. A more comprehensive and diverse history of American art, embracing a wider range of visual culture and a redefined notion of artistic success, has made room for artists other than the canonical forebears of high modernism. With the present exhibition and catalogue, we offer a major reassessment of Eastman Johnson's career and the evolution of his art.

We have investigated with new freedom and frankness Johnson's role in the culture of his time, both as one of the most influential artists of his day and as a chronicler of a turbulent and challenging era. Johnson reemerges as a painter who set out on an independent course as a student of Dutch art in The Hague and, subsequently, as an ambitious young talent in the New York art world of the 1860s; as an artist who probed the nuances of representing race, painted in praise of domesticity, and poignantly revealed the aging face of rustic New England; and finally, as an exemplar of the individualism and moral consciousness of the Civil War generation.

It gives us great pleasure to thank all of the many individuals and institutions that have made possible this exhibition and catalogue. We are deeply grateful to Arnold L. Lehman, Director of the Brooklyn Museum of Art, for embracing this institution's long tradition of important exhibitions of historic American paintings. Special thanks are due Linda S. Ferber, Chief Curator and Andrew W. Mellon Curator of American Art, who has been an unfailing advocate of the project from its inception and a wise and generous advisor throughout its gestation. Roy R. Eddey, former Deputy Director, kindly provided counsel and encouragement.

The exhibition owes its existence to an extraordinarily generous group of lenders, public and private, who demonstrated their own enthusiasm for Johnson's art by supporting our exhibition plans from the earliest stages. We also have been greatly assisted by descendants of Eastman Johnson. We offer particular thanks to the indefatigable Sarah May Edmonds Broley for putting us in touch with far-flung family and renewing our own excitement about the project.

Our colleagues at the subsequent venues for *Eastman Johnson: Painting America*— D. Scott Atkinson, Curator of American Art, San Diego Museum of Art, and Trevor Fairbrother, Deputy Director of Art/Jon and Mary Shirley Curator of Modern Art, Seattle Art Museum—have been invaluable and generous advocates for the project. Among those who will bring the exhibition to fruition at the San Diego Museum of Art are Louis M. Goldich, Dana K. M. Bottomley, Mitchell Gaul, Scot Jaffe, Erick Guide, JoAnn Silva, Shelley McReynolds, Marilen Sedlock, Caroline Harwood, Denise Therieau, and Wes Brustad.

Over the course of four years' preparation for *Eastman Johnson: Painting America*, we received the unflagging support of the remarkable staff of the Brooklyn Museum of Art. Encouragement, advice, and help were offered in the Department of American Painting and Sculpture by Barbara D. Gallati, Sarah Kelly, Amanda Shaw, and Joan Blume. Other curatorial colleagues who offered indispensable assistance and moral support include Elizabeth W. Easton, Diana Fane, Barry R. Harwood, Patricia Mears, and Kevin Stayton. Throughout the course of this endeavor, we relied on the expertise and energy of Cathryn Anders and the staff of Collections Management; Dean Brown; Lisa Cain; Christina Dufresne; Charles Froom; Catherine Fukushima; Faith Goodin; Phillip Glahn; Richard Kowall; Raina Lampkins-Fielder; Deirdre Lawrence and the staff of the Art Reference Library; Hannah Mason; Ken Moser; Antoinette Owen; Vicki Quinn; Elizabeth Reynolds; Deborah Schwartz; Carolyn Tomkiewicz; Peter Trippi; Heidi Vickery-Uechi; Sally Williams; and Deborah Wythe. Kevin Cooper saved the day on more than one occasion.

We owe a particular debt to those colleagues and friends who assisted in locating and helping to secure works by Johnson for loan to the exhibition, including John Coffey; John Davis; Stuart P. Feld and M. P. Naud; Vance Jordan; and Theodore E. Stebbins, Jr. Individuals who generously replied to repeated inquiries with good humor and invaluable information include William D. Barry; Judith A. Barter and Andrew J. Walker; Joseph Benford; Jonathan Harding; Donna J. Hassler and Robert Anderson; Michael A. Jehle; Nancy Malloy; Hans Nieuwenhuis and Nel Noordevleit-Jol; Martha Op de Coul; and Kathryn A. Clippinger and Michael R. Florer.

Among the many other individuals who advocated loans and assisted in our research are Joan Barnes; Claire Bertrand; Alex Boyle; Laurene Buckley; Timothy A. Burgard; Cliff Chieffo; Margaret C. Conrads; Susan Danly; Kerry Dean; David B. Dearinger; Lynn Deines; Susan Faxon; Brandon Brame Fortune and Ann P. Wagner; L. Jane Gallop; Julian Ganz, Jr.; William H. Gerdts; Eleanor Jones Harvey; Norman Hirschl; Erica E. Hirshler and Carol Troyon; John K. Howat, H. Barbara Weinberg, and Catherine Hoover Voorsanger; Roger Howlett; Joseph A. Jacobs; Diane Jones; Arthur Lawrence; Barbara A. McMillan; Diane Martz; Dara Mitchell; Jane Myers; Meg Perlman; Lisa Peters; Thomas Piche; Paul Provost; Melissa Rountree; Mary Saunders; Linda Simmons and Sarah Cash; Marc Simpson; Nancy Sojka; Michael Swicklik; William H. Truettner; Gilbert Vincent and Paul D'Ambrosio; Meredith Ward; Bruce Weber; Melanie Wisner; and Sarah Woolworth. Eli Wilner & Co. kindly reframed a number of works in the exhibition to great advantage.

We have been privileged to work with a highly creative and collegial team of contributing catalogue authors—Sarah Burns, Anne C. Rose, and Jane Weiss—whose fresh and diverse perspectives on Johnson and the culture in which he worked have enriched our own and made this volume more challenging. At the Brooklyn Museum of Art, James Leggio guided the production of the catalogue with precision and humor; Joanna Ekman edited a large and demanding manuscript with subtlety and insight; and Abby Sider provided dedicated editorial support. At Rizzoli, we thank Christopher Lyon and Laura Kleger. We are grateful to Katy Homans for her elegant and sympathetic design of the catalogue.

For invaluable assistance in bringing the exhibition and catalogue to fruition, we are indebted to Julie M. Douglass.

We wish to give special thanks to our respective partners, Robert B. Goldsmith and Kevin Whitfield, for their support and sustaining enthusiasm, not least of which was their willingness to detour family trips to see one more Johnson painting.

T.A.C. and P.H.

Lenders to the Exhibition

Addison Gallery of American Art, Phillips Academy, Andover, Massachusetts
Albright-Knox Art Gallery, Buffalo
The Art Institute of Chicago
Sarah May Edmonds Broley
Brooklyn Museum of Art
Carnegie Museum of Art, Pittsburgh
The Century Association, New York
The Chrysler Museum of Art, Norfolk, Virginia
The Corcoran Gallery of Art, Washington, D.C.
Curtis Galleries, Inc., Minneapolis
Dallas Museum of Art
Deerfield Academy, Deerfield, Massachusetts
Everson Museum of Art, Syracuse, New York
Elizabeth Feld
Peter A. Feld
Mr. and Mrs. Stuart P. Feld
Fine Arts Museums of San Francisco
Fraunces Tavern Museum, New York
The Free Library of Philadelphia
Jo Ann and Julian Ganz, Jr.
Georgetown University, Washington, D.C.
Howard and Melinda Godel
Hallmark Cards, Inc., Kansas City, Missouri
Kathleen Hammer and Arthur Seelbinder
Teresa Heinz and the late Senator John Heinz
Hevrdejs Collection
Kennedy Galleries, New York
Kenneth Lux
Manoogian Collection
Mead Art Museum, Amherst, Massachusetts
The Metropolitan Museum of Art, New York
Milwaukee Art Museum
The Minneapolis Institute of Arts
Museum of Fine Arts, Boston
Nantucket Historical Association, Nantucket, Massachusetts
National Academy Museum, New York
National Museum of American Art, Smithsonian Institution, Washington, D.C.
National Park Service, Longfellow National Historic Site, Cambridge, Massachusetts
The Nelson-Atkins Museum of Art, Kansas City, Missouri
The Newark Museum, Newark, New Jersey
New Britain Museum of American Art, New Britain, Connecticut
The New-York Historical Society
Private collections
Donald and Lisa Purdy
Reynolda House, Museum of American Art, Winston-Salem, North Carolina
Rockefeller Family
St. Louis County Historical Society, Duluth, Minnesota
San Diego Museum of Art
Santa Barbara Museum of Art, Santa Barbara, California
Timken Museum of Art, San Diego
The Walters Art Gallery, Baltimore
Mr. and Mrs. Patrick Wilmerding

NO. 1
Head of a Woman, July 1844
Charcoal and chalk on paper, 13½ x 10⅝ in.
Brooklyn Museum of Art, Carll H. de Silver
Fund, 32.1717.1

NO. 2
Head of a Man, July 1844
Charcoal and chalk on paper, 12¾ x 10¾ in.
Brooklyn Museum of Art, Carll H. de Silver
Fund, 32.1717.2

From Crayon to Brush: The Education of Eastman Johnson, 1840–1858

TERESA A. CARBONE

Eastman Johnson had the good fortune to be born in a setting for which he felt an early and deep affinity. The town of Lovell, Maine, lies inland (fig. 1), in the shadow of the White Mountain foothills and on the Saco River's broad, rural flood-plain, where dense maple groves even today appear to resist settlement or industrial growth. It was in this region that Johnson took his first tentative steps as a portrait artist and established the ties with native son Henry Wadsworth Longfellow that would lead to some of his most important portrait commissions. Johnson would travel farther afield in the first decades of his career, making history in the early 1850s with his lengthy apprenticeship as a student of Dutch art in The Hague and venturing to the western frontier on his return to reformulate for himself the possibilities of American subject matter. The discussion that follows will chart the education of Eastman Johnson in the first two decades of his career, before he returned east in 1860 and permanently reclaimed a native New England identity for his art and for himself.

About 1820, the year that Maine achieved statehood, its underdeveloped inland regions were experiencing a temporary period of prosperity, led by a rising middle class of entrepreneurs.[1] This moment of growth provided opportunity for Johnson's parents, Philip Carrigan Johnson and his wife, Mary Chandler, who built the ell of their Lovell home in 1824, the year of Johnson's birth. Philip Johnson operated a tavern there, and having attracted the regular visits of the mail stage, he assumed his first government position as postmaster of the hamlet.[2] His business apparently was profitable: he built a number of other houses in Lovell before moving his family to nearby Fryeburg by November 1828.[3] There, the remaining four of Johnson's seven siblings were born (Eastman was the third in line) and his father briefly operated the fine Oxford House hotel on the town's broad, elm-lined Main Street. Johnson was ten years old when the family moved again, this time to the much larger town of Augusta (pop. 3,980). Philip Johnson eventually prospered there as well, assuming the position of secretary of state for the conservative Democratic administration under Governor John Fairfield in 1840[4] and taking up residence in an ample house (now known as the Shelton House) built in the new Italian Villa style. Having completed his basic schooling by the end of the decade, young Johnson began his own professional pursuits, first in Concord, New Hampshire, presumably as an apprentice (according to his younger brother's autobiographical notes), and subsequently as a clerk in the Augusta dry-goods store run by his elder sister Judith's first husband, Hiram Jones.[5]

According to the turn-of-the-century art critic William Walton, who wrote the early authoritative, albeit brief, biographical sketch of Johnson in 1906, the aspiring young artist first sought to sharpen his rudimentary skills about 1840, when he found employment in a Boston lithography shop.[6] Boston's blossoming art circles must have been a revelation to the young Johnson, who quite likely came in contact with the leading Boston portraitist and gallery owner Chester Harding (1792–1866); the younger Francis Alexander (1800–1880), who rendered a portrait of Charles Dickens during the writer's visit to the city early in 1842; and even the great Washington Allston (1779–1843), elderly dean of Boston painters until his death. All three of these established artists participated in the formation of the Boston Artists' Association in 1842 and the organization of its first annual exhibition that year at Harding's Gallery on School Street.[7] Young and inexperienced, Johnson may have found the competition in Boston too stiff, for he returned to Augusta in 1842[8] and set out to establish his reputation on more familiar ground.

A Sketch of the Artist as a Young Portraitist

In the tradition of early nineteenth-century "face-painters," Johnson appears to have moved from town to town in southern Maine to execute the "crayon" portraits with which he first earned his reputation.[9] Two of his earliest located works, *Head of a Woman* (No. 1) and *Head of a Man* (No. 2), both dated July 1844, demonstrate a careful attention to individualized details as well as a somewhat halting execution. Despite any tentativeness, however, his precisely descriptive use of shading in the faces, intuitive application of chalk highlights, and strong characterization suggest the natural talent that Johnson would cultivate to a more fluid proficiency before the end of the decade. In 1845 a writer for the *Portland Advertiser* noted the rapid rise of this "very promising young artist" in southern Maine and remarked, "Considering the extreme simplicity of [Johnson's] process, for he uses only black crayon, with a very little white for lights, the results are extraordinary. . . ."[10]

Presiding over the Portland art scene at the time was the portrait and occasional landscape painter Charles Octavius Cole (1814–1858), who attracted particular notice in 1842 when he undertook a portrait (Wadsworth-Longfellow House, Maine Historical Society, Portland) of the Portland native Henry Wadsworth Longfellow (1807–1882). Determined to raise the consciousness of the city's potential patrons, Cole opened in 1845 a motley exhibition of his own works, as well as landscapes and fancy pieces by the Maine artist Charles Codman (1800–1842) and more suspect items attributed to Gentile Bellini and "Carrachi."[11] Johnson is conspicuous in his absence from the exhibition, especially given that he rented a room in the Portland city hall that year to receive sitters; but his ambitions were revealed by his contribution of one of his portrait drawings (of the wife or daughter of Edmund T. Bridge, editor of the Democratic Augusta newspaper, the *Maine Patriot*) to the 1845 annual exhibition mounted by the Boston Athenaeum.[12] Johnson's Portland stay may have proved a turning point in his activities, for among the sitters he appears to have rendered at the time was the aging lawyer and former United States congressman Stephen Longfellow (1776–1849), father of the writer.[13] If Johnson saw Longfellow's portrait (Wadsworth-Longfellow House, Maine Historical Society, Portland) painted in 1824 by the preeminent Washington, D.C., artist Charles Bird King (1785–1862), he may have been particularly disposed to follow his family to the capital in 1846, when Philip Johnson assumed the position of chief clerk in the Navy Department's Bureau of Construction, Equipment, and Repair under the patronage of Maine's new senator, John Fairfield.[14]

Johnson probably arrived in Washington early in 1846. He would work there for a brief but formative period of less than a year, during which time he made contact with a roster of famous sitters. His auspicious start was owed at least in part to the assistance of his father's associates, through whom he apparently secured permission to receive sitters in a committee room in the Capitol.[15] Johnson's original plan may have been to compile portrait drawings of Supreme Court judges (he completed twenty-two, according to the records of Patricia Hills), perhaps for reproduction in some sort of portfolio, but his reach soon extended higher. By March 1846 he counted the famous Dolley Madison (fig. 2) and Mrs. Alexander Hamilton (The New-York Historical Society) among the notables whose portraits he had drawn. In a recollection fifty years later of his first encounter with Mrs. Madison, he wrote to the antiquarian Charles Henry Hart: "[Mrs. Madison] wandered in of her own accord and I asked her to let me make a sketch of her to which she readily assented. . . . It was a perfectly good likeness and a pretty frowsy old lady she was. I value it very much and would not be willing to have it go out of my possession. . . ."[16] He apparently began his formal portrait drawing of Mrs. Madison by March 16, when he wrote to his father: "[Mrs. Madison] is very agreeable, and I take pleasure

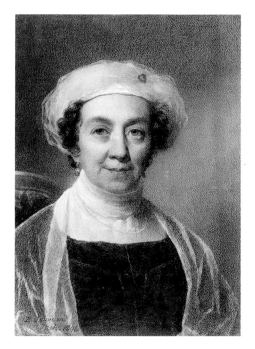

FIG. 2
Eastman Johnson
Dolley Madison, 1846
Black and white chalk on buff wove paper,
21¼ x 14¾ in.
Fogg Art Museum, Harvard University Art
Museums, Cambridge, Massachusetts, Bequest
of Grenville L. Winthrop

in going every morning to her house. She comes in at ten o'clock in full dress . . . , she looks quite imposing with her white satin turban and black velvet dress and a countenance so full of benignity and gentleness. . . . Today she was telling me of Lafayette, Mr. Jefferson, and others."[17] Johnson surely was even more pleased when he had the opportunity to draw the portrait of John Quincy Adams, then a member of the House, in April (fig. 97). During this period he clearly benefited as well from the presence of other portrait painters at work in the Capitol: his execution of a head of Daniel Webster (location unknown) on commission for Senator R. C. Winthrop of Massachusetts, for example, was facilitated when Webster sat for the French-trained American George P. A. Healy (1813–1894) in a room in the Capitol and Johnson was permitted to attend.[18] If Johnson was contemplating some sort of printed edition of his portraits at the time, which his lithographic skill would have prepared him to undertake, he would have been encouraged by the example of Charles Bird King, who had contributed portraits for reproduction in two of the most famous serialized portrait portfolios and by all accounts was a hospitable colleague to artists visiting the capital.[19] Johnson is likely to have seen replicas of some of the original paintings in King's gallery, in the latter's home on Twelfth Street, where more than two hundred fifty of his paintings were on view.[20] Fewer sitters were likely to have been at Johnson's disposal during the hot Washington summer, however, and attentions were likely to have been diverted by the Mexican War, into which President James K. Polk had plunged the country that May; but Johnson's Maine connections came to his aid once again, when the rising young poet and Harvard professor Henry Wadsworth Longfellow invited him to Cambridge to execute a group of portrait heads.

Johnson was in Boston by September 17, when Longfellow recorded his first sitting in the artist's new studio, in Amory Hall, an auditorium building and the site of occasional art exhibitions at the corner of Washington and West Streets. After a total of three sittings, Longfellow, who by all reports was quite conscious of appearances and fashion, was pleased with the handsome and lively portrait (No. 3).[21] It appears that four days later, while visiting Nathaniel Hawthorne (1804–1864) in Salem on October 10, Longfellow proposed that his friend, whose "manly beauty" he remarked on in his journal later that month, also sit for Johnson.[22] Hawthorne apparently warmed to the idea, for he closed his letter of the fourteenth to Longfellow as follows: "If you will speak to Mr. Johnson, I will call on him the next time I visit Boston, and make arrangements about the portrait. My wife is much delighted with the idea,—all previous attempts at my 'lineaments divine' having resulted unsuccessfully."[23] Hawthorne did visit Johnson's studio but put off returning, and as late as March 1847 he expressed his desire to delay further.[24] Though Hawthorne's final visit was not without incident,[25] the finished head (No. 4) was impressive, and it is perhaps the most evocative of the group completed for Longfellow. Owing to the somewhat freer description of the hair and richer use of shadow around the head and in the area of the large, liquid eyes, it has an emphatically Romantic air about it.

Johnson meanwhile completed pleasingly direct portraits of Longfellow's two sisters, Mary Longfellow Greenleaf and Anne Longfellow Pierce (Longfellow National Historic Site, Cambridge, Massachusetts), in two sittings on October 13 and 23.[26] In an effort to further his project of collecting the heads of his most admired friends and colleagues, Longfellow next wrote to Ralph Waldo Emerson on November 25, "When you are next in Boston pray take the trouble to step into Johnson's room & see the portrait of Hawthorne he is making for me."[27] Emerson, whose new volume of poems was to be published in December, was apparently free to oblige his friend, though the exact timing of his own sittings with Johnson is

NO. 3
Henry Wadsworth Longfellow, 1846
Crayon and chalk on paper,
21 x 19 in. (oval)
National Park Service,
Longfellow National Historic Site,
Cambridge, Massachusetts

NO. 4
Nathaniel Hawthorne, circa 1846–47
Crayon and chalk on paper,
21 x 19 in. (oval)
National Park Service,
Longfellow National Historic Site,
Cambridge, Massachusetts

NO. 5
Ralph Waldo Emerson,
October 22, 1846
Crayon and chalk on paper,
21 x 19 in. (oval)
National Park Service,
Longfellow National Historic Site,
Cambridge, Massachusetts

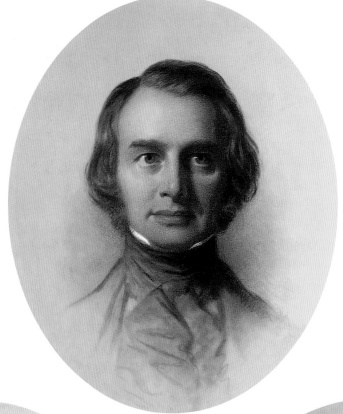

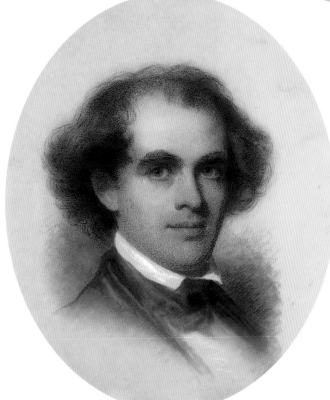

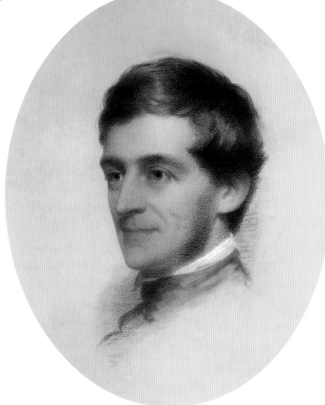

FIG. 3
Longfellow House, Study, circa 1869–77
Photograph
Courtesy of the National Park Service,
Longfellow National Historic Site, Cambridge,
Massachusetts

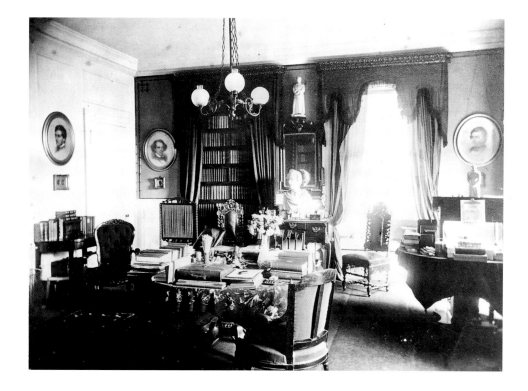

unclear. His expectations of the encounter are difficult to judge, given his deliberate meditations on portraiture just five months earlier, when he was frustrated by attempts to have a satisfactory daguerreotype portrait of himself made: "Daguerrotype [*sic*] gives the sculpture of the face, but omits of the expression, the painter aims at the expression & comes far short of Daguerre in the form and organization. But we must have the sea and the shore, the flowing & the fixed, in every work of art. On the sitter the effect of the Daguerrotypist [*sic*] is asinizing."[28] Given Emerson's opinions, Johnson's portrait of the philosopher (No. 5) may have been as pleasing in its handsome aspect as it was disappointing in its gentle idealization. Represented with a particularly light touch, Emerson appears bemused—more amiable than cerebral, and less the passionate orator of his July 1846 antislavery speeches than the contented man who would plant an orchard of picturesque varieties of apple trees that autumn. The image does accord with Johnson's later recollections of Emerson, though his memories may have been polished by retrospective idealization: "No one ever impressed me so as being a perfectly spiritual man, in mind, appearance and manner. His aspect was gentle and lovely . . . [and] every look, every word, every action was as beautiful as could be conceived. His beautiful smile—he was a lovely man to be near."[29] In December Longfellow's wife, Fanny, reported that Johnson had also completed the head of Charles Sumner (No. 70), which she described as "most excellent, with [Sumner's] softened best expression."[30]

Longfellow's commissions constituted an impressive accomplishment for Johnson, and the portraits demonstrate significant growth beyond the drawings that he had produced in Washington that spring. He clearly had achieved a greater facility of touch and sense of the expressive potential of his medium, thereby enhancing his ability to convey character and animation. Installed in the newly arranged study that Longfellow and his beloved young wife, Fanny, then shared at "Craigie House," the portraits represented the heady circle that the young artist had entered, albeit tangentially (fig. 3).[31] While Johnson cannot have come away from the experience unaffected by his sessions with some of the nation's most celebrated writers and thinkers, we can only suggest the subjects that might have arisen in their conversations, or the writings that his sitters may have inspired him to read. The voluble Longfellow, while experiencing the frustration of his demanding academic schedule,

was at work on *Evangeline*, his narrative poem of tragically parted Acadian lovers set in the Louisiana bayous during the pre-Revolutionary era. Although Johnson later described Hawthorne as "always a silent sitter,"[32] their encounter may have tempted him to read the novelist's just-published *Mosses from an Old Manse* (June 1846), a collection of seventeen imaginative tales ranging from the title story, a paean to the old Concord farmstead in which the writer and his new wife lived from 1842 to 1845, to the more Gothic yarns spun of the narcotic power of beauty in "Rappaccini's Daughter," or of early Salem sorcery in "Young Goodman Brown." It is tempting to surmise that Hawthorne's numerous evocations of New England "antiquities" might have provided Johnson food for imaginative thought in advance of the better-recognized manifestations of Colonial Revival after the Civil War. Hawthorne's story "Fire-Worship," in particular, in which he mourns the demise of the open hearth as a sad "revolution in social and domestic life," might have offered Johnson early encouragement for his own later preoccupation with the motif in his American subjects (see following essay and essay by Jane Weiss in this volume).

Johnson's contact with Emerson is perhaps the most intriguing, for the latter's own comments suggest that he regarded portrait sittings as the opportunity for some sort of exchange, and Johnson later recalled "his talk like an angel."[33] If the Sufi mysticism that had inspired Emerson's new volume of poetry was beyond Johnson, politics was a possible subject for discussion. Emerson was a vigorous opponent of the Mexican War, and in 1844 he had espoused the antislavery cause after much internal struggle, which required him to surrender both his faith in the essential nobility of New England character and his belief that individual virtue alone could remedy society's ills. On July 4, 1846, Emerson delivered a forceful address to the Massachusetts Anti-Slavery Society and continued thereafter to be a vigorous orator on behalf of the cause.[34] In October 1846, he also repeated his most recent series of lectures (at the Bangor, Maine, Lyceum) entitled "Representative Men," promoting an idealization of the individual that must have resonated for the young portraitist of famous personalities. In "The Uses of Great Men," Emerson proclaimed: "It is natural to believe in great men. . . . The world is upheld by the veracity of good men. . . . Our religion is the love and cherishing of these patrons."[35]

"Painting Away with Men Companions": Johnson's Düsseldorf Years

Given his stellar start in Boston, the most surprising feature of Johnson's subsequent three years in the city is the relative dearth of evidence of his activities. He worked for Longfellow again (completing portrait drawings of the writer's children in 1848), but he appears not to have taken the opportunity to exhibit again at the Athenaeum. He did move his studio, from Amory Hall to the more popular Tremont Temple,[36] and more important, he made the acquaintance of the young Boston-born artist George Henry Hall (1825–1913) (fig. 4).[37] It seems that by the summer of 1849, the two men had determined to set out together for Europe to further their training in a foreign academy. Andrew Warner, the president of the American Art-Union in New York and a patron of Hall's, was determined to convince Hall to choose Düsseldorf, where he might be trained to execute the type of crisply illusionistic genre paintings then enjoying a vogue on the New York art scene.[38] Hall had serious doubts about pursuing so rigid an academic routine and philosophy, but he wrote to Warner on June 19, 1849, to ask for further information and added, "I am to be accompanied by Mr. Johnson, a young artist of considerable reputation as a crayon draughtsman. . . ."[39] The advocacy of Düsseldorf by a patron as influential as Warner appears to have been convincing enough; Hall wrote to Warner a little more than a month later, "Mr. Johnson and myself have decided

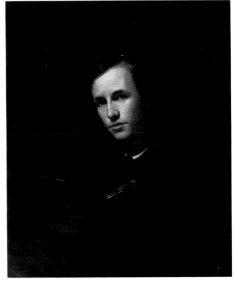

FIG. 4
George Henry Hall
Self-Portrait, 1845
Oil on canvas, 30⅛ x 25⅛ in.
Brooklyn Museum of Art, Gift of Miss Jennie
Brownscombe, 15.331

that the [Düsseldorf] Academy is the best place for us, and we shall be ready about the fifteenth of August for our departure."[40] The two sailed from New York on the fourteenth, but not before Johnson himself wrote to Warner, hoping to raise some cash for the enterprise with the sale of two drawings (presumably of recent date) titled *The Honey Moon* and *The Sweeps* (locations unknown). Warner bought the works, which provided a clear demonstration of Johnson's intention to undertake appealing narrative subjects, and both men looked forward to their future interaction, which would prove mutually profitable.[41]

When Johnson and Hall arrived in Düsseldorf (via Antwerp), the Revolution of 1848—a crusade for the unification of German states and a democratic legislature—was in its final throes. The Prussian government had refused to recognize the mayor of Düsseldorf, elected democratically in January 1849, and uprisings against the military had followed in April and May. The revolutionary faction of the Düsseldorf art world had organized the year before and, with the leadership of the American painter and activist Emanuel Leutze (1816–1868) (who had broken with the Royal Academy in 1843), founded an organization called Malkasten (literally, "paintbox"), to which painters including Karl Friedrich Lessing (1808–1880), Andreas Achenbach (1815–1910), and an occasional academic like Karl Sohn (1845–1908) belonged.[42] Among the younger members was the American John Whetten Ehninger (1827–1889), who had arrived in Düsseldorf in 1847 to hone his drawing skills. Leutze or Ehninger may have been responsible for guiding Johnson to the open anatomy classes held evenings at the Academy; and indeed, Johnson's earliest-known Düsseldorf production is a notebook from an anatomy class held there that fall (fig. 5).[43] Little documentation of Johnson's activities in the succeeding year has survived, though he evidently began to test his skills in oil.

Johnson finally wrote to Andrew Warner in October 1850, to announce the impending arrival in New York of two of his paintings for sale through the Art-Union. He described a small work titled *The Junior Partner* and a larger canvas, a costume piece titled *Peasants of the Rhine* (locations unknown). The letter reveals that Johnson's financial straits were uppermost in his mind: "I have not been a year [in] Düsseldorf & find I must speedily endeavor to turn my labor to some acct. in a pecuniary way or soon return to America. Some ill luck & unexpected rates of living have . . . made things somewhat different from my calculations. I am therefore obliged to send pictures home for sale rather earlier in my practice of oils than I should otherwise do. . . . "[44] Johnson also briefly mentioned Hall's recent departure for Paris, "so that we are only four," and suggested perceptively to Warner that the Düsseldorf masters had more to offer aspiring landscape painters than figure painters.[45] In the same letter, Johnson indicated the close contact that he had already achieved with Leutze, reporting on the older painter's temporary absence from the city and the progress of Leutze's *Washington Crossing the Delaware*. For his own part, Johnson reported that he had decided to enter the studio of the distinguished portrait painter Karl Sohn, whose appeal may have derived in part from his having taught Johnson's very talented American colleague, Richard Caton Woodville (1825–1855).[46]

Despite his plans, Johnson did not go with Sohn, for in January 1851 he dutifully reported to Warner that he had instead begun studies under Leutze, "in an immense atelier which [Leutze] rented for his big picture, with two others beside himself . . . forming an atmosphere & an aspect of art not less delightful than it is improving," and he added, "I regret now that I have not been with him during my entire stay in Dusseldorf."[47] The "big picture" on which Leutze was at work was a second version of *Washington Crossing the Delaware* (The Metropolitan Museum of Art, New York), the first having been damaged in a studio fire the previous November.

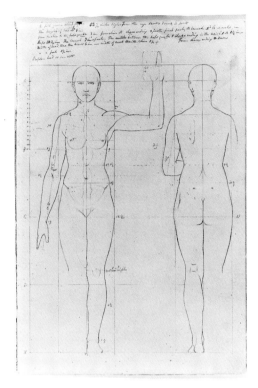

FIG. 5
Eastman Johnson
Anatomical Study, 1849
Pencil on paper, 17¼ x 11¼ in. (sheet)
Brooklyn Museum of Art, Gift of Albert Duveen, 40.61

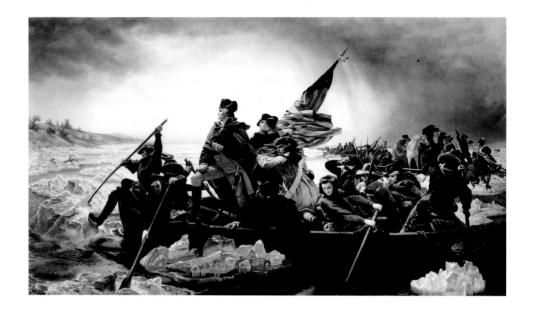

While Leutze painted the full-scale canvas with the assistance of such atelier
members as the accomplished landscape painter Andreas Achenbach and the young
American Worthington Whittredge (1820–1910), Johnson devoted his energies to
the production of a smaller replica (fig. 6) to be used by the French firm of Goupil,
Vibert & Co. in the production of an engraving.[48] The project was surely the most
significant of Johnson's Düsseldorf experience, linking the young student to one of
the most celebrated productions of his widely recognized master.

The most interesting source of information on the remainder of Johnson's stay
in Düsseldorf is a letter written in March 1851 to Charlotte Child, an acquaintance
from Maine. In a youthful mix of sarcasm and bravado, he suggested something
of his life abroad and of his travels into the more picturesque regions surrounding
Düsseldorf. Preceding a particularly evocative, descriptive passage, he wrote, "I
have now been here a year & a half, but my time has been most entirely spent in
this quiet town . . . whose interesting & distinguishing points are very few, and are
now to me as *hum-drum* as any of the peculiarities of our down-east villages."[49] In
a margin, however, he described Düsseldorf as "a beautiful town with gardens and
immense groves," the chief one being opposite the house he shared with "a young
painter from Cincinnati [Whittredge]." The most telling passage is, perhaps, his
description of the gregarious nature of the Germans ("with none of the cold shyness
of one another that with our people almost forbids the exchange of necessary civili-
ties till doubts & suspicions are removed by the ceremony of a formal introduction")
and the jovial club life in which he participated:

> *The men all belong to clubs & a great many to half a dozzen. Their word*
> Gesellschaft *designates germans as essentially as a* roast beef *does English-*
> *men. . . . I limit myself to two—one of which is the painters club [Malkasten],*
> *& the smartest in town—The other, of quite an opposite character composed*
> *chiefly of the King's best friends & a great number of his military servants, &*
> Lovers of their country *as it is, where republicanism cant be mentioned above a*
> *whisper. I belong to this because they have the only two billiard tables in town*
> *& take an English newspaper.*

If he had found camaraderie easy to come by, Johnson found progress in his
art a bit harder-won. He wrote to Charlotte Child with deliberate modesty: "I am
painting away with men companions & very diligently, trying to get *the hang of it*,
which I find I assure you no easy matter. . . . I do nothing in my old way of crayons."
By March he was already setting his sights on a move and was talking of Paris.

In July he sent notice to Warner that three pictures—two depicting Italian girls

and one a sleeping monk, all painted in Leutze's studio—would arrive soon in New York, and he announced as well, "I have about completed my stay in Düsseldorf."[50] He mentioned the possibility of traveling "to see the fine pictures of Holland" before returning to Dresden or Munich for the winter, and he spoke of Leutze's own impending departure for the States. By August 2, Johnson was in London;[51] with the departure of his much-admired mentor, there appears to have been nothing to hold him in Germany.

"Unexpected Opportunities": Coming of Age in The Hague

It is unlikely that Johnson anticipated the significance of his next move. After a relatively brief visit in England, he did go on to the Netherlands, and by November had decided to stay on through the winter at The Hague (fig. 7), where he wrote to Warner, "I find I am deriving much advantage from studying the splendid works of Rembrandt & a few other of the old Dutch masters, who I find are only to be seen in Holland."[52] Having come to Holland for "the fine pictures," Johnson would have lost little time in making his way to the Mauritshuis, the grand mansion purchased by the state in 1820 to house the Royal Cabinet of Paintings, established by the newly installed King Willem I eight years earlier. The opening of the museum to the public in 1822 was a source of great national pride, given that much of the collection of more than a hundred paintings had been looted at the time of the French occupation of Holland in 1795 and were returned only in 1815.[53] Several brilliant state purchases had been added to the collection in its early years, including Rogier van der Weyden's *Lamentation of Christ*, in 1827, and, more important for Johnson, Rembrandt's *The Anatomy Lesson of Dr. Nicolaas Tulp*, in 1828; few additional works entered the collection before Johnson's arrival in The Hague.

An American artist like Johnson would have had relatively little contact with such examples of Dutch seventeenth-century art at home or even in Germany (as suggested by his comments to Warner from Düsseldorf).[54] Even in France, the vogue for Dutch art that would prove so influential on midcentury Realist painting had yet to flower. Théophile Thoré, the French critic instrumental in fostering that taste, would publish his first two volumes on the museums of Holland in 1858. His reactions to the Dutch collections suggest something of Johnson's initial experience: "In the museum of The Hague [the Mauritshuis], as in the Museum of Amsterdam [the Rijksmuseum], it is Rembrandt who dominates all."[55] The subsequent pages

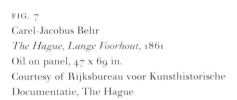

FIG. 7
Carel-Jacobus Behr
The Hague, Lange Voorhout, 1861
Oil on panel, 47 x 69 in.
Courtesy of Rijksbureau voor Kunsthistorische Documentatie, The Hague

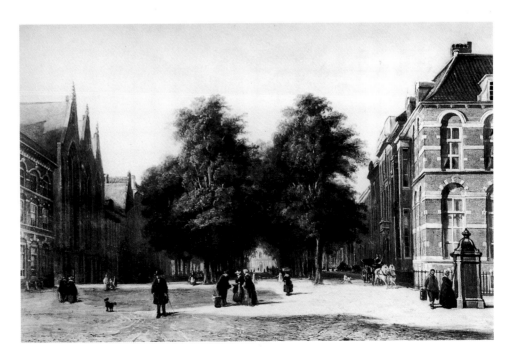

FIG. 8
Eastman Johnson
*Copy after "The Anatomy Lesson of Dr. Nicolaas
Tulp," by Rembrandt van Rijn*, circa 1852
Oil on canvas, 15 x 14 in.
Collection of Mrs. Frances van Reigersberg
Versluys

FIG. 9
Antoon François Heijligers
*Interior of the Rembrandt Room in the Maurits-
huis in 1884*, 1884
Oil on panel, 18½ x 23¼ in.
Mauritshuis, The Hague

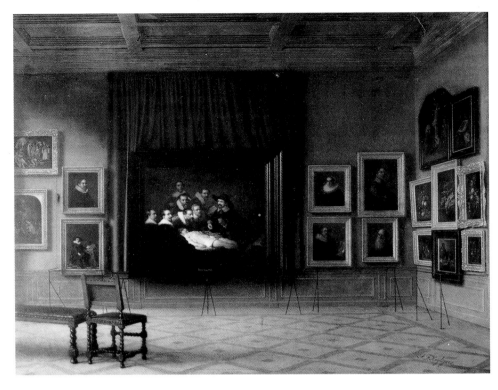

devoted to Rembrandt's *Anatomy Lesson* parallel Johnson's fascination with the
picture; a later representation of the Rembrandt gallery at the Mauritshuis, virtually
as it was when Johnson saw it (fig. 9), conveys something of the painting's dramatic
impact. Among Johnson's first known works done in The Hague is a rather labored
copy of two of the heads that appear just above and to the left of the head of the
corpse in *The Anatomy Lesson* (fig. 8; Johnson brought the two heads closer to-
gether). The canvas exhibits his attempt to emulate the great master's breadth in
the rich touches of flesh tones and in the broad description of the white ruffs.[56] Also
among the works in the Mauritshuis were Rembrandt's *Susannah at the Bath* and an
early self-portrait (fig. 10), the latter of which appears to have offered Johnson the
lens through which he would see his own artistic persona in numerous self-portraits
in the decades to come. The head of the young Rembrandt emerges, moonlike, from
shadow into light. The transition from darkness to brilliance along the turning pro-
file is so intuitively described as to be mysterious, while the forms delineated in full

FIG. 10
Rembrandt van Rijn
Self-Portrait with Gorget, circa 1630
Oil on panel, 14⅞ x 11⅝ in.
Mauritshuis, The Hague

FIG. 11
Eastman Johnson
Copy of Self-Portrait by Rembrandt van Rijn,
circa 1852
Oil on canvas, 12 x 9 in.
Collection of Mrs. Frances van Reigersberg
Versluys

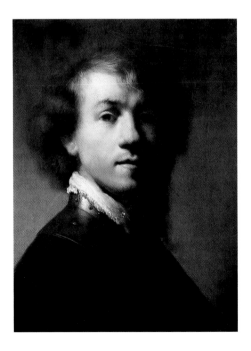

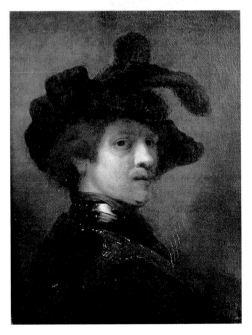

FIG. 12
Abraham de Pape
Old Woman Plucking a Rooster, circa 1655
Oil on panel, 19⁵⁄₁₆ x 16⅛ in.
Mauritshuis, The Hague

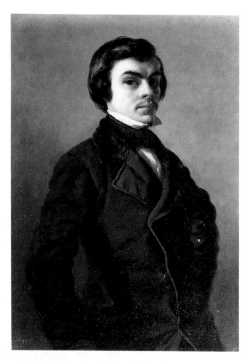

FIG. 13
Eastman Johnson
Portrait of Louis Rémy Mignot, circa 1851–55
Oil on cardboard laid down on panel,
20¾ x 14¼ in.
Collection of Mrs. Frances van Reigersberg
Versluys

light—the collar and the eye—are brushed in a palpable manner assertive of their materiality. Johnson's own naive attempts at such effects, seen in such works as his copy (fig. 11) after a later self-portrait by Rembrandt, imitate the fine passages of reflected light and the warm tones of flesh without achieving the convincing three-dimensional presence of the original.

If Johnson was first amazed and deeply inspired by Rembrandt, he was equally moved by the great seventeenth-century genre painters. Compared with the hard forms, clear color, and bright clarity of the Düsseldorf school productions, the more richly painted and evocatively tenebrous manner of the Dutch offered a new range of expression for consideration. The Mauritshuis collection catalogue of 1860 provides an accurate indication of those works available to Johnson, including a substantial group of interiors with figures by such well-known masters as Gerrit Dou, Gabriel Metsu, Frans van Mieris, Gerard Ter Borch, and Jan Steen.[57] Among those paintings that may have held particular interest for Johnson, to judge from his own later specialty in domestic genre, was Abraham de Pape's simpler *Old Woman Plucking a Rooster* (fig. 12). The painting may have conveyed to Johnson the evocative power of understated narrative and the expressive potential of well-worn utilitarian objects. Brooms, baskets, pots and bowls, and vegetables would make frequent appearances in Johnson's later narrative subjects, always in the context of the humble, half-lit interiors in which essential family life was enacted.

It is hardly surprising that a mid-nineteenth-century American would gravitate to such seemingly "realistic" subjects rather than religious or historical themes remote from his previous cultural experience. Even a person as erudite as Johnson's acquaintance Hawthorne, who was well aware of the lowly station of genre and still life in accepted academic hierarchies of subjects, found refuge in the Dutch aesthetic after taking in "the general run of Italians, who have tired me to-death in so many other galleries."[58] Hawthorne wrote in his journal after a visit to the Uffizi Gallery in 1858:

> It is a sign, I presume, of a taste still very defective, that I take singular pleasures in the elaborate imitations of Van Mieris, Gerard Dou, and other old Dutch wizards who painted such brass-pots that you can see your face in them, and such earthen jugs that will surely hold water.... I pause a good while, too, before the Dutch paintings of fruits and flowers.... Until we learn to appreciate the cherubs and angels that Raphael scatters through the air . . . it is not amiss to look at a Dutch fly settling on a peach, or a humble bumble-bee burying himself in a flower.[59]

Johnson eventually chose carefully from among the many types of Dutch figure subjects that he studied over the course of nearly four years. In his own later, Dutch-influenced work, he would eschew the typical parties of music makers and revelers, and scenes of sexually charged flirtation. He never emulated the indolent and unkempt young kitchen maids or female gazes coyly directed at the viewer. He inclined toward quietism rather than gregariousness, toward the representation of introspection rather than communication, and toward the sparing use of detail rather than a profusion of objects.

Given that Johnson had left a temporarily dwindling American community in Düsseldorf, he may have been tempted to remain in The Hague not only for the riches of the Mauritshuis, but also because of the presence there of two other Americans, the aspiring young painter from the American South, Louis Rémy Mignot (1831–1870), whose portrait Johnson painted (fig. 13), and George Folsom (1802–1869), American chargé d'affaires to the Court of the Netherlands in The Hague from 1850 to 1854. Mignot had arrived in 1848, his destination having been determined by the presence of family relations in Holland. His contact with the

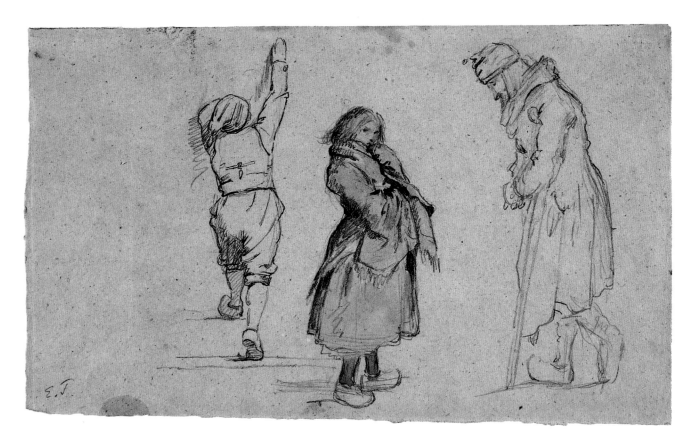

Three Dutch Figures, circa 1852
Pencil with body color on paper, 6½ x 10⅞ in.
Brooklyn Museum of Art, Purchased with
Funds Given by Mr. and Mrs. Leonard L. Mil-
berg, 1990.101.6

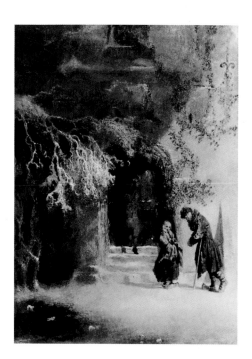

FIG. 14
Louis Rémy Mignot, with Eastman Johnson
Doorway of a Castle in Winter, circa 1852
Oil on wood panel, 21½ x 15¾ in.
Collection of Lawrence E. Bathgate II

art-student community was more direct than Johnson's: Mignot enrolled in The
Hague Academy of Fine Arts (Haagse Academie voor Beeldende Kunsten) and soon
thereafter entered the studio of the celebrated Dutch landscape painter Andreas
Schelfhout (1787–1870).[60] It is hardly surprising that Johnson did not enroll at the
Academy,[61] which offered only classes in cast and life drawing, thus continuing the
Dutch tradition of leaving the training of painters to those established artists who
accepted pupils in their own studios.[62] Johnson was already a proficient draftsman,
and by this time he appears to have been determined to work independently.

If the Academy was not an attraction for Johnson, the vibrant community of
Dutch landscape and figure painters then at work in The Hague certainly was. The
city was the liveliest artistic center in Holland at the time, owing at least in part to
the deliberate cultivation of indigenous art under the French occupation and subse-
quently under the auspices of the equally supportive new court under Willem I.
Among the most influential artists at work in The Hague in the 1850s were the
history painter Nicolaas Pieneman (1810–1860); the highly successful, French-
trained David Bles (1821–1899), who specialized in portraits and Boucheresque
cabinet pictures; the figure painter Thomas Simon Cool (1831–1870), known for
Romantic subjects as well as "updated" versions of seventeenth-century domestic
genre; and the portraitist Hermanus Anthonie de Bloeme (1802–1867).[63] More
important than any of these individuals for Johnson, however, was a smaller
community of progressive artists who were devoted to reinvigorating seventeenth-
century modes of landscape and genre, and who came to be viewed as the immediate
precursors of the highly popular Hague school, which blossomed in the city after
1870 with the arrival of the French-inspired Realists Jozef Israëls (1824–1911),
Hendrik Willem Mesdag (1831–1915), and Anton Mauve (1838–1888). The most
influential of these "precursors" were Mignot's teacher Schelfhout, in the field of
landscape, and the genre painters Johannes Bosboom and Hubertus van Hove, who
would be particularly important for Johnson (see below).

By 1852 Mignot and Johnson had embarked on a collaborative painting that
revealed their participation in the current revival of Dutch tradition. In *Doorway of*

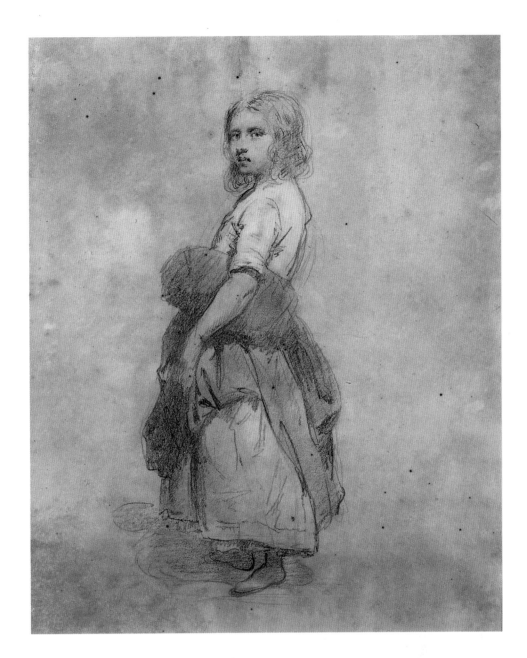

a Castle in Winter, circa 1852 (fig. 14), Mignot rendered the picturesque snow-
draped castle and trees with a frothy touch typical of snow scenes by Schelfhout.
Johnson's tattered figures, seeking food or alms, reveal his exploration of the
traditional Dutch use of small, gesturally expressive figural forms in a landscape
setting, also revived in the nineteenth century by the influential Wijnand Jan
Nuyen (1813–1839) and the townscape specialist Bartholomeus Johannes van Hove
(1790–1880), father of Johnson's contemporary. In Johnson's preparatory drawing
for the figural component (No. 6), which clearly demonstrates that the entire group
was worked out for application onto Mignot's preexisting background composition,
he achieved the poses with a quicker, more nervous, broken outline than was cus-
tomary in his earlier drawings, and he used a more ragged and spontaneous touch
in the shading. He is likely to have worked on these stylized poses at the same time
that he was producing more careful individual studies like *Portrait of a Young Girl*,
circa 1852–55 (No. 7). There too, however, one sees a shift in technique that may
have derived in part from his study of the drawings of Rembrandt; there is a more
relaxed sense of form and anatomy, a particular looseness in the description of the
head, with its more abbreviated modeling of features, and a breadth in the description
of such areas as the apron.

 Doorway of a Castle in Winter was one of four works that Johnson exhibited
in 1852 at one of the annual exhibitions of "Levende Kunstenaars" (Living Artists).

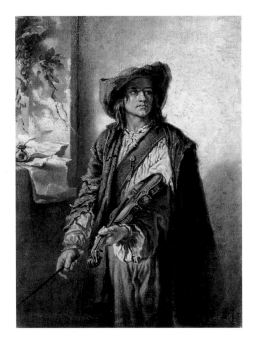

FIG. 15
Eastman Johnson
The Violin Player, circa 1852
Oil on canvas, 13½ x 10 in.
Kennedy Galleries, New York

Established in 1814 on the model of an 1808 exhibition initiated by Louis Napoleon to encourage indigenous arts during the French occupation of Holland, the annuals, held at various venues in Amsterdam, Rotterdam, and The Hague, were the primary showcase for Dutch painters for much of the nineteenth century. While artists of other European nationalities participated more frequently by the mid-1850s, Johnson was—with the exception of Mignot's single collaborative entry in 1852—the only American to participate in the years between 1850 and 1855.[64] Johnson's other entries from 1852 demonstrate more ambitious attempts at figure subjects. At the Rotterdam venue, where *Doorway of a Castle in Winter* appeared, he exhibited *Two Card Players*, a work inspired by the peasant interiors of Adriaen van Ostade and Adriaen Brouwer (whose *Peasants at the Inn* was at the Mauritshuis), and *The Violin Player*, circa 1852 (fig. 15).[65] At the Amsterdam venue that year, he exhibited a work titled *An Old Man Teaching His Granddaughter a Christian Lesson* (location unknown).[66] *The Violin Player* reveals, once again, a very deliberate, if somewhat labored, attempt at a looser, more intuitive manner. Johnson's model for the figure appears to have been the same dark-complected and dramatic-featured young man who sat for the drawing *My Jew Boy* (fig. 102) in February 1852. In the drawing, Johnson achieved the ease of outline and intuitively rich modeling that would begin to characterize his figure studies. He was unable at this point, however, to translate the same ease of execution into his paintings. In *The Violin Player*, there is an awkward quality to the broad modeling of the shirt, with impastoed whites and more thinly described dark brown shadows, and of the tattered brown cloth of the coat and hat. The face offers the most convincing breadth, with small, rich touches of highlights in flesh tones. Given Johnson's earlier complaints about the Düsseldorf manner, the most surprising feature of this painting and others from the period is the near-suppression of color. Equally unexpected is the praise for Johnson's "feeling for color" in *The Violin Player* offered by a reviewer for the local art magazine *Kunstkronijk*.[67]

By 1852 Johnson had also made the acquaintance in The Hague of George Folsom, who, as a native of Kennebunk, Maine, was likely to have taken Johnson under his wing. Trained as a lawyer, he made his career both as a historian with a specialty in the Dutch origins of New York and as a New York state senator from 1844 to 1850 from the conservative "Native American party."[68] It was to Folsom that Johnson wrote a long and detailed letter from Venice in March of that year, detailing his travels to date through France and into Italy, where he remained for several weeks. He described Venice as "the only city in Europe I have not been disapointed in," but no sketches of his Italian sojourn have survived.[69] On his return to The Hague, Johnson made one of presumably numerous visits to the nearby coastal village and bathing resort of Scheveningen, perhaps at the suggestion of his Dutch contemporaries, who had begun to gravitate to the spot a decade or two earlier.[70] Still officially part of The Hague at the time, Scheveningen was separated from the town by a long stretch of dunes and was accessible by horsedrawn coach; the local fisherwomen regularly made the trip to town by cart to hawk their wares. Johnson found new figure subjects among the local inhabitants and executed a number of drawings that anticipate his Nantucket subjects of the 1870s. His *Fishwoman of Schavininge*, 1852 (No. 8), with its attention to the typical costume of the area, is nearly documentary in character. As in France, regional peasant costume was rapidly becoming the object of lively interest and popular imagery; a plate from one of the first Dutch compilations of costume imagery, published in 1857 (fig. 17), illustrates the characteristic dress, cape, hat, and basket that appear accurately in Johnson's drawing.[71] Given the growing interest in such subjects, he may have considered executing a painting on the theme.

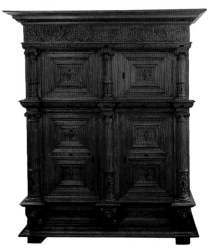

FIG. 16
Dutch Cupboard from the Collection of Willem II, 17th century
Owned by Eastman Johnson
Collection of Mrs. Frances van Reigersberg Versluys

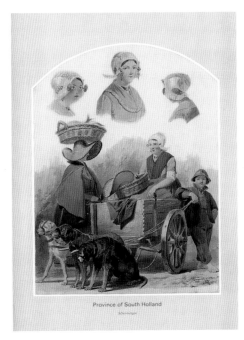

FIG. 17
"Costumes of South Holland"
From Valentyn Bing and Braet von Veberfeldt,
*Nederlandsche Kleederdragler Zeden En
Gebruiken Naar De Natuur Geteekend*
(Amsterdam: Frans Buffa en Zonen, 1857)

NO. 8
Fishwoman of Schavininge, 1852
Pencil and wash on paper, 12⅜ x 9½ in.
The Free Library of Philadelphia, Rosenthal
Collection, Print and Picture Collection

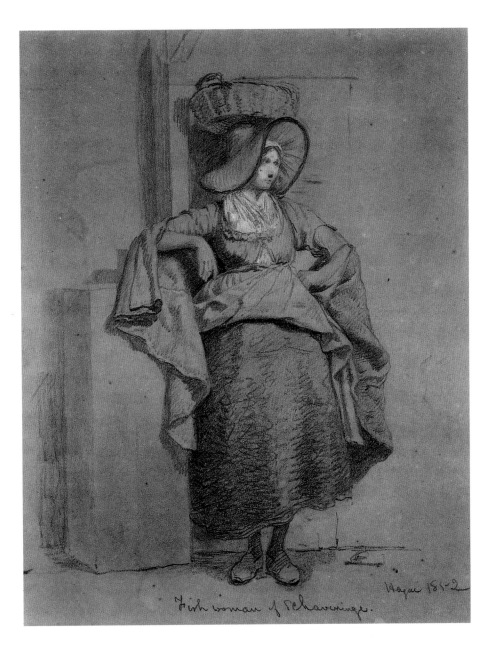

By the end of his first full year in The Hague, Johnson had begun to appreciate
and participate in Dutch culture. He went so far as to attend the auction sale of the
effects of Willem II (d. 1849) in Tilburg, where he purchased two large Dutch cup-
boards that remained in his possession until his death (fig. 16).[72] Though Johnson's
place of residence in The Hague remains a mystery,[73] he was apparently creating
for himself the type of domestic studio that had been traditional among Dutch
painters since the seventeenth century.

Johnson's known activities in The Hague before 1853 appear meager in com-
parison to the developments that took place in his art that year. Among the most
interesting was his choice of subject for the 1853 Hague venue of the Living Artists
annual exhibition. He submitted a work titled *Uncle Tom and Evangeline* (location
unknown), with reference in the catalogue to its origin in the novel *Uncle Tom's
Cabin*, by Harriet Beecher Stowe.[74] First serialized in the antislavery newspaper
the *National Era* in 1851–52, Stowe's evangelical novel was published in book form
in 1852 and sold an astounding 300,000 copies the first year; by 1860 it had been
reprinted in twenty-two languages. The volume might have been sent to Johnson
from America. Given, however, that 1853 was the year that Stowe made her highly
publicized (and eventually, harshly criticized) tour of Europe to promote her politics,
English and Dutch versions of *Uncle Tom's Cabin* were undoubtedly available for

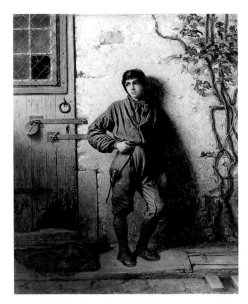

purchase in The Hague.[75] Johnson's choice of the Stowe subject is one of the first indications of his attraction to distinctly American themes, as well as to racially sensitive subject matter; notably few American painters at home were taking up subjects based on the novel.[76] He might have hoped that the extreme popularity of the book would attract a buyer for the painting, but he also seems to have sought to demonstrate his American identity within the Dutch milieu.[77]

The unknown whereabouts of *Uncle Tom and Evangeline* is all the more regrettable considering the evidence of the improvement in Johnson's painterly talents by early 1853. His *Portrait of Dr. Wybrandus Hendricksz* (fig. 18), the oculist for Willem III, reveals a new proficiency, which he would eventually achieve in his narrative subjects as well. The portrait also demonstrates that, within a year and a half, Johnson had found profitable patronage for his portraits among the highest circles in The Hague. His contact with the court and its military and diplomatic society was undoubtedly facilitated by Folsom, who himself commissioned a lithographic double portrait of his two young daughters, also 1853 (The Metropolitan Museum of Art, New York), and may have given Johnson the sobriquet "America's Rembrandt."[78]

Johnson also made progress toward achieving increased facility in his figure painting with several versions of a composition known as *The Savoyard Boy* (fig. 19, No. 9).[79] The subject, generally popular in European painting of the period, represents one of the many young boys of the Savoy region of the Italian Alps who commonly eked out meager livings as traveling street performers or chimney sweeps in more prosperous European towns. In the small-scale, full-figure version (fig. 19), Johnson revealed a new focus on illusionistic details. With studied precision, he undertook the textural description of the tattered gray clothing and the splintered wood, rusty padlocks, and broken glass of the ancient door. He also achieved a particularly pleasing breadth in his description of the grapevines climbing the rough plastered wall. *The Savoyard Boy* was later described by the critic Henry T. Tuckerman as "[Johnson's] first original and elaborate work in oil." Finding particular satisfaction in the details, Tuckerman wrote, "There is a finish in this picture, a truth of expression, . . . and a maturity of execution . . . which indicates a mastery of the best principles of art."[80] Johnson subsequently executed the half-length version (No. 9), in which he suppressed details in favor of a more expressive focus on the figure. While he employed the same fine touch in painting the head (with painstakingly small brushstrokes), he rendered the clothing in a heavier, broader manner, allowing a reddish brown underlayer to remain visible in the folds. The wall, too, is broadly described, with dragged layers of earth tones and dark, discontinuous outlines defining the loosely brushed branches of the grapevines.

While Johnson employed a similarly detailed manner in other works from 1853,[81] he also made very deliberate efforts in the direction of a more vigorous, brushy manner, as in *Portrait of a Man with a Hat* (fig. 20), which may be a self-portrait.[82] He sought new visual material and details in the course of a visit to Dongen in the southwestern province of North Brabant that July, when he compiled a number of sketches, including a drawing of a fellow artist painting *en plein air* (No. 10). Johnson's fortunes in the portrait business improved as well that fall, with the arrival in The Hague of the wealthy new American ambassador August Belmont, the American agent for the Rothschilds' banking firm and founder of his own New York financial house in 1837. Provided with an introduction by Folsom, Johnson undertook the first of his Belmont family portraits in November.[83]

We are provided with a clearer picture of Johnson's place in the art world of The Hague in 1854, when he was accepted into the Pulchri Studio, founded in 1847 by The Hague's most progressive artists. A dated membership register provides the

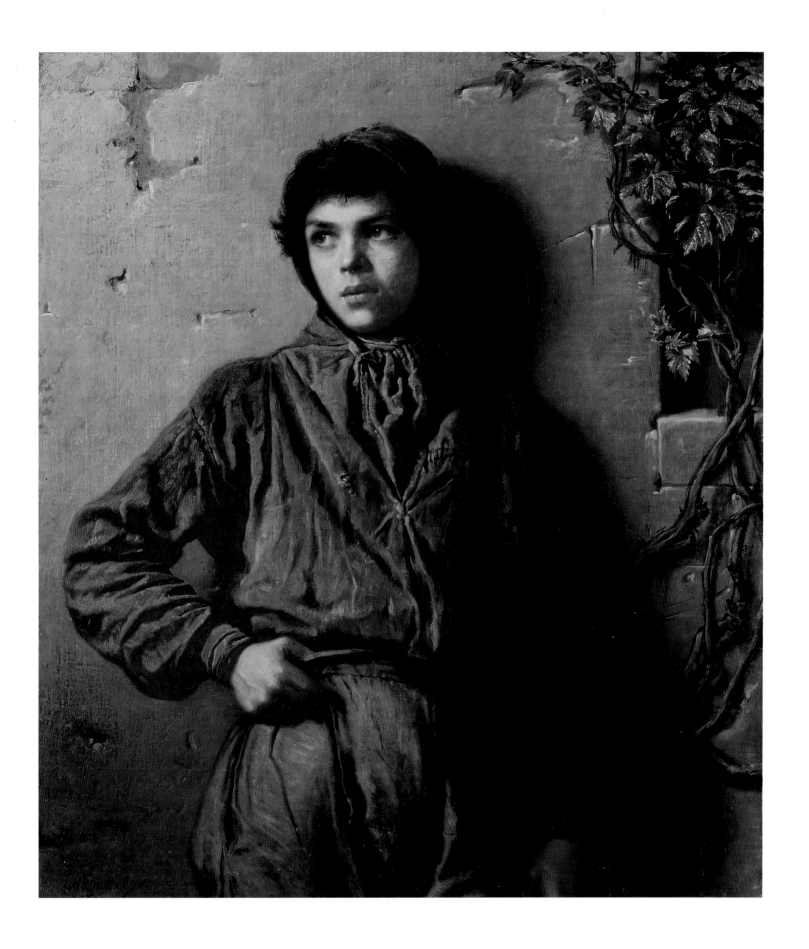

NO. 9
The Savoyard Boy, 1853
Oil on canvas, 37⅜ x 32⁷⁄₁₆ in.
Brooklyn Museum of Art, Bequest of
Henry P. Martin, 07.273

FIG. 20
Eastman Johnson
Portrait of a Man with a Hat (Self-Portrait?),
1853
Oil on canvas
Courtesy of Rijksbureau voor Kunsthistorische
Documentatie, The Hague

NO. 10
Sketching at Dongen, 1853
Graphite on paper, 7 x 10½ in.
Collection of Elizabeth Feld

NO. 11
Portrait of Johannes Bosboom, April 1855
Charcoal on paper, 20⅜ x 16⅜ in.
Museum of Fine Arts, Boston, M. and M.
Karolik Collection, 59.1115

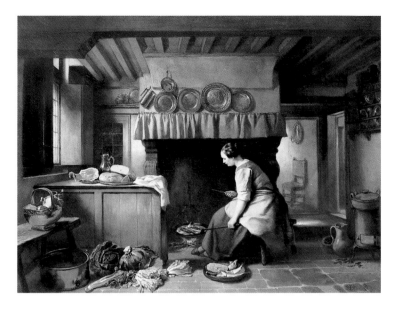 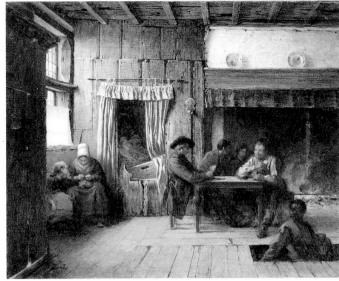

FIG. 21
Hubertus van Hove
A Flemish Kitchen, circa 1854–65
Oil on canvas, 24¼ x 31⁵⁄₁₀ in.
Rijksmuseum, Amsterdam

FIG. 22
Eastman Johnson
The Card Players, circa 1853
Oil on canvas, 15½ x 19 in.
Courtesy of Christie's Images

only accurate indication of Johnson's Dutch contacts at the time.[84] Among the painter members who may have exerted a particular influence on the direction of Johnson's art was Hubertus van Hove (1819–1865), author of such well-received *doorkijkes* (domestic views) as *A Flemish Kitchen* (fig. 21), variants on the stark interiors of Dutch masters like Pieter de Hooch. Equally important for Johnson was the Pulchri member Johannes Bosboom (1817–1891), a painter known for quietist church interiors inspired in part by the earlier work of Pieter Jansz Saenredam. In April 1855 Johnson executed a striking profile portrait of Bosboom (No. 11), who would become a key figure in the formation of the Hague school. Bosboom's *Kloosterkeuken* (Private collection, the Netherlands), exhibited at the 1852 Living Artists exhibition, might have held particular appeal for Johnson in its spare description of the age-worn interior of a monastery refectory. The degree to which Johnson experimented with typical Dutch settings while in The Hague is demonstrated in a rendition of *The Card Players*, circa 1853 (fig. 22), set in an interior with an expansive hearth and "box-bed."[85] This type of simple, domestic backdrop would recur time and again in Johnson's mature work (for example, *Sunday Morning*, 1866 [No. 34]; and *The New Bonnet*, 1876 [No. 45]), along with specific details like the dull brown planking and the mound of glowing embers.

Johnson may have become more involved with his Dutch colleagues after the departure of Mignot for America about May 1854. He nevertheless had contact with certain American artists, including Worthington Whittredge, whose portrait he painted during a visit that year in Düsseldorf, or on the occasion of one of Whittredge's frequent visits to The Hague.[86]

Johnson's impressive success as a portraitist in The Hague continued well into 1855, when he completed such finely finished portrait heads as those of the Baron and Baroness Bentinck (figs. 23, 24).[87] He also drew a striking likeness of the young Polly Gary (No. 12). The remarkable evolution of his drawing technique while in Holland is visible in works other than his formal portraits as well. His *Study of an Oriental*, circa 1852–55 (No. 13), clearly inspired by a figure type that Rembrandt had often employed, and *Portrait of a Gentleman Smoking a Pipe*, circa 1854–55 (No. 14), very likely a portrait of a colleague, reveal a sureness of line, greater vocabulary of touch, and vigor and expressive power missing from his earlier work.

Johnson had been drawn to The Hague by the reputation of the Mauritshuis and its royal collections, but his works from this period only begin to reveal the impact that the aesthetic of Rembrandt and the great masters of seventeenth-century Dutch genre would eventually have on his interior subjects of the 1860s

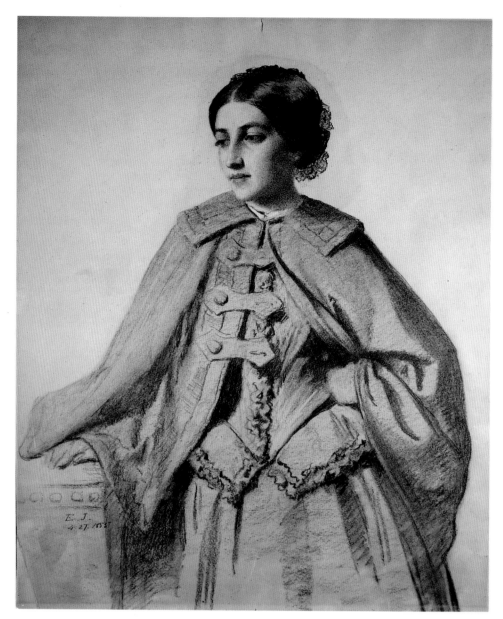

FIGS. 23, 24
Eastman Johnson
*Portraits of Volkert Willem Rudolph Baron
Bentinck and Wilhelmina Anna Maria Baroness
Fagel-Bentinck*, 1855
Crayon on paper, each 24⅝ x 20⅞ in. (oval)
Courtesy of Rijksbureau voor Kunsthistorische
Documentatie, The Hague

and 1870s. Johnson became a painter in his own right in The Hague under the
Dutch influence, and he would continue to draw inspiration from Rembrandt's
light-bathed forms and expressive nuance and from the quiet intimism of rustic
Dutch interiors by Dou and his own contemporary Bosboom. Having made his way
into the most vital community of painters at work in Holland, he found an environ-
ment that appears to have suited him in the domestic character of studio life and
aesthetic reverence for humble material detail. Within this context he achieved his
first successes as a painter and won the respect of Dutch and American patrons
alike. Johnson's intended four months in The Hague became four years, during
which he found the artistic practice and aesthetic that he would eventually adopt
as his own. It is hardly surprising that in paraphrasing Johnson's own comments
on his Dutch stay, Henry T. Tuckerman reported that the experience was one of
"unexpected opportunities."[88]

Even after four years in Holland, Johnson was not yet ready to return home in
1855. He set out for Paris, where he rented a studio space at 14, boulevard Poisson-
nière,[89] apparently for an extended stay. (His plans to remain there were altered
only when his mother's death in early September led him to return home in late
October.) Among the relative legions of artists at work in the French capital at this
moment were his former Düsseldorf colleagues Woodville and Ludwig Knaus
(1829–1910), both of whom were in the position to encourage their friend to seek

NO. 13
Study of an Oriental, circa 1852–55
Pencil on paper, 21¼ x 15 in.
Museum of Fine Arts, Boston, M. and M.
Karolik Collection, 1971.380

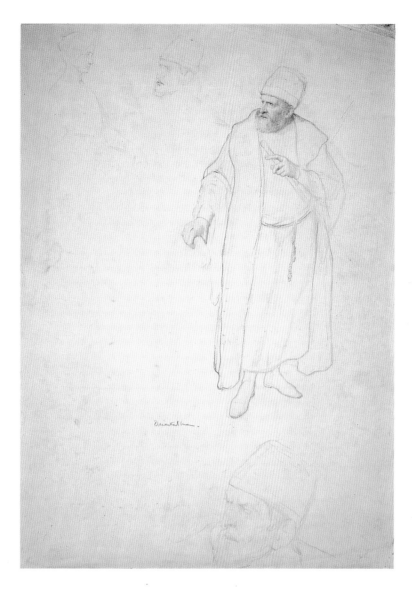

NO. 14
Portrait of a Gentleman Smoking a Pipe,
circa 1854–55
Charcoal, pencil, and chalk on paper,
10¾ x 9⅛ in.
The Free Library of Philadelphia, Rosenthal
Collection, Print and Picture Collection

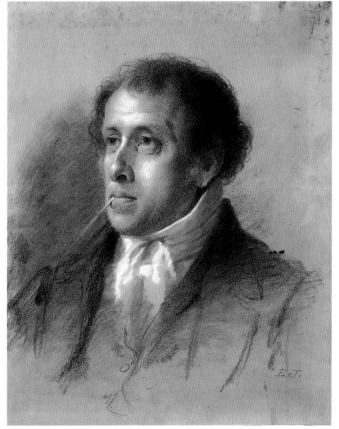

contact with the influential French academician Thomas Couture (1815–1879).[90] While much has been made of the impact of Johnson's eight or so weeks with Couture,[91] in fact he had already begun in Holland to employ the type of reddish brown underlayer of paint and the application of impastoed lights that are signal features of the Frenchman's execution (as, for example, in *The Violin Player* and *The Card Players*). Johnson, moreover, was hardly ready to undertake at this time the vigorous preparatory *ébauches*, or oil sketches, that were the hallmark of Couture's process. While Johnson had made contact with a new and sympathetic method in Couture's studio, its impact on his work would not be definitive until the late 1860s and 1870s, when the publication of the Frenchman's *Méthode et entretiens d'atelier* (a collection of his studio lectures published in 1867) had an impact on more than one American painter.[92]

"America's Rembrandt" Comes Home

After six remarkable years abroad, Johnson sailed home on October 24[93] and made his way to Washington, D.C., where he would soon reveal a determination to apply his dramatically expanded abilities to subjects that were clearly original and distinctly American. On November 30, 1855, Washington's *National Intelligencer* welcomed back Eastman Johnson, "the well-known Washington artist,"[94] for whom the return must have been something of a culture shock. The artist rejoined his father and siblings in the new brick row house at 266 F Street (between Thirteenth and Fourteenth Streets), located very near the White House and the offices of the Navy Department, where Philip Johnson was securely ensconced.[95] Perhaps in an effort to reassert his earlier reputation while demonstrating his improvement, Johnson immediately resumed his essential métier of portraiture. Among the first works that he would complete after his return was a strong and expressive portrait of his father's employer, James Cochran Dobbin, secretary of the navy. Reporting on the Washington art scene the following March, the *Crayon* noted that among the portrait painters at work in the District were Johnson and Charles Bird King, a pairing that demonstrated the hope that observers held for the newcomer's career.[96] Johnson appears to have done relatively little new painting in this initial period, however, and he tellingly made his debut at the National Academy of Design that spring with two favorite Dutch subjects, versions of *The Card Players* and *The Savoyard Boy*. He did complete one particularly fine pastel portrait of the daughter of the Washington notable James C. McGuire, *Portrait of Nannie McGuire (later Mrs. Richard T. Merrick)*, 1856 (fig. 25).

By the summer of 1856, however, Johnson was tempted away from his new artistic practice by the lure of the northwestern frontier and the possibilities that it offered for land speculation. In 1854 his oldest sibling, Reuben (1819–1884), had moved to the budding town of Superior, Wisconsin, where he established a lumber mill. The Anishinabe (Ojibwe) people had reluctantly ceded their territory on Lake Superior to the federal government that year, and Superior was quickly surveyed and platted. Among the "Proprietors of Superior," a group of Minnesotans who purchased shares in the town, was William H. Newton, who married Johnson's sister Sarah in February 1856, in Washington, D.C.[97] Johnson joined his siblings in Superior by the fall and promptly made real-estate investments with his own and his father's money. In October he completed an attractive portrait of his sister Sarah Osgood Johnson Newton (No. 15), and about that time he executed a beautifully subtle drawing of her sister-in-law, Mary Newton Hayes (No. 16). The former work is particularly distinguished by the evident vitality and panache of the sitter: the dash of her riding habit and ivory-handled crop is matched by the liveliness of her gray eyes and rosy coloring.[98]

FIG. 25
Eastman Johnson
Portrait of Nannie McGuire (later Mrs. Richard T. Merrick), 1856
Pastel on paper, 25½ x 21 in.
The Corcoran Gallery of Art, Washington, D.C., Gift of George Hamilton, Jr.

Johnson ventured into the wilder reaches of his new environment as well, setting out that winter to explore the farther shores of Lake Superior. He traveled as far as the Apostle Islands and Isle Royale in the company of a man named Stephen Bonga, a local guide of mixed Indian and African descent whose family had been active in the area's vast fur trade. They established a cabin at Pokegama Bay (opposite Duluth on the Saint Louis River), where Johnson completed a sketch of the interior with a figure that may represent his companion (fig. 26).[99] Johnson may have recalled this cedar log cabin when he painted *The Boy Lincoln* (fig. 73) more than a decade later.

Johnson was intrigued by the challenge of frontier life, but he had not yet decided to abandon the East completely. He returned to Washington that spring and contributed four works to the exhibition organized by the Maryland Institute in Baltimore; all four, including an oil version of *My Jew Boy* (location unknown), were owned by his supportive early patron John F. Coyle. Johnson participated that May in the first annual exhibition of the Washington Art Association with five paintings and five drawings.[100] The only work that he appears to have painted specifically for the exhibition was *The Pets*, 1856 (fig. 27), in which his illusionistic treatment of detail suggests the impact of his Dutch years. The painting was lent by the retired banker and philanthropist William W. Corcoran (1798–1888), one of the most influential directors of the Art Association and the owner of the building in which the exhibition took place. Corcoran's energetic determination to promote American art would lead him to embark on the construction of The Corcoran Gallery of Art in 1859.[101] One of Johnson's versions of *The Savoyard Boy* was lent to the 1857 exhibition by Corcoran's former business partner, George Washington Riggs (1813–1881), whose sons had sat for Johnson for crayon portraits earlier that year. Riggs was something of a beginner in the field of collecting, but within a decade he was cited among notable collectors of American art by Henry T. Tuckerman— and he would later purchase an 1864 version of Johnson's *Kitchen at Mount Vernon* (Mount Vernon Ladies' Association, Mount Vernon, Virginia).[102]

Perhaps the most talked-about painting in the 1857 exhibition was a large historical treatment of the Puritan uprisings titled *The Foraging Party* (location unknown), painted by Johnson's old friend Mignot in collaboration with another acquaintance, John Ehninger. The artists withdrew the painting from the exhibition prematurely to exhibit it at the National Academy of Design, where, incidentally,

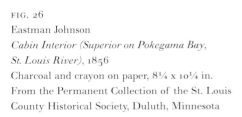

FIG. 26
Eastman Johnson
Cabin Interior (Superior on Pokegama Bay, St. Louis River), 1856
Charcoal and crayon on paper, 8¼ x 10¼ in.
From the Permanent Collection of the St. Louis County Historical Society, Duluth, Minnesota

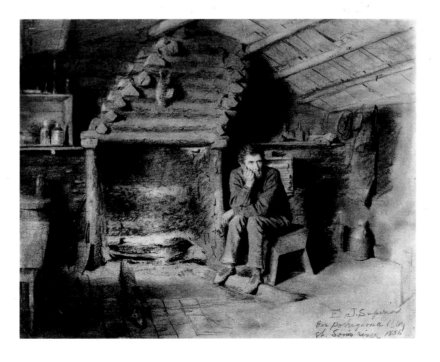

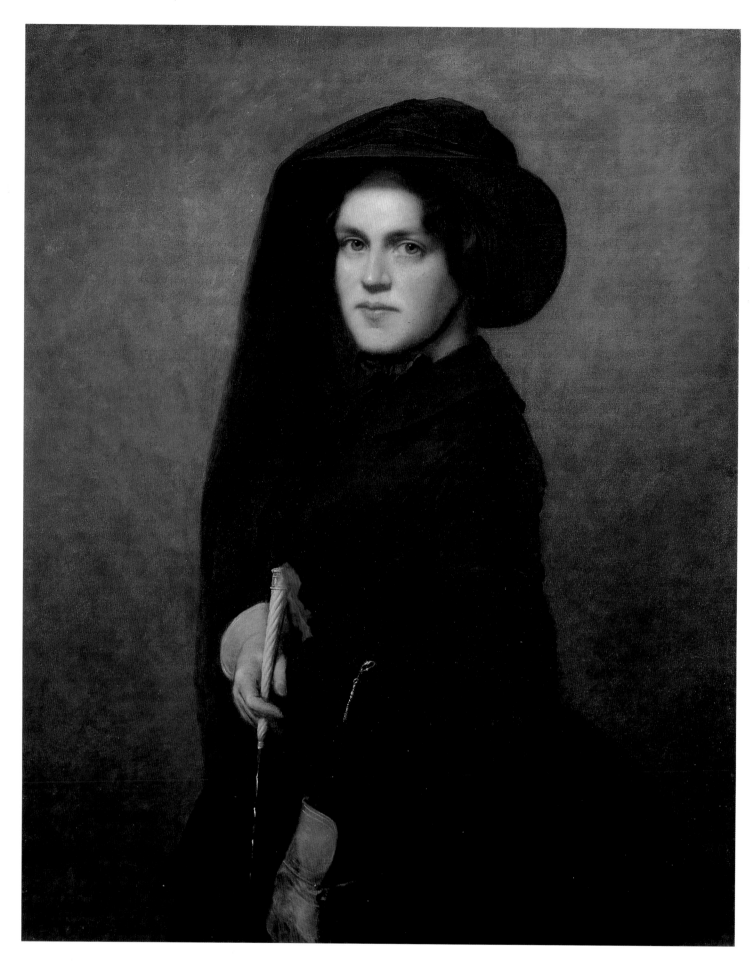

NO. 15
Sarah Osgood Johnson Newton, October 1856
Oil on canvas, 35¼ x 28½ in.
Collection of Sarah May Edmonds Broley

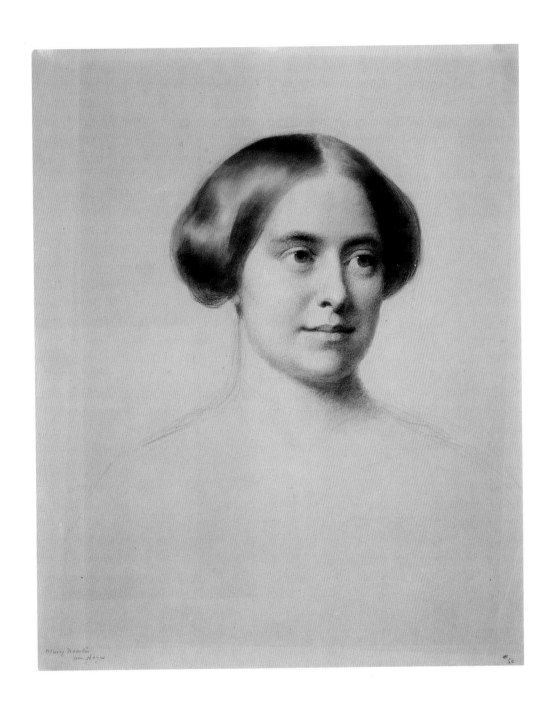

NO. 16
Portrait of Mrs. Hayes (Mary Newton),
circa 1856
Charcoal on paper, 21¾ x 16⅞ in.
Museum of Fine Arts, Boston, Gift of Maxim
Karolik, 1959, 59.112

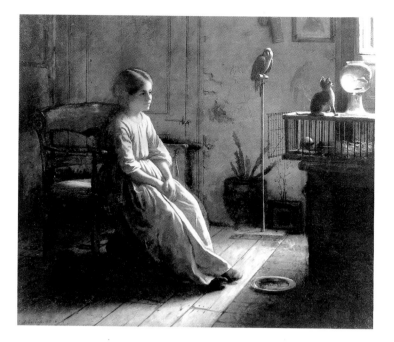

Mignot and Johnson's early collaboration, *Doorway of a Castle in Winter* (referred to there as *Winter Scene in Holland*), was on loan from George Folsom. The attention devoted to Mignot and Ehninger's more impressive production may have encouraged Johnson to renew his own collaborative relationship with Mignot, for at some point that summer the two painters were the guests of John Augustine Washington at the declining estate of the first president, where Johnson completed *The Old Mount Vernon* (No. 68). Their entrée to the mansion would have been facilitated by the impending marriage that August of Johnson's father to a Washington descendant, Mary Washington James (see essay by Patricia Hills in this volume).

Johnson among the Anishinabe (Ojibwe)

Despite his successful Washington season and the promise of new work with Mignot, Johnson decided to leave the city once again in midsummer 1857 to return to Superior. He explained his motives in a letter to his former patron Henry Wadsworth Longfellow, who had just written to commission a portrait of his young daughters:

> One might reasonably wonder what attraction that wild region can have for an artist, in comparison with such advantages as would result to me from your kind & flattering offer, the patronage of the most celebrated in the most refined of places. Perhaps I cannot entirely justify it, but in a visit to that country last season I found so much of the picturesque, & of a character so much to my taste & in my line, that I then determined to employ this summer or a portion of it in making sketches of Frontier life, a national feature of our present condition & a field for art that is full of interest, & freshness & pleasing nature, & yet that has been but little treated. My chief desire is to paint pictures. In Europe I worked six or seven years with diligence & zeal to this end, sacrificing much, & my wish is that it may come to something.[103]

Johnson's emphatic desire to "paint pictures" demonstrates that he had goals beyond portraiture; and he surely expected a sympathetic response from the poet who two years earlier had published the narrative poem *The Song of Hiawatha*, which was largely based on an Anishinabe (Ojibwe) story. Longfellow, who had never traveled west, had taken the details of his narrative from the writings of the seminal ethnologist Henry Rowe Schoolcraft (1793–1864), whose work was based in part on information provided by his Ojibwe-Irish wife, Jane Johnson Schoolcraft.[104]

Johnson was one of a host of American artists to consider Indian subjects at

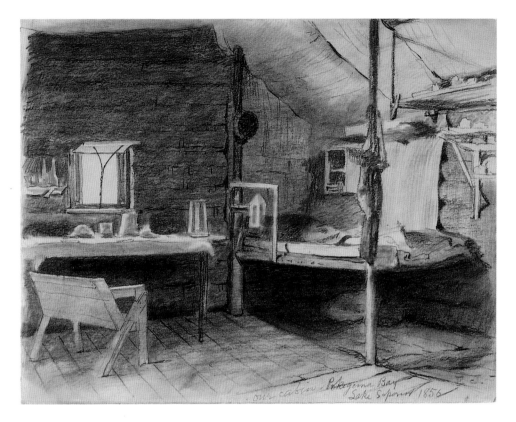

midcentury. Prompted in part by literary manifestations like Longfellow's, the call
for indigenous American subject matter, and more specifically Indian themes in the
visual arts, had been in the air at the time of Johnson's return from Europe. In January
1856, just months after his return, the *Crayon* published a piece in which American
artists were encouraged to make haste in recording the appearance and habits of the
Indian: "Soon the last red man will have faded forever from his native land, and
those who come after will trust to our scanty records for their knowledge of his habits
and appearance. . . ."[105] Johnson also had at his easy disposal in Washington the most
successful example of such art in Charles Bird King's Indian Gallery. The popularity
of this collection of bust portraits of visiting Indian leaders (commissioned by the
chief of the Bureau of Indian Affairs over the course of decades beginning in 1816
and installed in the War Department Building) may have suggested to Johnson the
potential American appetite for more elaborate variations on the theme.[106]

On his return west, Johnson settled in for an extended stay in the more remote
area of Grand Portage (150 miles north of Superior, at the Canadian border). There
he completed a fascinating body of imagery of the native Anishinabe (Ojibwe) in
preparation for an ambitious painting. About a hundred and fifty Anishinabe lived
in the Grand Portage area in the early nineteenth century, and a temporary summer
village was maintained at Grand Portage Bay.[107] Even after the circumscription of
the reservation in 1854, Grand Portage served the Anishinabe primarily as a summer
fishing ground and harvest site for wild rice and cranberries in the early fall; hunting
and maple sugaring took place farther inland in the winter and spring. Groups
based farther away also gathered in Grand Portage each summer to collect their
government annuities at gatherings that recalled pretreaty summer rendezvous
attended by a thousand or more Anishinabe each year. Johnson completed two oil
studies of the settlement by way of general documentation of the site for use as a
possible landscape setting; in *Camp Scene at Grand Portage* (No. 102), an array of
wigwams, cabins, canoes, and figures appear in the shadow of Mount Rose, at the
far left. At least one of the cabins served as a school established by the government
in 1856. Johnson's shelter there was probably similar to his cabin at Pokegama
Bay—whose interior he had documented in a sketch (No. 17).

FIG. 28
Paul Kane
Sault Ste. Marie from the American Side,
circa 1855
Oil on canvas, 18 x 29 in.
Royal Ontario Museum, Toronto, 912.1.9

During the period from August 24 to October 22, Johnson executed and dated a series of portrait heads that for several reasons have come to be regarded as perhaps the most sensitive midcentury likenesses of Native Americans. Johnson was the most highly trained figure painter to undertake Indian portraits at the time, and his already significant experience as a portraitist allowed him to achieve a greater degree of accuracy in physiognomic detail and a more convincing sense of the character of his sitters, whom he had come to know personally. His artistic abilities surpassed King's, for example, and his sensibility for portraiture freed him from the figural generalizations that occur in the more ethnographically oriented Indian subjects by such artists as Seth Eastman (1808–1875) and Paul Kane (1810–1871) (fig. 28).[108]

In *Sha Wen ne gun* (No. 18) and *Ojibwe Boy* (No. 19), Johnson exercised the suggestive line and evocative shading that were among his best talents, producing works that adhere to the traditional western European canon of portrait devices (see also Nos. 100, 101). That Johnson saw his efforts as continuous with the European classical tradition is suggested in a recollection by his wife, Elizabeth, after his death: "Mr. Johnson said the ancient Romans had no more patrician features nor more noble bearing than they. . . ."[109] A number of these works nevertheless are strikingly forceful, including his intensely expressive *Studies of an Ojibwe Man* (No. 21). This work recalls Charles Bird King's remarkable group portrait *Young Omaha, War Eagle, Little Missouri, and Pawnees,* 1822 (fig. 29), which Johnson was sure to have seen on view at King's gallery, just blocks from the Johnson home in Washington. King's Indian portraits openly participated in the paradoxically earnest American effort to document for posterity the race that it actively sought and expected to fully extinguish. In their less emphatic drive toward the documentary and their intimacy of expression, Johnson's Indian portraits appear to refrain from full participation in the more disingenuous antebellum enthusiasm for portraying Native Americans.[110]

Among the most compelling of these images is Johnson's study of *Sha men ne gun* (No. 20), a strikingly direct portrayal of a standing figure. Similarly posed figures appear in a number of the relatively awkward preliminary oil sketches for a never-completed elaborate multifigure Indian subject (St. Louis County Historical Society, Duluth, Minnesota). Johnson prepared other motifs as well in the form of spontaneous plein-air oil studies like *Ojibwe Wigwam at Grand Portage* (No. 22).

The most finished composition of Johnson's Grand Portage sojourn is a pastel that has come to be known as *Hiawatha* (No. 23), which this author interprets as Johnson's attempt to represent a bereaved Ojibwe woman. (An Anishinabe representative has recently stated that an attempt by Johnson of such a subject would have been offensive to Anishinabe observing traditional burial customs, as is this inter-

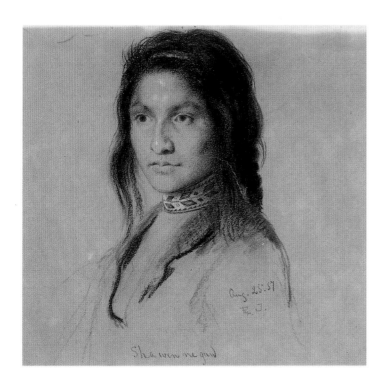

NO. 18
Sha Wen ne gun, August 25, 1857
Charcoal and crayon on paper, 7¼ x 7½ in.
From the Permanent Collection of the St. Louis
County Historical Society, Duluth, Minnesota,
62.181.20

NO. 19
Ojibwe Boy, 1857
Charcoal and crayon on paper, 5 x 4¾ in.
From the Permanent Collection of the St. Louis
County Historical Society, Duluth, Minnesota,
62.181.24

NO. 20
Sha men ne gun, 1857
Charcoal and crayon on paper, 21¼ x 9⅛ in.
From the Permanent Collection of the St. Louis
County Historical Society, Duluth, Minnesota,
62.181.17

NO. 21
Studies of an Ojibwe Man, 1857
Oil on canvas, 7 x 12 in.
From the Permanent Collection of the St. Louis
County Historical Society, Duluth, Minnesota,
62.181.6

FIG. 29
Charles Bird King
Young Omaha, War Eagle, Little Missouri,
and Pawnees, 1822
Oil on canvas, 28 x 36⅛ in.
National Museum of American Art,
Smithsonian Institution, Washington, D.C.,
Gift of Miss Helen Barlow, 1985.66.384.222

pretation of Johnson's image.)[111] The precise source of inspiration for the image remains unclear, and no evidence exists to link it to Longfellow's poem. Johnson prepared another version of the composition (inscribed "Oct. 3, 1864") for presentation to the poet William Cullen Bryant (1794–1878) seven years later as part of a seventieth-birthday gift of small artworks from fellow members of The Century Association. Whether or not Johnson completed a new drawing for Bryant or redated an earlier Grand Portage piece, his association of this motif with the writer suggests a possible source for the pastel in Bryant's well-known poem "The Indian Girl's Lament" (1823), whose first stanza begins: "An Indian girl was sitting where / Her lover, slain in battle, slept; / Her maiden veil, her own black hair, / Came down o'er eyes that wept. . . ."[112] If Johnson found his original inspiration elsewhere in 1857, his rededication of the image in 1864 would provide a compelling example of the fluidity of such themes within the culture of the period.

Johnson's stay in Grand Portage was cut short at the end of the year when the widespread financial panic of 1857 rendered his Wisconsin real-estate investments worthless. His expansive plans to record the "fresh and pleasing national feature" that the Anishinabe (Ojibwe) constituted in his eyes were abruptly halted, and he left the frontier for Cincinnati to raise cash with some quick portrait commissions. Surprisingly, Johnson failed to return to the Ojibwe project, though not for lack of encouragement. Ten years after Johnson's stay in Grand Portage, the critic Henry T. Tuckerman attempted to rekindle the painter's interest, albeit in the racist language of the time. Tuckerman wrote: "[W]e cannot but hope that Eastman Johnson will do for the aborigines what he has partially but effectively done for the negroes. In a few years the Indian traits will grow vague; and never yet have they been adequately represented in art. . . ."[113] Tuckerman's encouragement apparently had little effect on Johnson: the artist's Ojibwe portfolio remained, valued but untouched, in his studio through the end of his life.[114]

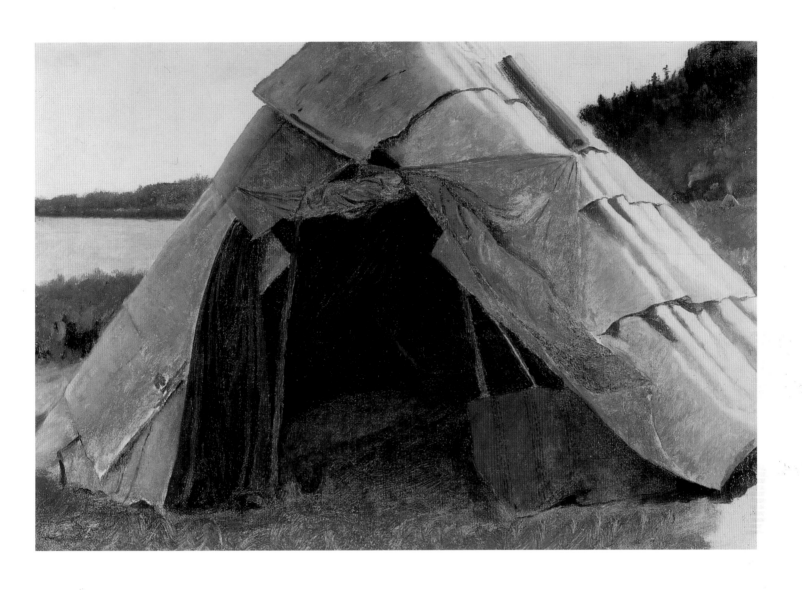

NO. 22
Ojibwe Wigwam at Grand Portage, 1857
Oil on canvas, 10¼ x 15¼ in.
From the Permanent Collection of the St. Louis
County Historical Society, Duluth, Minnesota,
62.181.10

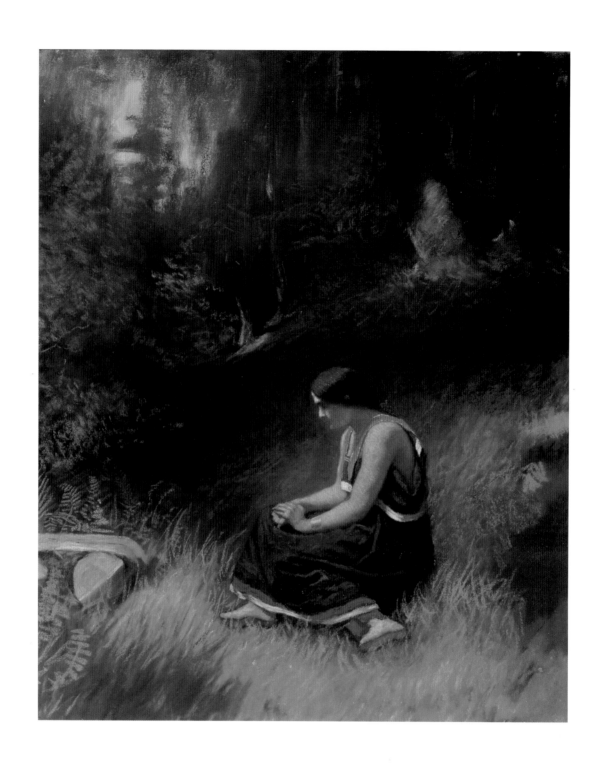

NO. 23
Hiawatha, 1857
Pastel on paper, 13½ x 11 in.
From the Permanent Collection of the St. Louis
County Historical Society, Duluth, Minnesota,
62.181.9

Despite his ultimate failure to achieve the goal that he had described to Longfellow in the summer of 1857, Johnson's letter to the poet identified the direction in which he hoped to move his artistic practice on his return from Europe. Perhaps as early as 1853, when he had undertaken his painting based on Stowe's novel, he had determined to address in his art the "present condition" of his native country. It may have been this consideration that ultimately led him to decline the Mount Vernon collaboration with Mignot—who painted a nostalgically mannered tableau, *Washington and Lafayette at Mount Vernon, 1784* (The Metropolitan Museum of Art, New York), in 1859 with Thomas P. Rossiter—in favor of his own stark and quietist vision of the descendants of Washington's slaves at home in the decrepit kitchen dependency adjacent to the mansion, *Kitchen at Mount Vernon*, 1857 (No. 69). Apparently willing to forego the fanfare and accolades that works like the Mignot-Rossiter could easily accrue, Johnson was about to create American subjects that possessed the originality and immediacy that he professed to value. It is tempting to believe that his colloquy with Emerson some ten years earlier had led him to that writer's ubiquitous collections of essays, and particularly to Emerson's discourse on "Art," where he would have read, "No man can quite emancipate himself from his age and country, or produce a model in which the education, the religion, the politics, usages, and arts of the times shall have no share." With characteristic lucidity, Emerson elaborated, "Above his will and out of his sight [the artist] is necessitated by the air he breathes and the idea on which he and his contemporaries live and toil, to share the manner of his times, without knowing what that manner is."[115] In 1857 Johnson began to anticipate a broader movement in the direction of Realism, and his drive to make his art out of the American present would soon prove him to be a man of his times.

Notes

I owe a debt of gratitude to Patricia Hills, co-author of this volume and co-curator of the exhibition, for generously allowing me open access to her extensive documentary card file on Johnson's works; for answering innumerable questions on the scope and details of his career; and for responding to drafts of these essays with care, enthusiasm, and insight.

I am also deeply grateful to Julie M. Douglass for her invaluable research support in all phases of the preparation of this essay and the one that follows. Thanks are due as well to John Coffey, of the North Carolina Museum of Art, for his excellent advice on archival resources in The Hague; and to Dr. Martha Op de Coul, of the Rijksbureau voor Kunsthistorische Documentatie (RKD) in The Hague, for her exceedingly generous assistance during and after my stay in The Hague. I would like to offer a special note of thanks to Robert B. Goldsmith, for encouraging my travel to The Hague and for making it possible.

1. This prosperity was tied to the rise of a middle class of entrepreneurs and the ascendancy of their Democratic party in state politics. For a discussion of Maine's regionalism, see Alan Taylor, *Liberty Men and Great Proprietors* (Chapel Hill: University of North Carolina Press, 1990). I thank Anne C. Rose for suggesting this source.

2. For information on the Johnson family in Lovell and Fryeburg, Maine, I relied on Eva W. Barbour, "Eastman Johnson, 1824–1908," typescript, 1975, Fryeburg Historical Society.

3. See Patricia Hills, *The Genre Painting of Eastman Johnson: The Sources and Development of His Style and Themes* (New York: Garland, 1977), p. 21, n. 2.

4. Fairfield served as governor from 1838 to 1840 and from 1842 to 1843, elected annually. See *Biographical Dictionary of the Governors of the United States, 1789–1978*, ed. Robert Sobel and John Raimo, vol. 2 (Westport, Conn.: Meckler Books, 1978), p. 602.

5. See Hills, *The Genre Painting of Eastman Johnson*, p. 22, n. 5.

6. William Walton, "Eastman Johnson, Painter," *Scribner's Magazine* 40, no. 3 (September 1906), pp. 263–74. The exact site of Johnson's lithographic work has never been ascertained. John I. H. Baur suggested John H. Bufford's shop, where the young Winslow Homer would find employment from 1854/55 to 1857; see Baur, *An American Genre Painter: Eastman Johnson, 1824–1906* (Brooklyn: Institute of Arts and Sciences, 1940), p. 5. Johnson initially may have been hired by Thomas Moore, who was bought out by Bufford in 1841 or 1842 and who had hired other rising young artists like Fitz Hugh Lane (1804–1865). (Moore had purchased the firm from the Boston lithographer William S. Pendleton in 1836.) There were other possibilities,

however, including the firms of Sharp, Michelin and Co., run by the English printer William Sharp, who also ran Sharp's Drawing Academy at 17 Tremont Row. See Harry Twyford Peters, *America on Stone*, 20 vols. (New York: Doubleday, 1931).

7. See Carol Troyen, *The Boston Tradition: American Paintings from the Museum of Fine Arts, Boston*, exh. cat. (New York: American Federation of the Arts, 1980), p. 18.

8. See Walton, "Eastman Johnson, Painter," p. 264.

9. During the nineteenth century, the term *crayon* denoted a variety of drawing implements in stick form, including graphite, charcoal, and chalk, as well as fabricated sticks composed of pigments bound with water-soluble or fatty media. See James Watrous, *The Craft of Old-Master Drawings* (Madison: University of Wisconsin Press, 1957), p. 91.

10. *Portland Advertiser*, October 9, 1845, as quoted in William D. Barry, "The Rembrandt of Sugaring Off," *Down East* 38 (April 1992), p. 36. I am grateful to William D. Barry of the Maine Historical Society, Portland, for his generous assistance in answering questions regarding Johnson's career in Maine.

11. The subjects ranged from portraits to other favorites of the period: shipwrecks and pirates, Indians and monks. See "Cole's Gallery of Paintings," *Weekly Tribune and Bulletin* (Portland, Maine), July 11, July 24, and August 14, 1845.

12. William D. Barry notes Johnson's rental of space in the city hall in "The Rembrandt of Sugaring Off," p. 36. Johnson's ties to the Bridge family of Augusta, Maine, are the subject of Hildegard Cummings's "Eastman Johnson and 'Horatio Bridge,'" *Bulletin of the William Benton Museum of Art* 1, no. 4 (1975–76), pp. 17–32.

13. Congressman Longfellow lived with his wife, Zilpha Wadsworth, in a fine three-story brick house, the Wadsworth-Longfellow House, now part of the Maine Historical Society.

14. See John Davis, "Eastman Johnson's *Negro Life at the South* and Urban Slavery in Washington, D.C.," *Art Bulletin* 80, no. 1 (March 1998), p. 68. Davis determined the exact nature and timing of Philip Johnson's government position using Washington city directories.

15. Permission to work in rooms in the Capitol, by far the largest public building in the city at that time, was granted routinely by the Speaker of the House and the Commission of Public Buildings and was seldom formally recorded. Information provided to Julie M. Douglass by Bill Allen, Architectural Historian for the Architects to the Capitol Building, July 1998.

16. Eastman Johnson to Charles Henry Hart, December 31, 1896, frames 150–51, reel 934, Charles Henry Hart Papers, Archives of American Art, Smithsonian Institution, Washington, D.C. Johnson indicated that this first sketch measured about six inches in height; he also noted in the

same letter, "I have an elaborate crayon drawing of Mrs. Madison, about half life size, made the same year, in her beautiful turban and attire such as she was always seen in and never otherwise, as also with her smiling and beautiful countenance."

17. Quoted in Edgar French, "An American Portrait Painter of Three Historical Epochs," *World's Work* 13, no. 2 (December 1906), pp. 8311–12.

18. Edgar French would later write that "Johnson was invited to make his sketches at the same sittings. . . . Healy set up his easel while the younger artist moved about the room making his sketches from several points of view." French, "An American Portrait Painter," p. 8321.

19. The portfolios were *The National Portrait Gallery of Distinguished Americans* (published 1834–39 by Herring and Longacre) and *Delaplaine's Repository of Portraits and Lives of the Heroes, Philosophers, and Statesmen of America* (published in part in 1814–16 but never completed). See Andrew J. Cosentino, *The Paintings of Charles Bird King (1785–1862)*, exh. cat. (Washington, D.C.: Smithsonian Institution Press, 1977), pp. 42–43.

20. See ibid., p. 38.

21. Longfellow wrote in his journal on October 6: "We drove to town with the Portland visitors [his parents?]. All delighted with [Johnson's] portrait of me, thinking it the best ever made." The quotations here and in nn. 26 and 27 from Longfellow's journals and letters, now in the collection of the Longfellow National Historic Site, Cambridge, Massachusetts, were first cited in Baur, *An American Genre Painter*, p. 8. I used *The Life of Henry Wadsworth Longfellow, with Extracts from His Journals and Correspondence*, ed. Samuel Longfellow, vol. 2 (Boston: Houghton, Mifflin and Company, 1891), p. 58.

22. On October 27 he wrote, "I am more and more struck with Hawthorne's manly beauty and strange original fancies." Ibid., pp. 59, 61.

23. Nathaniel Hawthorne to Henry Wadsworth Longfellow, October 14, 1846, *Nathaniel Hawthorne, The Letters, 1843–1853*, ed. Thomas Woodson, L. Neal Smith, and Norman Holmes Pearson (Columbus: Ohio State University Press, 1985), p. 183.

24. Nathaniel Hawthorne to Sophia Hawthorne, March 20, 1847, in ibid.

25. According to Johnson's later reminiscences over punch and Welsh rarebit at The Century Association, when Hawthorne returned with his wife and daughter Rose to view the portrait, "[a] sudden scream from Mrs. H. called their attention to the little girl, who, in a fur-lined cloak and white wollen [*sic*] gloves, had been occupying herself in reworking the pictures along the wall." Johnson apparently described Mrs. Hawthorne "profuse with apologies and tears" and Hawthorne "greatly troubled." Hawthorne returned within the hour to offer assistance, but

said little, thus ending their last encounter. Johnson's reminiscences were recorded by the Centurian James Herbert Morse in a diary entry dated April 1, 1894. "Excerpts from the Diary of James Herbert Morse," compiled by William G. Morse, typescript, 1945, The Century Association Archives Foundation. I am grateful to John Harding, Curator of The Century Association, for bringing this source to my attention.

26. Henry Longfellow Journal, 1846, Collection of Houghton Library, Harvard University, as quoted in Nancy Jones, "Art Tour: The Works of Eastman Johnson and Samuel Rowse, Longfellow National Historic Site," typescript, 1996, Archives of the Longfellow National Historic Site, Cambridge, Massachusetts.

27. Henry Wadsworth Longfellow to Ralph Waldo Emerson, November 25, 1846, *The Letters of Ralph Waldo Emerson*, ed. Ralph Rusk (New York: Columbia University Press, 1966), vol. 3, p. 365.

28. Undated entry from Emerson's journal of 1846, *The Journals and Miscellaneous Notebooks of Ralph Waldo Emerson*, ed. Ralph H. Orth and Alfred R. Ferguson (Cambridge, Mass.: Belknap Press of Harvard University Press, 1971), vol. 9, *1843–47*, p. 382. Emerson wanted to exchange daguerreotype portraits with his friend, the English philosopher Thomas Carlyle. His reaction to his own second effort was not happy: "I brought home three shadows not agreeable to my own eyes. The machine has a bad effect on me. My friends say, they look ten years older, and, as I think, with the air of a decayed gentleman touched with his first paralysis." Emerson to Carlyle, May 31, 1846, *The Correspondence of Emerson and Carlyle*, ed. Joseph Slater (New York: Columbia University Press, 1964), p. 400.

29. As recalled by Edgar French in "An American Portrait Painter" (see n. 17 above), p. 8317.

30. Frances Appleton Longfellow to Emmeline Austin Wadsworth, December 23, 1846, as quoted in *Mrs. Longfellow: Selected Letters and Journals of Fanny Appleton Longfellow (1817–1861)*, ed. Edward Wagenknecht (New York: Longmans, Green, 1956), p. 123. Letters and journals yield no further information regarding the final portrait in the group (Longfellow National Historic Site, Cambridge, Massachusetts), that of Cornelius Felton, a Harvard professor of Greek and one of Longfellow's closest friends.

31. Until 1845 the Longfellows had maintained a study on the floor above. Longfellow clearly sought to promote his home as a hub for Boston literati as well as the site of cosmopolitan entertainments.

32. Morse diary, April 1, 1894.

33. French, "An American Portrait Painter," p. 8317.

34. Emerson's attitudes toward slavery and his gradual embrace of the antislavery movement are charted in detail in Len Gougeon, *Virtue's Hero: Emerson, Anti-Slavery and Reform* (Athens: University of Georgia Press, 1990).

35. *The Collected Works of Ralph Waldo Emerson*, vol. 4, *Representative Men: Seven Lectures* (Cambridge, Mass.: Belknap Press of Harvard University Press, 1987), p. 3.

36. This is known anecdotally. Johnson's name does not appear in the Boston city directories for the years 1846 to 1849.

37. A portrait drawing by Johnson, dated 1848 (formerly IBM Corporation; present location unknown) and previously identified as a self-portrait, is probably a likeness of his friend Hall.

38. "The Düsseldorf Gallery," a collection of more than fifty works by Düsseldorf artists owned by the Prussian consul John G. Boker and available for sale, had opened in New York to enthusiastic reviews in January 1849 and represented the kind of popular subject matter and legible style that Warner had found most appealed to the participants in his public art lottery. The enthusiasm for the Düsseldorf manner would begin to fade by the late 1850s, by which time the style was viewed as overly dependent on mechanical technique at the expense of artistic expression. See Barbara Groseclose, *Emanuel Leutze, 1816–1868: Freedom Is the Only King*, exh. cat. (Washington, D.C.: Smithsonian Institution Press, 1975), p. 51.

39. George Henry Hall to Andrew Warner, June 19, 1849, American Art-Union, Letters from Artists, The New-York Historical Society. Hall's and Johnson's revealing correspondence with Andrew Warner was first quoted extensively by Patricia Hills in *The Genre Painting of Eastman Johnson*, pp. 26–35 (see n. 5 above).

40. George Henry Hall to Andrew Warner, July 24, 1849, American Art-Union, Letters from Artists, The New-York Historical Society.

41. Johnson's letter reveals that he had come to view his limitation to the medium of drawing as a liability: "I am not aware whether the Art-Union is in the habit of purchasing drawings in black and white merely & I venture to send these more from my present necessity than from any disposition to exhibit attempts in what is generally considered an unsatisfactory method of making pictures." He also notes having completed the drawing of *The Sweeps* three years earlier, demonstrating his interest in varying his production soon after his arrival in Boston. Johnson to Andrew Warner, August 3, 1849, American Art-Union, Letters from Artists, The New-York Historical Society; the two drawings were exhibited at the Art-Union in 1849 and 1850, respectively.

42. The primary source on the activities of Leutze and his American circle in Düsseldorf is Groseclose, *Emanuel Leutze* (see n. 38 above).

43. Groseclose has suggested that Johnson's attendance in these classes would explain his absence from the official Academy rolls during his years in Düsseldorf; see ibid, pp. 136–37.

44. Johnson to Andrew Warner, October 10, 1850, American Art-Union, Letters from Artists, The New-York Historical Society. The letter explains, "Rents are very low, but living or board is no cheaper here, or at any rate but very little than in N. York or Boston. And until one has acquired some knowledge of the language and worn off a little of his foreign aspect he pays a premium on everything he purchases or sees."

45. The three in addition to Johnson would appear to be Leutze, Richard Caton Woodville—in Düsseldorf since 1845—and Worthington Whittredge, who arrived in 1849. Hall's deep dissatisfaction with Düsseldorf was conveyed to Warner in two letters dated July 8 and October 18, 1850, in which he complained about a lack of access to works of the Old Masters, the rudimentary nature of training at the Academy, the illustrational quality of the paintings, and the "dry, painty, and opaque" use of color. American Art-Union, Letters from Artists, The New-York Historical Society.

46. Woodville would leave Düsseldorf by the end of the year. Johnson to Andrew Warner, October 10, 1850, American Art-Union, Letters from Artists.

47. Johnson to Andrew Warner, January 16, 1851, American Art-Union, Letters from Artists.

48. Patricia Hills has devoted considerable attention to the various versions of the subject produced in Leutze's atelier that winter and to Johnson's role in completing the engraver's copy. She concludes that Johnson was largely responsible for the small-scale replica, with Leutze adding only finishing touches. See Hills, *The Genre Painting of Eastman Johnson*, pp. 34–41. Barbara Groseclose has suggested to the contrary that Johnson acted more in the role of assistant to Leutze in executing the reduced version. See Groseclose, *Emanuel Leutze*, p. 84. In a postscript to the same letter to Warner (see n. 47), Johnson alerted Warner to the impending purchase of the large *Washington Crossing the Delaware* by the new International Art Union under Goupil's auspices, hoping to stimulate Warner's interest in undertaking the project first.

49. In all quotations from Johnson's letters, original spelling has been retained. Johnson's letter to Charlotte Child was first quoted in full in Baur, *An American Genre Painter*, pp. 11–13. Eastman Johnson to Charlotte Child, March 25, 1851, frame 78, reel D30, Artists' Correspondence, Archives of American Art, Smithsonian Institution, Washington, D.C. Subsequent references here are to the same letter, frames 80, 81. Also see Appendix, where marginalia is omitted.

50. Johnson to Andrew Warner, July 19, 1851, American Art-Union, Letters from Artists.

51. Worthington Whittredge to Andrew Warner, August 2, 1851, American Art-Union, Letters from Artists.

52. Johnson to Andrew Warner, November 25, 1851, American Art-Union, Letters from Artists. Johnson here expressed his regret at "having spent so long a time in Dusseldorf when there is nothing to see but the present artists, who, whatever their merits may be, are very deficient in some of the chief requisites. . . ."

53. The paintings had been part of the collection of Willem's father, Stadtholder Willem V, in the late eighteenth century and formally housed in 1774 in a gallery regularly open to the public. Information on the early history of the Mauritshuis is drawn from Ben Broos, *The Mauritshuis, Royal Cabinet of Paintings Mauritshuis and Gallery Prince William V* (London: Scala, 1994), and Ben Broos, *De Rembrandt à Vermeer: Les peintres hollandais au Mauritshuis de la Haye*, exh. cat. (The Hague: Edition de la Fondation Johan Maurits van Nassau, 1986).

54. Though H. B. Nichols Clark has demonstrated a notable presence of Dutch works in the United States during the antebellum era, the majority of these were in private collections largely inaccessible to a young man like Johnson. Clark does point out the greater availability of prints after Dutch works. See Clark, "A Taste for the Netherlands: The Impact of Seventeenth-Century Dutch and Flemish Genre Painting on American Art, 1800–1860," *American Art Journal* 14, no. 2 (Spring 1982), pp. 23–38.

55. W. Bürger [Théophile Thoré], *Musées de la Hollande*, vol. 1, *Amsterdam et La Haye* (Paris: Ve Jules Renouard, Librairie-Editeur, 1858), p. 190 (my translation here).

56. This is one of three known details after *The Anatomy Lesson of Dr. Nicolaas Tulp*, two of which are in the hands of descendants of the artist. Though they appear to be fragments, it is unclear how much of the composition Johnson originally copied.

57. In the collection as a whole, Jan Steen was particularly well represented with six works. There were also representative still lifes by Willem van Aelst and others; landscapes by Nicolaes Berchem, Aelbert Cuyp, and Jacob van Ruisdael; portrait and figure subjects by Peter Paul Rubens, and portraits by Anthony van Dyck; and representatives of the foreign schools, including Albrecht Dürer, Claude Lorrain, Nicolas Poussin, Bartolomé Murillo, Raphael, and Giovanni Bellini. See *Notice des Tableaux du Musée Royal à la Haye* (The Hague: A. H. Bakhuyzen, 1860).

58. Journal entry dated March 1, 1858, Nathaniel Hawthorne, *The French and Italian Notebooks*, ed. Thomas Woodson (Columbus: Ohio State University Press, 1980), p. 297.

59. Ibid., journal entry dated June 15, 1858, pp. 317–18.

60. Detailed biographical information on Mignot is drawn from an unpublished chronology compiled by John W. Coffey, co-author (with Katherine Manthorne) of the exhibition catalogue *Louis Rémy Mignot: A Southern Painter Abroad* (Washington, D.C.: Smithsonian Institution Press, 1996). I am exceedingly grateful to John Coffey for his assistance in clarifying Johnson's contact with Mignot.

61. In the process of his research on Mignot, Coffey confirmed that Johnson did not enroll.

62. The history of the Hague Academy is reviewed in detail by John Sillevis in "Romanticism and Realism," in *The Hague School: Dutch Masters of the 19th Century*, exh. cat. (The Hague: Haags Gemeentemuseum, 1983).

63. Early nineteenth-century Dutch painting remains a relatively understudied field. I relied on G. Hermine Marius, *Dutch Painting in the Nineteenth Century* (London: Alexander Moring, 1908).

64. It is particularly surprising that Mignot did not participate again after the exhibition of their collaborative effort. The Belgian Alfred Stevens exhibited as early as 1851 and the Frenchman Thomas Couture in 1853, and more numerous French entries appeared in 1854. The exhibition catalogues are available at the RKD, The Hague.

65. *Tentoonstelling van Schilder en Kunstwerken van Levende Meesters te Rotterdam in 1852*, exh. cat. Johnson's three works were, respectively, nos. 224, 152, and 151.

66. *Tentoonstelling van Schilder en Anderer Werken van Levende Kunstenaars te Amsterdam in den Jare 1852*, exh. cat. I am grateful to Valentijn Byvanck for his assistance in the translation of the Dutch titles.

67. The same writer expressed appreciation of Johnson's execution, if not the crude expression, of his *Two Card Players*. "De Tentoonstelling te Rotterdam in 1852," *Kunstkronijk* (1852), p. 70. I thank John Coffey for first bringing this magazine to my attention, and Valentijn Byvanck for translating the passage on Johnson.

68. See "George Folsom," *Dictionary of American Biography*, vol. 6.

69. Johnson to George Folsom, March 17, 1852, Folsom Papers, The New-York Historical Society. Also see Appendix.

70. In addition to Schelfhout, who counted Scheveningen among his numerous sketching grounds, the figure painter Elchanon Verveer (1826–1900) produced numerous works based on the fisherfolk during the years of Johnson's stay; and by 1854, Jacob Maris (1837–1899), later a key player among Hague school painters, painted humble Scheveningen interiors in a manner inspired by Pieter de Hooch. Ronald De Leeuw discusses those artists who undertook paintings of Scheveningen and its inhabitants before the 1860s, when it became a favorite subject for members of the new Barbizon-influenced Hague school. See "Towards a New Landscape Art," in *The Hague School* (n. 62 above), pp. 61–62.

71. I thank Hans Nieuwenhuis and Nel Noordervliet-Jol of the Museum Scheveningen, the Netherlands, for their generous assistance in making this and other archival images available for examination.

72. One of the two cupboards remains in the hands of a descendant of the artist. Written in the artist's hand on a sheet of paper tacked to the top door's interior is the following inscription: "This cabinet is the property of William the Second, King of Holland, and was bought by me at the sale of his effects, at auction, in his palace in Tilburg, Province of Brabant, a year or two after his death—William Second [*sic*], (till 1815 Prince of Orange) died insolvent. Most of his effects, including his splendid Art Gallery at The Hague, were disposed of in the same way by his son and successor, William Third, 1851–52. Eastman Johnson. William 2nd died March 17th 1849." The cupboards appear in a number of Johnson's paintings, including *Kneeling Child* (Hirshhorn Museum and Sculpture Garden, Washington, D.C.)

73. Johnson is not listed in the general census conducted in the area during the years 1850–60; Mignot is listed on the Spui. For this information, I am grateful to John Coffey, who consulted the census records at the Haags Gemeente Archief (The Hague Municipal Archives).

74. *Vader Tom en Evangeline, naar aanleiding van Uncle Tom's Cabine van Ms. Beecher Stowe* was no. 260 in the catalogue of the *Tentoonstelling van Schilderijen, Enz. s' Gravenhage.*

75. *The National Union Catalogue, Pre-1956 Imprints*, 1976, vol. 572, lists at least one edition translated into Dutch in 1852, and additional Dutch editions published in Haarlem and other centers in 1853.

76. Among the exceptions was Robert Scott Duncanson (1821–1872), an African American who undertook the subject of *Uncle Tom and Little Eva* (The Detroit Institute of Arts) in 1853 on commission for an abolitionist Episcopalian minister, who may have met the artist while living in Cincinnati. See *American Paintings in The Detroit Institute of Arts* (New York and Detroit: Hudson Hills and The Detroit Institute of Arts Founders Society, 1997), vol. 2, p. 73.

77. Relatively exotic American subjects appear to have held some fascination for Dutch artists, as they did for other artists in Europe. To cite one example, the nineteenth-century Dutch genre and history painter Thomas S. Cool exhibited a painting of the Indian character Chactas, from Chateaubriand's Romantic novel *Atala*, in the 1854 Living Artists exhibition.

78. This and two individual portraits of George Folsom and his wife, Magarate Winthrop Folsom, both less securely dated and executed in the lithographic medium, are the subject of Joan Mary Kaskell, "Eastman Johnson, Lithographer," *Imprint* 22, no. 1 (Spring 1997), pp. 11–15. On "America's Rembrandt," see Walton, "Eastman Johnson, Painter" (see n. 6 above), p. 267.

79. Two of the small-scale, full-figure types are in private collections.

80. Henry T. Tuckerman, "Our American Artists—No. VII Eastman Johnson," *Hours at Home* 4 (December 1866), p. 173.

81. Perhaps best known of this group is Johnson's *The Card Players* (Private collection), in which he appears to derive aspects of the figure composition from the painting *Die Fahlspieler* (Kunstmuseum Düsseldorf), of 1851, by his Düsseldorf colleague Ludwig Knaus. Patricia Hills has pointed out Knaus's influence on Johnson in Hills, *The Genre Painting of Eastman Johnson*, p. 42.

82. This work was brought to my attention by Dr. Martha Op de Coul of the RKD on the occasion of the June 22, 1998, auction sale of the Pulchri Studio collection in The Hague.

83. When Belmont was in need of a family portrait, he turned to the popular David Bles. Nevertheless, Belmont purchased one of Johnson's *Savoyard Boy* pictures by 1857, even though his tastes clearly inclined primarily toward nineteenth-century French and Dutch artists, including the Hague school precursors mentioned above. In fairness to Johnson, Belmont may have commissioned the portrait after the artist's departure from The Hague; but it is possible that he felt that Johnson was not yet equal to the demands of an elaborate multifigure composition. See *The Belmont Collection at the Rooms of the National Academy of Design*, exh. cat. (New York: George F. Nesbitt & Co., 1857), p. 15.

84. "Werkende Leden," inv. no. 229, Pulchri Archief (Papers of the Pulchri Studio), Haags Gemeente Archief. I thank Dr. Martha Op de Coul for providing me with a copy of the register.

85. The dating of this picture is somewhat difficult, though its freedom from the rather finicky detail of *The Savoyard Boy* and a greater sensitivity in the description of nuanced effects of light—as well as its closer relation to Johnson's late work—would argue for an 1854 or 1855 date.

86. Having had three of his works accepted for exhibition at the National Academy of Design that spring, Mignot may have felt that it was time to begin his American career. According to John Coffey, Mignot remained in The Hague—if not continuously—at least into May 1854, when that portion of the Dutch census of 1850–60 canvassed his neighborhood. See "Bevolkingsregisters en Volkstellingsregisters den Haag," Haags Gemeente Archief. Whittredge apparently visited The Hague often during his Düsseldorf years. See Anthony F. Janson, *Worthington Whittredge* (New York: Cambridge University Press, 1989), p. 44.

87. Among Johnson's other Dutch sitters were members of the family of Otto Leopold van Limburg Stirum; photographs of the portraits are on file at the RKD, The Hague.

88. Henry T. Tuckerman, *Book of the Artists* (1867; reprint, New York: James F. Carr, 1967), p. 467.

89. Baur, *An American Genre Painter*, p. 15. On the basis of the portrait *Miss Brinkley*, inscribed "Paris May 1855" (Elvehjem Museum of Art, Madison, Wisconsin), Patricia Hills suggests that Johnson may have arrived in France before August.

90. Couture was noted for his openness to American pupils, including Thomas Hicks (1823–1890) and Enoch Wood Perry(1831–1915).

91. In his enthusiasm for Couture's influence, Albert Boime has stated, "Yet this short period proved decisive for [Johnson's] development, for the example of Couture impregnated his entire future production." Boime, *Thomas Couture and the Eclectic Vision* (New Haven: Yale University Press, 1980), p. 596.

92. The impact of Couture's book on Johnson's work after 1867 was suggested by Patricia Hills in *Eastman Johnson*, exh. cat. (New York: Clarkson Potter and the Whitney Museum of American Art, 1972), p. 74; and in Hills, *The Genre Painting of Eastman Johnson*, pp. 129–32.

93. See Baur, *An American Genre Painter*, p. 15.

94. Quoted in Davis, "Eastman Johnson's *Negro Life at the South*," p. 69.

95. See ibid., pp. 76–77. Davis carried out detailed research on the location of the Johnson residence in connection with his study.

96. "Domestic Art Gossip," *Crayon* 3, part 3 (March 1856), p. 92.

97. Bertha Heilbron was the first to outline the context for Johnson's visits to the region in "A Pioneer Artist on Lake Superior," *Minnesota History* 21 (June 1940), pp. 149–57.

98. A portrait of her husband (St. Louis County Historical Society, Duluth, Minnesota), painted by Johnson at the same time, reveals a man experiencing success.

99. Heilbron derived the information on Bonga from John A. Bardon, "Eastman Johnson, Pioneer-Artist," Minnesota Historical Society, Minneapolis. While various sources have suggested that the figure is a self-portrait, there is little, if any, resemblance to Johnson. Johnson's only known sketch of the site that he and Bonga visited is a drawing completed in January 1857 at their camp on the Kettle River (The Detroit Institute of Arts).

100. The exhibition was noted enthusiastically by the New York art journal the *Crayon*. See "Domestic Art Gossip," *Crayon* 4, part 5 (May 1857), p. 156.

101. A great part of Corcoran's fortune had been made on the sale of Mexican War bonds in 1848. Embattled as a southern sympathizer, Corcoran left the country for Europe in 1862 and remained abroad for the duration of the Civil War. The gallery building meanwhile was used as an army post and finally was opened in 1872; see "William W. Corcoran," *Dictionary of American Biography*, vol. 4. Among the other works lent by Corcoran to the 1857 exhibition was Leutze's *Cromwell and Milton* (The Corcoran Gallery of Art, Washington, D.C.).

102. Riggs had established the banking firm of George W. Riggs & Co. after his split with Corcoran and in 1854 bought out Corcoran when he retired. Among the works in his collection by 1867 were figure subjects by William John Hennessey, Louis Lang, and Leutze, and landscapes by Albert Bierstadt, John F. Kensett, and Jervis McEntee. See Tuckerman, *Book of the Artists*, p. 633.

103. Johnson also explained that his haste in returning to Superior was necessitated by demands of "some interests of a different character" (his real-estate dealings). Eastman Johnson to Henry Wadsworth Longfellow, June 3, 1857, [bMs Am 1340.2 (3044)], Houghton Library, Harvard University, Cambridge, Massachusetts. I am grateful to Melanie Wisner for facilitating access to the Johnson letters at Houghton Library and to Maureen Donovan, Harvard University Art Museums.

104. Schoolcraft was an Indian agent in the Lake Superior region from 1822 to 1841. His six-part *Historical and Statistical Information Respecting the History, Condition, and Prospects of the Indian Tribes of the United States* was published from 1851 to 1857, with engravings after paintings by Seth Eastman. In 1851 he had published a more literary account, *Personal Memories of . . . Thirty Years with Indian Tribes*. See "Henry Rowe Schoolcraft," *Dictionary of American Biography*, vol. 16.

105. "Sketchings. The Indians in American Art," *Crayon* 3, part 1 (January 1856), p. 28.

106. Thomas McKenney, Chief of the Bureau of Indian Affairs, compiled lithographic copies of King's portraits—actually based on copies by Henry Inman—in a three-volume collection, *The Indian Tribes of North America with Biographical Sketches and Anecdotes of the Principal Chiefs*, published 1837–44. See Cosentino, *The Paintings of Charles Bird King* (n. 19 above), p. 60. In 1858 the paintings were moved to the gallery of the new Smithsonian Institution, where they were hung with more than two hundred Indian portraits and figure subjects by the American artist Johnson Mix Stanley. The entire collection was lost in a fire in 1865.

107. The southern Anishinabe (Ojibwe), who originally had inhabited a vast area to the north and east of Lake Superior, settled in the Grand Portage area in 1736 after conflict with the Dakota. By the mid-eighteenth century they were recognized as the proprietors of the site, which figured prominently in the booming French fur trade. Permanent fur-trading posts were established at Grand Portage by the British in the 1790s but were abandoned by 1820. Historical information on Grand Portage and its Ojibwe inhabitants is drawn from Carolyn Gilman, *The Grand Portage Story* (Saint Paul: Minnesota Historical Society Press, 1992).

108. Both Seth Eastman, a Maine native and West Point graduate who served with the army on the western frontier, and Paul Kane, a Canadian artist who painted scenes of the Anishinabe (Ojibwe) based on his visit to the area from 1845 to 1849, were seminal painters of Native Americans in the Great Lakes region.

109. Elizabeth Johnson to Herbert Putnam, February 23, 1908, frame 873, reel 2227, Richard Rathbun Letters, 1906–10, Archives of American Art, Smithsonian Institution, Washington, D.C. Johnson's comments recall Benjamin West's oft-quoted description of a classical sculpture, "How like a young Mohawk warrior!" West was quoted in William Dunlap, *A History of the Rise and Progress of the Arts of Design in the United States* (1834; reprint, New York: Dover, 1969), vol. 1, p. 148.

110. Johnson's true opinion on the subject, albeit retrospective, might be suggested in the conclusion to Mrs. Johnson's comment, cited in n. 109 above: "[Mr. Johnson said] that it was deplorable that [the Ojibwe] should become extinct" (frame 874).

111. There is no evidence that Johnson himself had linked this image to Longfellow's poem or the Ojibwe account of Wenabozho, on which Longfellow based his work. I base my interpretation on the resemblance of the object at the left of the image to a Johnson drawing of an Indian grave marker (St. Louis County Historical Society, Duluth, Minnesota). Rosemary Ackley Christensen, former American Indian Developer and Research Associate for the St. Louis County Historical Society, kindly offered her comments on this and other Ojibwe-related issues in this volume.

112. *Poems by William Cullen Bryant. Collected and Arranged by the Author* (London: C. Kegan Paul & Co., 1880), p. 49. See "The Bryant Album," *Evening Post* (New York), January 16, 1865, p. 2. I thank Jonathan Harding, Curator of The Century Association, for providing information about the circumstances of the gift.

113. Commenting on Johnson's sensitivity to his subjects, Tuckerman wrote, "[W]e have never seen the savage melancholy, the resigned stoicism, or the weird age of the American Indian, so truly portrayed: a Roman profile here, a fierce sadness there . . . with picturesque costume [and] scenic accessories. . . ." Tuckerman, *Book of the Artists*, p. 471.

114. Elizabeth Johnson made a valiant effort to place the Anishinabe (Ojibwe) material as well as other works with the Smithsonian Institution after her husband's death, but the offer was declined owing to lack of funds. Elizabeth Johnson to the Regents of the Smithsonian Institution, December 1, 1906, frames 851–56, reel 2227, Richard Rathbun Letters, 1906–10, Archives of American Art, Smithsonian Institution, Washington, D.C. The collection of Indian subjects was finally purchased for the city of Duluth in 1908 by the Chicago businessman Richard T. Crane, who had seen them on view at the American Museum of Natural History in New York. See Heilbron, "A Pioneer Artist" (see n. 97 above), p. 154.

115. Ralph Waldo Emerson, "Art," in *Emerson's Essays: First and Second Series* (New York: Gramercy Books, 1993), p. 185.

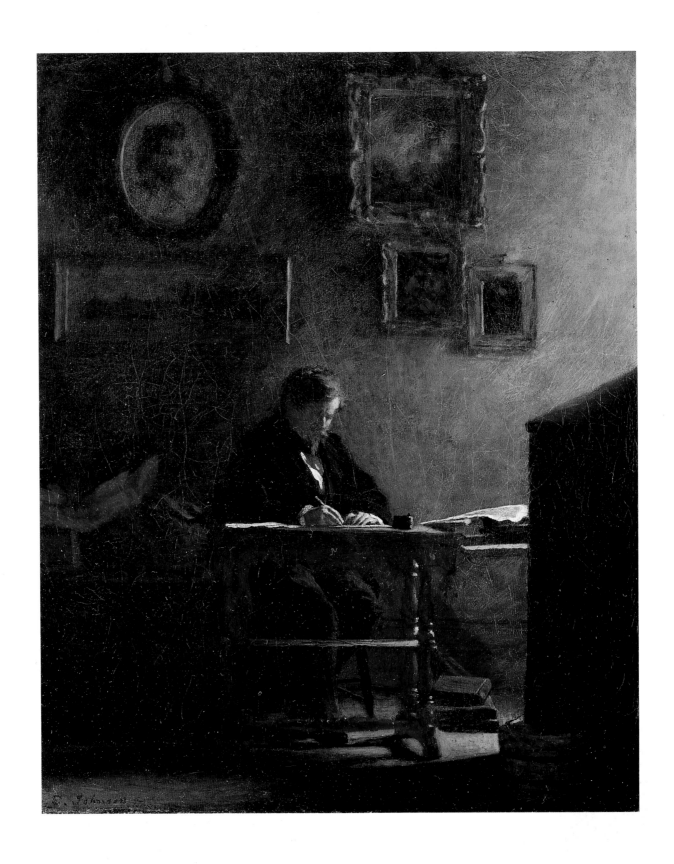

NO. 24
Self-Portrait, circa 1860
Oil on canvas, 10 x 8⅛ in.
Brooklyn Museum of Art, Purchased with funds
given by Mr. and Mrs. Leonard L. Milberg and
A. Augustus Healy Fund, 1994.64

The Genius of the Hour: Eastman Johnson in New York, 1860–1880

TERESA A. CARBONE

[T]he artist must employ the symbols in use in his day and nation to convey his enlarged sense to his fellow men. . . . The genius of the hour sets his ineffaceable seal on the work. . . .

—RALPH WALDO EMERSON, "Art" (1841)

FIG. 30
X-radiograph of Eastman Johnson, *Self-Portrait* (No. 24)

The first two decades of Eastman Johnson's New York career are often characterized as a time in which he produced a string of innovative works set against the background of routine, anecdotal genre subjects. This perspective is not wholly inaccurate, but the consistent attention devoted to certain of Johnson's most unusual paintings has to some degree skewed our sense of his career in the years bracketed by the smash success of *Negro Life at the South* (No. 67) in 1859 and the quieter debut of *The Cranberry Harvest, Island of Nantucket* (No. 60) in 1880. Interest in such original and finely painted works as *A Ride for Liberty—The Fugitive Slaves*, circa 1862 (No. 74), or the group portrait *The Hatch Family*, 1871 (No. 83), for example, has cast other canvases like *The Pension Claim Agent*, 1867 (No. 35), one of Johnson's finest works and his greatest critical success of the 1860s, into undue shadow. This discussion will trace Johnson's aesthetic progress, critical fortunes, and patronage from 1860 to 1880, the period during which he rose to ascendency as the country's most respected figure painter, and by the end of which he had settled into a more honorific role despite attempts to update his art. Johnson's career was a particularly sensitive barometer of the art world during the Civil War years and immediately afterward, when American painters grappled with defining a new American art. Each step of this vital period of his New York career merits close examination.

As early as 1857, Johnson informed Henry Wadsworth Longfellow, "I . . . for sometime have had N. York in view as a place to settle in."[1] Johnson's presence in the city was noted in prominent artistic circles by January 1859, when a writer for the *Crayon* reported, "Among figure-painters that have lately appeared among us, is Eastman Johnson. . . . [He] has a studio in the University, and several drawings and studies in it of decided interest."[2] A self-portrait dating from about this time (No. 24) provides a glimpse of Johnson at work in what is most likely his University Building studio, seated in a raking light whose path he described with beautifully contained fluidity. Johnson's recent European sojourn is suggested not only by the assortment of works depicted on the wall behind him, but also by another composition that lies under the self-portrait: a portrait probably copied by the artist while in Holland, revealed in an x-radiograph (fig. 30).[3]

The *Crayon* critic quoted above eagerly welcomed Johnson onto the New York scene, for it was in the field of figure painting that he found American artists to be lagging, in comparison to more robust developments in portraiture and landscape. Seeking to encourage an American school of figure painting, the writer urged, "Pictures must be painted that show how man thinks and feels, . . . what he believes in and what he hopes for—in short, representations of human beings struggling for spiritual life."[4] Within a year of his arrival in New York, Johnson's first substantial efforts seemed to express the thoughts and feelings of his entire audience; pro- and antislavery supporters alike deemed his *Negro Life at the South*, exhibited at the National Academy of Design in 1859, a stunning success (see essay by Patricia Hills in this volume).

So meteoric a rise with a work that was large, conceptually inventive, and technically complex left Johnson hard-pressed to surpass that performance in 1860. The city, moreover, was still a new working environment for Johnson, and he and his colleagues were faced with an increasingly uneasy patron class, cast into contentious camps and paradoxical alliances by the rising political storm surrounding Secession. Few New Yorkers failed to recognize their economic dependence on the southern slave economy, from which they derived hundreds of millions of dollars each year. By 1860 the majority of the city's leading merchants, Republican and Democratic, at least temporarily fell in with Mayor Fernando Wood as southern sympathizers. Their vocal efforts to reassure southern trading partners constituted tacit approval of the heightened slave-trade activity in New York harbor itself.[5]

In this context, it is extraordinary that Johnson submitted three black subjects to the National Academy of Design's annual exhibition in April 1860: *Washington's Kitchen at Mount Vernon*, *The Freedom Ring* (No. 71), and *Mating* (fig. 51) (see Hills essay). Another work, *Marguerite* (location unknown), based on Goethe's *Faust*, was a conventionally Romantic subject (see lithograph after the lost painting, fig. 31).[6] Johnson's artistic production in 1860 demonstrates the two veins of subject matter in which he would often work simultaneously during his first decade in New York: original themes of political relevance (as in *The Freedom Ring*) and more familiar narrative types that occasionally were based on recognizable literary or popular sources. Although Johnson does not appear to have undertaken any of the works exhibited in the 1860 annual as commissions, he did succeed in finding buyers for both types at this early stage in his career. Within the year, for example, *Marguerite* was bought by the Harvard-trained Boston lawyer Wilder Dwight (1838–1862), along with Johnson's *The Barefoot Boy*, 1860 (see fig. 53), based on John Greenleaf Whittier's nostalgic poem of the same name (1856).[7] On the strength of his work thus far, Johnson was elected an Academician of the National Academy of Design, and he submitted as his acceptance piece the simple but deliberately chosen image *Negro Boy*, 1860 (No. 72).[8]

"Dare to Be National!": Johnson's First Rural Subjects

In the summer of 1860, Johnson retreated to his native Fryeburg, Maine, as he would for much of the decade, to find respite from the summer heat and new material for his art. During this particular stay he prepared his most important composition since *Negro Life at the South*—a precisely composed and carefully painted rural subject titled *Corn Husking* (No. 25). Preferring the type of stagelike architectural space that had served him well in the former work, he chose for a setting the barn owned by the Day family, with whom he boarded in Fryeburg, and enlisted his hosts as his models.[9] Here we meet for the first time in Johnson's work the top-hatted and bearded old-timer, the courting couple, and the diligent New England farmer. In their firm physical presence, textural detail, and subtle characterization, one detects the degree to which Johnson had moved beyond the precedent of William Sidney Mount's (1807–1868) exuberantly colorful and comically expressive farmers.

Perhaps the most interesting detail in *Corn Husking* is the inscription that Johnson added to the weathered barn door. "Lincoln & Hamlon [*sic*]," written in large, clear script, makes an unusual reference to Maine's native son, Lincoln's running mate Hannibal Hamlin. The rifle propped emphatically below the slogan inserted the fall's burning political debate into an otherwise placid scene. Johnson undoubtedly was aware that preelection maneuvers were becoming more drastic and angry in New York. His former Hague patron August Belmont, now one of the city's most powerful bankers, influenced the city's overwhelming vote for the anti-Lincoln fusion ticket, whereas the citizens of Maine supported Lincoln by a clear majority.[10]

The aftermath of the 1860 election was a time of profound political confusion and economic uncertainty as northerners of all stripes anticipated the disastrous impact of Secession. The Republican *New York Times* editor Henry Raymond temporarily advocated peaceable Secession;[11] and at an uneasy "Peace Conference" held in Washington in February 1861, the Lincoln supporter William E. Dodge, Jr., soon to be counted among Johnson's patrons, represented the majority of New York merchants when he advocated compromise in the extension of slavery.[12] All this changed, of course, when—weeks after Lincoln's inauguration in March—Confederate troops fired on Fort Sumter and the war was begun. On April 20, nearly two hundred thousand New Yorkers rallied in Union Square in support of the Union (fig. 32).

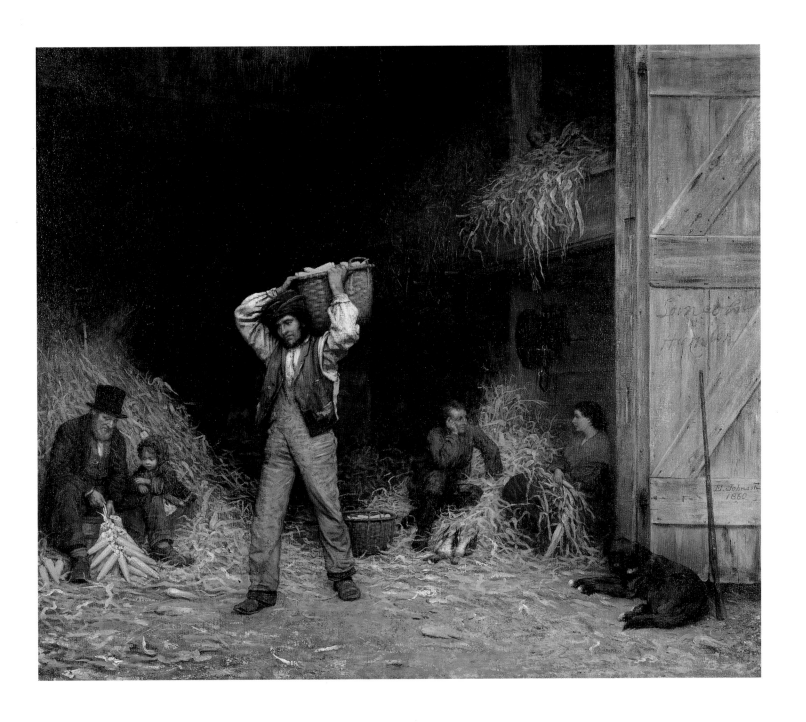

NO. 25
Corn Husking, 1860
Oil on canvas, 26½ x 30¼ in.
Everson Museum of Art, Syracuse, New York,
Gift of Andrew D. White

The National Academy of Design annual exhibition, which had opened on March 20 and would run until April 25, was no doubt eclipsed to a significant degree by unfolding events. One of an impressive six works by Johnson accepted into the exhibition, *Corn Husking* might have been expected to attract particular attention owing to the Republican boosterism inherent in the "Lincoln & Hamlon" inscription. Critics appear to have overlooked the phrase entirely, however, in their hearty praise of the young artist who had been among them for so short a time. A writer for the liberal *New-York Daily Tribune*, who drew particular attention to Johnson's authenticity of detail, described *Corn Husking* as "one of those homely scenes in which Eastman Johnson sees, with the eyes of genius, the true poetry, the real delicacy of sentiment, that underlies all life, even the coarsest." In the occupants of the "old-fashioned" barn, the critic recognized the codified types of the "ages of man," describing the central figure as "the representative of the care, and thrift, and necessities of daily life."[13] Despite its happy reception by critics, *Corn Husking* surprisingly became the first of important works by Johnson from the 1860s that failed to attract buyers soon after their debuts.[14]

In contrast to Johnson's *Corn Husking*, the majority of ambitious figure subjects exhibited in the 1860 annual were primarily literary or historical in nature, including three by his University Building colleagues Cephas Thompson (1809–1888) and Edwin White (1817–1877).[15] Well trained in Düsseldorf and Paris during the 1850s, White had ambitions in the field of history painting and must have attracted Johnson's attention with such works as the remarkable *Thoughts of Liberia: Emancipation* (fig. 33), of 1861, which raised the issue of the African colonization movement; and an early Colonial Revival theme titled *Spinning Flax, Olden Times* (The New-York Historical Society). Both paintings were purchased in 1862 by the wealthy New York sugar refiner Robert L. Stuart (1806–1882), who would buy Johnson's *Fiddling His Way* (No. 78) and *Sunday Morning* (No. 34) in 1866, and *Negro Life at the South* in 1867. Also at work in the University Building throughout the decade was the Irish-born William John Hennessey (1839–1917), a painter of cabinet pictures of domestic life and figure subjects of a literary cast, delicately rendered in a manner inspired by Ruskinian Pre-Raphaelitism. As suggested by the example of Robert L. Stuart, White and Hennessey may have provided Johnson his first contact with a number of patrons during the early sixties, including Hennessey's early buyers James W. Pinchot, George B. Warren, and Sheppard Gandy.

By July 1861, however, artistic activities in New York were altered sufficiently for a writer of the *Knickerbocker* to declare, "Little or nothing is now being done in the studios; many of our artists have shouldered the musket and gone off to the

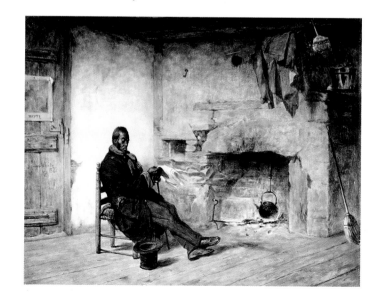

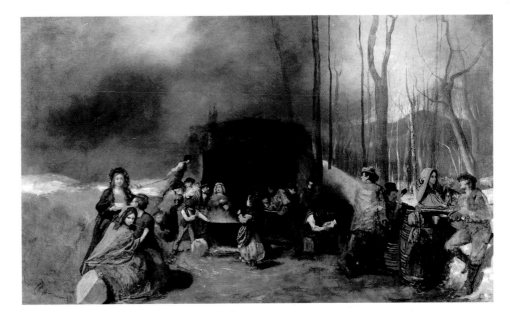

wars. . . ." On behalf of the artists who remained in the city, he prompted a distracted public to continue to view, order, and buy art. To the artists themselves, he offered the simple but emphatic advice, "Dare to be national!" in the hope that painters would undertake the pressing new themes of wartime.[16] Neither Johnson nor the majority of his colleagues were in fact overcome by an urgent patriotic calling.[17] Johnson appears to have made no effort to enlist and instead sought involvement in tangential war efforts, joining a group of artists who, under the direction of John F. Kensett (1816–1872) and Louis Lang (1814–1893), gathered paintings to auction for their Artist's Patriotic Fund that May.[18]

Johnson does appear to have heeded the *Knickerbocker* writer's further comments regarding national subjects: "Honestly evolve the spirit, the 'genus [*sic*] loci' of the country in which you live. Be true to the indigenous poesy of the soil which cherishes you."[19] Undoubtedly encouraged by the critical success of *Corn Husking*, he returned to Fryeburg for another season of painting. He appears not to have departed until the fall, however, when a report in the *Daily Tribune* provided one of the first indications of Johnson's next substantial project: "Mr. Eastman Johnson has gone to the State of Maine, where he painted his 'Husking in a Barn,' for the purpose of making studies for a picture representing that peculiar phase of American rustic life, a maple sugar camp. The subject has often been attempted by our artists, but Mr. Johnson will make it his own by his masterly pencil."[20] Just how ambitious his plan was at this time remains unclear; he would not begin to discuss a large canvas on the theme for about two years.

One ambitious composition is very likely from this earliest campaign. *Sugaring Off*, circa 1861–63 (fig. 34), displays a triangular arrangement in which two complementary groups frame the central motif of the sugaring shed and vat. Two of the figural motifs (the male figure tending the vat; and the group at the right where two men sneak a drink of hard liquor) reappear in his later compositional sketches. Among other possible products of this early campaign is Johnson's *Measurement and Contemplation*, circa 1861–63 (No. 26), in which two patient Yankee sages, in the tradition of the farmers in William Sidney Mount's *Bargaining for a Horse*, 1835 (The New-York Historical Society), ruminate before the setting of a rough shed, a vat of boiling sap, and two wooden barrels. The figures are delineated with the same firm and exacting outline visible in the central figure of *Corn Husking*. Johnson's use of a freer touch in painting these figures and the sketchy setting might argue for a date later than 1861, but the absence of this particular motif from his later, full compositional sketches on the theme suggests a pre-1864 date.

FIG. 35
Eastman Johnson
Warming Her Hands, 1862
Oil on canvas, 12⅜ x 9½ in.
Courtesy of Christie's Images

FIG. 36
George N. Barnard and James F. Gibson
Confederate Quaker Guns—Log Mounted to Deceive Union Forces in the Fortifications at Centerville, Virginia, March 1862
Photograph
National Archives, Washington, D.C., photo no. 165-SB-6

Negotiating the Early War Years

On his return to New York late in the year, Johnson must have experienced a distinct change in mood from the frenetic enthusiasm that attended the initial rallying and send-off of Union troops in the spring and summer of 1861. A series of disastrous losses had undermined the common belief that the war would be brief and the Union victory decisive, renewing doubts in the cause. By the end of the year, New York's newly elected Republican mayor, George Opdyke, escalated fears of foreign attack on the nearly defenseless and cash-poor city.[21] It was in this atmosphere that Johnson painted *Warming Her Hands* (fig. 35), his single entry in the National Academy annual of 1862. In this small and touchingly pathetic scene, a young girl in a tattered cape and hood attempts to warm herself behind the stove in what appears to be an artist's studio. The calendar on the wall, still turned to the year 1861, suggests that the primary occupant has been absent, and that the girl—a daughter or model—was among the many children temporarily abandoned during the war. Clearly susceptible to the picture's mood, a writer for the *New York Times* declared it "singularly beautiful."[22]

Warming Her Hands and Johnson's many works like it were those for which he was likened to Édouard Frère (1819–1886), a French painter first acclaimed in Paris for his peasant subjects in the early 1850s. Frère, who moved permanently to the rural village of Écouen, was avidly promoted by dealers in England, Holland, and America in the decades that followed. His paintings appeared in New York as early as 1857 (courtesy of the French firm Goupil, Vibert & Company) and were included in National Academy of Design annuals with some frequency from 1859.[23] Frère's scenes of rustic interiors and sadly burdened little waifs (see fig. 80), as well as their appeal to an American audience, provided aspiring American figure painters with food for thought.[24] The comparison of Johnson and Frère, made as early as 1861, was based on technique as much as subject matter.[25] In paintings like *Warming Her Hands*, Johnson embraced a soft touch and delicate breadth akin to Frère's. Whether or not Johnson appreciated the comparison, which was repeated frequently throughout the early sixties, it did his reputation no harm. He could also rely on nationalistic critics to defend his work against too close an association with a foreign style. A critic for the *Round Table* wrote, "Mr. Johnson . . . has already shown himself a painter of greater range and power than Edward Frère, with whom he is so often and unhappily compared."[26] The association of the two artists obviously reinforced the market that each of them commanded among American buyers, and not surprisingly, they attracted many of the same collectors for a period of about twenty years.[27] Johnson relied on the sale of his small, most Frèresque works for his basic income throughout the 1860s, regularly selling them for prices that exceeded the cost of comparable cabinet works by his American peers.

In late February, well before the 1862 National Academy annual opened on April 14, Johnson left New York and traveled to Manassas, Virginia, presumably under the aegis of General George McClellan and the Army of the Potomac. John I. H. Baur has suggested that Johnson's exploits with the Union troops were inspired by the enlisted service of his older brother, Reuben, who had written to Johnson from the site one year before.[28] He probably derived encouragement as well from those New York critics who were attempting to rally artists to document the dramatically unfolding events.[29] The timing of Johnson's arrival at the Confederate stronghold at Manassas (see fig. 36) by March 2 remains puzzling, however, given that the Confederate troops remained at the site until March 9, when they began a voluntary retreat owing to defeats in Tennessee and Kentucky, and McClellan's troops did not arrive in the area until March 11.[30] He nevertheless was inspired to begin his remarkable *A Ride for Liberty—The Fugitive Slaves*, circa 1862 (No. 74),

NO. 26
Measurement and Contemplation, circa 1861–63
Oil on paper board, 20¼ x 24 in.
Museum of Fine Arts, Boston, Bequest of
Martha C. Karolik for the M. and M. Karolik
Collection of American Paintings, 1815–1865,
48.435

NO. 27
Self-Portrait, 1863
Oil on paper board, 15⅞ x 11¹⁵⁄₁₆ in.
The Art Institute of Chicago, Gift of Mrs.
Arthur Meeker, 1924.126

a work that, surprisingly, he never chose to exhibit (see Hills essay). His stay in the area was relatively brief, and by early April he was again at work in the more sheltered reaches of Fryeburg to advance the maple-sugaring project.

Returning to New York after nearly three months in Maine, Johnson wrote to his friend Jervis McEntee (1828–1891) expressing his renewed pleasure in his urban environment. His enumeration of the common objects and local types in which he was finding new delight has a Whitmanesque ring, both in its rhapsodic arrangement as a running list and its emphatic appeal to the senses:

> The city appears delightful. Plug hats are soothing to the eyes. Napkins, butter knives, & salt spoons, bring a tear to the same organ. There is a rapture in beef-steaks and chops. The rumbling of omnibuses is an anthem to mine ear. Bill posters and lamplighters I greet with a becoming smile, & upon the small rag-muffins as they swear at Hopscotch & other metropolitan games goes forth my benediction. The good rank gutters are fragrant and familiar, the daily papers . . . sociable and authentic. . . . It is impossible to record the blessings . . . that rise up to greet an observer.[31]

Although his senses were newly attuned to the stimuli of the city, he appears to have derived relatively little inspiration for new subjects.[32]

In the same letter, Johnson reported to McEntee a minor exodus of their acquaintances, including Sanford Gifford's return to the front, where, Johnson noted, he would "find less romance & more drudgery this time."[33] Johnson remained an observer even in the face of the increasingly urgent Union call to arms necessitated by the most recent, serious losses under McClellan.[34] In September, New Yorkers like Johnson were afforded an intimate view of the grim casualties when Mathew Brady opened a photographic exhibition unflinchingly titled *The Dead of Antietam.*

Johnson's secure place in New York's premier cultural circle was confirmed in December 1862, when he was nominated by his colleagues William Stanley Haseltine (1835–1900) and Thomas Hicks (1823–1890) for membership in the exclusive Century Association; at the same meeting his good friend McEntee was nominated by Gifford and Lang.[35] Even in view of his personal progress, it might seem odd that in 1863, the worst year of the war, he would paint a self-portrait in which he is popping the cork of a champagne bottle (No. 27). Still, there were reasons for celebration: the Emancipation Proclamation had taken effect on January 1; and the Union army garnered long-awaited victories with the taking of Gettysburg and Vicksburg in July. Alternatively, as the two flutes on the table and the palette hanging on the wall together suggest, the occasion may have been a moment of professional success: Johnson produced noteworthy paintings in 1863 like *Sunday Morning (formerly "The Evening Newspaper")*(No. 95) and *The Lord Is My Shepherd* (No. 76), though oddly, he refrained from exhibiting any works at the National Academy of Design annual that spring.[36]

Johnson could not shield himself entirely from the tragic events of 1863. He was called upon to complete a posthumous portrait of his former patron, Colonel Wilder Dwight, 1863 (Harvard University Portrait Collection, Cambridge, Massachusetts), who had died of wounds suffered at Antietam.[37] He also returned to the battlefront that summer, according to a letter written by Gifford on July 9 from Fredericksburg, Maryland, where New York's Seventh Regiment awaited further action. Johnson, who was there "to see the operations of the army," may have been contemplating a more ambitious Civil War subject.[38] While few American painters had met the artistic challenge that the war presented, a number of Johnson's closest colleagues, including two University Building neighbors (Edwin White and Winslow Homer), had been represented by pertinent themes in the 1863 National

Academy annual from which his own work had been entirely absent.[39] If Johnson
had intended a prolonged stay with the Seventh to develop new material, his plans
were frustrated; within days of his arrival, the entire regiment was recalled to New
York to quell the incendiary and, ultimately, bloody draft riots that overtook the city
for five days beginning on July 13. Outraged by the impending enforcement of a
federal draft order that allowed substitutions or exemptions for a fee of $300, mobs
of working poor, fearful of a free-black labor force, overtook entire neighborhoods,
burning and looting, and assaulting and killing Republicans and African Americans.[40]
(It remains unclear whether Johnson himself, who was eligible for the draft as an
unmarried man between the ages of twenty and forty-five, found a substitute, bought
an exemption, or was never called in the lottery.) The riots fully escalated hostilities
between the two primary factions of the monied class in New York: the racist
Belmont circle, which opposed government intervention through black emancipation,
the draft, and trade restrictions; and the culturally elitist, Republican Union League
Club (formed in the winter of 1863), which avidly supported emancipation, sought
severe punishment for the rioters and their supporters, and advocated tighter gov-
ernment controls on arriviste entrepreneurs.[41] No one in Johnson's circle undertook
to represent the violence of this episode.

What Johnson did produce, presumably in the latter part of 1863, was a highly

finished drawing of a heroically idealized battle subject. In *The Wounded Drummer Boy* (No. 28), he distilled the entire Union effort into a single, emblematic figural group striding toward certain victory. With its allusion to factual details,[42] the image appealed to an opinionated writer for the *Round Table*, who accused the majority of American artists of ignoring the war or focusing only on the humorous or grotesque.[43] *The Wounded Drummer Boy* was among the numerous works that Johnson or his patrons lent to the series of fund-raising fairs organized by various branches of the United States Sanitary Commission in 1864.[44] In the public eye, and particularly in the eyes of one faction of the patron class, Johnson benefited from his association with this righteous cause.

At the Brooklyn and Long Island Fair held in February 1864, Johnson's *Negro Life at the South* made a return appearance. Johnson also served that year on the Fine Arts Committee for New York's larger Metropolitan Fair, which gathered 360 works for the picture gallery installed in April.[45] If the committee anticipated the taste of the general public by including such familiar favorites as Frederic Church's *Heart of the Andes*, 1859, and Leutze's *Washington Crossing the Delaware*, 1851 (both The Metropolitan Museum of Art, New York), their efforts were distinctly less successful in the eyes of the critics, who found the display imbalanced. A writer for the *Round Table* underscored the fair's purpose in his criticism: "This exhibition was not gotten up for the glory of men who have covered the largest canvases and are in the flood-tide of popularity; it was gotten up for the benefit of the soldier. . . ." The same writer protested that Johnson, "the most genuine and comprehensive painter of home life that we ever had," was underrepresented.[46] In addition to *The Wounded Drummer Boy*, the display included three of Johnson's smaller oils: his Frèresque *The Post-Boy* (location unknown), lent by the Republican capitalist Marshall O. Roberts (1814–1880), whose collections were funded during the war years by near-scandalous profits from chartering and selling steamships to the government;[47] the topical subject *Knitting for the Fair* (location unknown), sent by the merchant Sheppard Gandy; and *The Young Sweep*, 1863 (No. 77), offered for sale by Johnson or its unspecified owner.

Critical appreciation of Johnson's paintings was not diminished by their modest scale; suggesting their relevance within a turbulent moment in American life, the *Round Table* writer contended that they possessed "that simple and domestic look that . . . makes us feel grateful to the artist for so affectionately rendering subjects that are so closely connected with the heart of today. . . . [T]hey mean more than they pretend. . . ."[48] More tangible recognition of Johnson's achievements came with the purchase of *The Wounded Drummer Boy* from the fair by a subscription of Century Association members, along with two other works.[49]

The preponderance of large canvases at the Metropolitan Fair may have contributed to Johnson's need that spring to embark on more ambitious work worthy of wide critical notice and higher prices. He wrote to his friend and early patron John F. Coyle in March:

> *I hope in the next year to do something more considerable than I have done, to paint two or three larger & more pretenscious pictures, which are in fact all well under way. . . . The scene is a Down-east Sugaring, a picturesque & in one way interesting one, partly on account of its being associated with my pleasantest early recollections. . . . There will be forty figures or more, the occasion an entirely social one, even jolly, & very well adapted as I think to exhibit character & picturesque combination of form color & c.*[50]

Johnson's plans were recorded more publicly by the end of the month in the *Evening Post*, which reported that he had had the subject in mind for several years.[51] It probably was on this foray that he undertook a series of friezelike studies in

NO. 29
Sugaring Off at the Camp, Fryeburg, Maine,
circa 1864–66
Oil on canvas, 19¾ x 34 in.
Curtis Galleries, Inc., Minneapolis

60 TERESA A. CARBONE

NO. 30
The Story Teller of the Camp (Maple Sugar
Camp), circa 1861–66
Oil on canvas, 22¾ x 26¾ in.
Reynolda House, Museum of American Art,
Winston-Salem, North Carolina

which he arranged and rearranged a variety of lively figural groups before colorful backdrops of Maine woods.[52]

In one particularly dynamic study, *Sugaring Off at the Camp, Fryeburg, Maine,* circa 1864–66 (No. 29), Johnson distributed about forty-one figures within the length of a muddy clearing. In a backdrop evocative of the heavy, moist air of an early thaw, he described the light of a late-winter sky filtered by a screen of bare, brown trees and included a glimpse of the White Mountains in the distance at the right. In this version, Johnson arranged more than ten separate figural motifs, characterized by expressive, active postures for which he had particular talent. Men in hats encircle the steaming vat, while at the left, parties dance or listen to the fiddler sitting atop a pile of logs. At the right, a handful of figures mill about, engaged in conversation. Johnson's touch throughout the study is fresh and animated.

In various other versions, Johnson experimented with compressing the figural group and adjusting the dominant tonalities (see, for example, the study in the Fine Arts Museums of San Francisco). The resolution to which he was moving may be suggested by a substantially larger version (fig. 96), in which a denser and more unified arrangement of figures is reduced in scale and set at an oblique angle to the picture plane. On this larger, unfinished canvas, to which he may have returned in 1876 (see below), Johnson continued to work out individual figural motifs in the margins. This work also has more of the quality of an underpainting than a full *esquisse peinte* (painted sketch) and probably represents Johnson's closest approach to the final composition that he envisioned.

A number of Johnson's more highly resolved studies of individual motifs may also date from this campaign. In *At the Camp, Spinning Yarns and Whittling,* circa 1864–66 (No. 103), he recast the two figures at the far left of *Sugaring Off at the Camp, Fryeburg, Maine* in a setting closer to the central shed and vat with an economy of means. In the lively *The Story Teller of the Camp (Maple Sugar Camp),* circa 1861–66 (No. 30), the broadly brushed figures are expressively animated. It is often in connection with these works that Johnson's link to Thomas Couture's method is invoked—and indeed, his manner of oil sketching resembles Couture's in its vigor, expressive capacity, and dominant tonalities. If Johnson was drawing on Couture's example at this time, it may have been a result of his renewed contact with the Frenchman's paintings through access to the collection of William T. Blodgett (d. 1875), ultimately Couture's most loyal American patron and his personal friend.[53]

Johnson's association with Blodgett led to his artistic triumph of the war years in *Christmas-Time (The Blodgett Family)* of 1864 (No. 31). Johnson had counted Blodgett among his patrons by 1860;[54] their contact undoubtedly became more regular after 1862, when Johnson joined Blodgett as a member of The Century Association. By that time Blodgett, who derived his wealth from a successful varnish-manufacturing business, had demonstrated himself to be an enlightened and generous patron with his purchase of Church's *Heart of the Andes,* 1859 (The Metropolitan Museum of Art, New York), for an unprecedented sum of $10,000. Johnson and Blodgett had further occasion for close contact early in 1864 as members of the Metropolitan Fair's twenty-man Committee on the Fine Arts; and it may have been that collaborative effort that led Blodgett to purchase Johnson's modest but poignant *Corn-Shelling,* 1864 (fig. 37).

Given their increasingly close relationship, Johnson was the likely candidate to execute a family portrait for Blodgett in early 1864. Set in an intimate corner of the Renaissance Revival parlor in the Blodgett home at 27 West Twenty-fifth Street, the scene represents the family basking in the combined glow of firelight and sunshine from the arched hearth and window. Blodgett, with his back turned temporarily

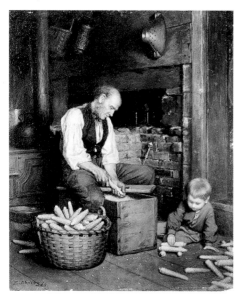

FIG. 37
Eastman Johnson
Corn-Shelling, 1864
Oil on paper board, 15⅜ x 12½ in.
The Toledo Museum of Art, Gift of Florence Scott Libbey, 1924.35

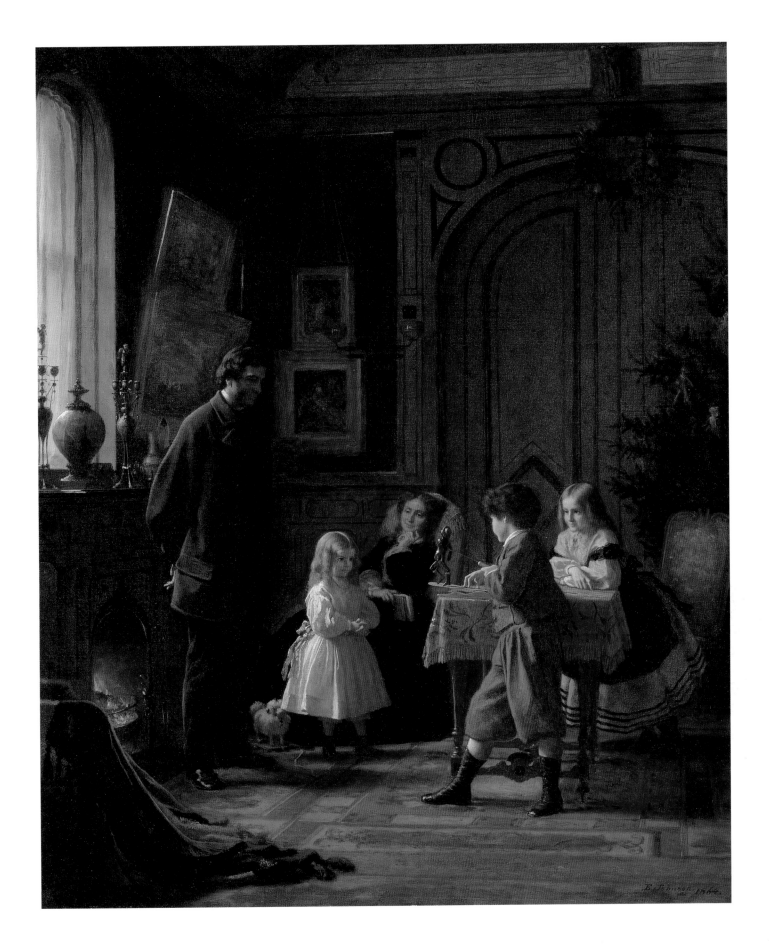

NO. 31
Christmas-Time (The Blodgett Family), 1864
Oil on canvas, 30 x 25 in.
The Metropolitan Museum of Art, New York,
Gift of Mr. and Mrs. Stephen Whitney Blodgett,
1983 (1983.486)

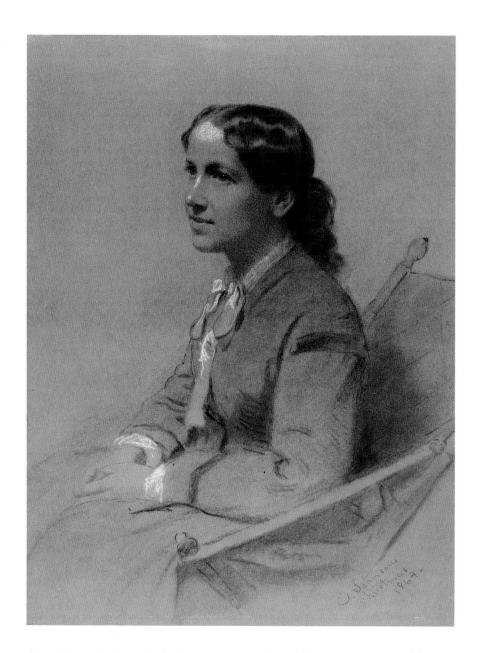

from the world beyond this family circle, is framed by a small portion of his substantial art collection. With the exception of his wife, Abigail, the family is held rapt by the kinetic toy—a dancing black figure whose jerky movements mimic those associated with minstrel dance—operated by William Blodgett, Jr.[55] This puppet, in mock military dress, would have been recognizable to a wartime audience as a Union recruit.[56] Given that Blodgett, a member of the Union League Club from its inception, had supported the raising of the black Twentieth Regiment in the early months of 1864, it bears particular significance here. In Johnson's scene, Blodgett watches approvingly as William, Jr., parades his own soldier before the approving eyes of his family. If the toy suggests Blodgett's and the Union League's support of black emancipation, it does so only under an overarching paternalism, in which even the most liberal attitudes were couched at the time.[57]

Christmas-Time, as the family portrait was called, debuted to enthusiastic reviews at a Century Association exhibition in June 1864, while the war raged at its height.[58] The work made a more emphatic stir nearly a year later, at the 1865 National Academy of Design annual, an exhibition that opened three days after Lincoln's body arrived in New York to lie in state, and the glow of Union victory was overshadowed by communal mourning. The *Tribune*'s critic appears almost too effusive in this context: "If the Academy building were on fire we know the picture we would risk a scorching to save! Eastman Johnson's 'Christmas-time' is of all the

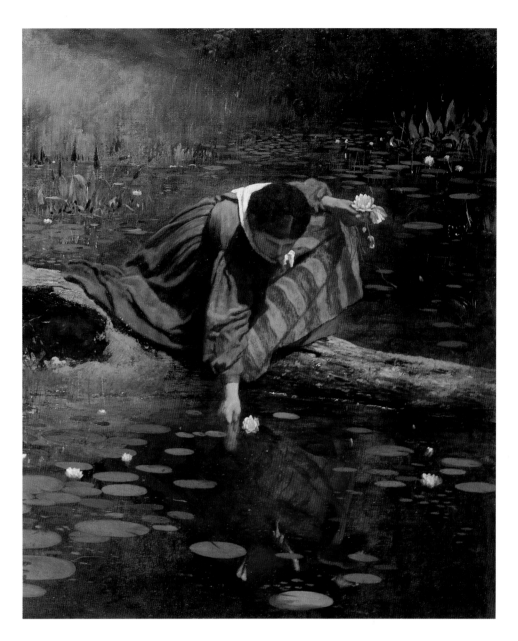

gallery the strongest, sweetest, best."[59] Remarking on Johnson's innovative approach to the group portrait, the writer added that "we can enjoy it as an imaginative creation."[60] One might expect more to have been made of the black presence in *Christmas-Time*. The *Tribune* reviewer did take notice of the dancing toy, but in his description of the figure as "one of these new-fashioned negro puppets [that] dances his ridiculous heel-and-toes," with "an irresistable [*sic*] absurdity," alluded to the most racist aspects of minstrelsy.[61] The picture's evocative mood of domestic harmony founded on patriotism was clearly of greater interest.[62]

Near the close of this very successful year, Johnson spent time in the company of a favorite sister, Harriet, whom he depicted in a tenderly expressive drawing inscribed "Christmas 1864" (No. 32). In 1865, at the age of thirty-two, she would marry Johnson's close friend Joseph May, a Harvard Divinity School student and the son of the ardent Unitarian reformer and antislavery activist Samuel Joseph May (1797–1871).

Although Johnson had implied in his letter to John F. Coyle that he would complete the maple-sugaring picture in winter 1864–65,[63] the New York press reported his return to Maine the following summer to continue his studies on the theme.[64] His campaigns in Maine placed him in proximity to his closest colleagues, nearly all of whom were landscape painters. They often worked in the vicinity of Conway, New Hampshire, at the edge of the White Mountains and a mere ten miles

from Fryeburg.[65] Johnson's ties to the landscape group had intensified through his participation in the intimate circle of writers and artists who gathered regularly at the East Thirteenth Street apartments of the writers Bayard Taylor (1825–1878) and Richard Henry Stoddard (1825–1903) and their wives.[66] During the winter of 1865–66, the same group frequented the studio-residence that Jervis McEntee and his wife occupied in the Tenth Street Studio Building that season; additional regulars there included Kensett, Whittredge, and the landscape architect Calvert Vaux (1824–1895) and his wife, Mary (McEntee's sister). Johnson did not practice the subjective landscape aesthetic prized by Taylor and represented most distinctly by Gifford's atmospheric works, but his work was highly valued within the circle and earned a tribute in Taylor's 1866 poem "The Picture of St. John."[67]

If Johnson did devote more energy to the maple-sugaring project in 1865, it was to no avail. Possibly for lack of a prospective buyer, he abandoned the project for nearly a decade. That year he experimented with a handful of ideal feminine subjects, including *Gathering Lilies* (No. 33), which found a buyer in the Boston aesthete and Barbizon enthusiast (and Longfellow's brother-in-law) Thomas Gold Appleton. In 1866–67 he would also complete three paintings more ambitious than any that he had produced in the five preceding years: *Sunday Morning* (No. 34), *Fiddling His Way* (No. 78; see Hills essay), and *The Pension Claim Agent* (No. 35).

Finding a Postwar Voice in New England: "Sunday Morning" and "The Pension Claim Agent"

As a figure painter in the postwar period, Johnson was more directly challenged than his landscape-painting colleagues to retune his subject matter to the altered tenor of the times. With *Sunday Morning* and *Fiddling His Way*, both completed in 1866, Johnson rose to address a society shaken and altered to its very depths, and one in the process of recuperation and redefinition. With the entry of both works in the National Academy of Design annual exhibition that opened in late April, he reasserted himself on the postwar art scene with visions of sobriety and hopeful expectancy.

Johnson's *Sunday Morning* is one of the earliest treatments of a theme of Sabbath Bible reading that would be reiterated with notable frequency by American painters for more than two decades. The painting speaks of the renewal of an essential, nativist piety that intensified during the war years, and of a fresh appreciation for the vernacular New England setting that many Union supporters saw as the repository of the nation's moral underpinnings. Such sentiments were promulgated by influential clergymen like the Unitarian Henry Bellows (1814–1882) during the war years;[68] but the nativist moral vision was promoted in northern cultural circles as well. The editors of the *Atlantic Monthly*, founded in 1857, anointed New England culture as the nation's spiritual exemplar. Beginning in the early sixties (first under James Russell Lowell and, from 1861 to 1871, under James T. Fields), the magazine avidly sought to publish "local color" productions characterized by authentic regional locations, details, and dialects. The majority of these literary works, which offered critiques of urbanization without idealizing rural existence, consistently referred to the inherent religiosity of New England life. Harriet Beecher Stowe expressed this view in her novel *The Minister's Wooing*, serialized in the *Atlantic* in 1858–59: "It is impossible to write a story of New England life and manners for a thoughtless, shallow-minded person. . . . In no other country were the soul and spiritual life ever such intense realities, and everything contemplated so much (to use a current New England phrase) *in reference to eternity*."[69]

Imagery of the surviving features of New England's rural culture and religious life was a highly accessible language for Americans bent on reinvesting their lives

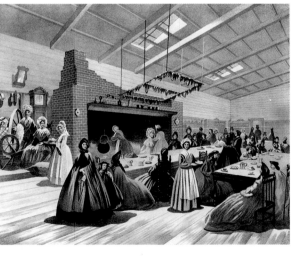

FIG. 38
"The New England Kitchen"
From *History of the Brooklyn and Long Island Fair* (Brooklyn, 1864)
Brooklyn Museum of Art Library Collection

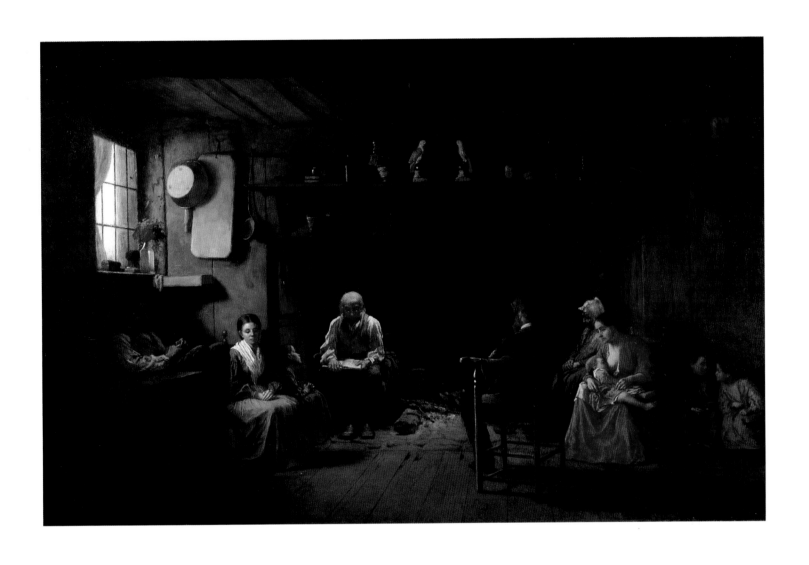

NO. 34
Sunday Morning, 1866
Oil on canvas, 24½ x 36 in.
The New-York Historical Society

67 THE GENIUS OF THE HOUR

with domestic values and stability. Johnson adopted that vocabulary in *Sunday Morning*, the first elaborate statement of the type of Colonial Revivalist setting that he would continue to refigure in his work of the 1870s. In the thick of the war, New Yorkers had paid homage to the old-time kitchen in displays at their Sanitary Fairs.[70] The most "serious" example among these displays, at the Brooklyn and Long Island Fair (fig. 38), codified for a mass audience the key antiquarian components of an authentic New England kitchen, at the heart of which was a hearth of "huge dimensions." A pamphlet produced for visitors explained, "The idea is . . . to illustrate the domestic life and habits of the people, to whose determined courage, sustained by their faith in God, we owe that government, so dear to every loyal heart."[71]

In keeping with the mode of contemporaneous local-color fiction, Johnson chose to represent in *Sunday Morning* the perpetuation of an early New England way of life amid the turbulent change of a new century, rather than a re-created colonial scene. A time-worn hearth is the setting for a simple and visibly arduous life; the mood is as somber as a proper Sabbath observance would have warranted. Seated within the embrace of the vast fireplace, the grandparents abide by the strict religious code in which they were raised, embodying types (an aging sea captain and his pious wife) described by Stowe in her early local-color novel, *The Pearl of Orr's Island*: "a pair of worthy, God-fearing people, . . . [who] never read anything but the Bible, the 'Missionary Herald,' and the 'Christian Mirror.' "[72] Like the great sea chest that stands in the sparsely furnished kitchen of Stowe's characters, the two colorful export-porcelain parrots on the mantel in Johnson's painting reconfirm the couple's New England identity through a connection to the once prosperous China sea trade. With the exception of the rapt young girl at the old man's side, the younger generations gathered around the hearth—including a young man fingering a gold ring—appear distracted by concerns that lie beyond the Sunday circle. Even the pose of the father, seated in a provincial Queen Anne style corner chair with his back to the viewer, suggests impatience.

Perhaps owing to its subdued mood, *Sunday Morning* (like *Fiddling His Way*) won Johnson far fewer accolades than his less ambitious *Christmas-Time* and earned him the more sober designation as "sincere man and conscientious painter."[73] The painting found a particularly appropriate owner, however, in the Scottish-born sugar refiner and ardent Presbyterian Robert L. Stuart, for whom observance of the Sabbath was a passionate cause.[74]

If Johnson's abandonment of the maple-sugaring project liberated him to undertake new subjects, it was not until 1867 that he managed to create a highly powerful work with *The Pension Claim Agent* (No. 35).[75] In confronting the postwar existence of the tens of thousands of disabled veterans, he produced his most ambitious canvas since *Negro Life at the South*, and perhaps the most beautifully

FIG. 39
Alfred R. Waud
"Paying United States Pensioners at the Pension Office in the New York Custom-House"
From *Harper's Weekly* (March 24, 1866)
Brooklyn Museum of Art Library Collection

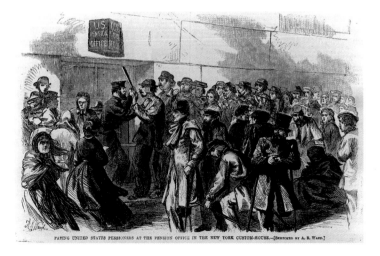

PAYING UNITED STATES PENSIONERS AT THE PENSION OFFICE IN THE NEW YORK CUSTOM-HOUSE.—[SKETCHED BY A. R. WAUD.]

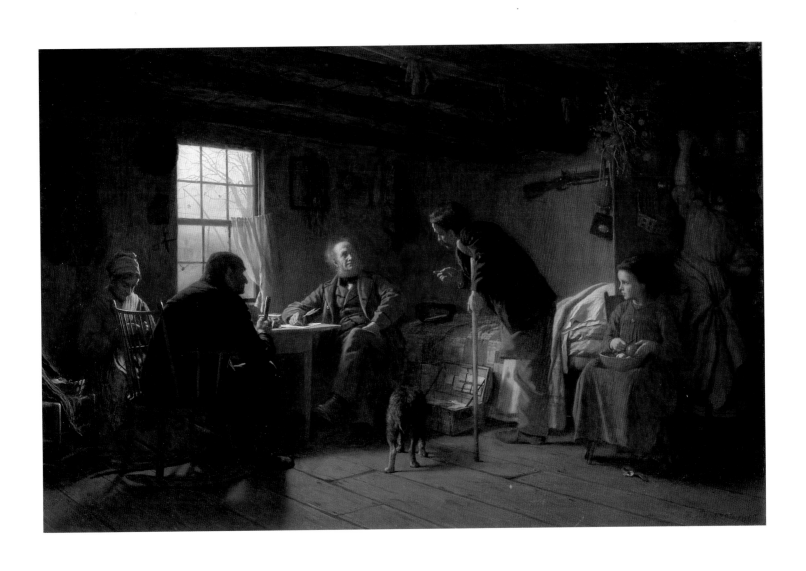

NO. 35
The Pension Claim Agent, 1867
Oil on canvas, 25¼ x 37⅜ in.
Fine Arts Museums of San Francisco,
Mildred Anna Williams Collection, 1943.6

painted work of his career thus far. Unanimously acclaimed as the outstanding work of the National Academy annual of 1867,[76] the painting was praised both for its subject, "one of numerous incidents of real life, resulting from the late war,"[77] and for its treatment, with "grouping of the most natural kind, drawing admirable for its truth and force . . . [and] action without recourse to melodrama." The latter reviewer asserted, "The quality of this excellent picture, indeed, lies in its absolute fidelity to nature, and in the admirable types of nature selected by the artist."[78] The architect, critic, and Ruskinian advocate Russell Sturgis (1836–1909) glowingly described *The Pension Claim Agent* as "at once a memorial of the war, and of New England domestic life."[79] Johnson had accurately anticipated the theme's appeal to a broad public inclined to honor veterans and the home life to which they had returned. Interest in the picture was undoubtedly related as well to the widely acknowledged generosity of the newly restructured pension system.[80]

The incident represented by Johnson was readily legible to his audience as the visit of a traveling pension agent charged with the firsthand verification of disabilities. Equally clear was the subtext of the young man's loyalty to the Union, on which his eligibility for benefits was founded. While the undeniable focus of the painting is the veteran's amputated leg, Johnson offered a subtle diversion in his articulation of light on the turned heads and poised hands. The intensely linked gazes of agent and veteran were unanimously praised for their expressive power and evocative delineation.[81] Somewhat unexpectedly, the young man's profile and his gently expressive hand are defined by slight and somewhat low-toned highlights, while the universally admired head of the agent is illumined in a rich, Rembrandtesque manner.

Johnson reinforced the subtle expression of the central group in his disposition of the secondary characters. For both the figures and the setting, perhaps the most finely distilled of his country interiors, he clearly drew on his intimate knowledge of the precisely half-lit rooms and quietist narrative of seventeenth-century Dutch painting. The rich, milky light emanating from the window, "a picture by itself,"[82] traces a path of subtle narrative detail. The interior and its occupants are models of the cleanliness, moral character, and industry required of pension recipients.[83]

Johnson's widely praised "truthfulness" in the rendering of this subject indeed obscured its fictionality.[84] Not surprisingly, viewers preferred Johnson's rendition to the more immediate reality of urban veterans, whose ill-met needs were blatantly represented in a *Harper's Weekly* illustration of March 1866 (fig. 39).[85] *The Pension Claim Agent* nevertheless was upheld as "truly representative" and propelled Johnson into the spotlight. Russell Sturgis, who commended Johnson's increasing "power of vigorous conception," equated the painting's importance with Emerson's newly published volume of poetry. Revealing his Pre-Raphaelite biases, Sturgis continued, "[*The Pension Claim Agent*] is true realistic work, out of which . . . comes true work of all sorts. We find that the painter who has painted the real with all his strength, and has mastered it, would paint the ideal too. . . ."[86] For all the enthusiasm with which it was critically received, *The Pension Claim Agent* remained unsold for some time; it was purchased by the wealthy flour merchant Josiah Fiske (b. 1828) by 1876 and was sold a second time to the leading collector Thomas B. Clarke by 1892. The painting nevertheless won Johnson new esteem, and at least temporarily the designation of "the most progressive of American artists."[87]

At this point in his career, Johnson increasingly felt confined by the demands of his own specialization in figure painting. After a day trip on the New Jersey coast with Whittredge in July, he lamented to McEntee, "I wish I could only rove around as other painters do." Complaining that the city left him "most dead with heat & dreadfully tired," he explained his resignation in staying there: "I must work this

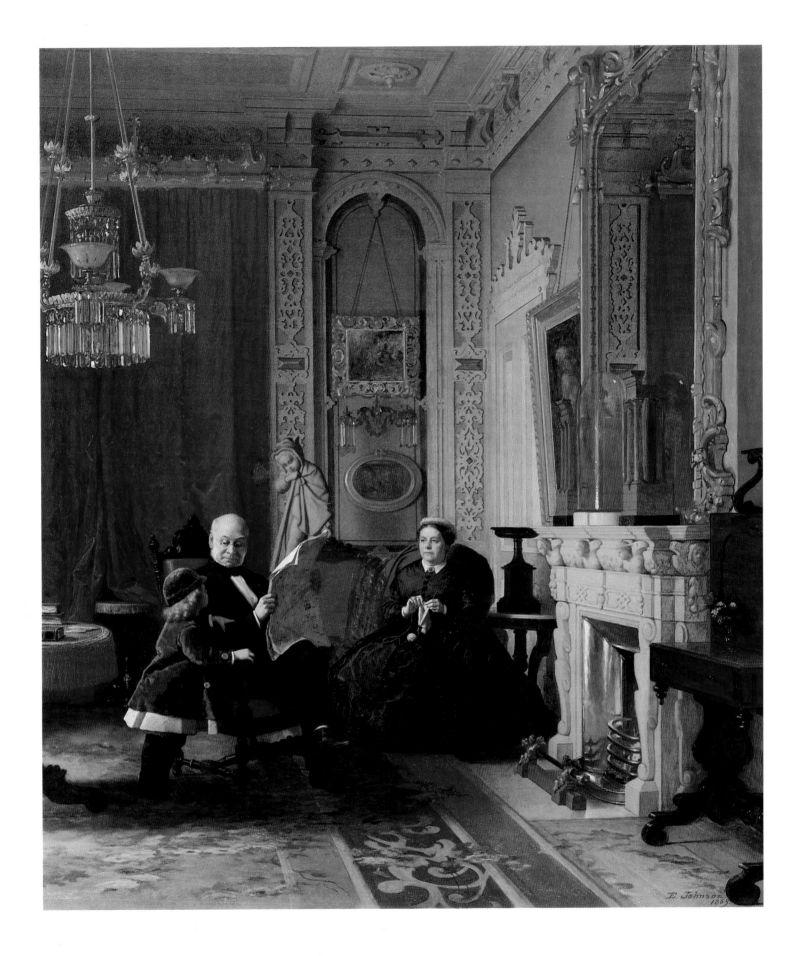

NO. 36
The Brown Family, 1869
Oil on canvas, 38½ x 32⅜ in.
Fine Arts Museums of San Francisco,
Gift of Mr. and Mrs. John D. Rockefeller 3rd,
1979.7.67

summer where I can make it tell the most."[88] He found some respite in an excursion to Connecticut as the guest of his supporter and patron James W. Pinchot.[89] Recounting their visit to the prosperous city of Hartford and to Armsmeer (the sumptuous home and art gallery of Elizabeth Colt) in a letter to McEntee, he vented his frustrations: "I am tired of this struggle & am thankful if I have discovered a place where people are spontaneously rich." He returned to New York only to lament to his friend once again, "The whole summer is pretty much without record & the last few weeks so much more than wasted that I must do something or sink into utter hopelessness."[90]

Johnson made up for lost time in the ensuing months, and by the National Academy annual of 1868, he had prepared *The Field Hospital* (No. 82), *The Boy Lincoln* (fig. 73), and his distinctly Frèresque *The Early Scholar* (National Gallery of Art, Washington, D.C.). The trio of works earned him generally positive reviews, though some critics found Johnson's idealized evocation of the president's youth somewhat calculated in its nostalgic effect.[91] He achieved a more mixed success in 1869 with his Academy entry *The Brown Family* (No. 36), described by the *Evening Post* as a pretty, though artificial, domestic scene but dismissed by the *New York Leader* as a "bad picture."[92]

So blatantly negative a response to Johnson's work was an aberration: his reputation was nothing if not secure by 1869. It is true that most tributes to his work emphasized its wholesomeness and attention to the familiar and even common aspects of life. In a typical assessment, Johnson's former University Building colleague Eugene Benson (1839–1908) described his genius as "lacking fantasy and imagination." It was, instead, "wide and healthy . . . perfectly sane and . . . striking always the average experience." The latter qualifications suited Johnson's audience, in whose eyes he was, to quote Benson, "unquestionably the first name among American *genre* painters."[93]

"Blessed Is He Who Has a Wife and House": Johnson's Experiment with Personal Narrative

Although thriving professionally, Johnson had yearned for the physical comforts and companionship of married domestic life for nearly a decade. He wrote his married friend McEntee in 1867, "If I had a good loving wife such as I can imagine & even know—I wouldn't care a rush for all the rest. . . ."[94] He finally found the partner for whom he had longed in the attractive and intelligent Elizabeth Williams Buckley (b. 1840), whom he married in June 1869. The daughter of the New York flour and iron merchant Phineas H. Buckley, and granddaughter of the wealthy Quaker merchant and banker Thomas Buckley (1771–1846),[95] Elizabeth Buckley spent her early childhood in Troy, New York. She returned there from 1851 to 1856 to attend the highly progressive Troy Female Seminary (now the Emma Willard School).[96] In keeping with the philosophy of its founder, the feminist educator Emma Willard, the academy's mission was to instill in young women a love of diverse intellectual pursuits in order to prepare them for responsible motherhood or teaching careers.[97]

Johnson may have met his future wife through his own substantial Troy connections during the early 1860s, by which time Elizabeth Buckley may have been living there once again.[98] Like a number of his closest New York colleagues, he participated in the annual exhibitions established by the Troy Young Men's Association in 1858, and as a result counted Troy notables among his early patrons.[99] It is also interesting that among the lenders to the association's 1862 exhibition was a "Miss Buckley," who sent *Twilight*, by Louis Rémy Mignot.[100]

A year after their marriage, in May 1870, the Johnsons delighted in the birth of their only child, a daughter named Ethel. They do not appear to have established a

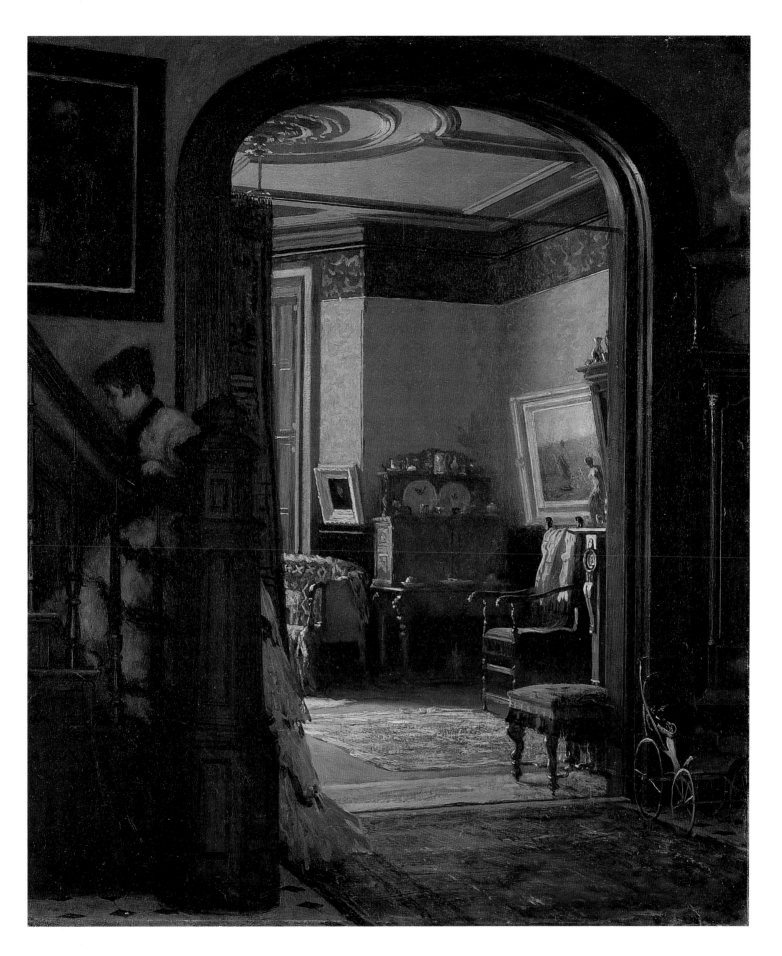

NO. 37
Not at Home, circa 1873
Oil on paper board, 26½ x 22¼ in.
Brooklyn Museum of Art, Gift of
Miss Gwendolyn O. L. Conkling, 40.60

FIG. 40
Madison Avenue, Looking Northwest from 55th Street, circa 1870
Photograph
Museum of the City of New York,
The J. Clarence Davies Collection

FIG. 41
Eastman Johnson
Woman at the Window, circa 1872–73
Oil on cardboard, 26½ x 22 in.
Thyssen-Bornemisza Collection, Lugano,
Switzerland

new residence together until 1871, when they lived for about a year at 238 East Thirteenth Street (Johnson maintained his University Building address through that year). In 1872 they purchased the stone town house at 65 West Fifty-fifth Street in which they would pass the length of their married life. The ever-practical Johnson had selected a neighborhood—in the mid-Fifties between Fifth and Sixth Avenues—just on the verge of development (fig. 40).[101] If his external surroundings were still shy of fashionable, the interior of 65 West Fifty-fifth nevertheless became the new center of his emotional and professional universe. In the relocation of his workspace to a domestic setting (on the uppermost floor)—a highly unusual move for an artist of Johnson's stature in New York during this period—he approximated the Dutch tradition wherein studios were contiguous with home.[102] Perhaps more inclined by this situation to draw on the seminal imagery of domesticity coined by Dutch artists like de Hooch and Dou, he found a new, intimist subject matter in his young wife and child and the spaces that they gracefully inhabited.

Among the most beautiful works produced by Johnson during his first years at Fifty-fifth Street is a painting eventually titled *Not at Home*, circa 1873 (No. 37), a domestic "portrait" of Elizabeth Johnson ascending the stairs to the second floor, leaving behind the sunlit parlor visible through an arched doorway.[103] Particularly in the context of the post–Civil War era, when images of family life were newly poignant, *Not at Home* is unusual in its representation of a solitary female removed from the space associated with her active life as "woman of the house." The fact that Elizabeth Johnson is depicted wearing a "day dress," appropriate for receiving visitors or making calls, indeed suggests that her "at home" has just ended; and the presence of the little stroller next to the tall-case clock in the hallway implies her return to her child's side in the upper story of the house. Her maternal role is reiterated by the large painting, hanging in the parlor at the right, representing Johnson's own copy (No. 88) of a painting by Jules Breton (1827–1906) in which a child is pulled in a rustic perambulator along the edge of a sunny field.[104]

The partial view through one interior space to a brighter one clearly recalls seventeenth-century Dutch interiors, and particularly the quietist images of de Hooch, for which Johnson had developed an affinity during his years in Holland. In *Not at Home*, the temporarily uninhabited parlor space is similarly evocative of tranquillity and domestic comfort. The depiction of the room is distinctive among American parlor images in its relative informality and the implication of regular use. Despite the couple's recent marriage and move to these new quarters, the furnishings—a Federal style sofa casually draped with an afghan, and several modest pieces of Renaissance Revival furniture—appear relatively well worn, as do the carpets that plot a path from the hallway to the sunlit bay. Insomuch as a home was considered at the time to be a "personification" of the woman who oversaw it, we are led to believe that Elizabeth Johnson was suitably unpretentious.[105]

Not at Home remains a particularly fascinating image, not only for its unusual, suppressed narrative, but also for the meaning that arises from our knowledge of the specific domestic situation in which it was created. Although the painting participates in domestic genre's traditional delineation of exclusively female preserves that attain their virtue from the absence of men, our sense of Johnson's own daily presence in the house prompts an alternative reading of this interior.[106] Johnson and his wife enjoyed happy domestic arrangements, and unconventional works like *Not at Home* suggest something of the intimacy in which he studied and catalogued Elizabeth's shape and movements, and the domestic world in her orbit. Here the edges of her form and profile dissolve in gradations of soft brown tonalities.

Other paintings suggest that Elizabeth Johnson played a key role in her husband's reformulation of his domestic imagery during their first years together. In

NO. 38
Woman in a White Dress, circa 1873
Oil on paper board, 22⅜ x 14 in.
Fine Arts Museums of San Francisco,
Gift of Mr. and Mrs. John D. Rockefeller 3rd,
1979.7.62

NO. 39
The Toilet, 1873
Oil on paper board, 26 x 22 in.
The Corcoran Gallery of Art, Washington, D.C.,
Purchase, Hickey Memorial Fund as a Gift of
Captain A. S. Hickey U.S.N. (ret.) in memory of
his wife Caryl Crawford Hickey, 57.21

his sketchy *Woman at the Window*, circa 1872–73 (fig. 41), a young woman in a loose, "at-home" garment perches on the wide sill of a first-floor parlor window. Her intimate dress and position at the border of the private and public spheres may derive once again from the many Dutch examples that represented women at windows or in courtyards yielding onto the world outside the home. One of the most elegant images of Elizabeth Johnson from this period is a work known as *Woman in a White Dress*, circa 1873 (No. 38), in which she is turned to reveal the evocatively outlined shape of her simple hairstyle and the broadly brushed profile of her cotton lingerie dress with its trailing "sacque back" (or "Watteau back").[107] Both the back-turned pose and the attention to the dress may have been inspired in part by fashion plates of the period.[108]

Johnson did not immediately share these highly personal images with the public.[109] He first exhibited a painting of Elizabeth Johnson in a major exhibition in 1873: in *Catching the Bee*, 1872 (No. 90), she appears in a smart ensemble with a red traveling purse and displays her delicately laced ankle in a daring manner that was highly unusual in American painting of the period. Johnson put his home environment on view in a major exhibition with two of his entries to the 1874 National Academy of Design annual: *Bo Peep*, 1872 (Amon Carter Museum, Fort Worth), an image of a woman and child at play on a fabric-draped chaise longue; and *The Tea Party*, 1874 (fig. 76), both of which were set on one of the upper floors of the Johnson household.

Before his gradual move away from imagery directly representative of his wife and home, Johnson completed a work that is his most resolved and in some ways the most traditional of the group. Painted in 1873 and included among his four entries to the 1875 National Academy annual, *The Toilet* (No. 39) presents a woman paused before a mirror to adjust her earring. While attempting here to shape his personal domestic narrative for a public audience, Johnson clearly resisted the European vogue for interiors with women dressed in the height of opulent style.[110] Even among American interiors, however, this setting is unusual in its modesty and the idiosyncratic nature of certain still-life objects: a covered Anishinabe (Ojibwe) basket, obviously dating from Johnson's time in Wisconsin, sits on the Federal style sideboard at the left; and what appears to be a child's sketch is tacked up to the right of the mirror. Perhaps the most interesting aspect of the picture is the woman's attire, for she appears in a morning dress—a loose robe worn over a simple chemise and petticoat, without corset and bustle, that was an intimate garment intended for use among family at home. Together with the informality of the interior, the costume of the *robe d'intérieur* accents the modest intimacy of the scene and speaks of the painter's personal tie to his model.[111] Enhanced by his use of oil on a paper support, Johnson's technique in *The Toilet* was particularly fine in the modeling of the face and its vaguer, bluish reflection in the glass; both are complemented by his sketchy suggestion of the velvet gown.

While much of the critical attention to Johnson's Academy entries that year was devoted to his ambitious but uncharacteristic, and rather unsuccessful, rendition of *Milton Dictating to His Daughters* (location unknown; an 1876 version is in Blanden Memorial Art Museum, Fort Dodge, Iowa), *The Toilet* was generally noted for its grace.[112] Johnson's paintings also attracted the more particular attention of the young Henry James (1843–1916), whose remarks were compelling: "Mr. Johnson has the merit of being a real painter—of loving, for itself, the slow, caressing process of rendering an object. Of all our artists, he has the most coquetry of manipulation. We don't know that he is ever wasteful or trivial, for he has extreme discretion of touch. . . ." Although unenthusiastic about *The Toilet*, James was once again perceptive in his recognition of Johnson's affinity for the humble and understated: "Mr.

Johnson will never be an elegant painter—or at least a painter of elegance. He is essentially homely."[113]

The early 1870s was a time of energetic experimentation for Johnson, as his new domestic subjects reveal. While he would continue for a brief period to reiterate popular Frèresque subjects—such as his *Scissors Grinder*, 1870 (New York State Historical Association, Cooperstown)—he sought to reinvigorate his repertoire with such ambitious, highly successful efforts as *The Old Stage Coach* (No. 86) (see essay by Sarah Burns in this volume), the highlight of the 1871 National Academy exhibition.

Johnson nevertheless appears to have struggled with the process of finding a successful new idiom. When he briefly reverted to the Civil War theme, completing his ultimate version of *The Wounded Drummer Boy*, 1871 (fig. 106), for the Academy's 1872 annual, even a positive critic could not overlook an element of artificiality in the work.[114] Johnson also attempted to build on his new repertoire of feminine imagery in 1874 with *Hollyhocks*, 1874–76 (No. 94), reworking his well-received *Catching the Bee* into a more complex composition that reportedly represented "a country schoolyard."[115] Another effort in this vein was his surprisingly melodramatic and self-consciously artful *The Girl I Left behind Me*, circa 1875 (No. 93), to which one reviewer bitingly responded, "No one could be blamed for leaving this particular maiden behind him."[116]

It was generally an uneasy period for artists in New York, who in 1873 found themselves burdened by the effects of a serious economic depression. Johnson and his friends were also troubled by a heightened level of apathy among Academicians, who increasingly withheld their work from the important annuals, thus severely reducing the income generated for the Academy by sales from the exhibitions.[117] A *Tribune* writer who took the majority of the Academy membership to task on the occasion of the 1873 exhibition singled Johnson out and praised his significant showing.[118] The same writer alluded pointedly to the growing taste for European art among American patrons, a third factor contributing to general frustration in the Academy's circle.[119] In early 1874, Johnson spoke with McEntee about possibly refraining from debuting important work at the smaller club exhibitions in order to heighten the impact of their key works in the Academy annual[120]—a significant plan, given Johnson's regular exhibition of paintings at The Century Association— but he appears not to have done so. Johnson did attract new patrons in the early seventies. The major collector George Whitney had snapped up *The Old Stage Coach*, apparently through the dealer Samuel P. Avery,[121] and the patronage of such prominent collectors as the banker and Union League colleague Henry Gurdon Marquand (1819–1902),[122] the respected New York physician Fessenden Nott Otis (1825–1900), and the banker and Union Leaguer Harris Charles Fahnestock (1835–1914) demonstrated the sustained market value of Johnson's Frèresque works.[123]

Island Home

Johnson had meanwhile found in the island of Nantucket the new locale that would inspire his best and most original paintings of the decade. He had begun casting about for a new summer spot by June 1870, at a time when he apparently was suffering great anguish, caused at least in part by Elizabeth's apparent poor health after Ethel's birth in May.[124] Eager to find a site near sea breezes for his wife's relief and his own sense of freedom, he considered Narragansett, Rhode Island, Martha's Vineyard, and Saco, Maine, before settling on Nantucket by early August.[125] Johnson and his family enjoyed a restorative season, and within a year they purchased a house and property on the island.[126]

Johnson was hardly the first to take notice of Nantucket's aesthetic potential. Perhaps inspired by the isolated ocean setting as described in Herman Melville's

FIG. 42
"Residence and Studio of Eastman Johnson,"
circa 1873
From Henry M. Baird, "Nantucket," *Scribner's Monthly* 6, no. 4 (August 1873)
Brooklyn Museum of Art Library Collection

Moby Dick (1851), a correspondent for the *Crayon* in 1858 recommended Nantucket as a rich source of material for painters. That writer described the picturesque quality of the whaling port and its activities, but observed the slow demise of its way of life and suggested that in place of those fading features an artist might be attracted by the Greek Revival houses "blazing away in white paint" and the low heath stretching beyond the town.[127] The decline of the Nantucket whaling trade that began at midcentury would be complete by the time of Johnson's first visit to the island. In 1866 a writer for the *Atlantic Monthly* described it as a place "whose life stands still, or rather goes backward, whose ships have sailed away to other ports, whose inhabitants have followed the ships."[128] If the writer was pleased to have found a place "which railways can never reach, and where there is nothing to attract fashionable travellers," the enterprising population that remained on Nantucket saw tourism as their primary hope and promoted rail travel to the local ferry service, called Island Home.

Johnson was among the earliest touristic arrivals and for more than two decades would be among Nantucket's most enthusiastic promoters. By 1873 the agglomeration of old houses in which he made his home and studio (fig. 42), overlooking a long stretch of beach on the north shore at a high point known as the Cliff, was a feature of a lengthy article in *Scribner's Monthly* vaunting Nantucket's touristic appeal.[129] Probably reminded of the Dutch sea town of Scheveningen, Johnson relished Nantucket's simple way of life, its setting, and its population that offered models of substantial visual appeal and character.

Johnson's formulation of his Nantucket aesthetic, drawing directly on the visual character of the place and the tenor of life there, came slowly. His *Winding Yarn*, 1872 (fig. 43), for example, is a slightly awkward attempt that borrows from earlier genre formulas by William Sidney Mount and Francis W. Edmonds (1806–1863).[130] Present there, however, is the spare colonial kitchen that would be the mainstay of his Nantucket imagery. By 1873 Johnson began to explore more seriously the physiognomy of the local types. The quintessential Nantucketer in this period of the island's "decline" was the aging sea captain, whose bent form and weathered face could speak volumes, of the adventurous nature of his former occupation, as well as of its demise. Among the earliest of these representations is Johnson's *Captain Nathan H. Manter* (No. 40), a study of one of the island natives whom the artist would come to know well. Johnson's expressive drawing is visible along the edge of the weathered face, and the rest is painted with a breadth evocative of the subject's rough skin and rumpled clothes.

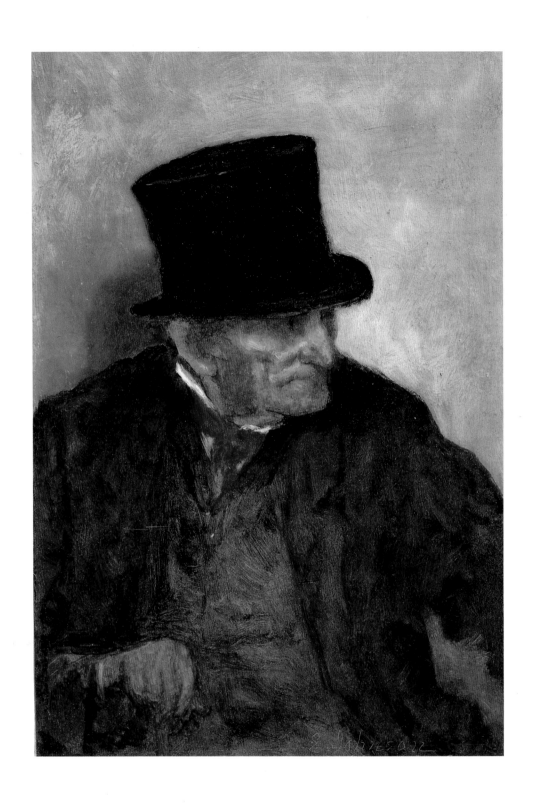

NO. 40
Captain Nathan H. Manter, November 1873
Oil on paper board, 12¾ x 8⅝ in.
Private collection

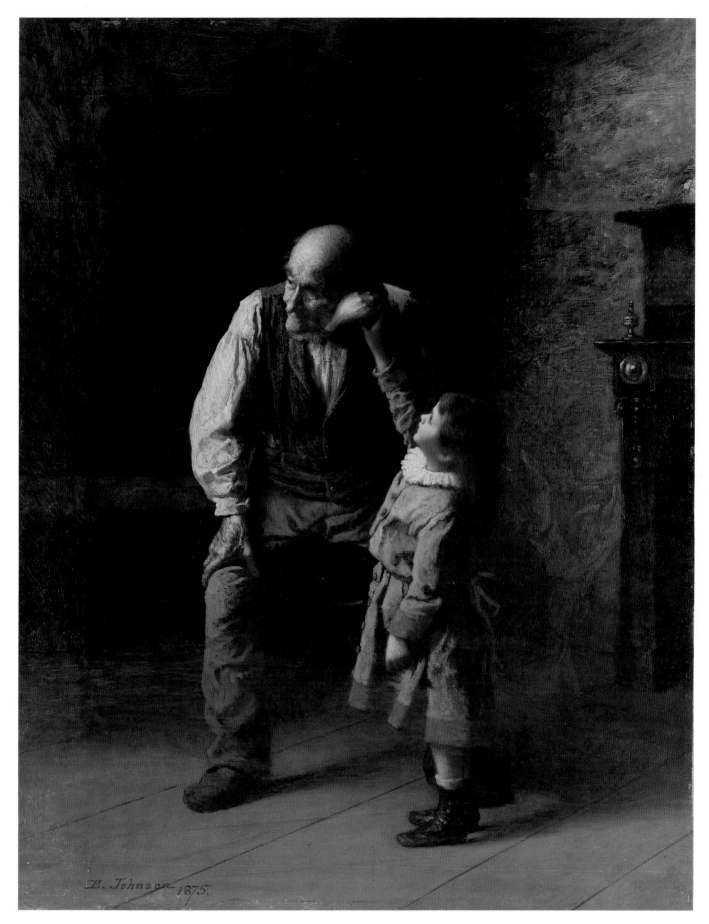

NO. 41
What the Shell Says, 1875
Oil on paper board, 21⅞ x 16¾ in.
Fine Arts Museums of San Francisco,
Gift of Mr. and Mrs. John D. Rockefeller 3rd,
1979.7.64

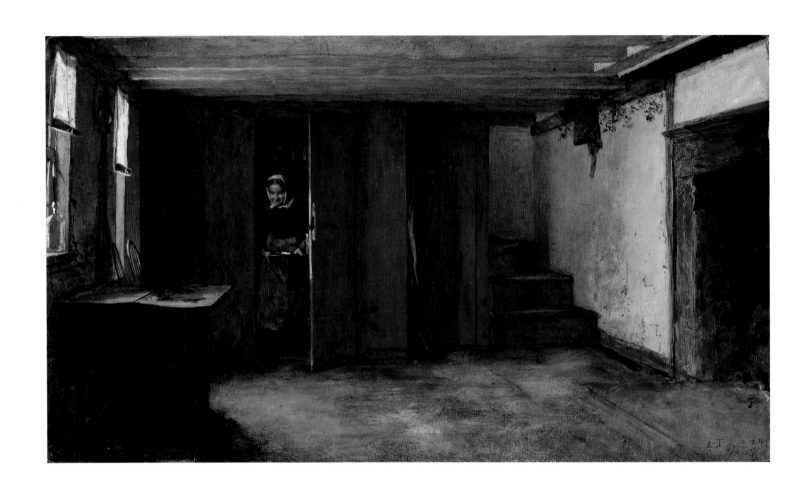

NO. 42
Susan Ray's Kitchen—Nantucket, 1875
Oil on paper board, 13 x 22¼ in.
Addison Gallery of American Art, Phillips
Academy, Andover, Massachusetts, Gift of John
K. McMurray in memory of Dr. James Graham
Leyburn, 1994.69

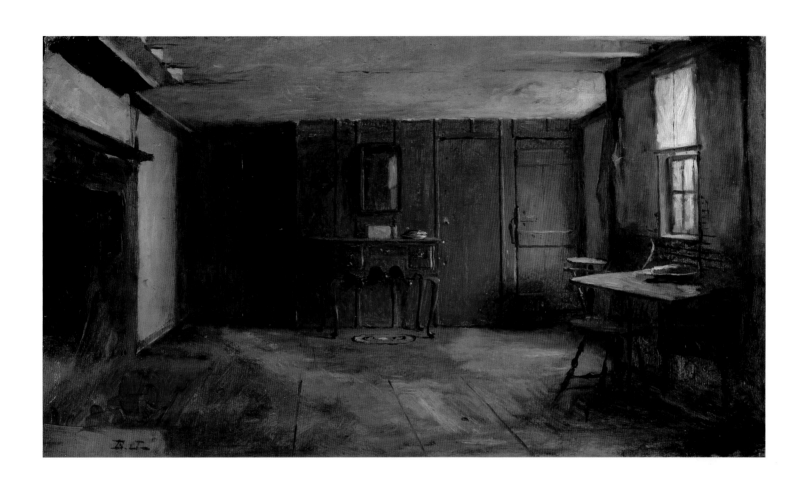

NO. 43
The Other Side of Susan Ray's Kitchen—
Nantucket, circa 1875
Oil on paper board, 13¼ x 22¾ in.
Addison Gallery of American Art, Phillips
Academy, Andover, Massachusetts, Museum
Purchase, 1996.74

Johnson's new direction—his choice of distinctly regional models and the use of a more attentive realism in their representation—was of a piece with continuing developments in the literary circles of New England. Of the older generation, John Greenleaf Whittier, who for much of his early career had written of his New England childhood, turned increasingly in the late 1860s to the New England of his adult years.[131] The most interesting parallel to Johnson's Nantucket work, however, was a series of stories by the young author and Maine native Sarah Orne Jewett (1849–1909) that was first published in the *Atlantic Monthly* beginning in 1873 and was reformulated in 1877 in the volume *Deephaven*.[132] By her own account, Jewett's espousal of a local-color aesthetic was inspired by the early chapters of Harriet Beecher Stowe's *The Pearl of Orr's Island* (quoted earlier here), whose very first paragraph contains the description of "the peculiarly hard but expressive physiognomy which characterizes the seafaring population of the New England shores."[133] In *Deephaven*, Jewett told the story of two young girls who become acquainted with the elderly population of a declining maritime village. According to her preface to the 1894 edition, she undertook the subject out of fear that old-fashioned New England towns, and the customs of their inhabitants, were fast being swept away during the post–Civil War years by progress and an insensitive new population of tourists. She speaks too of her "unconscious desire to make some sort of explanation to those who still expected to find the caricatured Yankee of fiction. . . ."[134] Early in the novel, she describes the "curiously ancient, uncanny look" of the weathered sea captains and observes, "These were not modern American faces, but belonged rather to the days of the early settlement of the country, the old colonial times."[135]

Johnson's deliberate Realism parallels Jewett's authentic dialect. His first finished canvas on the theme appears to have been *Old Captain* (location unknown), exhibited at a December 1875 National Academy exhibition and described by a *Times* reviewer as "free and masterly."[136] That year Johnson also offered a domesticated version of the mariner theme in his beautifully tenebrous *What the Shell Says* (No. 41), in which a child's naive curiosity conjures myriad memories of a perilously adventurous, and bygone, life.[137] Johnson here employed the same type of narratively significant light as in *The Pension Claim Agent* (No. 35), but his touch has become palpably broad and his palette expressively limited; the combination of the two suggests that he was reflecting again on the example of Rembrandt. *What the Shell Says* was described as among the most notable works in the January 1876 Artists' Fund Society exhibition and auction, where it brought the top price.[138] The buyer was the retired China trade merchant and highly respected philanthropist Benjamin Hazard Field (1814–1893), who traced his ancestry to early seventeenth-century settlers of Rhode Island.[139]

In 1875 Johnson also explored the subtler aspects of Nantucket interiors in two distilled and intuitively painted studies (Nos. 42, 43) of the old kitchen in one of the island's eighteenth-century houses (fig. 44).[140] In *Susan Ray's Kitchen—Nantucket* (No. 42), inscribed with the date September 24, 1875, the Nantucket native Susan L'Hommedieu Ray (1821–1904) emerges from the pantry carefully carrying a bowl, whose edge is touched with a reflection of the light that filters through the white muslin shades. In the absence of ornament or amenities, the character of the room emerges in Johnson's description of the plaster walls, wooden doors and paneling, heavy beams, and vast hearth that holds a small bed of embers. He employed a brushy freedom of execution to suggest the room's crooked floor and ceiling, and the universally worn aspect of everything in it. These images are the extreme opposite of such overappointed Colonial Revival settings as that in Edward Lamson Henry's *A Lover of Old China*, 1889 (Shelburne Museum, Shelburne, Vermont). As in his images of the sea captains, Johnson chose to represent Nantucket of the 1870s in its honest disrepair rather than as a quaint re-creation of the past.

The Ray House. Nantucket, Mass.

FIG. 44
"The Ray House. Nantucket, Mass."
From Knowlton Mixer, *Old Houses of New England* (New York: The Macmillan Company, 1927)

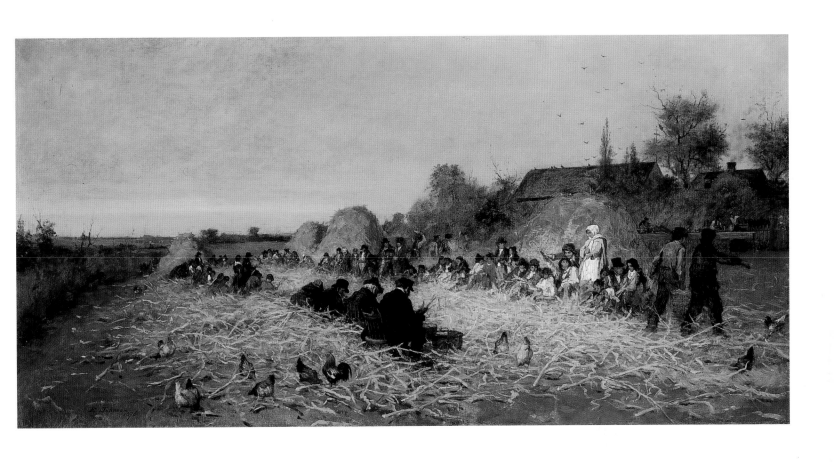

NO. 44
Husking Bee, Island of Nantucket, 1876
Oil on canvas, 27¼ x 54⅜₆ in.
The Art Institute of Chicago, Potter Palmer
Collection, 1922.444

85 THE GENIUS OF THE HOUR

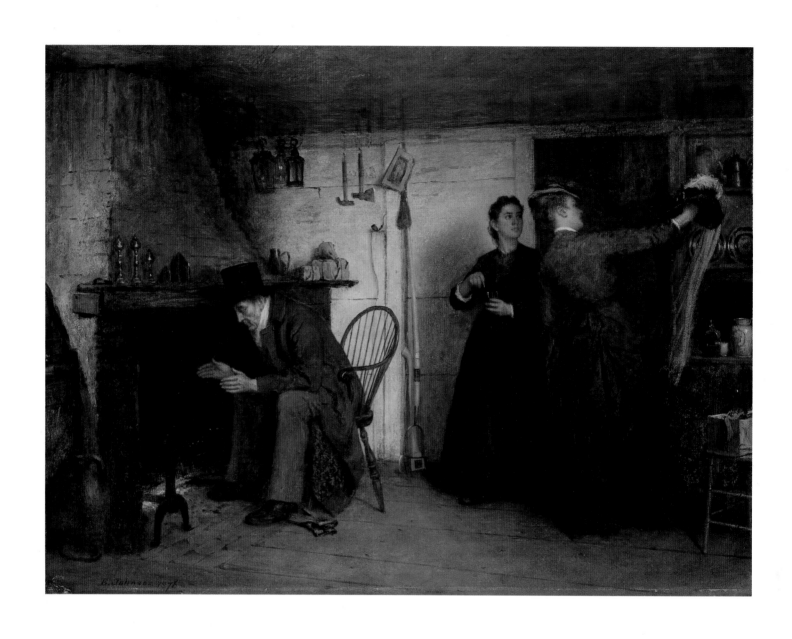

"No Insignificant Step": 1876–79

In 1875 Johnson began to cast about for a new, grand theme. He recorded as early as that August, "I am *drawing* my *cranberry* picture in—black and white pastels," suggesting that he had already started work on the subject that he would finally bring to fruition four years later.[141] He apparently also held out hopes for the abandoned "maple sugaring" project after the wealthy collector A. T. Stewart expressed interest in seeing some sketches in February 1876.[142] That March, however, Johnson was completing what would be his most highly praised work of the decade.[143] Begun the previous fall, *Husking Bee, Island of Nantucket* (No. 44), represented his renewed attempt to complete a large, multifigure composition set outdoors.

Johnson finished the painting for the National Academy annual by the end of the month and submitted along with it a finely composed and painted Nantucket interior titled *The New Bonnet* (No. 45). Because a large percentage of Academy members refrained from exhibiting that year, Johnson's entries played a particularly outstanding role.[144] They also were notable as a pair for their significantly divergent styles. A reviewer for the *Times* suggested that "*Cornhusking*," with its exceptional freedom of execution, "reminds one . . . [of] anybody, rather than Eastman Johnson" and criticized only its lack of "intensity," meaning an absence of visual focus, a characteristic he cited as Johnson's "greatest gift."[145] The *Tribune* reviewer, probably Clarence Cook, commented incisively, "Husking Bee seems done to please the artists and connoisseurs; the New Bonnet to please the world as it goes, and the world in particular for whom Johnson has so long been working." In a reference to the rising controversy in the New York art world over the concept of "finish," the same writer suggested that Johnson's execution was "coarse" but fell short of "slap-dash" because "every stroke on the canvas tells, and the artist's intention rules every inch of its surface." Along with Homer's entry, *Breezing Up (A Fair Wind)*, 1876 (National Gallery of Art, Washington, D.C.), Johnson's *Husking Bee* constituted, in this writer's opinion, a lesson on finish.[146]

Husking Bee, Island of Nantucket was indeed Johnson's most liberated "official" response yet to the younger generation of Munich Realists returning to the New York art scene. His large compositional sketch for the finished canvas (The Metropolitan Museum of Art, New York) is only slightly more sketchy. The long, opposing rows of huskers comprise a lively assortment of poses and colorful accents, set against the backdrop of a moody tonal landscape and the brighter carpet of exuberantly brushed stalks.[147] With deliberate breadth, Johnson convincingly described recognizable types, such as the hunched, top-hatted old seafarer in the first row. Only a sheet of beautifully executed drawings for the composition (No. 46) demonstrates the careful study and fine line on which he based the final, freely executed elements. Two additional sheets from the same period (Nos. 47, 48), done in preparation for other compositions, provide additional examples of the fine pencil work that he customarily employed to delineate heads and the broader touch that he reserved for other details.

More in keeping with the character of his preparatory drawings, Johnson rendered *The New Bonnet* with the careful sense of form and eye for detail that characterize his best-known works of the 1860s. Only the loosely described veil of the hat, the cropping of certain details at the picture's edge, and the generally cool, muted tones suggest its later date. The subtle clarity of the narrative led more than one critic to retell the story; the writer for the *Tribune* even named the vain owner of the bonnet "Eliza Jane," and her more modest counterpart "Sary Ann."[148]

Reactions to the pair of entries varied; the *Times* reviewer suggested, regarding *The New Bonnet*, that "never before has Johnson painted something equal in strength,"[149] while the reviewer for the *Atlantic Monthly* considered *Husking Bee*

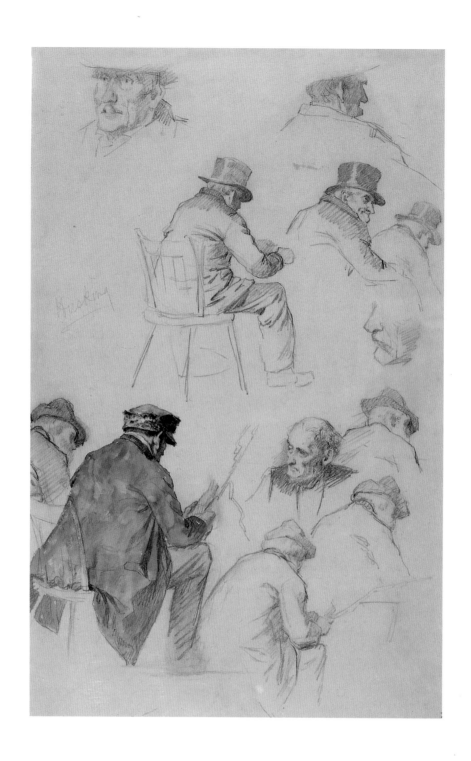

NO. 46
Study for "Husking Bee, Island of Nantucket,"
1876
Pencil and watercolor on paper, 18¾ x 12¼ in.
The Free Library of Philadelphia, Rosenthal
Collection, Print and Picture Collection

NO. 47
Sketches, circa 1872–80
Graphite, crayon, chalk on wove paper, 12⅜ x 18¾ in.
Addison Gallery of American Art, Phillips Academy,
Andover, Massachusetts, 1935.47

NO. 48
Sheet of Sketches with Child Drinking, circa 1875
Pencil and black chalk on paper, 18¾ x 12¼ in.
Museum of Fine Arts, Boston, Gift of Maxim Karolik,
55.758

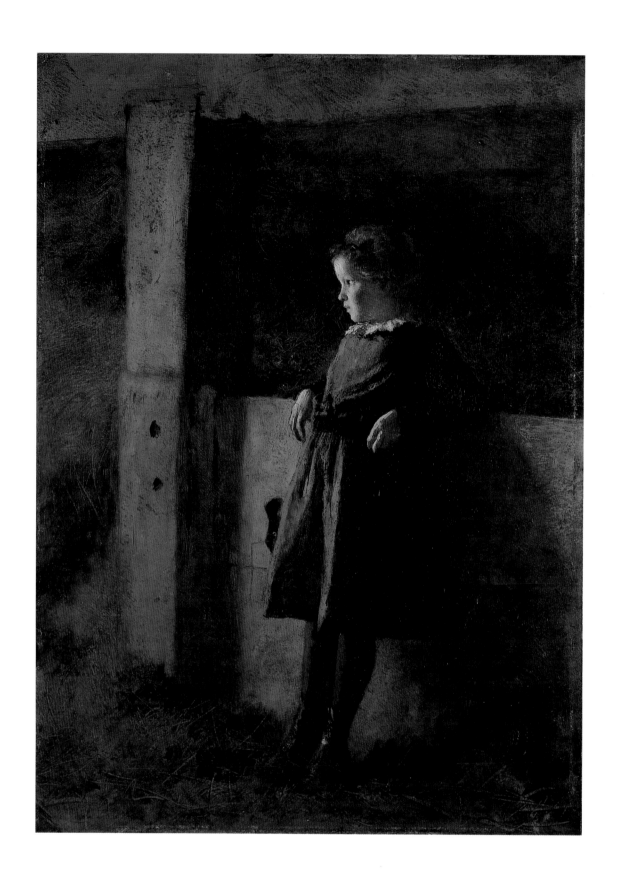

Girl in Barn (Sarah May), circa 1877–78
Oil on panel, 16⅛ x 11⅜ in.
Collection of Sarah May Edmonds Broley

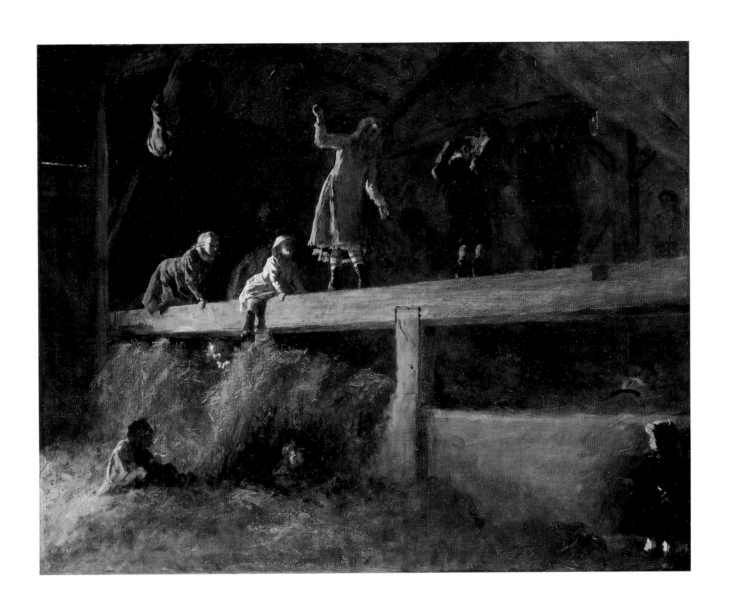

NO. 50
In the Hayloft, circa 1877–78
Oil on canvas, 26¾ x 33 in.
San Diego Museum of Art, Gift of
Mrs. Herbert S. Darlington, 1935.54

91 THE GENIUS OF THE HOUR

to be "no insignificant step in the right direction."[150] The point of consensus was that *Husking Bee* was a truthful representation of the free and voluntary labor within rural American society, and in this respect was superior to the many French paintings of laboring peasants by artists like Jean-François Millet (1814–1875) and Jules Breton, then enjoying a surge of popularity among American patrons. The *Times* writer commented, "It is not a show picture in any sense, but a careful record of a peculiar phase of American country life."[151] *Husking Bee* was purchased quickly by the photographer and painter Napoleon Sarony (1821–1896); in 1889 or 1890 it passed into the hands of the Chicago collector of Monet, Potter Palmer (1826–1902). By 1880 *The New Bonnet* found its way into the collection of Collis P. Huntington (1821–1900), a shrewd railroad magnate who had made his start in life as a traveling peddler.[152] Despite these purchases, Johnson was troubled by what he considered poor sales that year and made moves to place his work with dealers.[153]

The following year, 1877, was a difficult one for artists in New York. The growing generational controversy over the control of Academy exhibitions and membership came to a head in early April upon the opening of that year's annual, when a dispute arose over the amount of prime gallery space reserved for works by the members of the hanging committee.[154] While loud protests were offered on behalf of the new European-trained generation, most critics felt that the younger men had been treated well; new-guard works such as Frank Duveneck's *The Turkish Page*, 1876 (Pennsylvania Academy of the Fine Arts, Philadelphia), and Walter Shirlaw's *Sheep Shearing in the Bavarian Highlands*, circa 1877 (location unknown), attracted a great deal of attention. Johnson's reaction to the situation is difficult to gauge. His personal appreciation of European training, as well as his current inclination for formal experimentation, suggests the likelihood of a sympathetic reaction to the younger men, but he apparently refused to attend the May meeting at which the eight-foot rule—instituted after the opening that spring to reserve prime space for Academicians in future exhibitions—was rescinded.[155] He had the misfortune of receiving a large share of attention for his entry *The Tramp*, 1876–77 (Flower Memorial Library, Watertown, New York), an image of a vagrant approaching a farmhouse, which most reviewers singled out for its interest but criticized for its flaws in conception and composition.[156] Like many of his colleagues, Johnson experienced poor sales throughout the year, in part because of competition from the auction sales of a number of prominent private collections.[157]

In the summers of 1877 and 1878, however, Johnson found respite from the controversy and heat of New York in visits to the Kennebunkport farm owned by his sister Harriet and her husband, Joseph May. There he produced a series of charming and richly brushed barn interiors that demonstrate his growing talent for describing the fall of light on moving figures. In *Girl in Barn (Sarah May)* (No. 49) and *In the Hayloft* (No. 50), both circa 1877–78, the May children and their friends emerge from the shadowy brown interiors as schematic patterns of bright accents. *In the Hayloft* was among Johnson's entries to the 1878 annual, an exhibition from which, as one critic pointed out, most of the old guard abstained, "[seemingly] disposed to yield room willingly to bolder and younger spirits."[158] It also was the first of numerous annuals in which Johnson's portrait entries would outnumber his figure subjects; and it was the first annual to run concurrently with the rival exhibition of the youthful Society of American Artists, to which he would gravitate by 1880. The ambiguity of Johnson's position among Academy loyalists is further indicated by the fact that in January 1879, he alone was not reelected to the Academy Council, and was replaced by John LaFarge (1835–1910).[159]

Regardless of Academy politics, a group of works painted largely in 1879 demonstrates the degree to which Johnson continued to invest in a broader and

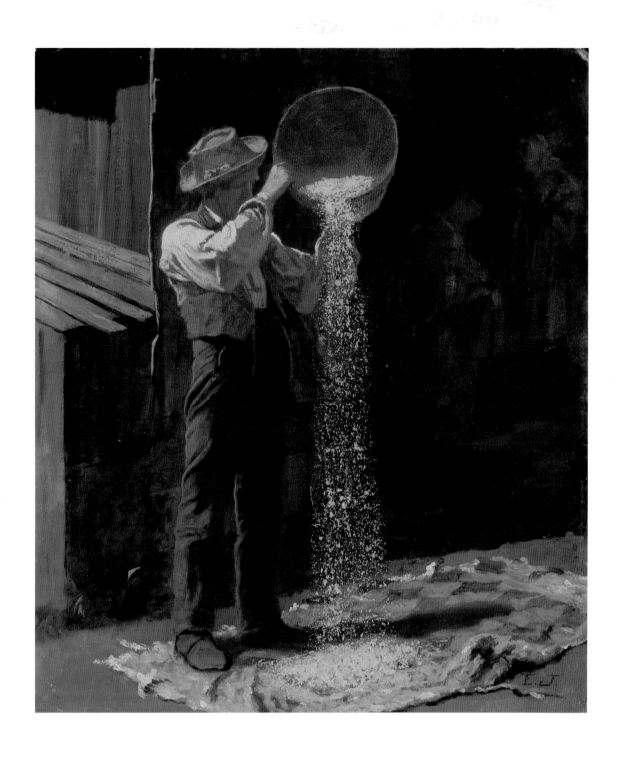

NO. 51

Winnowing Grain, circa 1877–79

Oil on paper board, 15½ x 13 in.

Museum of Fine Arts, Boston, Bequest of Martha
C. Karolik for the M.and M. Karolik Collection of
American Paintings, 1815–1865, 48.436

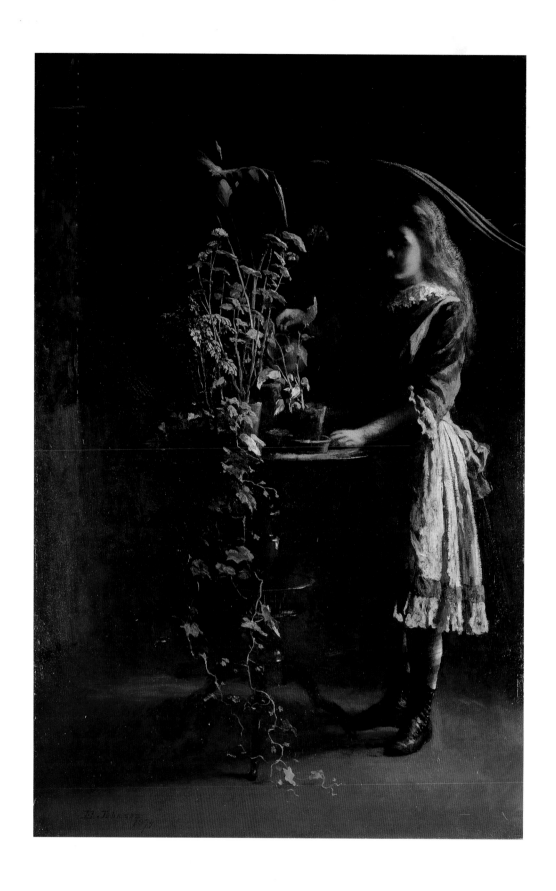

NO. 52
Watering Flowers, 1879
Oil on paper board, 29 x 19 in.
Collection of Kenneth Lux

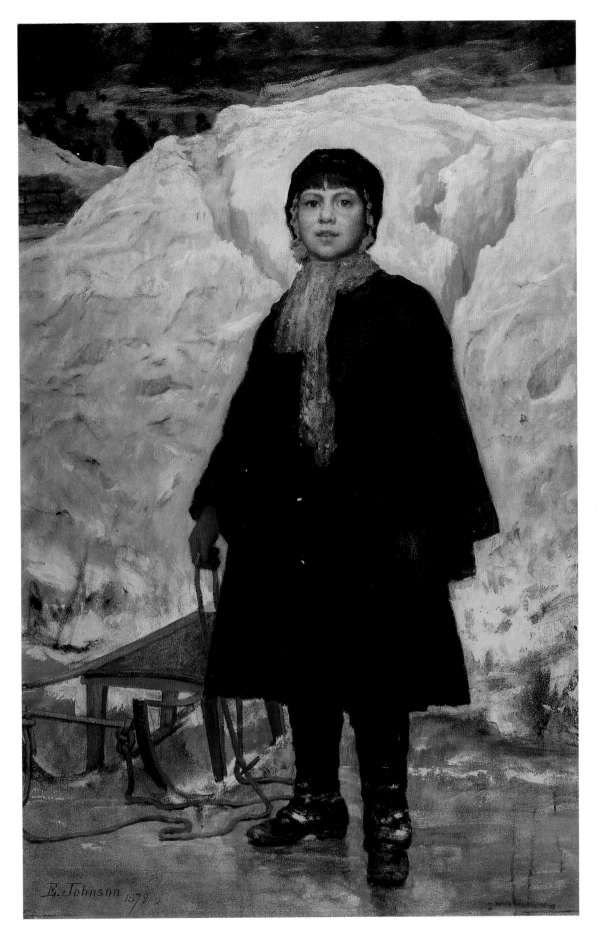

NO. 53
Winter, Portrait of a Child, 1879
Oil on canvas, 50⅞ x 32 in.
Brooklyn Museum of Art, Gift of Charles M.
Kurtz Trust, 1992.108

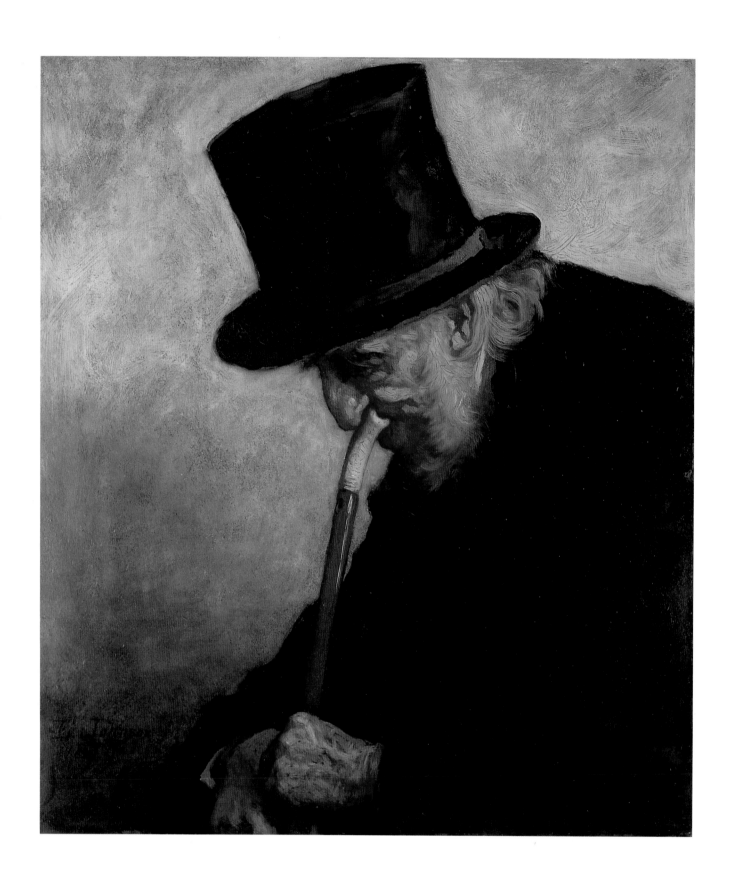

NO. 54
*Portrait of Captain Charles Myrick (Study for
"Embers"),* 1879
Oil on panel, 22 x 20⅞ in.
Collection of the Nantucket Historical
Association, Nantucket, Massachusetts

NO. 55
Captain Coleman, 1880
Charcoal and white chalk on paper, 12⅛ x 9⅛ in.
The Free Library of Philadelphia, Rosenthal
Collection, Print and Picture Collection

bolder manner. In *Winnowing Grain*, circa 1877–79 (No. 51), probably painted during one of his stays on the May farm, he employed a path of scumbled paint to suggest a shower of grain onto the brushy surface of a tattered diamond-patterned quilt. In the tenebrous *Watering Flowers*, 1879 (No. 52), forms emerge within the half-lit interior as richly brushed passages of color. Johnson's bold description of the brilliantly lit edge of the dress suggests that he may have begun to borrow from some of the younger Munich-trained artists like Frank Duveneck. It is not insignificant that Johnson and the critic S. G. W. Benjamin nominated William Merritt Chase (1849–1916) for membership in The Century Association that same year.[160] In 1879 Johnson also painted *Winter, Portrait of a Child* (No. 53), an unusually large, direct, and broadly rendered image of the rugged little Ethel posed before the sketchy form of a snowbank. He debuted the painting at The Century Association in June 1879, but he also employed it as his debut piece at the 1881 exhibition of the Society of American Artists, a clear indication that he regarded the canvas as a departure from his usual production. Among the newer effects in this work were the relatively bright backdrop, the rough surface texture that is particularly prominent in the background, and the sacrifice of fine details. The same year Johnson also furthered his treatment of the Nantucket sea-captain theme with *Portrait of Captain Charles Myrick (Study for "Embers")* (No. 54), which he would later develop into his ultimate essay on age. This image of the hunched form and ruddy face of Johnson's elderly friend, with his lips pressed to the ivory tip of a cane, is characterized by an expressive but careful breadth of description. Johnson's unforgiving delineation of the rough, spotted skin of the hands is among the work's most interesting passages. His equally bold charcoal likeness *Captain Coleman* (No. 55), of 1880, shares a similar assurance and expressive freedom.

"The Cranberry Harvest, Island of Nantucket"

As remarkable as they are, the works just discussed do not constitute the most ambitious of Johnson's projects in 1879. By late September or early October, the Johnsons had arrived in Nantucket for the fall season, as was their recent habit, and the artist had begun in earnest the cranberry-harvest subject for which he first made studies in 1875. In a now often-quoted letter, he wrote to McEntee: "I was taken with my cranberry fit as soon as I arrived . . . as they began picking down in the meadow a day or two after we arrived and I have done nothing else since I have been here, *not a thing*. . . . I have no finished picture at all, maybe further off than ever. . . ."[161] By mid-October he clearly was immersed in completing the exhaustive series of oil sketches that preceded his impressive finished canvas, *The Cranberry Harvest, Island of Nantucket*, 1880 (No. 60).

As Marc Simpson has explained in rich detail, Johnson's scene was set on a coastal heath that lay below the Cliff and North Road, where the Johnson home was situated. In the completed composition, the town of Nantucket lies in the distance at the left, with the Brant Point Light farther to the left, and a characteristic Nantucket windmill scenically placed nearer the center of the image. At such spots on the island, the cultivation of cranberries had in recent years become one of the means by which Nantucketers attempted to replace income lost with the whaling industry's demise. For Johnson, the yearly communal project of harvesting the crop provided the type of landscape-and-figure combination that he had explored in his maple-sugaring project and in his successful *Husking Bee, Island of Nantucket* (No. 44).[162]

Johnson's studies for the painting are among his most visually stunning works of the decade, revealing his now-superb ability to summarize the effects of natural light on moving forms and his ease in the practice of the reductive, expressive sketch. In a number of these studies, Johnson experimented temporarily with

NO. 56
The Conversation, 1879
Oil on paper board, 22½ x 26½ in.
Addison Gallery of American Art, Phillips
Academy, Andover, Massachusetts, Museum
Purchase, 1942.42

NO. 57
Cranberry Pickers, circa 1879
Oil on paper board, 22½ x 26¾ in.
Private collection

NO. 58
Study for "The Cranberry Harvest, Island of Nantucket," circa 1879
Oil on paper board, 19¾ x 30 in.
Collection of Teresa Heinz and the late Senator John Heinz

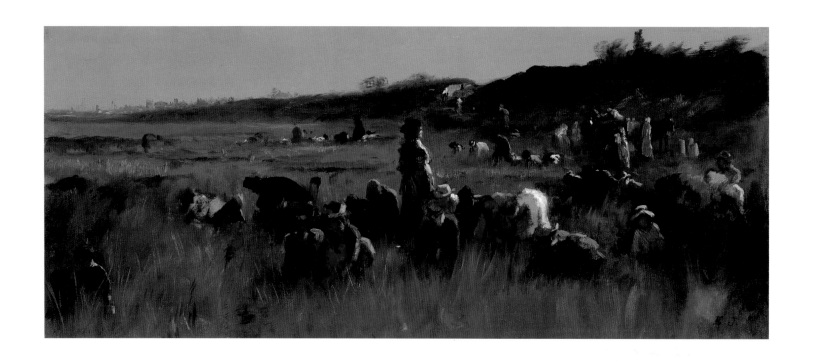

NO. 59
Cranberry Pickers, Nantucket, circa 1879
Oil on canvas, 19 x 43½ in.
Manoogian Collection

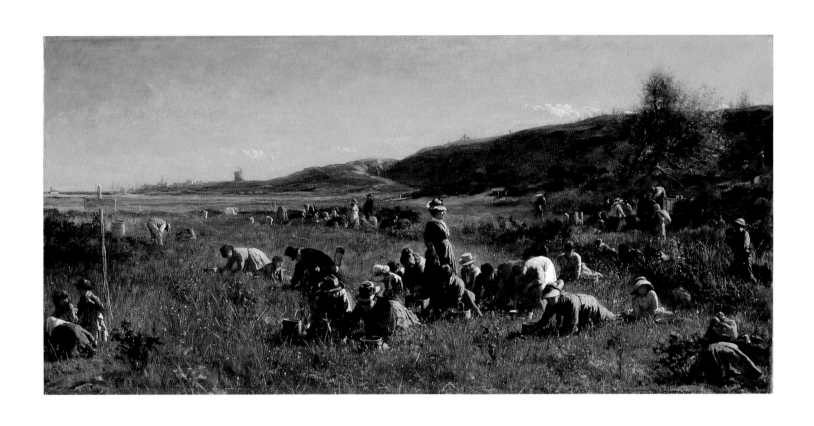

NO. 60
The Cranberry Harvest, Island of Nantucket, 1880
Oil on canvas, 27⅜ x 54½ in.
Timken Museum of Art, San Diego, Putnam
Collection

motifs that do not appear in the final work (see also No. 92). The forms of two Nantucket women set against the horizontal bands of land, sea, and sky in *The Conversation* (No. 56) are strongly volumetric, like the barrel and basket with which they are paired and the two buckets that flank their long, black shadows. Johnson directed our attention to their interchange through a pattern of warm, raking light on their heads and shoulders. Another example, *Cranberry Pickers* (No. 57), employs an expressive arrangement of five distinctly characterized figures who converse in the dramatic light of a setting sun. Though Johnson cast the forms almost entirely in shadow, he achieved a surprising measure of physical detail and narrative life with sparingly selected highlights.

In his more advanced compositional studies, Johnson experimented with various vantage points on the cranberry heath, contrasting times of day, and alternate arrangements of the figural composition.[163] Two that approach the final composition quite closely (Nos. 58, 59) reveal that, even at this late stage in the process, he was drawn to the evocative and coloristically daring effects of a late-day sun. In each of these the central figure of a standing female who dominates the finished composition is established, though in the former work she appears younger and more lithe, in a white cotton dress. In that apparently earlier sketch, however, the figural groups behind and in front of the standing woman are visually balanced; in the later work (one that approximates the size of a large finished canvas), the eye is drawn to the right half of the canvas by the path of light that meets the direction of the woman's gaze.

Johnson did not easily achieve the complex arrangement of his finished canvas (No. 60). An update to McEntee in November revealed his frustration, as well as a reluctance to make the disruptive move back to New York at the season's close.[164] Determined to finish, he remained on the island, with his family, well into December; he wrote to McEntee, "[T]he models are here and whatever materials I require, and that is all there is of the pictures."[165] The forms in their final configuration in *The Cranberry Harvest, Island of Nantucket* achieve a dynamic balance, like so many musical themes that have come to rest after a series of complex variations. Though the dynamism of his final canvas derives from Johnson's long process of exhaustive study, the painting differs from the preliminary works in the high key of its palette and in Johnson's touch, which is rich and lively but precise in its efforts. The figures, a calculated variety of types and groupings, appear to radiate, almost spokelike, from the form of the woman who stands erect, just to the right of the picture's center. With her gaze directed purposefully ahead, she exerts a formal dominance over the old man seated behind her (already a familiar type in Johnson's art) and the younger men on their knees around her, conveying a sense of the matriarchal society that had come to characterize Nantucket in the postwar period.[166] The theme of postwar rural New England communities of few men and strong, intuitive women was an essential element of local-color fiction in the decades of the 1860s and 1870s, including Stowe's *The Pearl of Orr's Island* and *Oldtown Folks* (1869), and Jewett's *Deephaven*.[167] This distinctive aspect of Johnson's representation of communality and labor emerges more emphatically in comparison with two other American paintings also executed in 1879: John Whetten Ehninger's *Turkey Shoot* (fig. 45), an image that offers a version of American outdoor rural life that is distinctly male; and John George Brown's more challenging view of organized urban labor, integrated and male, in *The Longshoreman's Noon* (fig. 46), which also appeared in the National Academy annual of 1880.

When *The Cranberry Harvest, Island of Nantucket* was exhibited at the National Academy exhibition that spring, the painting was repeatedly singled out as among the finest of the more than seven hundred pictures on view. Centrally placed on a

FIG. 45
John Whetten Ehninger
Turkey Shoot, 1879
Oil on canvas, 25 x 43½ in.
Museum of Fine Arts, Boston, Gift of Mrs.
Maxim Karolik for the M. and M. Karolik Collection of American Paintings, 1815–1865,
46.854

FIG. 46
John George Brown
The Longshoreman's Noon, 1879
Oil on canvas, 33¼ x 50¼ in.
The Corcoran Gallery of Art, Washington, D.C.,
Purchase, Gallery Fund, 00.4

prominent wall, it was widely admired for its brilliant effects of sunlight and its naturally varied figure composition.[168] Paired in the press with the artist's *Husking Bee, Island of Nantucket*, simultaneously on view in The Metropolitan Museum of Art's inaugural loan exhibition, *The Cranberry Harvest, Island of Nantucket* once again placed Johnson in the forefront of the New York art scene, and within a year, the painting was purchased by the wealthy New Yorker Auguste Richard. At the same time, Johnson's reassertion of his reputation was contextualized by at least one reviewer: the *Times* critic assessed the work as very likely "the most agreeable picture by any one of the older band of artists."[169]

Life after "The Cranberry Harvest"

As Marc Simpson has noted, 1880 was a good year for Johnson; but it was also something of a turning point. The painter successfully debuted other Nantucket subjects early in the year, including *A Glass with the Squire* (fig. 47), a vignette posed before an assemblage of Johnson's own antiques—for which he completed a study that is sure and expressive (No. 61).[170] He also demonstrated his flexibility by exhibiting a group of his sketches and paintings at the newly founded Art Students League, along with works by H. Humphrey Moore (1844–1926), a follower of the Spanish painter Mariano Fortuny y Carbo (1838–1874) and a specialist in Orientalist subjects.[171] Despite his interest in building ties with the younger generation, however, Johnson was quite conscious of being very much a member of his own advancing one. On learning of the death that August of his good friend and Academy stalwart Sanford Gifford, he confided to McEntee that he felt it to be "a great break into our particular circle."[172] Johnson probably realized that he would never again undertake a figure subject as ambitious as *The Cranberry Harvest, Island of Nantucket*; under the weight of that gargantuan effort in December 1879, he had despaired to his constant friend, McEntee: "I am trying to get some work done—The harder I try the more I cant."[173] The question as to what he would do was answered quite naturally with his very deliberate rededication to the practice of portraiture.[174]

At the 1881 Academy exhibition, Johnson won largely positive reviews for *The Funding Bill—Portrait of Two Men* (No. 97), a tenebrous, informal portrait of his wife's brother-in-law Robert W. Rutherford and the portraitist Samuel Rowse (1822–1901) discussing a controversial congressional bill to re-fund the national debt.[175] At about the same time, Johnson also painted the expressive *Portrait of a Woman* (No. 62)—very likely Elizabeth—in the very same corner of their parlor. There he devoted exceptional attention to the suggestive description of the patterned white satin, achieving a broad textural richness unequaled in his portraits of the period. As mentioned earlier, for his debut with the youthful Society of American Artists that spring, he selected his 1879 work *Winter, Portrait of a Child*. From 1882 through 1886, all of his National Academy exhibition pieces were portraits.

The shift may have been liberating for Johnson in some respects. In 1884 he exhibited a group of more than eighty sketches and studies at The Century Association, affording his immediate social circle a more intimate view of his creative process. Johnson's Nantucket subjects of this period, admittedly few in number, took on a different character as well. He lamented to McEntee in 1881: "[Nantucket] is no longer such a good place to work in as formerly—This summer there has been a throng of people—A good many New Yorkers and there are various excitements, land speculations & C. They have a *railroad* across the island. . . ."[176] In response, his figure subjects appear to be more deliberately about introspection and isolation. In *Ruth*, circa 1880–85 (No. 63), a single-figure subject that restates Johnson's theme of woman and stove (see essay by Jane Weiss in this volume), the figure is frozen in solitary meditation, while the cast-iron form takes on new expressive life. In terms of its purely intuitive execution and poignant realism, Johnson's *Old Man, Seated*, circa 1880–85 (No. 64), may be his most remarkable work of this period. The visible outline of the body, sure and expressive, is countered by the subtly illusionistic description of the soft and wrinkled flesh of the face and hand. Here Johnson's vision of age, presented starkly against a white plaster wall of a Nantucket interior, was more direct and emotionally evocative than any by his American peers.

In a more lighthearted vision, *The Nantucket School of Philosophy*, 1887 (No. 104), Johnson offered a gentle parody of the daily colloquies held by Nantucket's local authorities on the world. The painting reintroduced Johnson's Nantucket persona to the New York art world at the National Academy exhibition of 1887. A *Times* reporter, describing the well-liked painting as "a group of old whalers . . . around that genial thing, a small castiron stove," noted that it brought the highest price of any picture—$3,000, paid by the Boston-born banker and industrialist Edward Dean Adams (1846–1931)—in the sale following the exhibition.[177]

Johnson might well have continued his production of narrative subjects, had they not been more taxing and time-consuming than portraiture. For forty years he had made his way as an artist who aspired always to reinvent himself, but with his talents as a portraitist in great demand by a roster of eminent figures, it may have been too tempting to settle into a more predictable routine. Johnson's earlier achievements were well established and were being regularly acknowledged in the numerous new histories of American art that began to appear during the 1880s. Alfred Trumble described Johnson in 1887 as "the founder of a school of genre painting of the highest order," and he drew attention once again to those features that time and again had been described as the artist's forte: originality, a highly evolved technique, and praiseworthy sentiment.[178]

Johnson may have chosen an artistic routine for the duration of his career, but he never stopped looking at new art, and he occasionally even dipped into new aesthetic waters, as he had in 1879. Proof of the latter appears in his striking portrait of Ethel (No. 66) as a young woman, painted about 1895, perhaps to mark the moment of her impending marriage to Ronald Conkling in 1896. The treatment of the hands and the use of the thin veils of color in the landscape backdrop suggest that Johnson may have studied the work of Degas on one of his extended European visits, perhaps in 1891.

In his later years, though he seldom chose to display it in his commissioned portrait work, Johnson continued to be capable of achieving the expressive intensity that is so strikingly apparent in his *Old Man, Seated*. He rendered a study for *Embers* (location unknown), one of his last narrative canvases, exhibited at the National Academy of Design in 1899, in an unusual combination of graphite and wash on canvas (No. 65). Among the most beautiful works from his hand, it is a final postscript on Johnson's mode of vision: the delicately brief touches of drawing

FIG. 47
Eastman Johnson
A Glass with the Squire, 1880
Oil on canvas, 30½ x 23½ in.
Brown University Library, Providence, Rhode Island, Annmary Brown Memorial Collection

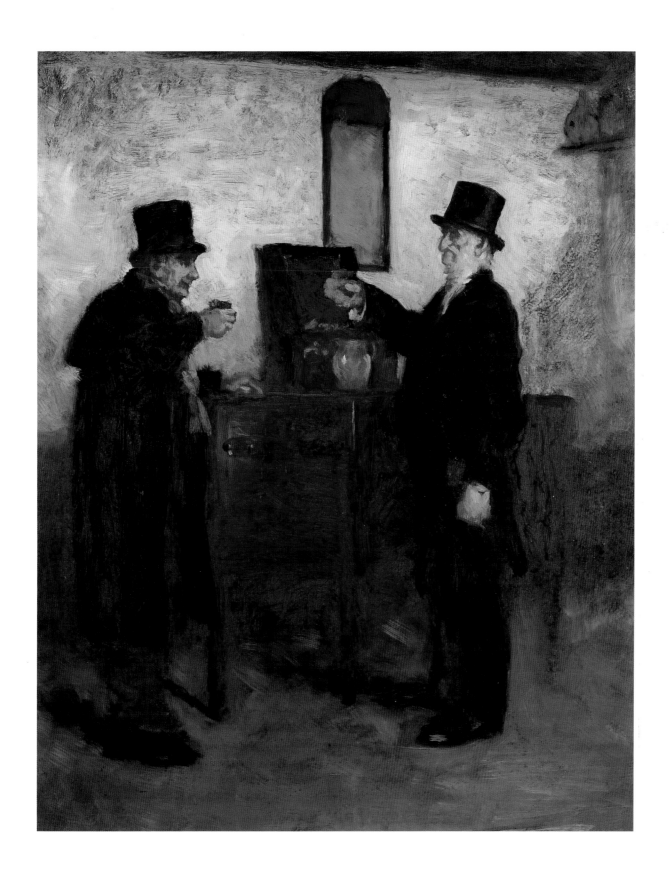

NO. 61
Study for "A Glass with the Squire," circa 1880
Oil on paper board, 25½ x 20⅝ in.
Private collection (Courtesy of Hirschl & Adler
Galleries, New York)

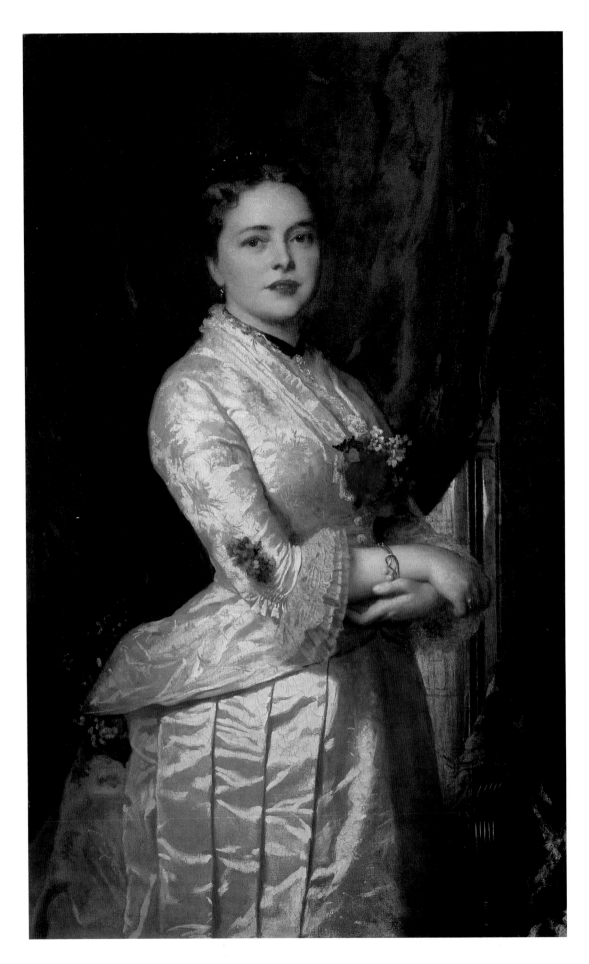

NO. 62
Portrait of a Woman, 1881
Oil on canvas, 46 x 28 in.
Collection of Donald and Lisa Purdy

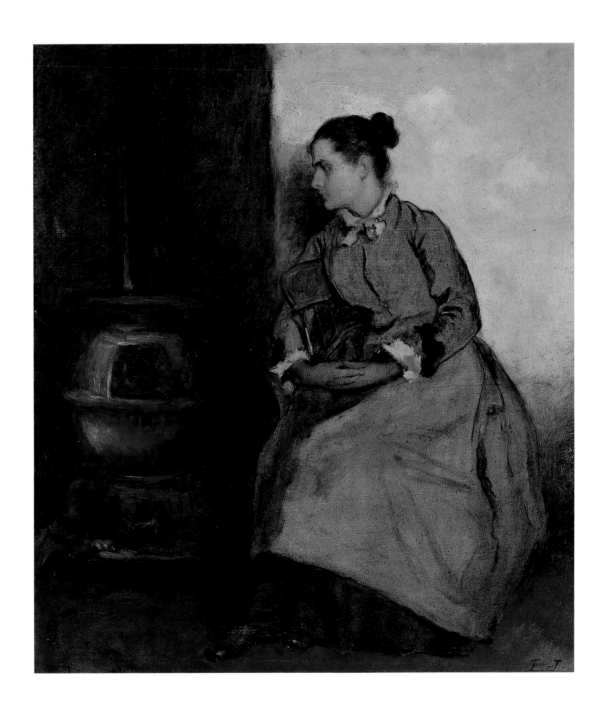

NO. 63
Ruth, circa 1880–85
Oil on panel, 17½ x 15⅝ in.
Albright-Knox Art Gallery, Buffalo, Gift of
Isabella S. Kurtz in memory of Dr. Charles M.
and Julia S. Kurtz, 1982 (1982.40)

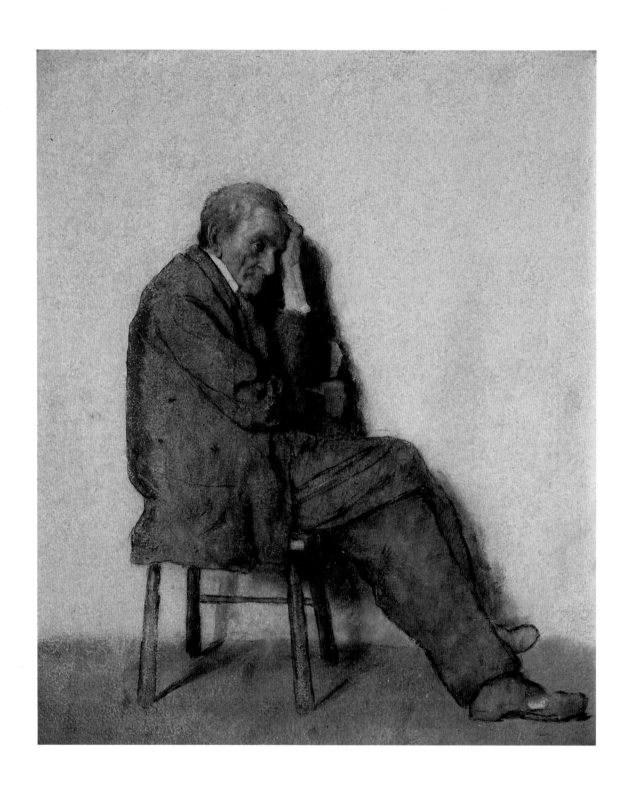

NO. 64
Old Man, Seated, circa 1880–85
Oil on paper board, 15¼ x 12⅞ in.
Private collection, the Netherlands

110 TERESA A. CARBONE

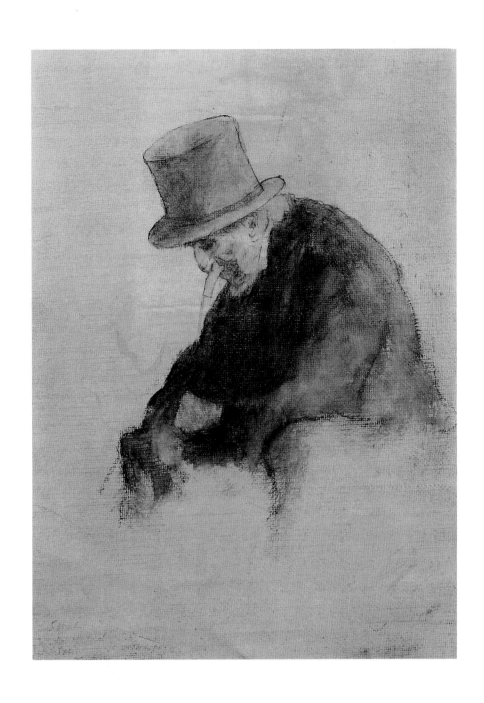

NO. 65
Captain Charles Myrick (Study for "Embers"),
circa 1880–95
Graphite and wash on primed canvas, 8¼ x 5¾ in.
Collection of Peter A. Feld

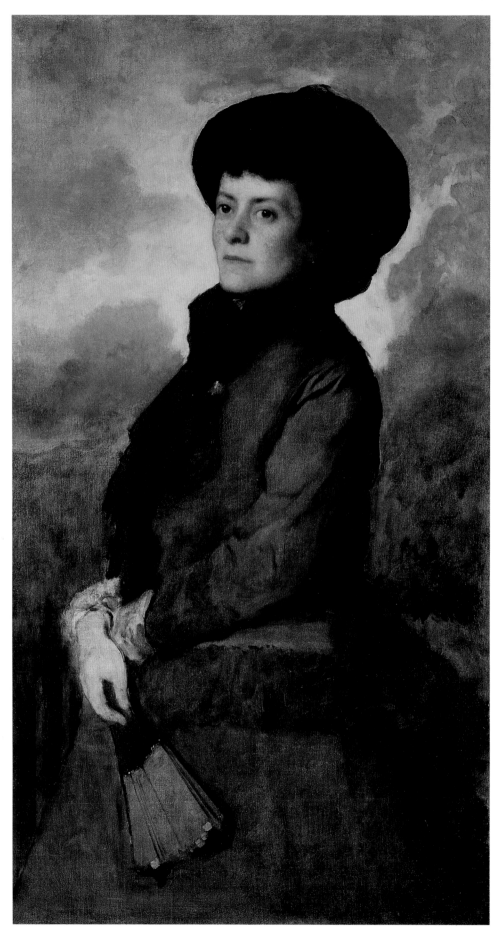

NO. 66*
Ethel Eastman Johnson Conkling with Fan, circa 1895
Oil on canvas, 46 x 24½ in.
Collection of Mrs. Frances van Reigersberg Versluys
*not in exhibition

in the head establish resemblance and character, and the broken passages of charcoal outline and the rich shading of the figure set a mood.

By 1890 Eastman Johnson was an emeritus dean of American painting—widely liked as a person and respected as an artist who had achieved an original success grounded in his technical prowess. Those critics and writers who remembered American narrative painting before 1860 praised his role in preparing the path for the younger generation of Realists, even if it was recognized that Johnson had stopped short of keeping pace with the new guard. But at the close of Johnson's era, "devotion to truth," as one critic put it,[179] still had value in some circles, and in tributes to the artist at the time of his death, this quality was cited liberally in reference to the man as well as to his art.

FIG. 48
Eastman Johnson, circa 1895
Photograph
Brooklyn Museum of Art Library Collection,
Schweitzer Gallery Files

Notes

1. Eastman Johnson to Henry Wadsworth Longfellow, June 3, 1857, [bMs Am 1340.2 (3044)], Houghton Library, Harvard University, Cambridge, Massachusetts.

2. The newcomer Johnson surprisingly was the first in his list of figure painters, a familiar midcentury roster of names that are less prominent in our minds today: George Boughton (1833–1905), William P. Dana (1833–1927), Henry Peters Gray (1819–1877), Daniel Huntington (1816–1906), Charles Blauvelt (1824–1900), Louis Lang, Thomas P. Rossiter (1818–1871), and George W. Flagg (1816–1897). See "Sketchings. Domestic Art Gossip," *Crayon* 6, part 1 (January 1859), p. 25.

3. The assortment of works includes an oval portrait similar to those of his Boston years; a broad and vaguely Dutch cityscape below it; and an evocatively painted sea- or landscape at the upper right. I thank Carolyn Tomkiewicz and Richard Kowall of the Brooklyn Museum of Art Conservation Department for their careful examination and photography of this work.

4. "Sketchings. Domestic Art Gossip."

5. Before an audience of thousands of New Yorkers at the Academy of Music on December 19, 1859, business leaders, including John Jacob Astor, Alexander T. Stewart, and William E. Dodge, openly defended slavery in an effort to rally public opinion against Secession. The *Evening Post* editor William Cullen Bryant lamented that February, "The City of New York belongs almost as much to the South as to the North." Quoted in Ernest A. McKay, *The Civil War and New York City* (Syracuse, N.Y.: Syracuse University Press, 1990), p. 18. Philip S. Foner writes, "While the slave trade in New York City went back 'for an indefinite number of years,' it was not until after 1857 that almost all expeditions were fitted out from this port, and that the city became known as 'the commercial center of the slave trade.'" Foner, *Business and Slavery: The New York Merchants and the Irrepressible Conflict* (Chapel Hill: University of North Carolina Press, 1941), p. 164.

6. The lithographic version was part of an edition of prints titled *The Porte Crayon*, published by the Crayon Gallery owner George Ward Nichols.

7. *The Boston Athenaeum Art Exhibition Index, 1827–1874*, ed. Robert F. Perkins, Jr., and William J. Gavin III (Boston: The Library of the Boston Athenaeum, 1980), pp. 85–86.

8. The other artists elected to the status of Academician that year were Leutze, Ehninger, Albert Bierstadt (1830–1902), and A. H. Wenzler. See "Domestic Art Gossip," *Crayon* 7, part 6 (June 1860), p. 176.

9. The barn is still standing today on Fish Street. I thank the staff of the Fryeburg Historical Society for identifying and locating the site. The identification of the models is recorded in a 1975 typescript, compiled from earlier sources, in the Fryeburg Historical Society, and confirmed by Diane Jones, Director, a relation of descendants of the Day family.

10. See Foner, *Business and Slavery*, p. 179. New York's urban vote was narrowly checked by a statewide Republican majority of 353,804 (to 303,329). Lincoln won in Maine by a popular vote of 62,811 to 35,007. See *The American Almanac and Repository of Useful Knowledge for the Year 1861*, vol. 32 (Boston: Crosby, Nichols, Lee and Company, 1861), p. 417.

11. See McKay, *The Civil War*, p. 24.

12. See Foner, *Business and Slavery*, pp. 267–69. William E. Dodge, Jr., owned one version of Johnson's *Warming Up* (location unknown) by 1863.

13. "National Academy Exhibition," *New-York Daily Tribune*, March 27, 1861, p. 8.

14. It appears to have been some time before Andrew Dickson White (1832–1918), the liberal educator and cofounder of Cornell University in 1865, purchased the painting.

15. Thompson exhibited *Prospero Relating His Trials to Miranda*; White, *The Landing of the Huguenots in Florida*; and John Whetten Ehninger, *The Wedding Procession, from the Courtship of Miles Standish*. See National Academy of Design, *Catalogue of the Thirty-sixth Annual Exhibition* (New York, 1861). Other "country" subjects included Jerome Thompson's (1814–1886) *The Old Oaken Bucket* and Seymour

Joseph Guy's (1824–1910) *Rustic Courtship*. In 1860 Johnson's University Building colleagues also included James H. Cafferty (1819–1869), who had made a stir at the 1858 National Academy annual with an unusual urban subject, *Wall Street, Half Past Two, October 13, 1857* (Museum of the City of New York), commemorating the currency crisis that plunged the nation into widespread financial panic.

16. "American Art," *Knickerbocker* 58, no. 1 (July 1861), p. 48.

17. His good friend Worthington Whittredge, reportedly turned away by the exclusive Seventh Regiment of New York, wrote sanguinely in his diary: "I began to see that there were many things I could do to help on the war if I stayed at home, and soon found myself busy with fairs, exhibitions of pictures, sewing societies and what not for the benefit of the soldiers." "The Autobiography of Worthington Whittredge, 1820–1910," ed. John I. H. Baur, *Brooklyn Museum Journal* (1942), p. 43.

18. The sale, which included works by Hall, Leutze, McEntee, and Bierstadt, was held at the Merchant's Exchange. Johnson contributed a work called *A Foxy Morning* (location unknown). See "Literature and Art," *Home Journal* (June 8, 1861), p. 3.

19. "American Art," p. 49.

20. "Art Items," *New-York Daily Tribune*, October 4, 1861, p. 7. The writer was apparently untroubled by the timing of his report—maple sugaring takes place in early spring.

21. McKay, *The Civil War*, p. 116.

22. "The National Academy of Design. A Second Visit to the Gallery," *New York Times*, April 27, 1862, p. 5.

23. The American taste for Frère's work was encouraged by the English critic John Ruskin (1819–1900), who in 1857 attributed to the Frenchman's paintings "the depth of Wordsworth, the grace of Reynolds, and the holiness of Angelico." Ruskin especially admired the idealized type of poverty represented in Frère's peasant interiors, which he had described as "accepted and submissive . . . yet not without its own sweet, complete, untainted happiness. . . ." Quoted in "Foreign Correspondence, Items, etc.," *Crayon* 5, part 7 (July 1858), p. 205.

24. A writer for the *Crayon* identified the painter James Suydam (1819–1865) and the Baltimore collector William T. Walters (1819–1894) as among his first American patrons. See "Artist Biography," *Crayon* 7, part 6 (June 1860), p. 166.

25. With reference to his 1861 exhibition entry titled *The Culprit*, a writer for the *Evening Post* referred enthusiastically to Johnson as "that élève copiest of the school of Frère." "Fine Arts. The Exhibition of the National Academy of Design," *Evening Post* (New York), April 9, 1861, p. 1.

26. "Art. Artists' Reception," *Round Table* 1, no. 12 (March 5, 1864), p. 184.

27. Among the patrons they shared in the 1860s were James Suydam, James M. Burt (both painters), William T. Blodgett, Irving Browne, Silas Evans, Sheppard Gandy, Robert Hoe, and Robert L. Stuart; and they also attracted the major collectors Henry Marquand, George Whitney, and John Taylor Johnston after 1870.

28. "I was at the grand fight yesterday at Bull's Run, and such a sight I have never before, nor do I ever again, expect to see." Reuben Johnson to Eastman Johnson, July 22, 1861; as quoted in John I. H. Baur, *An American Genre Painter: Eastman Johnson, 1824–1906* (Brooklyn: Institute of Arts and Sciences, 1940), pp. 18–19.

29. A writer for the *Leader* suggested that American artists were obliged to consider "events and incidents which, in dramatic character, scenic beauty, and pathetic interest, as well as historic importance, absolutely demand the perpetuity which great art has to offer every worthy reality of life." *Leader*, October 18, 1862, p. 1.

30. The only surviving record of Johnson's presence in Manassas is the inscription he added to the Virginia Museum of Fine Arts version of *A Ride for Liberty—The Fugitive Slaves*: "A veritable incident / in the civil war seen by / myself at Centerville / on the morning of / McClellan's advance / towards Manassas. March 2d, 1862 / Eastman Johnson." McClellan's disastrous fall at the Second Battle of Bull Run (Manassas) would occur in late August of that year. Jim Burgess, Manassas National Battlefield Park, kindly provided information on troop movements at Manassas.

31. Eastman Johnson to Jervis McEntee, June 28, 1862, frame 507, reel D30, Charles E. Feinberg Collection of Artists' Letters, Archives of American Art, Smithsonian Institution, Washington, D.C. Also see Appendix. Johnson quite possibly was familiar with Whitman's more widely distributed 1860 edition of *Leaves of Grass*.

32. Among the few paintings that might have derived from Johnson's new attention to his urban environment was his *The Little Musicians*, an image of poor Italian immigrant children, though this type derived directly from his Hague period Savoyard subjects. For further discussion of the type, see Martha J. Hoppin, "The 'Little White Slaves' of New York: Paintings of Child Street Musicians by J. G. Brown," *American Art Journal* 26, no. 1/2 (1994), pp. 4–43.

33. Johnson to McEntee, June 28, 1862, frame 505, reel D30, Charles E. Feinberg Collection of Artists' Letters. Also see Appendix. The first well-heeled and educated recruits of the exclusive Seventh Regiment were initially slated to serve for thirty days rather than the three months required of other regiments. They saw little serious action before the majority mustered out in June. See McKay, *The Civil War*, pp. 68, 80–81.

34. In August, Lincoln demanded an additional 300,000 troops to take Richmond and thereby end the war. See McKay, *The Civil War*, p. 139.

35. "Committee on Admissions, 1854–1874," manuscript in the collection of The Century Association Archives Foundation.

36. Johnson could have painted his self-portrait as a complement to his 1863 portrait of McEntee in his studio, exhibited at the Brooklyn Art Association that spring; see *Evening Post* (New York), March 5, 1863, p. 1.

37. In a letter to Francis R. Appleton, chairman of the Committee on Art and Literature of the Harvard Club of New York City, written after her husband's death regarding another version of the portrait, Elizabeth Johnson commented on their contact: "I have many of [Wilder Dwight's] letters to Mr. Johnson and he as a very young man was so interested in art, and use [*sic*] to buy many paintings of Mr. Johnson, even when so young, as soon as they were painted. His letters are most delightful & such a noble sweet friendship existed between those two high minded young men. This portrait was begun before the war, and Eastman was at work at it just before Wilder died." Elizabeth Johnson to Francis R. Appleton, March 30, [1908/9]. I am grateful to Mary Saunders, curator of the Harvard Club of New York City, for bringing this letter to my attention.

38. Sanford R. Gifford to Elihu Gifford, July 9, 1863, as quoted in Ila Weiss, *Poetic Landscape: The Art and Experience of Sanford Robinson Gifford* (Newark: University of Delaware Press, 1987), p. 98.

39. Edwin White had exhibited his sober, dramatic *Major Anderson Raising the Flag on the Morning of His Taking of Fort Sumter, December 27, 1860* (location unknown); and young Winslow Homer had offered two glib scenes of military camp life, *Home Sweet Home* and *The Last Goose at Yorktown* (see Burns essay). Even the enlisted Gifford had exhibited a surprisingly Romanticized "view" titled *Baltimore, 1862—Twilight* (Seventh Regiment Fund). Lucretia Giese has calculated that at none of the National Academy annuals between the years 1861 and 1865 were more than 4.5 percent of the paintings obviously related to the war. See Giese, "Harvesting the Civil War: Art in Wartime New York," in *Redefining American History Painting*, ed. Patricia M. Burnham and Lucretia Hoover Giese (New York: Cambridge University Press, 1995), pp. 64–81.

40. One hundred five people were killed in the riots. For a close and penetrating study of the subject, see Iver Bernstein, *The New York City Draft Riots* (New York: Oxford University Press, 1990).

41. See ibid., pp. 125–61.

42. Despite the subtitle of his ultimate oil version on the theme, "An Incident of the Late War," and an accompanying catalogue description of the scene (quoted in Baur, *An American Genre Painter*, p. 19), there is no surviving evidence that Johnson was present at Antietam in any capacity.

43. That writer singled out *The Wounded Drummer Boy* as "large in manner and dramatic in feeling." "Painting and the War," *Round Table* 11, no. 32 (July 23, 1864), p. 90.

44. Formed in 1861 to oversee the conditions in army camps, ambulance corps, and hospitals, the commission was directed by the leading Unitarian minister Henry Bellows (1814–1882) and the landscape architect Frederick Law Olmsted (1822–1903) (both Union League founders), with the surprisingly dispassionate goal of "[economizing] for the National service the life and strength of the national soldier." See George M. Fredrickson, *The Inner Civil War: Northern Intellectuals and the Crisis of the Union* (New York: Harper and Row, 1965), pp. 102–3.

45. Other artist-members of the committee included Johnson's friends Haseltine, Leutze, and Whittredge, as well as the photographer Mathew Brady. See *Catalogue of the Art Exhibition at the Metropolitan Fair in Aid of the U.S. Sanitary Commission* (New York, 1864).

46. "Art. Pictures at the Metropolitan Fair," *Round Table* 1, no. 18 (April 16, 1864), p. 280.

47. Roberts collected a representative mid-century roster of American artists including George Henry Boughton and John F. Kensett. His many loans to the fair also included Richard Caton Woodville's *War News from Mexico* and an Orientalist subject by Jean-Léon Gérôme. See *Catalogue of the Art Exhibition at the Metropolitan Fair*, pp. 6, 7.

48. "Art. Pictures at the Metropolitan Fair," p. 280.

49. The other works were a bas-relief portrait of Major General John Dix (1798–1879) by Launt Thompson (1833–1894) and a work by Junius Brutus Stearns (1810–1885) titled *The Widow*. See "Catalogue of Paintings and Other Art Objects Belonging to The Century Association," handwritten list compiled by Viggo Conradt-Eberlin, librarian, 1907, collection of The Century Association. I am grateful to Jonathan Harding, curator of The Century Association, for making this archival material available.

Johnson's paintings notably appeared in even greater number at the Philadelphia Fair's larger exhibition that same month. The lenders of his works included the Philadelphia businessman and Fine Art Committee member James L. Claghorn (1817–1884); and the wealthy China-trade merchant Robert Olyphant (1824–1918); and J. M. Burt, an organizer, lent an impressive twenty-five works, including three Johnsons and a Frère.

50. Eastman Johnson to John F. Coyle, March 13, 1864, frame 1372, reel D10, Artists' Correspondence, Archives of American Art, Smithsonian Institution, Washington, D.C.

51. *Evening Post* (New York), March 22, 1864, p. 1.

52. Patricia Hills has determined that Johnson completed at least ten of these studies, which range from 16 to 96 inches in width. The state of

the project is suggested by his comment to Coyle, "[I] have spent a good deal of time on it already & not yet begun the picture nor indeed got nearly all the materials." He added in his defense, "The period of sugar making lasts only about a month, which is the reason I have had to go so many times." Eastman Johnson to John F. Coyle, March 13, 1864, frame 1372, reel D10, Artists' Correspondence. Also see Appendix.

53. Blodgett's close friendship with Couture may have postdated Johnson's maple-sugaring pictures; three of the Frenchman's works were included in the 1876 sale of Blodgett's collection. See Kurtz Art Gallery, New York, *Executor's Sale of the Collection of Paintings Belonging to the Estate of the Late W. T. Blodgett*, sale cat., April 27, 1876. Sally Mills considers Johnson's sources in the work of Couture at greater length in Marc Simpson, Sally Mills, and Patricia Hills, *Eastman Johnson: The Cranberry Harvest, Island of Nantucket*, exh. cat. (San Diego: Timken Art Gallery, 1990), pp. 55–58.

54. "Eastman Johnson has had an evening, and some fine works from the collection of . . . Blodgett . . . have been exhibited." "Sketchings: Domestic Art Gossip," *Crayon* 7, part 3 (March 1860), p. 84.

55. Suzaan Boettger has suggested that the occasion was a celebration of the boy's birthday on December 20. See "Eastman Johnson's *Blodgett Family* and Domestic Values during the Civil War Era," *American Art* 6, no. 4 (Fall 1992), pp. 51–67.

56. The enlistment of blacks as Union troops was among the essential themes of minstrelsy from 1863 through 1864, and was treated with some ambiguity by songwriters both sympathetic and hostile to the idea. In addressing this subject, Sam Dennison has explained, "Even though sympathetic to abolitionism, the composer who adopted the mannerisms or technique of minstrelsy in order to extol the black soldier risked having his effort misunderstood, or even mistaken, as the work of the opposition." For examples and further discussion, see Dennison, *Scandalize My Name: Black Imagery in American Popular Music* (New York: Garland, 1982), p. 216.

57. By regarding the figure primarily as a minstrel dancer—rather than a "soldier"—in her discussion of the painting, Boettger interprets the toy somewhat differently. I disagree with her suggestion that "the decorous figure it personifies" offered "a positive image of race." It more likely represented a race viewed by liberal Republican Union Leaguers as happily malleable and suited for grooming as a new, more obedient, urban working class.

58. The stature Johnson had attained by this point in his career is demonstrated by the introductory remark of a critic: "Whatever Mr. Johnson does is sure of appreciation and needs no critic's word as confirmation. . . ." "Art. Art and the Century," *Round Table* 1, no. 2 (June 11, 1864), p. 407.

59. "National Academy of Design," *New-York Daily Tribune*, May 13, 1865, p. 9.

60. Ibid. A writer for the *Times* remarked, "When portraits can be painted in this way, they cease to be a burden to art, or a bore to criticism." "National Academy of Design—East Room," *New York Times*, June 7, 1865, p. 5.

61. Noting its fine delineation, the critic suggested, "One fancies that Mr. Johnson himself must have enjoyed the toy hugely. . . ." "National Academy of Design," *New-York Daily Tribune*. Any more uplifting significance it may have held for Blodgett and his family was lost even on the curious eye of the critic.

62. The *Tribune* writer remarked: "The picture, perfectly drawn, is low in tone, lower than we like, but not lower than Mr. Johnson habitually likes. . . . If it had a hundred faults of execution, which it hasn't, its marvelous expression, its depth of sentiment would easily forgive them all." "National Academy of Design," *New-York Daily Tribune*.

63. He wrote, "I shall hope to paint it next autumn & winter. . . ." Eastman Johnson to John F. Coyle, March 13, 1864, frame 1372, reel D10, Artists' Correspondence.

64. "Eastman Johnson has been passing a pleasant summer in Fryeburg, Me., making careful studies for a picture of a New England 'sugaring off' in the maple districts." "Art. Art Notes," *Round Table* n.s. 1 (September 9, 1865), p. 7.

65. The summer before, for example, Johnson was visited by Gifford, and McEntee and his wife. See Weiss, *Poetic Landscape* (n. 38 above), p. 100.

66. The poets Thomas Baily Aldrich and Clarence Edmund Stedman (the latter of whom Johnson and Taylor had nominated for membership in The Century Association in December 1864) also were regulars at the Saturday evenings, as were Jervis McEntee (and his wife, Gertrude) and the sculptor Launt Thompson. Ila Weiss describes the group and their meetings in further detail in *Poetic Landscape*, pp. 21–45.

67. In praise of the "native warmth of life," evoked by Johnson's rural scenes in particular, Taylor spoke of the artist's autumnal palette ("jacinth and ruby, blent") and his imagery of "barns and homesteads," "vintage revels, round the maple tree," and "the dusky race." Bayard Taylor, *The Picture of St. John* (Boston: Ticknor and Fields, 1866), p. 6. Ila Weiss identified Johnson as the subject of stanza XI in *Poetic Landscape*, p. 23. Taylor devoted stanzas to others in the group, including Gifford ("Opal") and McEntee ("Bloodstone").

68. A letter to Jervis McEntee in June 1866 suggests that Johnson at least occasionally attended Bellows's Church of All Souls, formerly the congregation of his First Unitarian Church. Eastman Johnson to Jervis McEntee, June 12, 1866, frame 134, reel 4707, Jervis McEntee

Papers, Archives of American Art, Smithsonian Institution, Washington, D.C.

69. Harriet Beecher Stowe, *The Minister's Wooing*, in *Three Novels* (New York: Literary Classics of the United States, 1982), p. 576.

70. A catalogue of the Brooklyn and Long Island Fair described the "New England Kitchen" as "the funny feature of the Fair." *History of the Brooklyn and Long Island Fair* (Brooklyn: "The Union" Steam Presses, 1864), p. 73. The visitors who constantly crowded the rooms undoubtedly paid fuller attention to the old-fashioned, fresh doughnuts than to the displays of authentic family Bibles. For a general discussion of "New England kitchens," see Rodris Roth, "The New England, or 'Old Tyme,' Kitchen Exhibit at Nineteenth-Century Fairs," in *The Colonial Revival in America*, ed. Alan Axelrod (New York: Norton, 1985), pp. 159–83.

71. As quoted in *History of the Brooklyn and Long Island Fair*, p. 73. This primary publication on the Fair emphasized the fact that the "New England Kitchen" had been the idea of "Authentic New Englanders" who lent many of the objects (p. 72).

72. Harriet Beecher Stowe, *The Pearl of Orr's Island* (New York: Houghton Mifflin & Co., 1896), p. 9. Originally published in 1862, Stowe's novel was set on an actual island off the coast of southern Maine.

73. "National Academy of Design. Forty-first Annual Exhibition. Concluding Article," *Evening Post* (New York), May 17, 1866, p. 1.

74. Stuart enforced the practice among his many employees (each of whom received a Bible on being hired), and eventually went so far as to deny The Metropolitan Museum of Art the gift of his collection because of its institution of Sunday openings. On Robert L. Stuart, see "Death of Robert L. Stuart," *New-York Daily Tribune*, December 13, 1882, and "Robert L. Stuart," *Dictionary of American Biography*, vol. 9.

75. The summer before, clearly eager to undertake a war-related theme, he had attempted to resume work on an oil version of his *The Wounded Drummer Boy*. See Eastman Johnson to Jervis McEntee, June 12, 1866, frame 134, reel 4707, Jervis McEntee Papers.

76. The *New York Times* critic wrote, "It is by far the most important contribution to the exhibition." "National Academy of Design," *New York Times*, May 23, 1867, p. 5. A writer for the *Evening Post* commented, "After looking at the works of Eastman Johnson it is difficult to bestow much praise upon those of the remaining figure painters." "National Academy of Design. Forty-Second Annual Exhibition. Third Article," *Evening Post* (New York), May 2, 1867, p. 1. The sole, interesting counterpoint in the exhibition was the trio of works by Thomas Waterman Wood (see Hills essay).

77. "National Academy of Design. Forty-second Annual Exhibition. Second Article," *Evening Post* (New York), April 30, 1867, p. 1.

78. "Pictures at the National Academy," *Round Table* 5, no. 120 (May 11, 1867), p. 294. The critic for the *New York Leader* went so far as to recommend Johnson as a model for the young generation of American Pre-Raphaelites, while stressing, "[he] is never painty by overdoing his detail or forcing his color." "National Academy of Design. Forty-second Annual Exhibition," *New York Leader*, May 4, 1857, p. 5.

79. Russell Sturgis, "American Painters. The National Academy Exhibition," *Galaxy* 4 (June 1867), pp. 230–31.

80. Pensions for Civil War veterans were first enacted in July 1862. The legislation was regarded as progressive for its inclusion of dependent mothers and sisters of deceased soldiers. See William Henry Glasson, "History of Military Pension Legislation in the United States," *Studies in History, Economics and Public Law* 12, no. 3 (New York: Columbia University Press, 1900), p. 73.

New rates, along with graduated payments for highly differentiated categories of disabilities, were legislated in 1864, and again in June 1866. See Glasson, "History of Military Pension Legislation," pp. 77, 294. They were established despite the fact that the demand on the pension fund far exceeded the early allocations for Civil War veterans. Total expenditures in 1866 exceeded $13 million on more than 126,000 claims. See *Annual Report of the Commissioners of Pensions* (Washington, D.C.: Government Printing Office, 1889).

81. The *Evening Post*'s critic wrote of "the almost perfect expression shown not only in the faces but in the figures" and stated, "The great power of the artist is shown in the slight means with which the effects are produced." The same writer suggested, "It would hardly seem that the painting of the 'agent' could be surpassed." "National Academy of Design. Forty-second Annual Exhibition. Second Article," *Evening Post* (New York), April 30, 1867, p. 1.

82. Ibid.

83. One critic noted Johnson's sensitive treatment of the poverty of the situation in *The Pension Claim Agent*: "Those who know how poor people are usually provided with bedding should examine the pillow and the ends of various articles of bed furniture that show beneath it." *Evening Post* (New York), April 30, 1867, p. 1. The humility of the setting and its inhabitants distinguishes this work from such thematic predecessors as Richard Caton Woodville's *Old '76 and Young '48*, in which a veteran of the Mexican War recounts his trials to his family and black servants, who gather in a richly appointed parlor.

84. The *Evening Post* described the painting as "truly natural" (April 30, 1867, p. 1); and the

Round Table praised its "absolute fidelity to nature" (May 11, 1867, p. 294). This was a fiction interestingly reinforced by the uncertain identity of Johnson's models; the only known model was the dog "Warrie," a mascot of the National Academy of Design. See the *Evening Post*, April 30, 1867, p. 1.

85. The accompanying article described the crush of battered veterans and needy widows at the inadequately staffed and physically inaccessible pension office in the basement of the Customs House. The thousands of the city's pensioners were paid at a rate of about two hundred and fifty people a day. See "Paying Pensioners," *Harper's Weekly* 10, no. 482 (March 24, 1866), p. 177.

86. Sturgis, "American Painters" (see n. 79 above).

87. Fiske's ownership of the painting is first recorded in the catalogue of the Centennial Loan Exhibition held at the National Academy of Design and The Metropolitan Museum of Art in 1876. Fiske's small, uneven collection included works by minor French academic painters. For the timing of Clarke's purchase, see H. Barbara Weinberg, "Thomas B. Clarke: Foremost Patron of American Art from 1872 to 1899," *American Art Journal* 8 (May 1876), p. 77.

88. Eastman Johnson to Jervis McEntee, July 27, 1867, frames 175, 173, reel 4707, Jervis McEntee Papers. His summer was further complicated by the troublesome installation of a new studio skylight, which he hoped would "pay in lengthening the winter days." Eastman Johnson to Jervis McEntee, August 30, 1867, frame 199, reel 4707, Jervis McEntee Papers.

89. Apparently a kind and supportive patron, Pinchot was the owner of Johnson's 1867 portrait of McEntee's elderly mother reading the Bible.

90. Eastman Johnson to Jervis McEntee, September 27, 1867, frame 205, reel 4707, Jervis McEntee Papers.

91. While the *Evening Post* critic admired Johnson's evocation of "the loose, spreading attitude, . . . the earnestness of expression, and the simple, honest nature of the man" ("Fine Arts," *Evening Post* [New York], April 15, 1868, p. 2), the *New York Times* writer found the figure "ungainly," and suggested that it had been painted "for the print-sellers" ("Fine Arts. National Academy of Design," *New York Times*, May 14, 1868, p. 5). Its appeal clearly derived from the identification of the setting and figure as entirely "characteristic of the boyhood of American public men." See Eugene Benson, "Eastman Johnson," *Galaxy* 6 (July 1868), p. 112.

92. "The Academy of Design. The Forty-fourth Exhibition," *Evening Post* (New York), April 27, 1869, p. 1; and "National Academy of Design," *New York Leader*, May 1, 1869, p. 3. The painting was executed on commission for the banker

John Crosby Brown (1838–1909); it represented his father, James Brown, founder of the New York banking firm of Brown Brothers & Co. and longtime president of the Society for Improving the Condition of the Poor, and the latter's wife and grandson, in the elaborate parlor designed by Leon Marcotte for their home at Ninth Street and University Place. John Davis suggests that the negative reviews derived in part from the perception of the decoration of the Brown parlor as conspicuously elaborate and in some ways dated, and the deliberately public display of so private a space as unseemly. See Davis, "Children in the Parlor: Eastman Johnson's *Brown Family* and the Post–Civil War Luxury Interior," *American Art* 10, no. 2 (Summer 1996), pp. 50–77.

93. Benson, "Eastman Johnson," p. 111.

94. Eastman Johnson to Jervis McEntee, August 8, 1867, frame 191, reel 4707, Charles E. Feinberg Collection of Artists' Letters. Johnson had admired the charming partner McEntee had found in his own wife, Gertrude. See also June 28, 1862, frame 504, reel D30: "What a thing it is to have such a wife." For both letters, also see Appendix.

95. Phineas Buckley is first listed as a merchant in New York in 1839; he and his brother John L. Buckley shared the same premises at 241 Front Street from 1841 to 1843, and at subsequent locations on Front Street from 1847 to 1855. The family's place of residence changed frequently during this period. See New York City directories. Thomas Buckley served as president of New York's Bank of America from 1816 to 1832. Information on the Buckley family is also included in the entry on Eastman Johnson in Lyman Horace Weeks, ed., *Prominent Families of New York* (New York: The Historical Company, 1897), p. 329.

96. Troy was the native city of Elizabeth Buckley's mother, Phebe McCoun Buckley, and the site of a branch of her father's business from 1832 to 1846. I am grateful to Robert Andersen of the Library of the Rensselaer County Historical Society, Troy, New York, for providing information on the Buckley family in Troy, New York. Elizabeth Buckley may have boarded at the school or with her mother's family.

97. See "The Ever-Widening Circle: The Diffusion of Feminist Values from the Troy Female Seminary, 1822–72," in Anne Firor Scott, *Making the Invisible Woman Visible* (Chicago: University of Illinois Press, 1984). Elizabeth Buckley thus had the opportunity to pursue a challenging curriculum rarely offered to young women of the period; she took courses in geography, chemistry, algebra, Latin, and German, and read such works as Madame de Staël's *Corinne*. I am grateful to Barbara Wiley, librarian of the Emma Willard School, for providing a record of the exact courses and readings undertaken by Elizabeth Buckley Johnson.

98. Phineas Buckley is listed in the New York City directories for the last time in 1859. There is no clear evidence as to where the family subsequently relocated.

99. In 1860 Johnson also was among the artists commissioned to produce a painting for the association's permanent gallery. He produced a variant of *Corn Husking* titled *Corn Shucking "Down East"* (location unknown). See "Sketchings: Domestic Art Gossip," *Crayon* 7, part 3 (March 1860), pp. 85–86. His Troy patrons included the Democratic mayor, George B. Warren, and the attorney Irving Browne (1835–1899).

100. James L. Yarnall and William H. Gerdts, *National Museum of American Art's Index of American Art Exhibition Catalogues: From the Beginning through the 1876 Centennial Year* (Boston: G. K. Hall, 1988), vol. 4, p. 2419.

101. Johnson's Thirteenth Street address is recorded in New York City directories. Their house on Fifty-fifth Street, one of the first freestanding town houses to appear on the block (north side), was likely to have been inexpensive. The primary presence in the area at the time was St. Luke's Hospital, which occupied the west side of Fifth Avenue between Fifty-fourth and Fifty-fifth Streets and extended a third of the way from Fifth to Sixth Avenues.

102. For a discussion of the domestic setting for artistic practice in seventeenth-century Holland, see Elizabeth Alice Honig, "The Space of Gender in Seventeenth-Century Dutch Painting," in *Looking at Seventeenth-Century Dutch Art: Realism Reconsidered*, ed. Wayne Franits (New York: Cambridge University Press, 1997), pp. 187–201.

103. The title first appears to have been used in the context of the 1907 memorial exhibition of Johnson's work held at The Century Association; a handwritten annotation to a typed checklist added "Not at home" to the title "An interior of the artist's house." The annotations were possibly made by Elizabeth Johnson.

104. The painting was first identified by Sally Mills, who also noted that Johnson would have had ample opportunity to make a copy of the original Breton when it was owned by William P. Wright, the first owner of Johnson's *Negro Life at the South*. See Sally Mills, "'Right Feeling and Sound Technique': French Art and the Development of Eastman Johnson's Outdoor Genre Paintings," in Simpson, Mills, and Hills, *Eastman Johnson: The Cranberry Harvest* (see n. 53 above), p. 67.

105. The ideological and formal identification of woman with home in mid- to late nineteenth-century culture is the focus of Beverly Gordon's discussion in "Woman's Domestic Body: The Conceptual Conflation of Women and Interiors in the Industrial Age," *Winterthur Portfolio* 31, no. 4 (Winter 1996), pp. 281–301. Gordon quotes Harriet Beecher Stowe from *We and Our Neighbors*, wherein Stowe addresses the married

woman's transference of her sense of self to an identification with her home: "[T]o her home passes the charm that once was thrown around her person. . . . Her home is the new impersonation of herself " (p. 282).

106. For a discussion of gendered space in seventeenth-century Dutch genre painting, see Honig, "The Space of Gender." For the nineteenth-century American context, see Gordon, "Woman's Domestic Body."

107. I am grateful to Patricia Mears, Assistant Curator of Costumes and Textiles, Brooklyn Museum of Art, for identifying the costume type.

108. Back-turned figures were particularly prevalent in fashion illustration after 1870 in order to accommodate the new profile's complex drapery and bustle arrangements.

109. *Not at Home* appears to have been exhibited only at The Century Association's memorial exhibition; it remained in the hands of descendants until it was purchased by the Brooklyn Museum of Art in 1940.

110. Johnson may have recalled one critic's praise for his and Homer's "purely American pictures from home subjects," when other painters had fallen under the influence of a wave of French and German paintings of women "draped in the highest and most modern styles of Parisian fashion. . . ." "Fine Arts," *Evening Post* (New York), May 17, 1869, p. 2.

111. In considering the role of costume in this work, I have drawn heavily from Anne Schirrmeister's insightful consideration of intimate dress in the works of Berthe Morisot. See Schirrmeister, "La Dernière Mode: Berthe Morisot and Costume," in *Perspectives on Morisot*, ed. T. J. Edelstein (New York: Hudson Hills, 1990), pp. 103–15.

112. A critic for the *Evening Post*, who described Johnson's entries as "the most beautiful and elaborate" of the genre and fancy works, noted the gracefulness of the figure and the back of the head. "The Academy Exhibition. III. Genre and Fancy Pictures," *Evening Post* (New York), May 1, 1875, p. 1.

113. Henry James, Jr., "On Some Pictures Lately Exhibited," *Galaxy* 20, no. 1 (July 1875), p. 93. James went on to credit *The Peddler* with "a Dutch humility of subject [and] a Dutch humility of touch."

114. The *Tribune* writer remarked on an absence of anything "confused or inharmonious" in the battle scene and gently questioned Johnson's qualifications to undertake the subject by comparing it to "an unpretending sketch" by the young artist and Civil War veteran Julian Scott (1846–1901). "Fine Arts—The Drama," *New-York Daily Tribune*, April 22, 1872, p. 5. Scott, a student of Leutze at the National Academy in the post–Civil War years, painted some of the most interesting visual records of the Civil War,

including *Surrender of a Confederate Soldier*, 1873, Collection of Jay P. Altmayer.

115. See "Art Notes," *Evening Post* (New York), May 27, 1874, p. 1. It was well received on exhibition at the Lotos Club in 1876 as "a decorative picture." "Art Reception," *New York Times*, December 19, 1876, p. 5.

116. A reviewer who disliked the figure's angularity also noted that Johnson called the painting "Maidenhood." See "Fine Art in the West," *New York Times*, September 26, 1875, p. 10.

117. The extensive absenteeism in 1873 was discussed by Johnson and McEntee. See Jervis McEntee Diary, April 27, 1873, frame 0028, reel D180, Archives of American Art, Smithsonian Institution, Washington, D.C.

118. Johnson's entries included *Catching the Bee* and a highly popular work, *The Woodland Bath* (location unknown), purchased before the end of the year by Henry Ward Beecher. "Fine Arts. The National Academy of Design," *New-York Tribune*, April 15, 1873, p. 4.

119. Had such works as Johnson's *Christmas-time* or *Sunday Morning* been produced in France or Germany, he wrote, "we should have heard tall crowing from the morning side of the ocean" (ibid.).

120. Jervis McEntee Diary, March 24, 1874, frame 0064, reel D18.

121. Avery was listed as the owner when the painting was exhibited at the Brooklyn Art Association exhibition in March 1871, a month before the Academy exhibition.

122. Marquand was, with Johnson, among the group of Union Leaguers who hatched plans to establish The Metropolitan Museum of Art in 1869. He made the modest purchase of a version of Johnson's *The Sulky Boy* by 1871, before the expansion of his railroad investments later in the decade, but went on to spend great sums of money in purchasing Old Master paintings for presentation to the Metropolitan from 1888 to 1902. See Daniëlle O. Kisluk-Grosheide, "The Marquand Mansion," *Metropolitan Museum Journal* 29 (1994), pp. 151–81.

123. Fahnestock, a banker for Jay Cooke & Company in Washington, D.C., during the Civil War (when he was a key trader of government bonds) and head of its New York office from 1866 to 1873, owned Johnson's *Playing Soldier* by 1871. See "Harris Charles Fahnestock," *Dictionary of American Biography*, vol. 6.

124. See Eastman Johnson to Jervis McEntee, June 21, 1870, frames 224–27, reel 4707, Jervis McEntee Papers. Also see Appendix.

125. See ibid. On the basis of his reading of a local newspaper account, Marc Simpson suggests that Johnson was on Nantucket in 1869. The fact that Johnson did not mention Nantucket among the scenic New England venues under consideration in his letter to McEntee may call into question the accuracy of the newspaper article. See Marc

Simpson, "Taken with a Cranberry Fit: Eastman Johnson on Nantucket," in Simpson, Mills, and Hills, *Eastman Johnson: The Cranberry Harvest*, p. 95.

126. This purchase occurred, notably, a year before they would purchase their new Manhattan residence. Marc Simpson provides a carefully detailed outline of the property purchased by Eastman and Elizabeth Johnson from 1871 to 1903, much of which after 1880 was speculative. See ibid., pp. 102–4.

127. "P.," "Country Correspondence," *Crayon* 5, part 9 (September 1858), pp. 269–70. This article is cited in Simpson, "Taken with a Cranberry Fit," p. 33.

128. "Nantucket," *Atlantic Monthly* 17, no. 101 (March 1866), p. 297. Yielding to the impact of the alternative fuels, better harbors served by railroads, and the gradual extinction of the whale population, many Nantucket families (and men in particular) moved to the mainland. For the island's fortunes at midcentury, see Simpson, "Taken with a Cranberry Fit."

129. "Nantucket," *Scribner's Monthly* 6, no. 4 (August 1873), pp. 385–99.

130. In other early attempts like his *What There Is Left of the Whaling Interest in Nantucket* (Private collection), an image of a young boy sailing paper boats in a rain barrel exhibited at The Century Association in 1873, he merely reiterated the Frère formula in a new setting.

131. Whittier's *Songs of Labor* and *Among the Hills* were particularly influential for subsequent authors. See Perry D. Westbrook, *A Literary History of New England* (Bethlehem, Pa.: Lehigh University Press, 1988), p. 178.

132. Jewett's "The Shore House" appeared in 1873, followed by "Deephaven Cronies" (1875) and "Deephaven Excursions" (1876). For further discussion, see Paul Blanchard, *Sarah Orne Jewett: Her World and Her Work* (New York: Addison Wesley, 1994).

133. Stowe, *The Pearl of Orr's Island* (see n. 72 above), p. 1.

134. Sarah Orne Jewett, *Deephaven* (New York: Houghton, Mifflin, and Company, 1894), pp. 5, 3.

135. Jewett, *Deephaven* (1877; reprint, New York: Library of America, 1994), pp. 44–45.

136. According to its description in the review, the figure was engaged in looking through a telescope. "Fine Arts. Exhibition at the National Academy of Design," *New York Times*, December 16, 1875, p. 4.

137. A shadow of an earlier composition on the canvas, a version of Johnson's *Boyhood of Lincoln*, of 1868, is visible to the naked eye.

138. "The Artists' Fund: Sale of Pictures in Aid of the Fund," *New York Times*, January 26, 1876.

139. Field also was among the early supporters of The Metropolitan Museum of Art. See

"Benjamin Hazard Field," *Dictionary of American Biography*, vol. 6.

140. On the Ray family, see Eliza Starbuck Barney genealogical record, Edouard A. Stockpole Research Center, Nantucket Historical Association. I am grateful to Mike Jehle, of the Nantucket Historical Association, Nantucket, Massachusetts, for providing genealogical material on the Ray family. On the Ray house, see Knowlton Mixer, *Old Houses of New England* (New York: The MacMillan Company, 1927). Johnson probably painted the kitchen in the ell that was a slightly later addition.

141. Eastman Johnson to Jervis McEntee, August 19, 1875, frame 232, reel 4707, Jervis McEntee Papers.

142. Jervis McEntee Diary, February 4, 1876, as quoted in "Jervis McEntee's Diary, 1874–1876," *Archives of American Art Journal* 31, no. 1 (1991), p. 12.

143. He apparently was at the point of adding details in March, when McEntee recorded having lent Johnson some of his own studies of chickens to complete the foreground. Jervis McEntee Diary, March 1, 1876, in ibid., p. 13.

144. See "The Fine Arts. Exhibition of the National Academy," *New York Times*, April 8, 1876, p. 6.

145. Ibid.

146. "Academy of Design. Fifty-first Annual Exhibition," *New-York Tribune*, April 22, 1876, p. 7.

147. One reviewer attributed the picture's "natural look" to Johnson's reversal of a standard pictorial rule: "[T]he scene is, so to speak, lit up from below." "The Old Cabinet," *Scribner's Monthly* 12, no. 2 (June 1876), p. 271.

148. "Academy of Design. Fifty-first Annual Exhibition."

149. "The Fine Arts. Exhibition of the National Academy."

150. That writer contrasted "the frank, firm touch, the unobtrusive strength of color, and the well-expressed bustle and busy movement" as preferable to "the wooly interior with figures, that hangs beside it." "Art," *Atlantic Monthly* 37 (June 1876), p. 760.

151. "The Fine Arts. The Academy Exhibition," *New York Times*, April 3, 1876, p. 5.

152. "Collis P. Huntington," *Dictionary of American Biography*, vol. 9.

153. In October 1876, he and McEntee visited Gustav Reichard's gallery to talk to the dealer about prospects for dealing in American art. See Jervis McEntee Diary, October 19, 1876 (n. 142 above), p. 18. Before the end of the year, he asked McEntee to speak to Michael Knoedler on his behalf. See Jervis McEntee Diary (see n. 117 above), December 27, 1876, frame 0154, reel D180.

154. See Saul E. Zalesch, "Competition and Conflict in the New York Art World, 1874–1879," *Winterthur Portfolio* 29, no. 2–3 (Summer–Autumn 1994), pp. 103–20.

155. Jervis McEntee Diary, May 11, 1877, frame 0168, reel D180.

156. Interestingly, the *Tribune* reviewer protested that *The Tramp* had been poorly placed in the installation. "National Academy of Design. The Annual Exhibition," *New-York Tribune*, April 3, 1877, p. 4.

157. McEntee noted Johnson's dismay at the high price brought by one of his works in the Robert Olyphant sale. Jervis McEntee Diary, December 20, 1877, frame 0183, reel D180.

158. "The Coming Exhibition," *New York Times*, April 1, 1878, p. 5.

159. Jervis McEntee Diary, January 18, 1879, frame 0250, reel D180.

160. "Committee on Admission, 1854–1874," manuscript in the collection of The Century Association Archives Foundation.

161. Eastman Johnson to Jervis McEntee, October 12, 1879, frame 517, reel D30, Charles E. Feinberg Collection of Artists' Letters. The letter was quoted most recently in Simpson, Mills, and Hills, *Eastman Johnson: The Cranberry Harvest.*

162. See Simpson, "Taken with a Cranberry Fit" (see n. 125 above), pp. 32 and (on cranberry cultivation on Nantucket) 41–44.

163. Sally Mills has devoted particular attention to the sequence and character of these oil sketches in "'Right Feeling and Sound Technique': French Art and the Development of Eastman Johnson's Outdoor Genre Paintings" (see n. 104 above), pp. 58–65.

164. Eastman Johnson to Jervis McEntee, November 17, 1879, frame 457, reel D30, Charles E. Feinberg Collection of Artists' Letters. Quoted by Simpson in "Taken with a Cranberry Fit," p. 38. Also see Appendix.

165. Eastman Johnson to Jervis McEntee, December 13, 1879, frame 461, reel D30, Charles E. Feinberg Collection of Artists' Letters.

166. Remarking on the predominantly female population of Nantucket in the postwar period, one author wrote, "Governor Andrew must have visited Nantucket before he wrote his eloquent lamentation over the excess of women in Massachusetts." See "Nantucket," *Atlantic Monthly* 17, no. 101 (March 1866), p. 298. Patricia Hills has also linked Johnson's use of this key figure to similar motifs in the works of Jules Breton; see Patricia Hills, *The Genre Painting of Eastman Johnson: The Sources and Development of His Style and Themes* (New York: Garland, 1977), p. 152.

167. This theme is addressed in Josephine Donovan, *New England Local Color Literature: A Woman's Tradition* (New York: Frederick Ungar, 1983).

168. Contemporary reviews of the painting are transcribed in full in Simpson, Mills, and Hills, *Eastman Johnson: The Cranberry Harvest*, pp. 99–101. There were dissenters, including the *Tribune* writer, Clarence Cook, who criticized both the scattered arrangement of figure groups and the ununified effect of the light. "National Academy of Design. Fifty-fifth Annual Exhibition. (Third Article)," *New-York Daily Tribune*, April 18, 1880, as quoted in Simpson, Mills, and Hills, ibid., p. 100.

169. In reviewing the exhibition, the *Times* discussed the Academicians and the new men as separate groups. See "The Academy Exhibition," March 27, 1880, *New York Times*, p. 5.

170. A descendant has identified the sideboard, the cask of flasks, and the Toby jug that appear in the painting as among those effects in the artist's estate. I am grateful for her assistance.

171. "American Art News," *Art Interchange* 4, no. 8 (April 14, 1880), p. 63. This source was cited in Simpson, "Taken with a Cranberry Fit," p. 39.

172. Eastman Johnson to Jervis McEntee, August 30, 1880, frame 466, reel D30, Charles E. Feinberg Collection of Artists' Letters.

173. Eastman Johnson to Jervis McEntee, November 17, 1879, frame 457, reel D30. Charles E. Feinberg Collection of Artists' Letters. Also see Appendix.

174. Patricia Hills offers an insightful consideration of Johnson's late career in "Afterword/ Afterwards: Eastman Johnson's Transition to Portrait Painting in the Early 1880s," in Simpson, Mills, and Hills, *Eastman Johnson: The Cranberry Harvest*, pp. 77–91.

175. With the December 1880 presidential election, which he described as the most important since Lincoln's, Johnson had reimmersed himself in politics. Writing to McEntee at that time, he looked forward to Garfield's election and to the settling of "the *Solid South*" business. Eastman Johnson to Jervis McEntee, December 2, 1880, frame 468, reel D30, Charles E. Feinberg Collection of Artists' Letters. Also see Appendix.

176. Eastman Johnson to Jervis McEntee, September 22, 1881, frame 476, reel D30, Charles E. Feinberg Collection of Artists' Letters. Also see Appendix. Marc Simpson has documented the Johnsons' increased involvement in land speculation on Nantucket at this very time. See Simpson, Mills, and Hills, *Eastman Johnson: The Cranberry Harvest*, pp. 102–4.

177. "Close of the Academy Exhibition," *New York Times*, May 16, 1887, p. 4.

178. Alfred Trumble, *Representative Works of Contemporary American Artists* (New York: Charles Scribner's Sons, 1887).

179. Edward King, "The Value of Nationalism in Art," *Monthly Illustrator* 4, no. 14 (June 1895), p. 267.

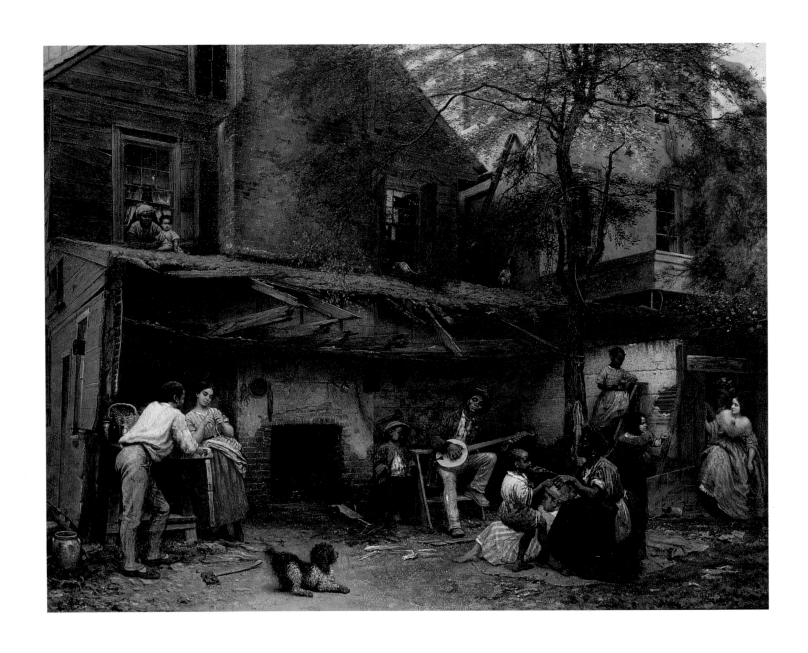

NO. 67
Negro Life at the South, 1859
Oil on canvas, 36 x 45¼ in.
The New-York Historical Society, Robert L.
Stuart Collection, on permanent loan from
The New York Public Library, S-225

Painting Race: Eastman Johnson's Pictures of Slaves, Ex-Slaves, and Freedmen

PATRICIA HILLS

Reading and charting the emergence of an Africanist persona in the development of a national literature is both a fascinating project and an urgent one, if the history and criticism of our literature is to become accurate.
—TONI MORRISON, Playing in the Dark: Whiteness and the Literary Imagination (1992)

Eastman Johnson moved into the first rank of American painters when his *Negro Life at the South* (No. 67) received overwhelming praise at the spring 1859 exhibition of the National Academy of Design in New York. With this picture he effectively demonstrated his ability to organize a complex, multifigured genre scene of slave activities, with marked attention to detail, composition, color, and the dignity of the slaves themselves. Throughout the 1860s the subject of African American life continued to fascinate him and his contemporaries, and Johnson painted many of the more sympathetic and daring pictures of slaves, ex-slaves, and freedmen of that time, including *The Freedom Ring*, 1860 (No. 71), *A Ride for Liberty—The Fugitive Slaves*, circa 1862 (No. 74), and *Fiddling His Way*, 1866 (No. 78).

On such paintings he built his reputation. By 1867 Henry Tuckerman, the leading art writer of the day, could praise Johnson's pictures of African Americans in *Book of the Artists*:

> *In his delineation of the negro, Eastman Johnson has achieved a peculiar fame. One may find in his best pictures of this class a better insight into the normal character of that unfortunate race than ethnological discussion often yields. The affection, the humor, the patience and serenity which redeem from brutality and ferocity the civilized though subjugated African, are made to appear in the creations of this artist with singular authenticity.*[1]

Nevertheless, instead of continuing with what might have been a fruitful and new subject for genre painting—the integration of emancipated slaves into American society—Johnson gave up painting pictures of African American life in the late 1860s.

In this shift, he was not alone. When we broaden the investigation and search out the artworks of other contemporary New York artists, we discover the same phenomenon: a great surge of paintings sympathetically representing African Americans during the mid-1860s and then a precipitous decline in interest after 1868. When we search for the reasons for this pattern, we discover that Johnson, like many other genre painters, as well as the critics and art patrons who encouraged him, was briefly caught up in a movement—the movement for political equality and social justice for African Americans. In the antebellum era this movement had been a crusade against slavery, kept in motion by the writings, speeches, and fieldwork of abolitionists such as William Lloyd Garrison, Frederick Douglass, Lydia Maria Child, Angelina and Sarah Grimké, Wendell Phillips, Gerrit Smith, and many others.[2] Midway through the war, when northern victory appeared inevitable, the antislavery movement—including the Radical Republicans and their liberal allies in Congress—began to confront the more difficult and tangled issue of how to integrate emancipated slaves into postwar society. Although some gains were made, enduring solutions did not achieve consensus. By the late 1860s the cause was abandoned. By then Eastman Johnson and his art-world contemporaries had also pulled away, and for almost all white Americans, the movement quickly faded into memory.

To come to a fuller understanding of American culture and these issues, we should heed the admonishment of Toni Morrison, quoted as our epigraph. We need not only to chart, but also to interpret, the emergence of the Africanist presence in the mid-nineteenth-century visual culture of white America—both in the fine arts and in the popular arts—before its temporary cessation in the Gilded Age that emerged in the 1870s. An examination of Eastman Johnson and his pictures may provide a beginning for this project.

The Year 1857

An investigation of the entrance and exit of African Americans in Johnson's work takes us back to the year 1857, a turning point for the United States. The issues and events of that year included the proslavery Democratic politics of the newly elected president, James Buchanan, which helped to spur the consolidation of his Republican opponents, and the Supreme Court decision in the Dred Scott case, which upheld the legitimacy of the property rights of white men to own black men. Two crises with profound impact were the bloodbaths in Kansas when proslavery forces sought to impose a proslavery constitution on that state and the Panic of 1857, which closed the banks and led to widespread unemployment, a temporary halt to speculative land investments, and falling prices in the winter of 1857–58. All these events exacerbated the growing sectional tensions between the North and the South.[3]

The events of 1857 also affected Johnson and his family, and his personal experiences of that year would point him toward a career as New York's premier genre painter of African American subjects. Having returned in the fall of 1855 from six years of study and professional practice in Europe, Johnson had moved in with his sisters and recently widowed father in Washington, D.C.[4] Still not settled into an artistic practice in the District by early 1856, Johnson accepted an invitation from his sister Sarah to visit her in Superior, Wisconsin, where she and her new husband, William H. Newton, had relocated and where land speculation provided opportunities for investment. The trip to the Superior area in the summer of 1856 provided the occasion for Johnson to see the West.[5]

Johnson returned briefly to Washington, D.C., in the late spring or early summer of 1857 to attend to the career that he had set in motion in the District.[6] It was at that time that Johnson visited Mount Vernon, the former home of George Washington, along with his friend, the painter Louis Rémy Mignot (1831–1870).[7] The results of Johnson's visit were a painting of Mount Vernon itself (No. 68), two paintings of the grounds before improvements began, a study of the empty interior of the north dependency with its large hearth, and three almost identical versions of *Kitchen at Mount Vernon*, a homey scene of a slave family sitting by that very hearth (No. 69).[8]

We do not know the specific catalyst for Johnson's turning to the subject of slave life in 1857, when he painted his first version of *Kitchen at Mount Vernon*, but certainly the subject was timely in that turning-point year; the abolitionists' moral invectives and the arguments by antislavery political and social leaders must have had their effect on the artist. As a young portrait draftsman in Boston in 1846, Johnson had been invited by Henry Wadsworth Longfellow to make crayon portraits of his family and friends (see Nos. 3, 4, and 5), all of whom were sympathetic to the abolitionists' cause. One of these crayon studies was of Charles Sumner (No. 70), well known in Washington in 1857 as the Republican senator from Massachusetts who argued eloquently against the extension of slavery into the western states. In addition, while Johnson lived in The Hague, he had exhibited in 1853 a picture of Uncle Tom and Little Eva, drawn from the characters in Harriet Beecher Stowe's inflammatory *Uncle Tom's Cabin*, which had been serialized in the *National Era* in 1851–52 and promptly translated into many languages.[9] Moreover, slavery was a contested fact of life in Washington, D.C., even in Johnson's own household. Mary Washington James, a widow whom his father, Philip C. Johnson, Sr., was courting and would marry on August 31 of that year, owned three slaves.[10]

Johnson's taking on the theme of blacks inhabiting domestic spaces struck a personal note, but the painting *Kitchen at Mount Vernon* also recalls the art-historical tradition of eighteenth-century painters such as the French artist Hubert Robert (1733–1808), who pictured peasants working and playing among the fallen

NO. 68
The Old Mount Vernon, 1857
Oil on canvas, 23½ x 34 in.
Fraunces Tavern Museum, New York

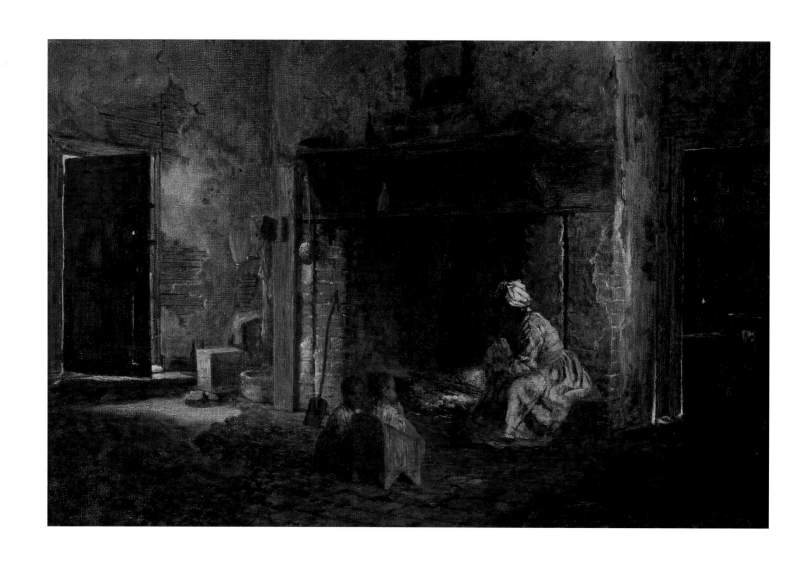

NO. 69
Kitchen at Mount Vernon, 1857
Oil on canvas, 14 x 21 in.
Hevrdejs Collection

monuments of Imperial Rome. Although Johnson's peasants are American slaves, they sup at the hearth of a major American historic homestead, then falling into picturesque disrepair. A turbaned African American mother sits by the fireplace in this room with fallen plaster and worn stone floors and holds a baby on her lap, while two very young boys, one seated on a low chair and the other on the floor, wait for her attention. One of the boys turns to acknowledge the presence of the viewer, as did the peasants in those eighteenth-century paintings.[11]

Johnson was only just beginning to paint slave subject matter when he decided to explore further the opportunities, both artistic and financial, in Superior. He returned to the West in July 1857 with funds from the Washington branch of his family for investment—perhaps in properties in Duluth, which had been laid out in lots in 1856.[12] Johnson did many drawings of the Anishinabe (Ojibwe), as well as portraits of family members in the area and other white settlers, and his fortunes appeared to prosper. Then the events of 1857 intervened. The Panic of 1857 seems to have quashed the family's dreams of profitable land investment, and one by one they left. After a brief stay in Cincinnati in the winter of 1858, Johnson returned to the East. By April he was in New York, where he rented a commodious studio in the University Building with the clear intention of making a New York career.[13]

It must have been evident to Johnson in 1858 that New York had become the center of the American art world and, therefore, would be the ideal place in which to make his reputation, in spite of the fact that he had previously established himself in the Washington art community. The University Building, constructed in 1840, rented studios to artists, and it was conveniently located and close to several galleries.[14] Johnson did not need to remain in Washington in order to paint what

NO. 70
Charles Sumner, September 19–October 6, 1846
Crayon and chalk on paper, 21 x 19 in. (oval)
National Park Service, Longfellow National
Historic Site, Cambridge, Massachusetts

was to become his chef d'oeuvre, *Negro Life at the South*, since he had already painted an oil study of the empty yard of the slave quarters next to his father's home. Like nature painters who make outdoor studies of scenes and then use them as templates later to paint finished landscapes back in their studios, Johnson habitually made and kept studies of actual interiors without figures, which he copied as the settings for his genre scenes.[15]

"Negro Life at the South"

Johnson sent six pictures to the National Academy of Design's spring exhibition, which opened on April 13, 1859, and immediately was catapulted to the forefront of New York image-makers. Four of the works were drawings, of which three had been shown at the Washington Art Association in 1857. An oil, *The Pets*, 1856 (fig. 27), had also been shown there; the new crayon drawing was *Roman Girl* (location unknown). The work that captured the attention of all the critics, however, was Johnson's *Negro Life at the South* (No. 67), a painting quickly embraced by both high and popular culture. Perhaps without even calculating the potential of the subject, he had become the premier painter of African American life.

Besides essaying novel subject matter, Johnson had also learned his European lessons well, in the eyes of New York connoisseurs and discriminating artists. Johnson's masterpiece exhibits well-studied details of architecture, clothing, individualized faces, and still-life elements; luminous shadows; deft scumblings of dry paint throughout the foreground to give the illusion of unlabored paint application; convincing spatial recessions; anatomically correct proportions for each figure; and the orchestration of twelve figures onto a 36-by-45-inch canvas. One connoisseur who admired Johnson's work was William P. Wright, who amassed a considerable collection of paintings before selling much of it at auction in 1867. The day after the Academy exhibition opened, the older landscape painter John F. Kensett (1816–1872) bought *Negro Life at the South* for the considerable price of $1,200,[16] and at some point within the next year, the painting was transferred to Wright.[17] As the art historian John Davis has pointed out, the subject matter of happy slaves might well have appealed to Wright, a successful cotton broker, but we do not know for certain where his personal sympathies lay. A central contradiction of Johnson's times was the fact that many people who were morally outraged by slavery often benefited, directly or indirectly, from the economic profits of that system.[18]

To a popular audience, *Negro Life at the South* was both timely and highly appealing. Like the long-running dramatizations of Stowe's *Uncle Tom's Cabin*, the painting presented a panorama of episodes of life under slavery in a way meant to remind the viewer of the humanity of African Americans while also hinting at the more "pathetic" aspects.[19] The episodes, or vignettes, in Johnson's painting include a central figure playing the banjo while a black child looks on. A mother at right center encourages her young son to dance, while a young girl lies on a blanket on the ground. At the far left a young mulatto man talks with a young, light-skinned African American woman. To the far right, a young white woman, the only white person in the painting, is greeted by two slave girls as she steps through the passageway, accompanied by her maid, to observe the proceedings.

The contemporary critics who wrote at length about the painting for the New York newspapers provide commentary that helps us understand the cultural tastes and ideological concerns of their times. It must be kept in mind, however, that these writers wrote for editors who held a range of opinions about slavery, about abolitionism, and about the need to support the Union.[20] William Cullen Bryant of the *Evening Post*, Henry J. Raymond of the *New York Times*, and Horace Greeley of the *New-York Tribune* were all Republicans who editorialized against slavery. James

Gordon Bennett of the *New York Herald*, however, was a southern sympathizer.[21] Although the critics no doubt had a degree of independence in what they wrote about art, editors would have been alert both to the critics' ideology and to what sold papers. Hence, quotations from a range of such critics offer us clues not only to the social and political attitudes of the writers, but also to their sponsoring publications and those publications' intended audiences. Such texts also provide us with an understanding of the criteria by which individual critics judged art and even information about the debates at the time over the relationship of the fine arts to popular culture. When taken together, such writings also give us insight into whether a consensus reigned—whether a common outlook prevailed among a dominant set of artists, patrons, and art audiences of that era—or whether ideologies and power groups were competing for cultural hegemony.

The critic from the *New-York Daily Tribune* considered all of Johnson's paintings to be "the special attraction" of the National Academy's spring exhibition. He especially admired *Negro Life*, both for its aesthetic qualities and its subjects. After writing at length about the picture's aesthetic merits, he moved on to the subject matter, calling the work "a sort of 'Uncle Tom's Cabin' of pictures" that "gives rise, therefore, to quite as many painful as pleasant reflections":

> In the Life at the South there is a story within a story: first, that of slave-life, as telling as a chapter from "Slavery As It Is," or a stirring speech from the Anti-Slavery platform, the negro quarters teeming with life, human and animal: the old building, moss-covered, neglected, ruinous, and desolate, contrasted with the well-built and carefully kept dwelling just seen beyond it; the indolent servants enjoying to the full their only solace—music; the mistress, refined and elegant, just looking in upon what clearly, for that fact, is not a daily scene, with her maid behind her, better fed, better clothed, much more of a woman, much less of a slave in her outward life, than her fellow servants, all presenting a sad picture of Southern Slavery, when viewed from one stand-point.

The critic then sharpens his remarks about the contradictions of slavery:

> On the other side is the careless happiness of simple people, intent only upon the enjoyment of the present moment, forgetful, perhaps ignorant, of degradation, and thoughtless of how soon may come the rupture of all those natural ties in which lie the only happiness that life can give them; the delighted mother and her dancing child; the old man, wrapped up in the sweet sounds of his own creation; the little boy, with his neglected plaything, entranced by the true negro love of melody; the children wondering at the sight of "Missis" in the negro-yard; the young lovers, their very attitudes instinct with the fine sentiment which belongs alone to no condition, but is common to every human creature; and even the little dog which lends his hilarious bark to the general fun.

As his final assessment, the *Tribune* critic writes: "Both these paintings [*The Pets* and *Negro Life*], from their intrinsic merit of handling, and as works of imagination, must give Mr. Johnson a high rank among American artists."[22]

A sampling of other New York contemporary criticism indicates a consensus with the *Tribune* critic's appraisal. In the May 1859 issue of the *Crayon*, the American journal that expressed the views of the American followers of John Ruskin (1819–1900), an anonymous critic wrote: "Of figure-subjects, decidedly the most important are 'Negro Life in the South,' and various drawings by E. Johnson, [and] Darley's Illustrations for Cooper's Novels."[23]

In the June 1859 issue of the *Cosmopolitan Art Journal*, a magazine that promoted "American" subjects for art, the critic voiced his general disappointment with the exhibition at the National Academy that year but singled out Johnson's painting for praise, ranking it well above the landscapes exhibited: "[Of] the first-class works

there is not a single one, except it be Mr. Johnson's 'Southern Life,' which we are disposed to regard as, in several respects, a first-class character piece."[24]

Writing at length about the painting in the June issue of the *Crayon*, another reviewer began with the acknowledgment that exhibitions invariably reflect the public taste of the time and that painters who wish to be exhibited are obliged to cater to that taste. This reviewer's praise focused on the elements that were making *Negro Life* a popular success:

> One of the best pictures in respect to Art and the most popular, because presenting familiar aspects of life, is E. Johnson's "Negro Life at the South." . . . Although a very humble subject, this picture is a very instructive one in relation to Art. It is conscientiously studied and painted, and full of ideas. . . . The picture of "Negro Life at the South" . . . is a kind of Art that will be always popular, so long as lowly life exists to excite and to reveal the play of human sympathy. But "Negro Life at the South" is not "high Art," for the reason that the most beautiful thoughts and emotions capable of Art representation, are not embodied in the most beautiful forms, and in the noblest combinations.[25]

According to this critic, "high Art" meant only "beautiful thoughts and emotions": since *Negro Life* raised thoughts and emotions that were troubling to him, it only qualified as popular art. The work's aesthetic qualities and paint handling ranked high, however, with other critics less interested in distinctions between "high" and popular art. All critics seem to have acknowledged that subject matter and the sentiment it conveyed were of primary importance in attracting an audience and in making an artist's reputation.

With the advantage of hindsight and some knowledge of the contextual history in which nineteenth-century visual culture was produced, we may look more closely at the racial attitudes encoded in *Negro Life at the South*. Our project is not just to identify the overt stereotypes that history has passed down to us, but also to recognize where the stereotypes dissolved and what kinds of images superseded them. Indeed, Harriet Beecher Stowe in *Uncle Tom's Cabin* had already started the process; her representations of slave character would have been on the minds of Johnson's contemporaries, as the *New-York Daily Tribune* critic made explicit when he called *Negro Life* an "Uncle Tom's Cabin of Pictures." His reference to "Uncle Tom's Cabin" doubtless embraced illustrations to the book versions and theatrical productions that played throughout the 1850s in New York.

From the painting's details, poses, expressions, and spatial relationships, we can tease out some of the submerged meanings that had redirected contemporary white perceptions of blacks as a result of Stowe's book.[26] The most noticeable characteristic that individualizes the African Americans in the scene is the range of skin tones, which coded the reality of slave and free-black life.

The beautiful young mulatto woman, idly playing with a blade of corn leaf, leans toward and listens to the implorings of the young mulatto man, who faces away from the viewer. Their relationship is one of the first blush of love, as some critics noted. The two together make explicit to a white audience the reality of love between African American men and women—a reality that, until *Uncle Tom's Cabin*, was only dimly recognized, if at all, by the majority of the white middle classes, conditioned by years of blackface, minstrel-show stereotypes.[27] Stowe helped to change consciousness by creating a cast of sympathetic slave characters who loved each other and their children with deep, passionate feeling. The antislavery theatrical productions of *Uncle Tom's Cabin*, especially the George L. Aiken version, which opened at the National Theatre in New York on July 18, 1853, continued to work their cathartic effect on New York white audiences, reportedly reducing even the roughest men to tears.[28]

In the courting-couple vignette, the young woman is on display, facing the audience, which is being asked to consider her situation. We see that she demurs, following the protocol for young white women, who were never to seem too eager to their suitors. In the fiction of white America, a black woman was allowed to love, but if the object of her affection was white, her love could have tragic consequences. Zoe, the mulatto heroine of Dion Boucicault's play *The Octoroon*—which would open in New York in December 1859—necessarily had to die by play's end, because she and the scion of a white planter family had fallen in love.[29]

Real-life black women, trying to make sense of their own real lives in their autobiographies, addressed the issue of love between men and women in the slave community. Harriet Jacobs opens the chapter "The Lover" in her *Incidents in the Life of a Slave Girl* (1861) with the following meditation: "Why does the slave ever love? Why allow the tendrils of the heart to twine around objects which may at any moment be wrenched away by the hand of violence? . . . I loved him with all the ardor of a young girl's first love. But when I reflected that I was a slave, and that the laws gave no sanction to the marriage of such, my heart sank within me." Jacobs had the bitter knowledge that no court would sanction the marriage of slaves and that the vagaries of a master's fortune might spell permanent separation at any time.[30] Since *Incidents in the Life of a Slave Girl* was published so soon after the exhibition of *Negro Life at the South*, it is possible that, in the minds of some readers, the 1861 voice of Jacobs found its visual analogue in Johnson's 1859 image.

It is significant that Johnson has turned the young mulatto man away from the viewer, thereby hiding his response. A white audience would not have wanted to know his thoughts; black male power, like black male sexuality, made them uncomfortable. One way to subdue the black man was to turn him away from confrontation with an audience; another was to make him old. As the historian Thomas Gossett has pointed out, Uncle Tom in the novel was "a muscular, healthy, and fairly young man"; but in visual culture, particularly the repeated productions of the play, Tom made the transition from "a strong, black, labouring man" to "the meek, pious and subdued old negro."[31] In Johnson's painting, the young man's effacement directs the viewer to the only other man, the older banjo player absorbed in his music.

Before we leave the young man, however, we must question the presence of the ax on the ground, which the young man has apparently put down. Traditionally an emblem of manual work in general, or of clearing the land and hence the advancement of civilization itself, the ax could also represent raw, crude physical power engaged in terrible retribution. For example, at least one popular illustration of an account of the Nat Turner uprising of 1831 depicts male slaves wielding axes, as well as long knives, over the heads of their white victims.[32] At the end of *The Octoroon*, closer in time to Johnson's *Negro Life*, the Native American Wahnotee hatchets to death the evil overseer, Jacob M'Closky. In Johnson's picture the ax rests on the ground, available but only potentially an implement for violence.

Above the couple and looking out of a second-story window is a turbaned, slightly older woman with a pale mulatto baby. The baby's light skin codes the absent father as a white man—a reminder of the forced sexual relations on plantations, where white masters exercised power over their women slaves. In a review in the *Home Journal* of August 27, 1859, the writer referred to the older woman as "aunt Dinah." "Dinah" was a generic appellation frequently assigned to black women by whites, perhaps without even making the connection that Dinah in the Bible, the only daughter of Jacob and Leah, was raped by a man not of her people. If this writer knew his Bible, it would not be surprising that "Dinah" might spring to his mind as he observed the baby's skin color.[33]

Slightly left of center is the vignette of an older man who strums a banjo while

FIG. 49
Bufford's Lithographers, Boston
Jim Crow Jubilee, 1847
Lithograph, sheet-music illustration, 13⅜ x
10¼ in. (sheet)
Published by Geo. P. Reed
Boston Athenaeum

FIG. 50
"Oh Carry Me Back to Ole Virginny," 1859
Color lithograph, 17¼ x 13¹¹⁄₁₆ in.
Published by Robertson, Seibert & Shearman
Library of Congress, Washington, D.C.,
93510468/PP

a young boy gazes at him admiringly. The motif comes from images of minstrelsy but suggests none of the grotesqueries of the ragtag Zip Coon and Jim Crow images on antebellum sheet music (fig. 49). The face of this darker-skinned older man, with his high cheekbones, deep-set eyes, and pursed lips, is serious, perhaps even mournful—certainly not an exaggerated stereotype. He treats his banjo seriously and serves as a model for the young boy.

The mother-and-child motif in the center foreground again invokes the "musical instinct" assigned to African Americans. The mother smiles encouragingly at her young boy, and her dark skin denotes that her bloodline has been unmixed with white antecedents. Hence, she represents ancestral Africa as she teaches her son, the lighter-skinned African American, the steps of a dance that she may have learned from her forebears. Her face is individualized and composed; the delineation of her features, the blue highlights, and the tightly curled hair showing beneath her head scarf are neither caricatured nor exaggerated. One senses that Johnson used an actual model, either for previous sketches in Washington or later in New York, to replicate the face of this beautiful older woman. Behind the mother and son, lying on the ground, is a young girl whose glance at the banjo player tells us that he has another admirer.

The painting's only white figure is the pretty young woman who steps through the doorway from the "big house" next door, accompanied by her mulatto maid. Greeted by two black girls who look on with approval at her entrance, she looks across the scene with her eyes resting on the banjo player, or perhaps on the young slave woman at the left side—her metaphorical mirror image.[34] She has come to observe this scene of leisure and gaiety among the rotting boards of the lean-to kitchen, whose front façade has long since fallen into ruin and been removed, to judge from the age of the tree growing up in the center of the space. Johnson portrays her as the good mistress, ready to learn from her slaves and treat them kindly.

Negro Life entered into popular culture through frequent exhibition and mass-produced reproductions. The *Home Journal* reported that a photograph was made by Rintoul and Rockwood, and published by George W. Nichols.[35] It may have been this photograph that functioned as a source for a lithograph, published in 1859 by Robertson, Seibert & Shearman and titled *"O Carry Me Back to Ole Virginny"* (fig. 50).[36] The lithograph was used as a packing label for tobacco, with the corners of the label decorated with tobacco leaves. One can only speculate that the shipper might have insisted upon the Virginia reference since much of the South's tobacco being transported was produced in Virginia. The image focuses on the five central figures, transforming them into a family unit of father, mother, and three children.

Their skin tones are uniformly similar—perhaps of necessity, owing to the lithographic process; nevertheless, the uniform skin tone removes any distractions from a promotional image for tobacco.

The "Virginny" title of the tobacco label may partially explain the mystery as to why Johnson's painting came to be popularly known as *Old Kentucky Home*, with its reference to another tobacco state. The usual answer is that Stephen Foster's "Old Kentucky Home," written in 1853, was still popular in 1859, and the suggestion of mournful nostalgia for the "home far away" in Foster's song certainly resonates with the sober and serious look of Johnson's banjo player. A more compelling answer is the audience's association of Johnson's painting with *Uncle Tom's Cabin*, both the novel and the various plays, all of which situate the opening action on a Kentucky plantation, where Tom temporarily enjoys a more benign existence than he will have later in the story.[37]

The painting's first exhibition outside New York was in Boston, where it went on view at the Boston Athenaeum in the summer of 1859 with the title *Kentucky Home*.[38] A reporter for *Dwight's Journal of Music*, a periodical published in Boston, urged that summer visitors pay a visit to the Athenaeum, where they would find "a most pleasing collection of pictures, of popular subjects," of which one, *Kentucky Home*, was "a most characteristic picture of the domestic life of the Kentucky plantation, which delights all." The reporter then added that a commercial photograph of *Kentucky Home* (perhaps the print by Rintoul and Rockwood) could be purchased at the door. It was still unusual in the late 1850s for a commercial, photographic reproduction of a painting to be for sale at the door to an exhibition, but the photograph ensured the staying power of Johnson's image.[39]

The Year 1860 and Johnson's Continuing Popularity

Riding on the success of the 1859 exhibition, Johnson sent five paintings to the National Academy's 1860 spring exhibition, three of which were genre paintings of slave life: *Kitchen at Mount Vernon*, discussed above; *Mating*, 1860 (fig. 51); and *The Freedom Ring*, 1860 (No. 71).[40] *Mating* represents a black couple, obviously courting, under a platform of pigeon coops. As in the courting scene in *Negro Life at the South*, the black man turns away from the viewer; the young woman, whom the viewer sees full front, turns slightly away from her suitor. Acquired by General John Adams Dix, a pro-Union advocate and military man, *Mating* was later shown at the Maryland State Fair, organized by the Baltimore Sanitary Commission in April 1864.

FIG. 51
Eastman Johnson
Mating, 1860
Oil on canvas, 17 x 21 in.
Location unknown

NO. 71
The Freedom Ring, 1860
Oil on paper board, 18 x 22 in.
Hallmark Fine Art Collection, Hallmark Cards Inc.,
Kansas City, Missouri

Thus far, we have discussed pictures of African Americans that came out of Johnson's imagination, even if the sites of the scenes were drawn from real locations and the figures based on studies from models. As attitudes among liberal white painters changed, however, toward deeper sympathy for the situation of slaves in the crucial pre–Civil War years, Johnson, like others, moved away from more stereotyped depictions of "typical" blacks, as in *Negro Life at the South* and *Kitchen at Mount Vernon*, and began to rely more on his own experiences. He began to portray specific people from his times, such as the little mulatto child in *The Freedom Ring*, the third work submitted to the Academy's 1860 exhibition.

The Freedom Ring depicts the aftermath of an actual event. On February 5, 1860, Henry Ward Beecher, the brother of Harriet Beecher Stowe, presented a young slave to his congregation at Plymouth Church in Brooklyn and appealed to them to ransom her from slavery. According to one account: "The basket was passed and about $2,000 collected. Miss Rose Terry being present, not having sufficient money with her, drew a valuable ring from her finger and cast it into the basket. There being more than enough to purchase her freedom, the ring was given to the child as her Freedom Ring."[41] The child was christened Rose Ward, after Rose Terry Cooke and Beecher, and subsequently called "Little Pinky." A writer for the antislavery *Independent* declared, "The scene is likely never to be forgotten by those who witnessed it." Beecher subsequently took Little Pinky to Johnson's studio, where the artist painted her admiring the ring. The fact that Beecher called on Johnson indicates the extent to which Johnson was becoming involved with the movement.[42]

Conversely, influential men such as Beecher were becoming convinced of the moral and political power of art. At about this time Beecher wrote: "[T]he loves, the hopes, the joys, the friendships, the aspirations, the sorrows, of the great human family are always to be revered. Art dignifies itself when it embodies them." Beecher might have had Johnson in mind, as he continued: "And he only will be a true master whose education or disposition leads him to love the things which the race loves, and to paint them, not in condescension, not for the sake of a market, but because in his soul he feels that the life of the common people is the life of God, in so far as it is revealed in any age."[43] In his use of the word *race*, Beecher meant the "human race," which included, Beecher would vigorously preach, all African Americans. In May 1863 Beecher baptized another former slave child, Fannie Virginia Casseopia Lawrence, who had been "redeemed" in Virginia by Catharine S. Lawrence and then adopted (fig. 52). Lawrence seems to have taken Fannie on tour as part of the propaganda effort of the abolitionists, with carte de visite photographs being made in New York, Boston, and Hartford.[44]

By displaying his ability to paint pictures with mass appeal to the antislavery movement, Johnson had scored again. And now, in 1860, because of the high esteem that Johnson held among the older, more established artists and his obvious popularity with the public, he was elected a full Academician. He submitted the mandatory self-portrait (fig. 95) and one other painting to the National Academy's permanent collection. That painting was *Negro Boy* (No. 72), a small, modest study of a young African American absorbed in playing a homemade flute. He could have as easily submitted *Hannah amidst the Vines* (No. 73), painted in 1859, a close-up of a young black girl sucking on a string of beads as she peers out at the viewer.[45] Like "Little Pinky" in *The Freedom Ring*, who sits on the floor and experiences a private moment of wonder, the children in *Negro Boy* and *Hannah* are portrayed in quiet moments; these images differ greatly in content and composition from the bustling panorama of *Negro Life at the South*. The three children have interior lives that negate their transformation into stereotypes.

The figure in *Negro Boy* would have probably appealed to the other Academicians,

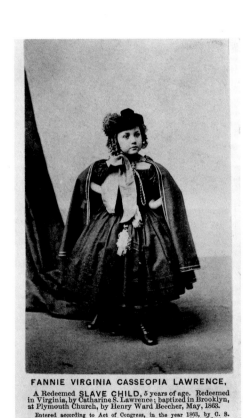

FANNIE VIRGINIA CASSEOPIA LAWRENCE,

A Redeemed SLAVE CHILD, 5 years of age. Redeemed in Virginia, by Catharine S. Lawrence; baptized in Brooklyn, at Plymouth Church, by Henry Ward Beecher, May, 1863.

Entered according to Act of Congress, in the year 1863, by C. S. Lawrence, in the Clerk's Office of the District Court of the United States, for the Southern District of New York.

FIG. 52
Renowden Studio, on a Kellog Brothers mount
Carte de visite, 1863
"Fannie Virginia Casseopia Lawrence, a Redeemed SLAVE CHILD, 5 years of age. Redeemed in Virginia, by Catharine S. Lawrence; baptized in Brooklyn, at Plymouth Church, by Henry Ward Beecher, May, 1863."
Courtesy of the Library of Congress, Washington, D.C., 94503862/PP

NO. 72
Negro Boy, 1860
Oil on canvas, 14 x 17⅛ in.
National Academy Museum, New York

NO. 73
Hannah amidst the Vines, 1859
Oil on canvas, 14 x 12 in.
Georgetown University Art Collection,
Washington, D.C.

since he plays a flute, an instrument of artistic expression. He sits in the frame of a doorway, symbolic of his transitional status between childhood and adulthood, between home and the outdoors, between slavery and freedom. He and his flute also recall the use of musical motifs in paintings of African Americans by genre artists, including Johnson, that perpetuated the stereotype of blacks as innately responsive to rhythm. Nevertheless, viewers at the time would have thought: the boy has a soul that appreciates music; he has a talent that shows his humanity.

In any event, *Negro Boy* and *Hannah* moved Johnson in the direction of Realism and provide a sharp contrast to Johnson's sentimental pictures done for the market, such as his cloying *The Barefoot Boy*, an image originally done as a commission to illustrate John Greenleaf Whittier's poem of the same name for an 1861 anthology of poetry and later, in 1866–67, mass-produced as a chromolithograph by the Boston publisher Louis Prang (fig. 53). In other words, when painting for himself, as with *Hannah*, or for his peers in the National Academy, as with *Negro Boy*, Johnson could experiment. At a time when real events inspired him, he freed himself to paint not what the market seemed to demand (that is, stereotypes of either farm boys or slaves), but rather, real-life children, with sociological and psychological realism.[46]

FIG. 53
Eastman Johnson
The Barefoot Boy, 1867
Chromolithograph, 13 x 9¾ in.
Boston Public Library

The Civil War at the Front and at Home: Images of Blacks

When war broke out in April 1861, Johnson was in Maine, making studies of the social and work activities connected with the maple-sugar harvest. He must have returned to New York by May in order to participate in an exhibition and sale held at Goupil's Gallery and then at the Merchants' Exchange to raise funds for the Union.[47] Some of his friends had enlisted, such as Jervis McEntee, who went off to the front in June. His brother Reuben had also joined the Union army and wrote Johnson in July 1861 from Washington after witnessing the battle at Bull Run.[48] John I. H. Baur, the first modern scholar to study Johnson's work, speculated that this letter fired up Johnson's imagination to such an extent that the artist resolved to go with the troops on their campaigns. According to Baur, Johnson was near Bull Run in March 1862, was at Antietam on September 17, 1862, and marched with the Union army through Maryland following the battle of Gettysburg in 1863.[49]

The result of the March trip was the picture *A Ride for Liberty—The Fugitive Slaves* (No. 74), which exists in three versions. Johnson felt it important to document the scene as truthful, as an actual event that he had witnessed, for he inscribed on the back of the canvas version: "A veritable incident / in the civil war seen by / myself at Centerville / on this morning of / McClellan's advance towards Manassas March 2, 1862 / Eastman Johnson." The carefully annotated, documented eyewitness account of events became part of the ethos of reportage during the Civil War. The wood engravers who worked for *Harper's Weekly* and *Frank Leslie's Illustrated Newspaper* and translated the sketches of the war artists into engravings to be reproduced in those weeklies regularly included inscriptions documenting that the war-correspondent artist had actually seen the event.[50]

By allowing the experience of real events to dictate the picture, rather than constructing an image from his imagination or from the traditional iconography of art, Johnson offered his audience a very new and radical image. The picture represents a slave family—father, mother, child, and baby—riding at dawn on a single galloping horse toward the Union lines, indicated by glints of light reflecting off the gleaming bayonets in the distance. Johnson toned down the light illuminating the figures in order to convey the sense of cool and dim morning light, but the viewer nevertheless senses the courage of this family. Unlike his earlier manumission picture, *The Freedom Ring*, where Pinky (Rose Ward) relies on the largesse of white benefactors, this work shows the fugitives as the agents of their own freedom.[51]

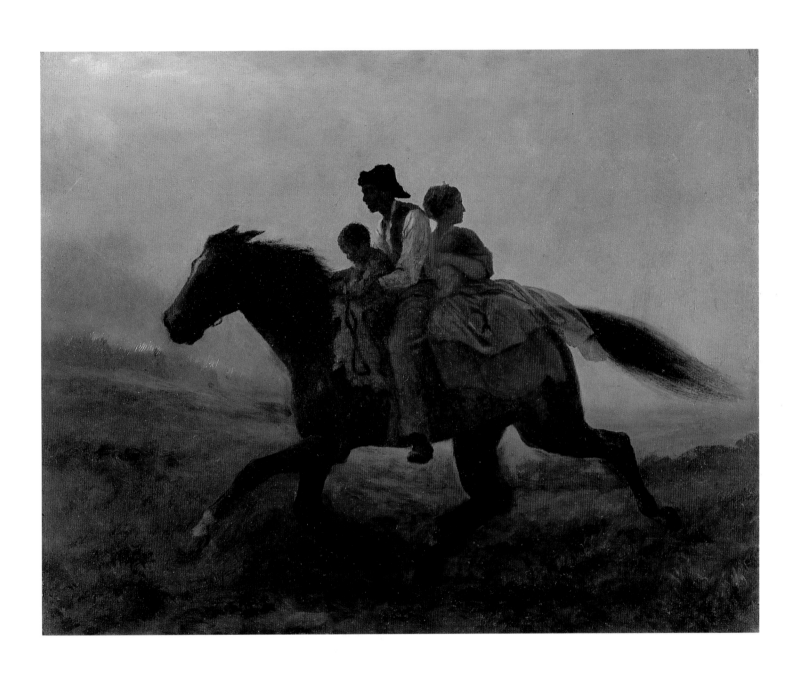

NO. 74
A Ride for Liberty—The Fugitive Slaves,
circa 1862
Oil on paper board, 22 x 26¼ in.
Brooklyn Museum of Art, Gift of Miss
Gwendolyn O. L. Conkling, 40.59.A

Johnson did only a few pictures of actual soldiers at the front; he seems to have left this task to the illustrators of the pictorial weeklies, such as Winslow Homer, Edwin Forbes (1839–1895), and Alfred R. Waud (1828–1891). A recently located but unsigned painting, *Union Soldiers Accepting a Drink*, circa 1865 (No. 75), represents two Union soldiers taking drinks from a black woman in front of a rural tavern. She has already given the standing soldier a drink in his cup, which he lifts to his lips. She is now about to pour another drink into the cup of the second soldier, who sits on an outcropping of the foundation of her house. She has descended one step to meet them. To the left center of the picture stands a girl of about nine, in profile, in the shadow of the apple tree, who looks on at the scene. Although no records of the painting have yet come to light, a similar painting without the soldiers and child remained in Johnson's studio until the estate sale of 1907. The catalogue description of that painting, *Dinnertime and Appletime in Old Virginia* (location unknown), tells us all that we know of the work:

> In the right foreground is the corner of a wooden house, which stands on a stone wall laid without mortar, and in the doorway stands a negro woman blowing a tin horn, apparently summoning the men to dinner. An apple tree laden with fruit, and an arch of climbing roses and other vines cast a broad shadow across the foreground, through which a tiny brook runs over a rocky bed. In the middle distance is seen an old-fashioned garden, with sunflowers and vegetables, all in brilliant sunlight, and beyond a vista over a meadow to a blue hill in the horizon.[52]

Like the painting described above, *Union Soldiers Accepting a Drink* has a complex composition, filled with spots of color and layers of light as the viewer's eye is drawn back through the silhouettes of the trees toward the field of summer grain and distant mountains.

Union Soldiers defies all of the unspoken conventions of nineteenth-century American art about the decorum for representing a group of African Americans and whites. Albert Boime has demonstrated that the convention of deploying figures in a composition to mirror social hierarchies in real life applies especially to pictures of racial types. White artists often depicted people of color sitting or standing at a level lower than that of whites, particularly when the latter were also benefactors of the people of color.[53] In this painting the racial relationship is reversed: the black woman stands at the apex of the triangle formed by the three figures. It is she who is the benefactor, as she offers the soldiers drinks. Johnson placed the young girl in the middle of the picture, but he does not allow us to fathom her thoughts. The position of the young girl—standing at a distance, in the shadow—acts as a metaphor for the unknown travails that await her. She is now unsure of her role or of the possibilities open to her, yet the sunny landscape background suggests a bright future.

Union Soldiers, unsigned, undated, and of which no exhibition record or sale record exists, is in marked contrast to Johnson's most famous war picture of Union soldiers, *The Wounded Drummer Boy*, 1871 (fig. 106), based on a drawing of 1863 and depicting another scene that he claims to have witnessed. Since wounded drummer boys were part of the sentimental lore of the Civil War, Johnson's picture appealed to popular taste.[54] Perhaps with the decidedly unsentimental *Union Soldiers*, Johnson felt he was reaching the limits of what an audience would find appealing. Indeed, he may have had trouble pinpointing an audience for this work, as well as for many of the other undated and unsigned pictures of African Americans discussed in this essay.

Lincoln's Emancipation Proclamation took effect on New Year's Day 1863, inspiring popular prints such as Thomas Nast's "Emancipation," published in the January 24, 1863, issue of *Harper's Weekly* (fig. 54).[55] Contrary to popular belief, the Emancipation Proclamation did not free all slaves, but only slaves in those states still loyal to the

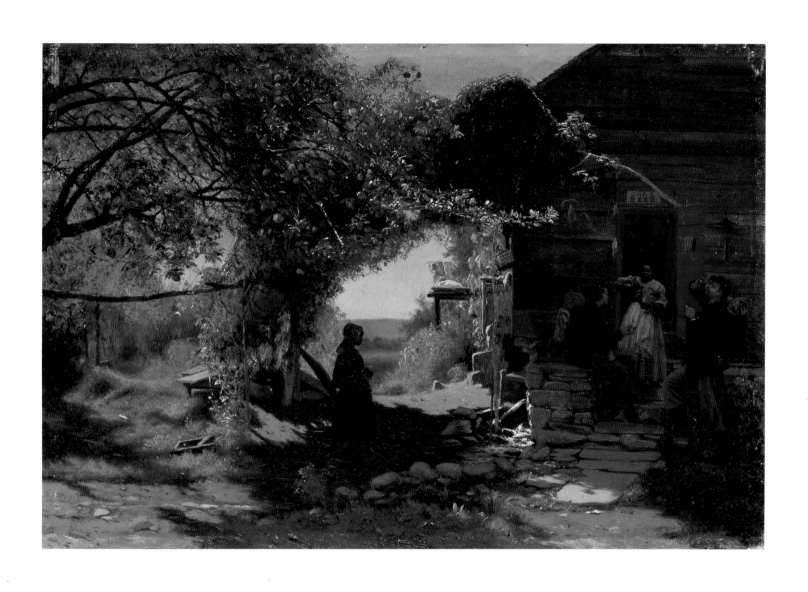

NO. 75
Union Soldiers Accepting a Drink, circa 1865
Oil on canvas, 10¾ x 15¼ in.
Carnegie Museum of Art, Pittsburgh,
Heinz Family Fund, 1996.45

139 PAINTING RACE

Confederacy. The Proclamation was intended as a war measure; slave-owning border states, such as Kentucky, could still retain the institution of slavery.[56] Nevertheless, the anticipation of the Proclamation, announced in September 1862, and the debates about encompassing African Americans within the body politic, no doubt encouraged Johnson to continue to represent the humanity of African Americans in his art.

One of Johnson's notable works from this period, and a good example of changing iconographical messages, is the painting *The Lord Is My Shepherd*, circa 1863 (No. 76), identical to *The Chimney Corner*, 1863 (Munson-Williams-Proctor Institute Museum of Art, Utica, New York), which was owned by Johnson's patron John Taylor Johnston.[57] This older black man, his walking cane propped against the back wall of a New England hearth, sits by a fire and studies his Bible. Such a picture, had it been painted for a southern audience before the war, would have had mixed messages. On the one hand, the figure meets the expectation of docility among slaves and he holds the Bible in his hands, an indication of his piety; but the very act of a slave's reading would have been disturbing. Teaching reading to slaves was an activity forbidden by laws in southern states. In 1863, however, after the Emancipation Proclamation, the motif held a different message. Debates about the manumission of slaves focused on the capabilities of African Americans to educate themselves in order to act as responsible freedmen.[58] Although the reading under-taken by Johnson's figure is a prelude to his citizenship, he remains pious and unthreatening, and sits at the hearth—long a symbol of piety and family values.[59]

During 1864, as civilian support for the war intensified, regional branches of the United States Sanitary Commission organized large fairs in a series of northern cities, including Chicago, Brooklyn, New York, Boston, Cincinnati, Philadelphia, and Saint Louis, in order to raise funds for food, clothing, and medical supplies for Union troops. The Brooklyn and Long Island Fair, which opened in February 1864, had a large art exhibition, to which the Reverend Henry Ward Beecher loaned a Johnson painting. Also on loan to Brooklyn was *Old Kentucky Home*, without the name of the owner appended to the catalogue entry.[60]

Across the river in Manhattan, Johnson immersed himself in committee work for the Sanitary Commission's Metropolitan Fair, which opened on April 14, 1864. His activities partially explain why he did not submit pictures to the National Academy of Design that year. Like the Brooklyn and Long Island Fair, the Metropolitan Fair included an art exhibition, to which Johnson sent three works, of which only one, *Working for the Fair* (location unknown), referred to the Civil War.[61]

For the Metropolitan Fair's auction of artworks, Johnson offered *The Young Sweep*, 1863 (No. 77). The subject is an African American boy of about eight or ten, who leans against a latched door. Wearing dark-colored clothes and cap, he holds a heavy blanket behind him with one arm, and under his other forearm in front he has

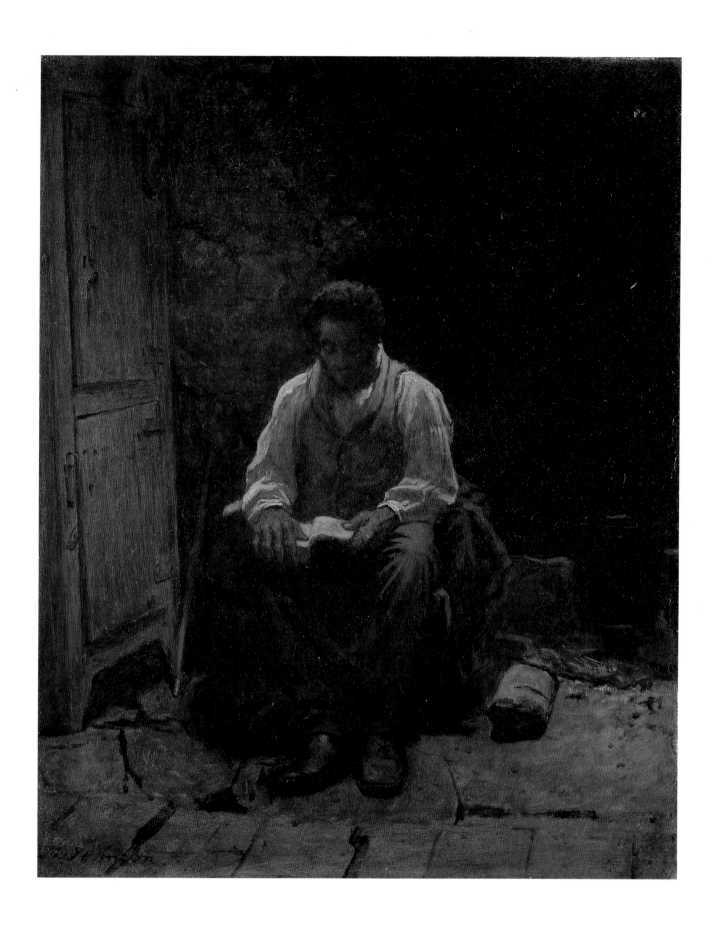

NO. 76
The Lord Is My Shepherd, circa 1863
Oil on wood, 16⅝ x 13⅛ in.
National Museum of American Art,
Smithsonian Institution, Washington, D.C.,
Gift of Mrs. Frances P. Garvan, 1979.5.13

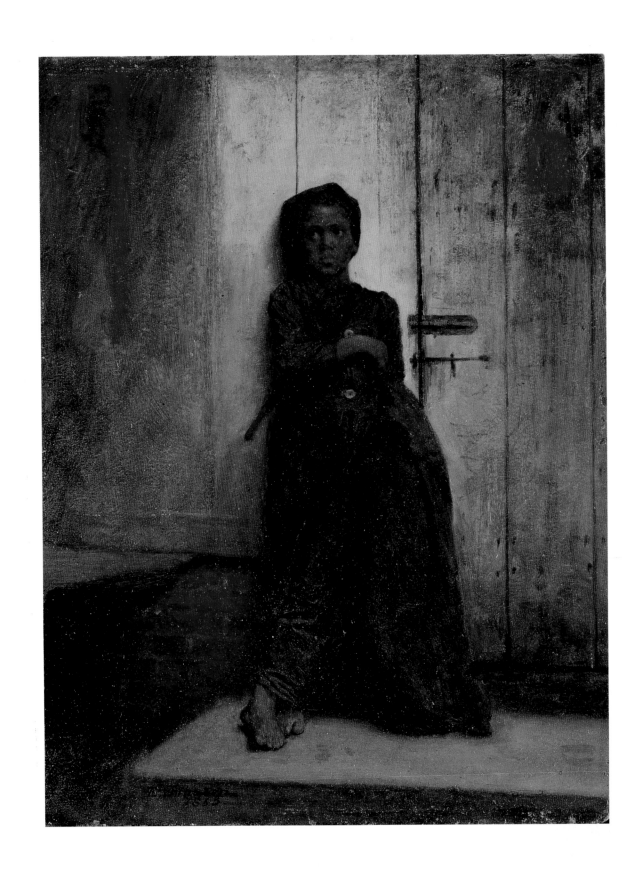

NO. 77
The Young Sweep, 1863
Oil on paper board, 12¼ x 9⅜ in.
Private collection

tucked his chimney-sweeping brush. His legs are crossed, and he glances off to the side.

The image of a single boy with tradesman's tools comes from the late eighteenth- and early nineteenth-century tradition of the "fancy picture," in which picturesque street children and youths posed as peddlers, chimney sweeps, itinerant fiddlers, street musicians, shoeshine boys, match girls, and flower vendors, presented without narrative and anecdote.[62] Beginning during his European sojourn, Johnson had frequently painted such types geared to market taste, such as *The Savoyard Boy* (see No. 9), and these subjects, like Johnson's *The Barefoot Boy*, were popular throughout the 1860s.

Unlike the usual "fancy picture" subject, however, the boy in *The Young Sweep* does not present himself to the viewer to be visually consumed as a delectably cute cultural commodity. His pose is defensive, and his expression guarded. Although the figure is Johnson's fiction, the viewer senses that Johnson used a specific individual as a model. The iconographic details suggest the boy's real-life situation in 1863: he seems to be locked outside of the building (symbolizing the Union); ready to earn his keep with his brushes and to live anywhere with his blanket; but, more than anything, anxiously awaiting the outcome of military and political events.[63]

The Sanitary Fairs provided occasions for artists to mingle socially with patrons on more than the artisan-patron level. Indeed, the friendships that Johnson made during his participation in the fair committees, such as those with William T. Blodgett, Abraham M. Cozzens, and Marshall O. Roberts, as well as his membership in The Century Association, which he was invited to join in 1862, consolidated his clients and patrons for the years to come. These organizations provided Johnson with the opportunity to know even better the mind-sets of his patrons and the kinds of pictures that would have topical appeal.[64]

While developing this new network of potential patrons, Johnson and other artists, writers, and critics continued to be involved in the abolitionist movement. They were optimistic about the future of African Americans and the possibilities for multiracial brotherhood, however vague they were about its practice. The liberal *Watson's Weekly Art Journal*, in its review of the National Academy of Design exhibition in spring 1865, offered this comment on Anne Whitney's sculpture *Africa*:

> *Perhaps the one great feature of the new art, will be the emphatic recognition of a common brotherhood, extending beneath all differences of race or opinion. . . . Miss Whitney reminds us of the common humanity underlying all differences of color; she images before us the future Africa rising in her might and taking her place among the nations, reaching forth her hand to God.*[65]

The theme of optimism about interracial brotherhood was again sounded in the December 1865 issue of the *Independent* by the abolitionist poet Lydia Maria Child. Responding to John Rogers's sculpture group *The Wounded Scout, A Friend in the Swamp*, 1862 (fig. 55), which represents an escaped slave supporting a wounded Union soldier, she wrote: "There is more in that expressive group than the kind negro and the helpless white, put on an equality by danger and suffering; it is a significant lesson of human brotherhood for all the coming ages." Rogers gave copies of *The Wounded Scout* to both President Lincoln and the Reverend Henry Ward Beecher. The latter wrote to thank the sculptor and to praise him for "the moral element" in his work. Neither Child nor Beecher may have noticed the copperhead snake that curls about the feet of the two soldiers, placed there by the sculptor, who knew the dangers presented by the backlash of the "Copperhead" Democrats against the abolitionist movement.[66]

Indeed, the brotherhood issue provoked anxieties and considerable resistance. A case in point is an article in the *New York Leader* of August 19, 1865, that rebutted the views of the art critic Clarence Cook and accused Cook of advocating both the

FIG. 55
John Rogers
The Wounded Scout, A Friend in the Swamp, 1862
Plaster, height 23 in.
The New-York Historical Society, 1928.31

cultural and social mixing of the races. The writer quotes a lengthy passage from Cook that praises the Irish for enriching the American stock, and then continues, still quoting Cook:

> *No race is good alone. God meant them to be combined. . . .*
>
> *. . . But the future has a more noble mixture still . . . grander by nature, more heroic, more intellectual even, yet higher than this, more spiritual, more religious. I mean the negro race. . . .*
>
> *This race has in it the seeds of a sweet and rich and generous culture. It shall be mixed with ours, is being mixed indeed; and in the future, we shall see a fruit of art, of literature, of social life, the product of this great engrafting, such as has not yet been seen in the world. . . .*

The writer for the *New York Leader*, to whom Cook's words suggest more than brotherhood and cultural synthesis, responds with alarm, "This is a recipe for intellectual black broth—for psychological miscegenation. . . . " At the time *miscegenation* was a word newly invented by racists to describe racial intermarriage; it was intended to be pejorative in order to polarize the attitudes of whites.[67] By using the term *miscegenation*, the *New York Leader* writer revealed himself to be opposed to any radical social transformations. In reality, the vision of a superior, future mixed race found few adherents. As the historian George Fredrickson has cautioned, even with such pronouncements from liberals like Cook, most "appeals for 'equality' . . . were carefully qualified by middle-class conceptions of social hierarchy."[68]

Reconstruction and the Radical Republicans

Before we turn to the visual culture of the immediate postwar years, it will be helpful to review briefly the political events of 1865. The following historical overview will set the context for the art exhibitions and illustrations published in the popular weeklies between 1866 and 1868.

Vice-President Andrew Johnson took office after Lincoln's assassination on April 14, 1865, only five days after General Robert E. Lee surrendered to General Ulysses S. Grant at Appomattox. During the next four years—until 1869, when Congress passed the Fifteenth Amendment—passions flared among politicians, freed slaves, journalists, and business leaders about the role of the old southern ruling class in the restructuring of the southern social fabric and the place of African Americans in postwar society.

At first it seemed that President Johnson, a Democrat from Tennessee who was known to agree with Lincoln on almost all issues, would support the civil rights reforms for Reconstruction proposed by Radical Republicans such as Senator Charles Sumner.[69] It soon became apparent that Johnson had no intention of backing the Radicals' measures. His view of Reconstruction was similar to that of Lincoln, who saw it as "essentially a work of restoration, not innovation," in the words of the historian Kenneth Stampp.[70] Johnson quickly pardoned many of the former rebels and restored to them their confiscated lands. He dismissed plans for compensation to former slaves and did little to intervene while, one by one, the southern legislatures enacted, as the historian Eric Foner describes it, "a series of vagrancy laws, apprenticeship systems, criminal penalties for breach of contract, and all the other coercive measures of the Black Codes, in an effort to control the black labor force."[71]

When Congress convened after its recess in December 1865, Republicans united to block the seating of white southern senators and representatives[72] and to step up plans for Reconstruction. In February 1866 Congress passed a bill extending the life and increasing the powers of the Freedmen's Bureau, a federal agency formed to establish schools in the South for blacks, to help blacks achieve their civil rights and gain employment, and to maintain law and order. When Andrew Johnson vetoed the bill to extend the Bureau and then made a public speech in New York on February 22,

1866, in defense of his actions, tempers flared. He also vetoed a civil rights bill in March, but the Republican-controlled Congress overrode him on both issues.[73] The Radical Republicans perceived that the measures necessary to ensure equality for freedmen included both land and the vote. Land for the freedmen meant confiscation of land from the old southern planter class. It was on this point that the moderates and even some of the Radical Republicans balked; abrogation of the rights of property horrified even the radical magazine the *Nation*.[74]

In the fall of 1866, the Radical Republicans won over a large part of the electorate. In that year Congress, embarrassed that some northern states had defeated Negro suffrage, passed a bill giving the vote to blacks in the District of Columbia. The following year Congress debated a measure that required southern states to write Negro suffrage into their constitutions. Other acts strengthening Reconstruction were also passed in 1867. The Fourteenth Amendment, which grew out of the civil rights measures, was adopted in 1868; it gave male blacks the rights of citizens and denied states the right to "deprive any person of life, liberty, or property, without due process of law."[75]

Because President Johnson resisted all of these measures, the Radical Republicans, by now vigorously joined by moderates in the party, began proceedings in Congress to impeach him. On February 24, 1868, the House voted for impeachment. The measure went to the Senate, where it failed by one vote to achieve the necessary two-thirds majority for passage. President Johnson thus finished out the final year of his term; in November 1868 the war hero Ulysses S. Grant was elected president, taking office in March 1869. With Republicans losing interest in reforms, in 1869 Congress backed away from many of the earlier measures and sabotaged the Freedmen's Bureau by providing for its termination, except for educational activities, which ended in 1870, and aid to black veterans, which ceased by 1872.[76]

The reasons for the Republican retreat from Reconstruction are manifold and complex, but a few points stand out clearly. Charges of corruption leveled against the Grant administration did not enhance the party's reputation. According to Stampp, the Republican party became, in part, "the political agency of the northern middle classes and of northern business enterprise." To Stampp, "the postwar era was the time of the Great Barbecue, when the federal government, under Republican control, generously turned the nation's natural resources over to individuals and corporations for private exploitation."[77] Certainly northern business enterprise, which still needed to buy southern products such as cotton, could see the advantages of a pool of landless black labor working on large plantations as opposed to freedmen owning "forty acres and a mule" and managing a living on subsistence farming.[78] Advocating amnesty for southern whites balanced by civil rights for blacks, Horace Greeley and others formed the Liberal Republican party in 1871, to which Charles Sumner gave guarded endorsement. In the end, however, for a variety of reasons, the program of full civil rights for blacks was abandoned.[79]

The Art World in 1866, 1867, and 1868

Many artists, writers, critics, and art patrons were caught up in the controversies concerning the place of former slaves in American society, but only gradually did the art of the period give visual evidence of such social issues and follow the lead of Eastman Johnson. At least three pictures that featured African Americans, however, were sent to the spring 1866 exhibition of the National Academy. Eastman Johnson contributed *Fiddling His Way* (No. 78); Mrs. C. A. Edwards, of Brooklyn, sent *Emancipation*, a picture difficult to trace since almost nothing is known of the artist; and John Rogers submitted his *Uncle Ned's School*, 1866 (The New-York Historical Society).[80] Two more pictures referred to the Civil War: Winslow Homer's *Prisoners from the Front*,

1866 (The Metropolitan Museum of Art, New York), the picture that made that artist's reputation, and George C. Lambdin's *At the Front*, 1866 (The Detroit Institute of Arts). Of 512 paintings on exhibit that spring, these five seem to be the only works that made reference to the war or to black life under Reconstruction.

Again, the critics singled out Johnson's paintings for special praise. It is not surprising that Clarence Cook, who had been quoted as favoring the mixing of the races, would give *Fiddling His Way* a positive review in his column for the July 4, 1866, issue of the *New-York Daily Tribune*:

> The young girl in the doorway is beautifully painted, and nothing could be more truthfully characteristic than the group of boys about the itinerant negro fiddler How little reason we have to envy France her Edouard Frère, when we have a man like Eastman Johnson, as able to do for our rural life what Frère does for France, and with no less quiet beauty and homely truth.[81]

The next year, 1867, saw the production of many more paintings referring to the Civil War and African Americans. In a review of the Academy's spring exhibition, the critic for the *Evening Post* noted that Eastman Johnson's figure paintings set a high standard that was difficult to match, but that nevertheless other works deserved mention, of which "some of the best [pictures] are delineations of negro character." According to this critic, "The African seems just beginning to assume a prominent place in our art, as he has for some time in our politics; and it is a natural consequence of the late war that the characteristics of the negro race in America should become a subject of study for the artist as well as the political philosopher." After expressing his disappointment that "still our artists have been slow in turning the new subjects offered them to account," he goes on to discuss the paintings by Thomas Waterman Wood (1823–1903)—*The Contraband, The Recruit,* and *The Veteran*, all 1866 (all The Metropolitan Museum of Art, New York)—three pictures depicting a southern slave liberated, then recruited, and finally discharged, and the Swiss artist Frank Buchser's (1828–1890) *The Soldier's Return from the War* (location unknown). Although regretting deficiencies in the artistic qualities of Wood's and Buchser's paintings, he found the choice of subjects meritorious. In this review the critic made no reference to the fact that Johnson had sent no pictures of African Americans to the Academy's show, although Johnson did submit a highly regarded postwar subject, *The Pension Claim Agent* (No. 35).[82]

The *Post* critic referred in his review to the "vigorous though crude productions of Thomas Noble." That artist's *Margaret Garner*, 1867 (Procter and Gamble Company, Cincinnati), which today exists as a study, a drawing, and a *Harper's Weekly* illustration of May 18, 1867 (fig. 56), was indeed one of the most horrific images of the 1867 Academy's exhibition. Noble (1835–1907), who came from the

FIG. 56
After Mathew Brady photograph of painting by Thomas S. Noble
"The Modern Medea—The Story of Margaret Garner"
From *Harper's Weekly* (May 18, 1867)
Brooklyn Museum of Art Library Collection

border state of Kentucky, had fought on the Confederate side during the war and had taken up residence in New York afterward. As if to assuage his guilt, he turned to the subject of Margaret Garner, called by some newspapers "the modern Medea," a fugitive slave who in 1856 murdered one of her four children and attempted to murder the rest rather than allow the slavecatchers to return them to slavery. In Noble's painting she presents the bloodied bodies of two children to her pursuers.[83]

Thomas Waterman Wood also painted another immediately topical subject in 1867, although it was not exhibited at the Academy's spring show. His *American Citizens (To the Polls)* (fig. 57) represents four figures—a German American, an Irish American, an English American, and an African American—stepping to the ballot box. Wood's work may well have been inspired by Alfred R. Waud's cover woodcut for *Harper's Weekly* of November 16, 1867, depicting a queue of freedmen, each waiting his turn to deposit his voting ballot (fig. 58). As Eric Foner has observed, the men in Waud's *Harper's Weekly* illustration show the different classes of African Americans. The first figure is a skilled workman with his pockets stuffed with his tools; the second, clearly an educated man, wears the clothes of a gentleman; the third is a high-ranking enlisted man in the Union army. Their stations in life and dignified bearing would assure the white liberals that these African Americans were capable of responsible citizenship.[84]

Besides the spring 1867 Academy exhibition, a major event the same year that highlighted images of African Americans was the American section of the Paris Exposition Universelle. The committee that chose the American works included William J. Hoppin, a founder of the Union League Club and formerly the editor of the *American Art-Union Bulletin*; Henry T. Tuckerman, who wrote the influential *Book of the Artists* (1867); the collector John T. Johnston; and others closely connected with the Union League Club. Although they selected paintings depicting the magnificence of the American landscape, such as Frederic Church's *Niagara*, 1857 (The Corcoran Gallery of Art, Washington, D.C.), and Albert Bierstadt's *The Rocky Mountains, Lander's Peak*, 1863 (The Metropolitan Museum of Art, New York), they had a decided preference for images relating to current events. Of the five works by Johnson chosen, three featured African Americans: *Negro Life at the South*, *Mating*, and *Fiddling His Way*. Johnson's other painting was *Sunday Morning (formerly "The Evening Newspaper")*, 1863 (No. 95), as well as one drawing, *The Wounded Drummer Boy*, 1863 (No. 28). Winslow Homer was represented by *Prisoners from the Front*; George Lambdin, by *The Consecration, 1861*, 1865 (Indianapolis Museum of Art); Edwin White, by *Thoughts of Liberia: Emancipation* (fig. 33); and the sculptor J. Q. A. Ward, by *The Freedman* (The Metropolitan Museum of Art, New York). John Ferguson Weir's *The Gun Foundry* (Putnam County Historical Society Museum, Cold Spring, New York) dramatically referred to the industrial strength of the North that had assured its victory in the Civil War. Two portraits of Lincoln were included: an oil by William Morris Hunt

and a sculpture bust by Leo W. Volk. George P. A. Healy sent *Portrait of General Sherman*, another Civil War hero. Given that there were only eighty-two paintings and a handful of drawings, sculpture, engraved medallions, engravings, and lithographs, it is notable that fifteen works (including two engravings) made reference to the war or to African Americans, suggesting that the jury of artists, critics, and Union League Club members may have considered these paintings as propaganda for the ultimate justness of the war.[85]

In 1868 Johnson's contributions to the Academy's exhibition did not feature African Americans, but they did refer to the war and hence had topical appeal to viewers. Johnson's homage to the women of the United States Sanitary Commission, *The Field Hospital*, 1867 (No. 82), refers to those women who worked as nurses and attendants in Union army hospitals.[86] *The Boy Lincoln*, 1868 (fig. 73), helped maintain the mythic stature of the martyred president.[87]

Thomas Satterwhite Noble made the strongest statement in the 1868 Academy exhibition with his dramatic painting *The Price of Blood* (Collection of Robert M. Hicklin, Jr., Inc.), showing a slave owner seated at a table piled high with stacks of gold coins and mentally estimating the price that he should demand from the trader, standing behind the table, for his slave-son. Standing at the edge, his mulatto son turns away in open disgust. Noble's paintings, however powerful, received less than favorable reviews in the papers. Already some critics were becoming weary of, or ideologically opposed to, such strong antislavery cultural statements.[88] In fact, a study of the National Academy's exhibition records reveals a sharp decline in the theme of war and African American life after 1868. The backlash was under way.

"Fiddling His Way" and Its Contradictions

A probe of the exhibition records also indicates that Johnson had already, by 1866, shown his last picture of African Americans at the Academy's spring show. Although the public had come to expect that Johnson might continue to exhibit pictures of African Americans, and even Henry Tuckerman in 1867 had praised Johnson's pictures of blacks for their "insight" and "singular authenticity," *Fiddling His Way*, 1866 (No. 78), was the artist's last publicly shown picture of African American life.

The picture is not without its contradictions, which are made explicit when the work is compared with a contemporary group portrait painted by Thomas Hicks (1823–1890), *The Musicale, Barber Shop, Trenton Falls, New York*, also done in 1866 (fig. 59). Hicks's picture, done as a commission for Charles Tefft, shown seated at lower left, portrays the clientele and staff of Moore's Hotel in Trenton Falls, north of Utica. Thomas Hicks portrays himself sketching in the background, while the

FIG. 59
Thomas Hicks
The Musicale, Barber Shop, Trenton Falls, New York, 1866
Oil on canvas, 25 x 30 in.
North Carolina Museum of Art, Raleigh, Purchased with funds from the State of North Carolina

NO. 78
Fiddling His Way, 1866
Oil on canvas, 24¼ x 36¼ in.
The Chrysler Museum of Art, Norfolk, Virginia,
Bequest of Walter P. Chrysler, Jr., 89.60

hotel's proprietor, Michael Moore, is behind, the artist's wife, Angelina, is seated at the left, and William Brister, an African American and chief barber at the hotel, is singing.[89] Another African American man plays the fiddle, and two white musicians accompany him. Through the doorway we see a black woman seated among the white women in the outdoor audience. Johnson's and Hicks's pictures seem to be positive scenes of an integrated society, but the integration in both instances is qualified because both scenes occur within the context of music making—then, as for most of the twentieth century, one of the few occasions when the visual culture of white America sanctioned an integrated scene. Moreover, other clues reveal this to be an image of equality compromised. Although Hicks's Brister stands in the middle of the musicians, he wears an apron—a reminder of his service status at Moore's Hotel. And Johnson's fiddler sits at the edge, at the margins where African Americans were traditionally placed in nineteenth-century paintings.[90] His placement reflects his real social status: acceptable and even admired as a musician but marginal to the New England rustic family that welcomes him.

Moreover, the very title of Johnson's *Fiddling His Way* tips us off to the black man's dilemma. An itinerant, he does not have—nor will he ever have—the "forty acres and a mule" that Radical Republicans had proposed for the freedmen. Although landless, he is earning "his way," as demanded by liberals such as Henry Ward Beecher, who felt that government handouts to the freedmen, or anyone else for that matter, were not only unconstitutional but immoral. Even before Andrew Johnson had vetoed the Freedmen's Bureau bill in February 1866, Beecher had written the president about "the fundamental law of society which says that every-man must help himself." Horace Greeley, the publisher of the *New-York Daily Tribune*, was well known for advocating self-help for the freedmen, as expressed in the old farm-boy saying, "Root, hog, or die!"[91]

Although Johnson did not write about such matters, some of his attitudes can be inferred from those with whom he associated and the critics who wrote about his work. By 1866 African Americans simply did not consume his thoughts. He knew that such paintings might continue to be popular, but he had ideas for other kinds of paintings that he knew would also appeal to an audience. One clue to the contemporary mood comes from a writer for the *Evening Post* who visited Johnson's studio in February 1865 and found that he was working on three pictures: one of a "young lad skating," which the critic praised; another "very charming picture of a young girl kneeling before an elaborately carved prie-Dieu, engaged in prayer." The writer gave more column space to the girl than to the other two paintings combined and noted, "The feeling of devotion in the maiden's face is nicely expressed, and the entire picture happily conveys the sense of purity and peace." The third picture that the writer mentions is *Fiddling*, about which he has this to say: "Mr. Johnson is also engaged on a large picture of New England life, representing a negro in an old-fashioned kitchen, playing on a fiddle, while the family are gathered around listening."[92] The African American gets mention only in passing. The writer clearly finds more appeal in Johnson's evocation of "purity and peace," so desperately yearned for that February 1865, when General Lee's Confederate forces in Petersburg were still resisting the prolonged siege by Grant's Army of the Potomac.

The critic makes only the briefest reference to the race of the fiddler, as if Johnson could just as easily have substituted a white man for the black man. And, in fact, he did. In the 1907 estate sale of Johnson's work another version, also called *Fiddling His Way* (fig. 60), was described in the catalogue as "a simple New England interior" in which "an old fiddler, apparently on the tramp, is playing his violin, surrounded by the farmer's family."[93] In that work Johnson had replaced the young, virile African American with an old New Englander. The painting never sold during his lifetime.[94]

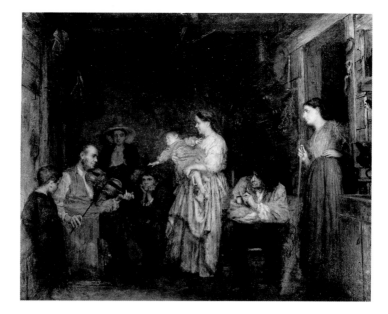

The debate about the abilities of African Americans to support themselves, however, came to be set aside by the Republicans, many of whom were looking ahead toward economic growth for the postwar years. In point of fact, the most talked-about picture in the 1866 Academy exhibition—the *American Art Journal* called it "the greatest of the Exhibition"—was John Ferguson Weir's ambitious picture *The Gun Foundry*, a depiction of the West Point Foundry at Cold Spring, commissioned by the owner, R. P. Parrott. The foundry had produced the big cannons used so effectively by the North in the Civil War. This sublime image of big industry and corporate power, with management in control over the movements of a united group of industrial workers, must have thrilled those viewers contemplating the future years of America's industrial strength. Appropriately enough, Weir's picture went to Paris for the 1867 Exposition Universelle to display the industrial might of the United States and America's shift from slavery to wage labor.[95]

Cultural Racism and Political Racism: Mount and Nast

Not all art-world people shared the liberal, humanitarian sentiments of Eastman Johnson, Clarence Cook, Henry Ward Beecher, Lydia Maria Child, Thomas Noble, and Thomas Waterman Wood. Toward the end of the Reconstruction debates in the late 1860s and as the movement waned, visual culture increasingly referred to, or actually pandered to, the racism and political machinations of the opposition.

William Sidney Mount (1807–1868), the major genre painter of the generation preceding Eastman Johnson, vigorously defended that other side. As an antiabolitionist Copperhead Democrat, Mount castigated the Radical Republicans throughout his journal entries in 1867 and 1868. After the November election in 1867, which brought Democratic victories, he painted *The Dawn of Day* (fig. 61), a large version of which he exhibited publicly in stores in the Port Jefferson–Setauket area of Long Island where he lived. He wrote in his journal that the picture represented *"A Rooster standing upon a dead Negro,"* meant "to commemorate the recent Democratic victories." One notice in the local paper copied into his journal, and possibly written by Mount himself, stated: "[T]he fact is, the painting represents the Negro Politically Dead. Radical Crowing will not awake him. It is the Radical Republican—Rooster—trying to make more capital out of the Negro, but, is *about used up for their purpose*; which is glorious news for the whole country. The African needs rest."[96] Underneath such gleeful partisanship, there may have been some truth to the charge of Republican opportunism, since many local Republican politicians courted African Americans simply for their votes. Nevertheless, Mount's reference

to the sleeping or prone black man as symbolic of black powerlessness makes explicit a trope that was to have continuing currency.[97] Mount followed the political events in Washington closely, noting in his journals Democratic victories in local elections and the proceedings surrounding President Johnson's impeachment.[98]

While following politics, Mount was planning his paintings for the 1868 Academy exhibition. On March 26, 1868, Mount wrote to August Belmont, the national chairman of the Democrats and, as we know, an early patron of Eastman Johnson. Mount responded positively to Belmont's interest in purchasing what the artist called "Politically Dead, Radical crowing will not awake him," but added that he wanted to send it to the National Academy's spring exhibition and to make arrangements for the publication of an engraving.[99] Knowing that Belmont would be sympathetic to his politics, Mount added: "It was painted to commemorate the Democratic victory last fall, and for all *democratic victories* for the next twenty years. Before I left town, I showed the painting to a number of democratic Editors; they were very enthusiastic about it. . . . I have been asked to exhibit it by conservative Republicans, as well as by Democrats." Belmont replied on March 30, declining to buy the painting. Mount responded that same day and noted, "'On sober second thought,' I have concluded not to exhibit the picture at present." It is tempting to speculate that Eastman Johnson, who was on the hanging committee in 1868 and already corresponding with Mount regarding the latter's Academy entries, took an active role in dissuading Mount.[100] In any event, it seems that by 1868 the fascination of the art world for any political images, on either side of the issue, was subsiding.

In popular visual culture Thomas Nast gave the reality of the backlash against Reconstruction its most vivid expression. As a Republican, Nast flourished at *Harper's*. His timely and issue-specific cartoons, which attacked the Democrats, were often published separately as campaign propaganda.[101] Nast's genius emerged most pungently when his cartoons targeted specific individuals. The legend under Nast's September 5, 1868, cartoon for *Harper's Weekly*, "This Is a White Man's Government" (fig. 62), comes from the Democratic party's platform and reads: "We Regard the Reconstruction Acts (so called) of Congress as usurpations, and unconstitutional, revolutionary, and void." The Democratic party objected to the process by which the federal government had instructed the southern states to write their constitutions, to extend the franchise to the freedmen, and to elect their representatives. In his cartoon Nast depicts a black soldier, pinned to the ground by the feet of a trio of villains and clutching an American flag as he vainly reaches toward the ballot box. Standing to the left is Nast's stereotype of a racist Irishman (note the clay pipe and cross in his hatband) from "Five Points," a slum in New York City's Sixth Ward. In the middle stands the knife-wielding former Confederate lieutenant general Nathan Bedford Forrest, his initials inscribed into his hatband; his "Fort Pillow" button refers to the scandalous murder of black Union prisoners by Confederates under his command at Fort Pillow, Mississippi. That was the least of it: by 1868 Forrest was Grand Wizard of the Ku Klux Klan. To the right is August Belmont, known as the dapper Fifth Avenue financier—identified by the "5 Avenue" button on his lapel and the "AB" monogram engraved on his cufflinks, shirt buttons, and wallet. Belmont largely financed the Democratic party, which, Nast implies by inscribing the wallet with "capital for votes," included buying the Irishman's vote.[102] In the left background burns the Colored Orphan Asylum with a lynched figure hanging from a lamppost inscribed "N. York"—scenes that had occurred during the New York draft riots of July 1863. In the right distance a "Southern School" burns—an incident typical of the outrages occurring in the South. Nast's message points to the complicity of both northern and southern Democrats in oppressing African Americans.

FIG. 62
Thomas Nast
"This Is a White Man's Government"
From *Harper's Weekly* (September 5, 1868)
Brooklyn Museum of Art Library Collection

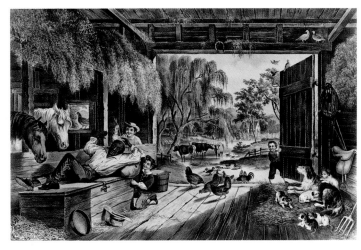

FIG. 63
Thomas Nast
"The Modern Samson"
From *Harper's Weekly* (October 3, 1868)
Brooklyn Museum of Art Library Collection

FIG. 64
Currier and Ives
Holiday in the Country—Troublesome Flies, 1868
Hand-colored lithograph, 12⅛ x 15⅛ in.
The Old Print Shop, Inc.

FIG. 65
Thomas Nast
"Worse than Slavery"
From *Harper's Weekly* (October 24, 1874)
Brooklyn Museum of Art Library Collection

The sleeping black man as a trope for powerlessness reappears in Nast's "The Modern Samson" (fig. 63) from the October 3, 1868, issue of *Harper's Weekly*. In this political illustration, the southern Democrat Delilah shears the hair (labeled "suffrage") of the sleeping black man, who loses his strength like Samson in the Bible. In the background looms a cast of characters including Forrest, the ambitious Frank Blair from Missouri, and Robert E. Lee. Two of the figures are robed as Roman warriors, with "K.K.K." emblazoned on their breastplates.[103]

Nast's image of the sleeping black man contrasts with another 1868 representation, the Currier and Ives mass-produced lithograph *Holiday in the Country—Troublesome Flies* (fig. 64). The intention of Nast's image was to comment specifically on the *political* racism inherent in the heatedly contested legislation over black suffrage. The intention of the Currier and Ives print was to entertain, but its *cultural* effect—we might even say its cultural work—was to circulate for mass consumption an image of the African American as powerless, not because his rights were being legislated away, but because of his "inherent" laziness and his association with teasing children. Cultural racism depends upon the successful outcome of establishing vivid racist stereotypes—images that stick in the mind to counter positive images from lived experience.[104]

A final small cartoon by Nast, "Worse than Slavery" (fig. 65), from *Harper's Weekly* of October 24, 1874, confirms the ineffectiveness of government measures to ensure the civil rights of the freedmen. With an economy of means, Nast depicted the murder and mayhem: the burning of schoolhouses, a lynched hanging figure, a Klan figure shaking hands with a White Leaguer, and the distraught black family huddled together. It is a fitting image of the failure of Reconstruction, in spite of the fact that the Fifteenth Amendment was ratified in 1870, extending the suffrage to African American males. In other words, the formal freedom of the suffrage is shown as the sham it was in Nast's cartoon. Although historians often situate the collapse of Reconstruction in 1877, when federal troops were withdrawn from the South, the visual culture of the late 1860s already reveals that the "second revolution" had failed. Pictures by Nast and others from popular visual culture tell a truth about the betrayal of African Americans in these difficult years of American history that fine artists no longer sought to address.

The Union League Club Retreats

The factions that developed in the Union League Club demonstrated the resistance that was gaining against the ideal of brotherhood and racial equality in 1866 and 1867 among those formerly associated with the antislavery movement.[105] Set up midway through the war to rally loyalty to the Union, the Union League Club was initially sympathetic to the movement for the political equality and civil rights

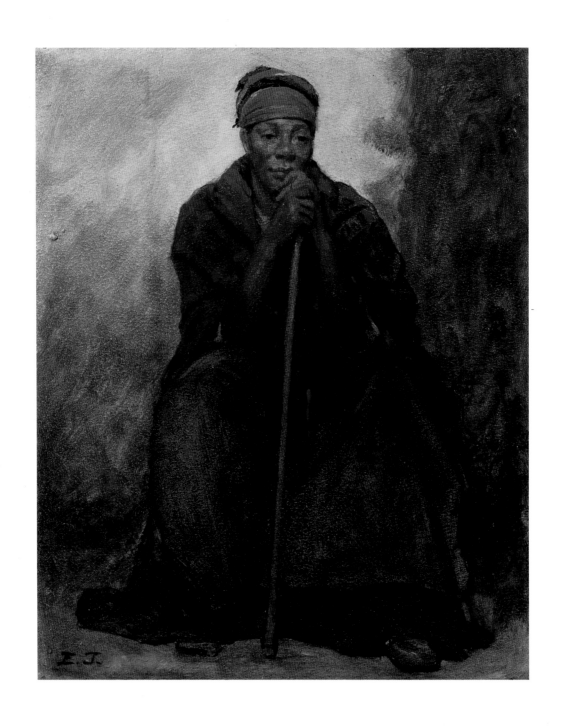

NO. 79
Dinah, Portrait of a Negress, late 1860s
Oil on paper board, 10½ x 8½ in.
Private collection

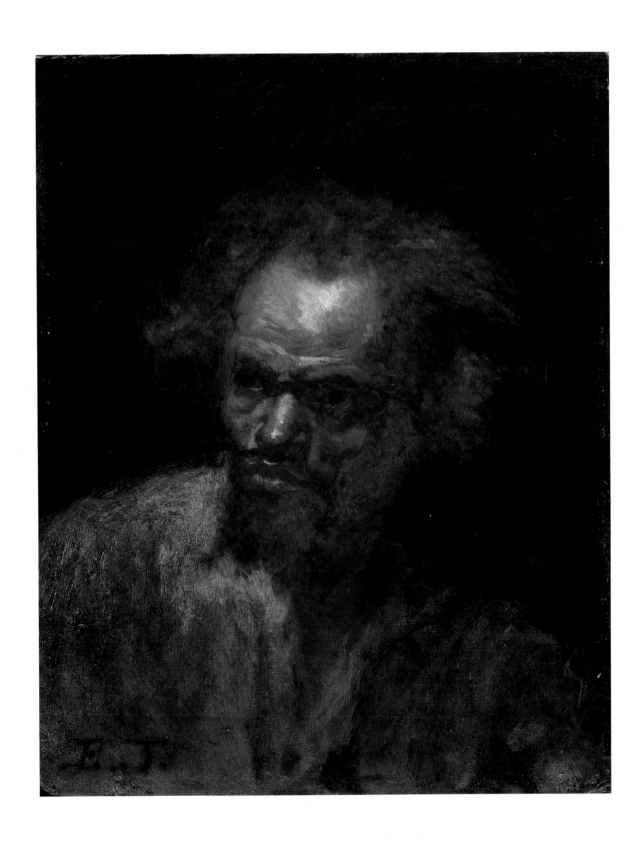

NO. 80
Head of a Black Man, circa 1868
Oil on paper board, 19¼ x 15 in.
Collection of Teresa Heinz and the late Senator
John Heinz

of African Americans. In January 1863 a handful of civic-minded New Yorkers (including Frederick Law Olmsted and Henry W. Bellows), who had been eager to organize a social club "to strengthen a love and respect for the Union,"[106] held an organizational meeting; their goal was to invite like-minded loyalists and encourage affiliated clubs in other northern cities. The first group of sixty-six men inducted into the club included the *Evening Post* editor William Cullen Bryant, the lawyer George Templeton Strong, the architect Richard Morris Hunt, and the businessman Jonathan Sturges. By the end of the year there were 528 members, including Parke Godwin, George Bancroft, Peter Cooper, and Horace Greeley.[107] One of the first projects of the club was to recruit and equip the Twentieth Colored Regiment, under Colonel Nelson B. Bartram, which marched through the streets of New York on March 5, 1864, to the club headquarters, where they received the regiment's colors. This march of African American soldiers, followed by club members and their wives, through New York streets—at a time when memories of the draft riots of 1863 were still vivid—was a bold move.[108] Many of the addresses delivered at the club were printed as pamphlets to propagandize the Union cause, and the first meeting of the 1864 Metropolitan Fair, discussed above, was held at the club head-quarters.[109] No one could dispute the loyalty of club members to the Union or their sincere desire to secure the freedom of slaves.

In January 1865 Union League Club members approved the passage of a constitutional amendment forbidding slavery (the Thirteenth Amendment), and they appointed a committee "to further the organization of [the Freedmen's] Bureau by the present Congress, with ample provision for the protection of the Freedmen in their rights, and for the establishment of schools for their instruction in reading and writing."[110] The official club history discusses the members' views on further measures: "The Radicals stood for the full, immediate enfranchisement of the blacks, and for repressive measures against the southern whites. . . . Eventually the Radicals won, both in the Republican party and, though less decisively, in the Union League Club."[111]

Although the club's original intention was to help the freedmen, by early 1867 it became clear that many members had drifted away from activism on behalf of African Americans.[112] According to its official historians, a "rift began" with discussions of the Fourteenth and Fifteenth Amendments. The official history states: "Perhaps because of a division of opinion which no one wished to emphasize, The Union League Club was relatively inactive in helping to get these last two amendments ratified. As to which members aligned themselves with one faction or the other, the official records and minutes give no clue—the habit of secrecy was still strong."[113]

The factions were not so secret as that official history would have us believe. For example, when President Johnson first vetoed the bill to extend the Freedmen's Bureau, a large public meeting in his support was held at the Cooper Institute on February 22, 1866. Among those actively participating were twenty-seven Union League members, including the art patrons Abraham M. Cozzens, Andrew Warner, and Prosper M. Wetmore.[114] Another public controversy marking the club's retreat from politics occurred in the spring of 1867, when Horace Greeley, the newspaper-man then championing the efforts of the Radical Republicans, offered $5,000 toward the $100,000 bail of Jefferson Davis. Some club members wanted to censure Greeley for this act, and the issue further divided friendships within the club.[115]

As club members retreated in 1867 from political activism for social justice, they welcomed the Union League's involvement with artists. From the club's beginning, artists had been permitted to defray membership fees by donating paintings, and in 1867, the year that Johnson joined, the club began presenting art exhibitions as part

of its program.[116] Also in early 1867 club members took charge of the American section of paintings being sent to the Paris Exposition Universelle, as discussed above. Ongoing members then included the artist John F. Kensett, the art writer Henry T. Tuckerman, and art patrons William T. Blodgett and Robert L. Stuart, all of whom had bought paintings or otherwise helped Johnson's career.[117]

Johnson's Post-Movement Paintings of African Americans

Since no letters or diaries exist from the 1860s that directly record Eastman Johnson's changing aesthetic, social, and political concerns in his own words, we must rely on accounts written by and about his contemporaries—friends, family, other artists, and patrons. In the case of Johnson, such sources are particularly valuable because letters and reminiscences show him to have been a sociable, amiable person with views much like those of his friends. In addition, the artworks that he exhibited provide rich evidence of the sentiments that he wanted to express publicly.

After 1867 Johnson apparently remained interested in African Americans as subjects. Stylistic analysis and other evidence suggests that two paintings from the estate sale of 1907, for which there are no records of exhibition or sale during the artist's lifetime—*Dinah, Portrait of a Negress* (No. 79) and *Head of a Black Man* (No. 80)—were painted after 1867.[118] *Dinah* shows a heavyset, older African American woman, leaning on her cane. The figure recalls the verbal and pictorial representations of Harriet Tubman, who was well known in abolitionist circles. In 1869 Sarah H. Bradford published her sentimental biography, *Scenes in the Life of Harriet Tubman*, in hope of raising funds for Tubman's support.[119] The woodcut that Bradford used as a frontispiece shows a standing Tubman leaning on a rifle (fig. 66); similarly, Johnson's seated figure leans on a long cane. An undated photograph of Tubman (fig. 67) indicates her broad features, rounded lips, and tight-fitting turban, all closely matching those of Johnson's painting. Analogously, the figure in *Head of a Black Man* resembles contemporary representations of Frederick Douglass, which invariably show his furrowed brow and determined look (fig. 68). An effective speaker and brilliant writer for the cause of the rights of African Americans, Douglass continued to be in the news during the 1860s.[120] Even if these figures are not actual portraits, and no evidence points to that, they seem to suggest the visages of Tubman and Douglass. That the two paintings remained in Johnson's studio, and that he never seems to have exhibited them, indicates that he did not want to, or could not, market them after the 1860s.

FIG. 69
Eastman Johnson
Family Cares, 1873
Oil on paper board, 15 x 11½ in.
Shelburne Museum, Shelburne, Vermont

Detail of fig. 69

Johnson's last painting to include an African American image is from the 1870s, long after the artist had turned his attention to other subjects and had sought inspiration in the antics of his only child, Ethel, born in 1871. Ethel and her dollies served as models for *Family Cares*, 1873 (fig. 69), which Johnson sent to an Artists' Fund Society exhibition that was reviewed in the *Brooklyn Daily Eagle* in January 1873. The image of the black doll in this painting is disturbing and provocative, and the reviewer's untroubled reference to it is puzzling:

> *Eastman Johnson contributes a cabinet interior entitled "Family Cares." A young girl is seated in a chair with her little flock of dolls around her. A big dolly engages her immediate attention, while others of less importance are scattered around on the floor. Some members of the family are fearfully dilapidated, and one colored baby, evidently to keep it out of mischief, is hung up by the neck. A beautifully expressed effect of light comes in at a window on the left, and its delightful influence is felt most strongly upon the little child and her interesting family. This is one of Mr. Johnson's most effective pictures.*[121]

It is the black dolly "hung up by the neck" that startles our contemporary sensibilities. Today, the image conjures forth the memory of black lynchings, but Johnson's intent remains a mystery. Perhaps on some level he did simply want to keep the black dolly "out of mischief," in an era increasingly concerned with redefining middle-class values, with becoming cosmopolitan in artistic matters and international in business.

The End of Genre Painting

The art world participated in the historical shift from a moralizing, socially concerned ethos of the 1860s to the abstract and materialist amorality that characterized the pursuit of success and dominated the body politic in the late 1870s. Thus, the critically praised and popularly admired anecdotal genre painting of the Civil War and early Reconstruction era that featured the struggles of African Americans and the notion of brotherhood was replaced by art-for-art's-sake painting divorced from morality or didactic purpose. The new art, inspired by French painting, emphasized tonal values rather than moral values; loose, spontaneous, and impressionistic brushwork rather than meticulous attention to detail; outdoor natural colors rather than the luminous sienna shadows of New England interiors; and cosmopolitan holiday subject matter rather than American regional subjects. In short, the sophisticated tourist's detached curiosity about the spectacle of flaneurs along the Parisian boulevards or of exotic nomads in the Middle East replaced the moralist's ideal of social justice and community.[122]

It is not difficult to understand that, after major social upheavals—the social struggles in England over the Reform Bills of the 1860s; the Franco-Prussian War, and the Paris Commune and its brutal suppression in France in the early 1870s; and the Civil War and Reconstruction in the United States—artists and their supporters in the art world would want to turn to a lighter, nondidactic art. In the name of "healing" and "amnesty," then as now, cultural amnesia would turn the attention of the art world to the "sweetness and light" advocated by Matthew Arnold in his *Culture and Anarchy* (1869).

The critic Clarence Cook exemplifies the paradigm shift in American culture from moralizing to art-for-art's-sake. In the antebellum period he wrote for antislavery journals, such as the *Independent*, and the Ruskin-influenced journal the *New Path*, before joining the *New-York Tribune* as its art critic in 1864. Cook consistently praised Johnson in his reviews, but he gradually shifted toward support for the art-for-art's-sake American crowd and became one of the organizers of the Society of American Artists in 1878.[123] His preference for the new French-inspired art was

evident in his April 9, 1875, *Tribune* review of the National Academy of Design spring exhibition, in which he accused the organizers of "making it appear by their present exhibition that we are still in the old ruts, that no breath of life has blown into our parched and sandy air, and that there is little hope we can ever move these stagnant waters."[124] In his review of the Academy spring exhibition a year later, in which he admired Maria Oakey's "decorative" painting, Cook commented, "If it is only moral or didactic it slips over from art to literature."[125]

The shift in visual culture away from moralizing and toward naturalism, impressionism, and art-for-art's-sake went hand in hand with the transformation of political culture toward pragmatism. If the radical measures proposed by the Radical Republicans had been enacted in the late 1860s, race relations would be far different today. It did not happen, and the country retreated. Earlier outspoken critics of slavery such as Henry Ward Beecher and his sister Harriet Beecher Stowe did not take the next step toward advocating full civil rights for African Americans. When the abolitionist Gerrit Smith died in 1874, the *New York Times* noted that the "'era of moral politics' had come to a definitive end."[126] The movement, of which Johnson had been a part, was over.

Given the historical circumstances, it is not surprising that Johnson and his white contemporaries did not embrace African Americans, in all their humanity, as subjects for art. For mainstream painters, African Americans elicited too much liberal guilt, so that they no longer even qualified as subjects for nostalgic images.[127] After the 1880s Johnson more or less gave up genre painting in favor of portraiture. He let the younger men, the Sargents, Chases, and Lows of American art, move toward modernism, toward an individually expressive art no longer interested in ideals of community and equality.

The suppression of the Africanist presence characterized late nineteenth-century visual culture by white artists, except for an occasional sympathetic image in painting, some memorial sculptures of Lincoln and emancipation, and the many grotesque caricatures in the turn-of-the-century popular press.[128] Not until the 1930s did white artists again turn their attention to the subject of African American life, at a time when another movement for social justice in America once more motivated radicals, and to a certain extent liberals, to make socially concerned art an urgent project.

Notes

I want to thank Laura Meixner for inviting me to participate in the College Art Association session "New Interpretations of Genre Painting in Europe and America, 1850–1900," held at the annual conference in February 1986, during which I first delivered a paper on Johnson's images of African Americans. I made subsequent slide presentations at Professor George Fredrickson's history seminar at Stanford University in October 1987 and at a symposium, "Making History at The Brooklyn Museum: John I. H. Baur," held on April 16, 1988. John Baur first encouraged my study of Eastman Johnson; all studies must begin with his *An American Genre Painter: Eastman Johnson, 1824–1906* (Brooklyn: Institute of Arts and Sciences, 1940). I am also grateful to the following for providing me with leads, information, and other kindnesses: my students and former students at Boston University —Peter Barr, David Brody, Abaegeal Duda, Leslie Furth, Charlotte Emans Moore, Natasha Seaman, Ann

P. Wagner; and colleagues in universities, museums, and commercial art galleries—Warren Adelson, Pamela Belanger, Richard Candee, Karen C. C. Dalton, John Davis, David B. Dearinger, Nick Edmonds, Stuart Feld, Abigail Booth Gerdts, Lucretia Giese, Roger Howlett, Michael Jehle, Phillip Johnston, Harry Katz, Judy Larsen, Ken Lux, Anita Patterson, Melissa Rountree, Marty Scherer, Paul D. Schweitzer, Ira Spanierman, Judy Throm, William H. Truettner, Meredith E. Ward, Judith Zilczer, and the late Robert Vose, Jr. The distant relatives of Eastman Johnson, Mary and Harold Lieberman, have been very helpful over the years with questions of genealogy. I especially want to thank William H. Gerdts, who for the thirty years I have known him has been most generous in sharing with me his knowledge and his extensive archives on Johnson and other nineteenth-century artists. With great humor and diligence, Kerry Dean assisted me in Boston by tracking down newspaper clippings and obscure bits of information,

and I want to thank her. As always, Kevin Whitfield has my deep gratitude for his precise critical reading of the many drafts of this essay.

Finally, but not least, I want to thank Teresa A. Carbone for inviting me to join with her on both the exhibition and the catalogue, and sharing with me her own enthusiasm for Johnson's paintings and drawings. I much admire the thoroughness with which she tackled organizational and research problems, the logic with which she thought through conflicting pieces of evidence, and the patience she showed in suggesting corrections to my own manuscript.

1. Henry T. Tuckerman, *Book of the Artists* (1867; reprint, New York: James F. Carr, 1967), p. 470.

2. See Martin Duberman, ed., *The Antislavery Vanguard: New Essays on the Abolitionists* (Princeton: Princeton University Press, 1965).

3. See Kenneth M. Stampp, *America in 1857: A Nation on the Brink* (New York: Oxford University Press, 1990).

4. The family house was at 266 F Street, between Thirteenth and Fourteenth Streets. Johnson's sisters who lived at home in late 1855 were Mary Kimball; Sarah Osgood, who would marry William Newton in 1856; Harriet Charles; and Eleanor Maria. For Johnson's years in Washington, see John Davis, "Eastman Johnson's *Negro Life at the South* and Urban Slavery in Washington, D.C.," *Art Bulletin* 80, no. 1 (March 1998), pp. 67–92.

5. Johnson's brother Philip C. Johnson, Jr., wrote to the oldest sister, Judith (who had married James G. Wilson), in September 1856: "I hear that East has gone out west on a pleasure trip. . . . I suppose Reub. and family are on their way out there by this time." Family Papers of Mrs. Elvira Johnson Elbrick, Washington, D.C. "Reub" was Eastman's brother Reuben Chandler Johnson, who had married Caroline Alexander in 1851.

6. During 1856 and 1857 Johnson was active in developing a reputation for himself not only in Washington, D.C., but also in Boston, New York, and Baltimore, where his paintings were exhibited at the Boston Athenaeum, the National Academy of Design, and the Maryland Institute, respectively.

7. For Mignot, see Katherine Manthorne with John W. Coffey, *The Landscapes of Louis Rémy Mignot: A Southern Painter Abroad* (Washington, D.C.: Smithsonian Institution Press, 1996). According to family history, John W. Carlisle had given Johnson a letter of introduction to John Augustine Washington, the owner of Mount Vernon; see Elizabeth Buckley Johnson (Johnson's widow) to the Regents of the Smithsonian Institution, December 1, [1906], frames 851–56, reel 2227, Richard Rathbun Letters, 1906–10, Archives of American Art, Smithsonian Institution, Washington, D.C. Mrs. Johnson mentions in her letter that she has diaries and an autobiography by Johnson, which unfortunately have not been located. His client George Riggs, whose children had sat for him the previous winter, may also have suggested the trip. Riggs became involved with fund-raising for the restoration of the house and grounds when the Association bought the estate in 1858.

8. The two studies of the grounds are dated 1858, which means that he either returned to Mount Vernon in 1858 or completed the paintings in his studio—in either New York or Washington, D.C.

9. See first essay by Teresa A. Carbone in this volume. Stowe's story was published as a book in 1852 and pirated for numerous subsequent editions. Translations of the novel were popular in Europe, as were numerous dramatic versions. See Thomas F. Gossett, *Uncle Tom's Cabin and American Culture* (Dallas: Southern Methodist University Press, 1985), chapter 13, "The Reception Abroad of Uncle Tom's Cabin." See also n. 19 below.

10. See Davis, "Eastman Johnson's *Negro Life at the South*," pp. 78 and 91, nn. 49, 50.

11. The scene also has an uncanny resemblance to Harriet Beecher Stowe's opening description of Uncle Tom's cabin, in which Tom's wife, Chloe, alternately feeds the baby on her lap and her two small boys. Seventeen families of slaves—a total of seventy-six—lived on the estate in January 1856; see "List of Slaves Belonging to John A. Washington (III) Mount Vernon, January 15, 1856, taken from a Diary Kept by John A. Washington, Mount Vernon Ladies' Association, Mount Vernon, Virginia.

12. For a discussion of Johnson's Superior visit, see Patricia Hills, *The Genre Painting of Eastman Johnson: The Sources and Development of His Style and Themes* (New York: Garland, 1977), pp. 45–54. According to Bertha A. Heilbron, Superior had been surveyed and plotted, as Duluth had been in 1856, and land speculation was considerable; see Heilbron, "A Pioneer Artist on Lake Superior," *Minnesota History* 21 (June 1940), p. 150 (cited in Hills, *The Genre Painting of Eastman Johnson*, p. 46). John B. Grant, Jr., has documented many of Johnson's movements at this time; see Grant, "An Analysis of the Paintings and Drawings by Eastman Johnson at the St. Louis County Historical Society," Master's thesis, University of Minnesota, 1960 (cited in Hills, *The Genre Painting of Eastman Johnson*, pp. 46–47). According to William Walton, Johnson invested his own money and $500 belonging to his family in land in the Superior area; see Walton, "Eastman Johnson, Painter," *Scribner's Magazine* 40 (September 1906), p. 268.

13. Walton noted that Johnson stopped in Cincinnati in November 1857 to establish a temporary professional career "until the family finances were restored to their original condition"; see ibid., p. 268. I am grateful to Richard Candee for additional information on Johnson family financial dealings.

14. The amount of time that Johnson spent in Washington after he rented the New York studio is not known. Davis speculates that he spent many months there not only painting *Negro Life at the South*, but also involving himself with the Washington Art Association, of which he had assumed the duties of director; see Davis, "Eastman Johnson's *Negro Life at the South*, p. 69. Johnson made his first payment of $37.50 for his studio in the University Building on April 27, 1858, and a subsequent payment of $262.50, plus repairs of $15.00 and a gas payment of $2.20 by May 1, 1858. See Rent Rolls [1853–1870], New York University Building, New York University Archives, New York. See also Hills, *The Genre Painting of Eastman Johnson*, p. 70, n. 14. Since he had paid substantial rent for the University Building studio in New York by May 1, 1858, it is most likely that he moved in fairly soon afterward. According to the Rent Rolls during the time he was a tenant, from 1858 to 1871, his neighbors at various times included Samuel F. B. Morse, Daniel Huntington, James H. Cafferty, Thomas W. Dewing, W. J. Hennessey, Winslow Homer, George Inness, and J. H. Twachtman, as well as the art critics Henry T. Tuckerman and Eugene Benson.

15. The study (location unknown) for *Negro Life* hung on the wall of Johnson's studio; see the photograph of his studio, reproduced in Edgar French, "An American Portrait Painter of Three Historical Epochs," *World's Work* 13, no. 2 (December 1906), p. 8517, and also reproduced in Patricia Hills, *Eastman Johnson*, exh. cat. (New York: Clarkson Potter and the Whitney Museum of American Art, 1972), p. 123.

16. See John K. Howat, "Kensett's World," in John Paul Driscoll and John K. Howat, *John Frederick Kensett: An American Master* (New York: Worcester Art Museum in association with Norton, 1985), p. 40 and p. 186, n. 105.

Recent general interpretations of *Negro Life at the South* by art historians besides Davis include Hugh Honour, *The Image of the Black in Western Art*, vol. 4, *From the American Revolution to World War I*, Part 1, *Slaves and Liberators* (Cambridge, Mass.: Harvard University Press, 1989), pp. 217–20; Albert Boime, *The Art of Exclusion: Representing Blacks in the Nineteenth Century* (Washington, D.C.: Smithsonian Institution Press, 1990), pp. 109–13; Elizabeth Johns, *American Genre Painting: The Politics of Everyday Life* (New Haven: Yale University Press, 1991), pp. 127–31; Nona R. Martin, "*Negro Life at the South*: Eastman Johnson's Rendition of Slavery and Miscegenation." Master's thesis, University of Pittsburgh, 1994; and Kirsten Pai Buick, "Eastman Johnson's 'Old Kentucky Home, Negro Life at the South': From Idealization to Nostalgia, 1859–1867," Master's thesis, University of Michigan, 1990.

17. Wright owned the painting in 1860, by then called *Old Kentucky Home*, when it was loaned by Wright to the Troy, New York, Young Men's Association; see James L. Yarnall and William H. Gerdts, *The National Museum of American Art's*

Index to American Art Exhibition Catalogues: From the Beginning through the 1876 Centennial Year, 6 vols. (Boston: G. K. Hall, 1986), entry 49590 (hereafter called *Index to American Art Exhibition Catalogues*). In 1863 *Old Virginia Home* was exhibited at the Weehawken Gallery in Weehawken, New Jersey —presumably the same work, at the home gallery of William P. Wright; see Yarnall and Gerdts, *Index to American Art Exhibition Catalogues*, entry 49596.

Davis discusses the perplexing problem of the name change in "Eastman Johnson's *Negro Life at the South*," p. 70. The mystery is not made easy by the existence of the smaller undated and unsigned version (18 by 24 inches; High Museum, Atlanta). In my opinion the High Museum version is by the hand of Johnson, but whether he kept it in his studio is unknown. Stylistic analysis of the 1876 chromolithograph after Johnson's painting, published by Bencke and Scott of New York, indicates a closer relationship to the High Museum version than to the version at The New-York Historical Society, which suggests that the lithographer copied the High Museum version. It was not unusual for artists, or students working under their supervision, to paint small copies to lend to print publishers, especially when the original paintings were already owned by private collectors or institutions. These were the same circumstances under which Johnson copied Leutze's *Washington Crossing the Delaware* for Goupil's in 1853.

18. According to his obituary in the *New York Times* (July 8, 1880, p. 5), Wright was an Englishman who established himself in New York in 1852, becoming a cotton broker and leading authority on cotton before he retired in 1874. He lived in Weehawken, New Jersey, and had a large collection of paintings, which he sold at auction in 1867, perhaps as an economic necessity because of the vicissitudes of the cotton market. See also Davis, "Eastman Johnson's *Negro Life at the South*," p. 91, n. 73, regarding Wright's *Cotton Circular*. Also useful is George Ruble Woolfolk, *The Cotton Regency: The Northern Merchants and Reconstruction, 1865–1880* (New York: Bookman Associates, 1958). Davis has also reminded us that the subsequent purchaser of the picture in 1867 was Robert L. Stuart, among other things a broker of sugar—another product dependent on slave labor.

Many of the New England and New York social and cultural elite lived on the profits of cotton manufacture. Henry Wadsworth Longfellow's wife, Frances Appleton, for example, was the daughter of Nathan Appleton, a leading manufacturer of cotton cloth and one of the founders of the city of Lowell, Massachusetts. A theme of Stowe's *Uncle Tom's Cabin*, articulated in the conversations of her characters, was the complicity of northern merchants in slavery.

19. The first version of the play *Uncle Tom's Cabin*, pirated from Stowe's novel, opened in Troy, New York, in 1852, and came to New York in 1853. Several versions, including proslavery

productions, played for years. Gossett remarks that the play "would eventually become the greatest popular hit in American dramatic history." Gossett, *Uncle Tom's Cabin*, chapter 14, "Uncle Tom's Cabin as a Play in the 1850s," p. 260. Historians agree that the best version of the play was that of George L. Aiken, reprinted in *Early American Drama*, ed. Jeffrey H. Richards (New York: Penguin, 1997). See also Christine Hult, "*Uncle Tom's Cabin*: Popular Images of Uncle Tom and Little Eva," *Nineteenth Century* 15, no. 1 (1995), pp. 3–9.

20. For the editorial views of newspapers during the Civil War era, the beginning point of scholarship is Frank Luther Mott, *American Journalism: A History of Newspapers in the United States through 250 Years, 1690 to 1940*, 4 vols. (New York: Macmillan, 1941), vols. 2 and 3.

21. It was Bennett's political ideology, as well as his need to sell newspapers, that helped in part to bring about the demise of the American Art-Union; see Patricia Hills, "The American Art-Union as Patron for Expansionist Ideology in the 1840s," in *Art in Bourgeois Society, 1790–1850*, ed. Andrew Hemingway and William Vaughn (Cambridge: Cambridge University Press, 1998), pp. 314–39. The fifth influential newspaper of the Civil War and Reconstruction eras was the *New York World*, founded in 1860 by a Republican editor; after its expansion in 1861 and with financing from August Belmont, however, it became the mouthpiece for the Democratic party under the editorship of Manton Marble.

22. Anonymous, *New-York Daily Tribune*, May 21, 1859, p. 6. The phrase "Slavery as It Is" was given wide currency by Theodore Dwight Weld, whose long study, *American Slavery as It Is*, was published by the American Anti-Slavery Society in 1839.

23. "The National Academy of Design," *Crayon* 6, part 5 (May 1859), p. 152.

24. "National Academy Exhibition," *Cosmopolitan Art Journal* 3, no. 3 (June 1859), p. 134.

25. *Crayon* 6, part 6 (June 1859), p. 191. This critic also gave an extended description of the painting.

To meet the demand for replicas of the picture, Johnson made three additional paintings of various parts of the painting: two of the banjo player and boy called *Confidence and Admiration*, circa 1859 (Mead Art Gallery, Amherst College, Amherst, Massachusetts) and 1859 (Private collection), and one of the courting couple, called *Southern Courtship*, 1859 (location unknown), reproduced in Hills, *Eastman Johnson*, p. 31.

26. *Harper's Weekly* 11 (May 4, 1867), p. 274, remarked on Johnson's role in showing the real emotions of slaves: "Mrs. Stowe broke the spell in literature. Eastman Johnson broke it in art." White perceptions of African Americans during the Civil War and Reconstruction eras are exceedingly varied and resist generalizations; see George M. Fredrickson, *The Black Image in the White Mind: The Debate on Afro-American*

Character and Destiny, 1817–1914 (New York: Harper and Row, 1971). The first scholar to tie Johnson's painting to *Uncle Tom's Cabin* is Sue Bridwell Beckman, "By n' By Hard Times . . . Eastman Johnson's 'Life at the South'; and American Minstrelsy," *Journal of American Culture* 6 (Fall 1983), pp. 19–25.

27. Gossett observes: "One way in which minstrel shows attempted to answer the charge that slavery was cruel because it separated families was to ridicule the idea of love between man and woman or between parents and children among blacks.... Parodies of *Uncle Tom's Cabin* emphasized the idea that it was not cruel to separate black families because the blacks had nothing corresponding to true family feelings. These parodies were popular for many years. They continued to be produced in the North, for example, throughout the period of the Civil War." Gossett, *Uncle Tom's Cabin*, p. 277.

28. Ibid., p. 271.

29. See Dion Boucicault, *The Octoroon; or, Life in Louisiana*, reprinted in *Early American Drama*, ed. Jeffrey H. Richards (New York: Penguin, 1997). See also Joseph R. Roach, "Slave Spectacles and Tragic Octoroons: A Cultural Genealogy of Antebellum Performance," *Theatre Survey* 33 (November 1992), pp. 167–87.

30. Harriet A. Jacobs, *Incidents in the Life of a Slave Girl Written by Herself*, ed. Jean Fagan Yellin (1861; reprint, Cambridge, Mass.: Harvard University Press, 1987), p. 37. The first edition of Jacobs's narrative was edited by Lydia Maria Child and printed in Boston.

31. Ibid., pp. 278–79. The second quotation is from a critic of the *New York Times* reviewing the white actor G. Germon's performance as Tom in the Aiken version in New York; the third quotation by a *New York Atlas* reviewer describes the performance of his successor, another white actor, J. Lingard. The lithograph, "Uncle Tom and Little Eva," printed by Nathaniel Currier in the mid-1850s, shows an older man. Gossett offers several reasons for the older age, including the speculation that a young man "might conceivably have been seen as a sexual threat . . . to the absolute purity of little Eva." Gossett, *Uncle Tom's Cabin*, p. 280.

32. The Nat Turner woodcut is reproduced in Jean Fagan Yellin, *The Intricate Knot: Black Figures in American Literature, 1776–1863* (New York: New York University Press, 1972), p. 182.

33. I want to thank Anne C. Rose for bringing the biblical allusion to my attention. Genesis 34 relates the story of Dinah, raped by Shechem, the son of Hamor the Hivite, the prince of the country in which the Israelites lived. Even though Shechem wanted to take Dinah as his wife, her brothers avenged her rape by murdering Shechem and his father. African Americans would know their Scriptures and seek comfort in the story of the revenge by Dinah's kin.

34. Period literature and drama focusing on black-white relations often turn on the concept of surrogation, with a young white woman identifying with the situation of black women. See Roach, "Slave Spectacles and Tragic Octoroons," pp. 180–81.

35. John Davis first noticed the reference to a contemporary, commercially available photograph in the *Home Journal* (August 27, 1859). See Davis, "Eastman Johnson's *Negro Life at the South*," p. 70.

36. I am grateful to Harry Katz, Curator, Popular and Applied Graphic Art, Library of Congress, for providing me with this information.

37. According to Gossett, Tom does not die in the proslavery versions, but returns as a slave to his "old Kentucky home"; see Gossett, *Uncle Tom's Cabin*, p. 274.

38. The *Boston Daily Evening Transcript* reported in its August 29, 1859, issue that for several weeks the Boston Athenaeum had been hosting a group exhibition of paintings; Johnson's name was included.

39. "Athenaeum Exhibition," *Dwight's Journal of Music* 15 (September 3, 1859), p. 181, first noted by Davis, "Eastman Johnson's *Negro Life at the South*."

40. The others were *Marguerite*, of which a lithograph exists (fig. 31), and *A Gentleman*.

41. Catalogue entry for no. 460, *The Ring of Freedom*, crayon, *Catalogue of the Bric-a-Brac, Rare Oriental Rugs, Oil Paintings, Furniture, Fine Curtains . . . belonging to the Estate of the Late Rev. Henry Ward Beecher*, sale cat. (New York: American Art Association, 1887), p. 29. Baur quotes a variation on the story from an undated *New York Times* clipping in *An American Genre Painter* (see headnote above), p. 39; Mrs. Eastman Johnson gives her version of the story in a letter [1909] to Mrs. Blatchford, Collection Newberry Library, Chicago. Pinky's father was "one of the leading physicians in Washington," according to "An Interesting Scene in Plymouth Church," *New York Times*, February 6, 1860, p. 80.

42. "Ransom of a Slave-girl at Plymouth Church," *Independent*, February 2, 1860, quoted in Clifford E. Clark, Jr., *Henry Ward Beecher: Spokesman for a Middle-Class America* (Urbana: University of Illinois Press, 1978), p. 142, n. 39. The account of Beecher's taking Little Pinky to Johnson's studio is included in a note to the sale of the painting, held at the American Art Association, New York, March 7, 1914, no. 181. Another tie to abolitionist circles was his sister Harriet Charles Johnson, who married the Reverend Joseph May, the son of the ardent abolitionist minister Samuel May, on October 24, 1865. Rose Ward (Mrs. James Hunt) returned the ring to Plymouth Church in 1927, where it is now on view. (Wall labels at Plymouth Church give the date as February 5, 1860.)

43. Henry Ward Beecher, "The Office of Art,"

in Beecher, *Eyes and Ears* (Boston: Ticknor and Fields, 1862), p. 229. The essays in this collection were reprinted from the *New York Ledger* and the New York *Independent*.

44. See Kathleen Collins, "Portraits of Slave Children," *History of Photography* 9, no. 3 (July–September 1985), pp. 187–209.

45. The painting remained in Johnson's studio and was sold at the 1907 Johnson estate sale; see *Catalogue of Finished Pictures, Studies, and Drawings by the Late Eastman Johnson, N.A.* (New York: American Art Galleries, 1907), no. 22.

46. I thank Abaegeal Duda for directing me toward John Williamson Palmer, ed., *Folk Songs* (New York: Charles Scribner, 1861), in which, on p. 286, a very crude rendition of Johnson's figure is reproduced. Interestingly, Palmer dedicates the book to Henry Wadsworth Longfellow, who, one suspects, may have urged Johnson's inclusion in the volume.

Prang first began producing chromolithographs in 1866, with Johnson's image as one of the first. *The Barefoot Boy*, 13 by 9¾ inches, sold for five dollars; in 1869 Prang added to its inventory Johnson's popular *The Boyhood of Lincoln*. See Katharine M. McClinton, *The Chromolithographs of Louis Prang* (New York: Clarkson Potter, 1973).

47. See notice of the sale in *New York Times*, May 29, 1861, p. 5. I thank Elizabeth Evans for first bringing the article to my attention.

48. The letter is quoted in Baur, *An American Genre Painter*, pp. 18–19.

49. Ibid., p. 19. Teresa A. Carbone raises valid questions in her second essay in this volume about Johnson's wartime activities; the evidence of his actual participation is slim.

50. The inscribed version belongs to the Virginia Museum of Art, Richmond. I thank Natasha Seaman for bringing the *Leslie* war artists to my attention in a Boston University seminar in Spring 1998. See Andrea G. Pearson, "*Frank Leslie's Illustrated Newspaper* and *Harper's Weekly*: Innovation and Imitation in Nineteenth-Century American Pictorial Reporting," *Journal of Popular Culture* 23, no. 4 (Spring 1990).

51. No works of Johnson's with the title of *A Ride for Liberty* or *The Fugitive Slaves* are included in Yarnall and Gerdts, *Index to American Art Exhibition Catalogues*, nor in any other references to nineteenth-century exhibitions of which I am aware. The Virginia Museum version remained in Johnson's studio at the time of the 1907 Johnson estate sale (no. 123).

For an extended discussion of representations of emancipated slaves, see Boime, *The Art of Exclusion*, pp. 153–219; and Freeman Henry Morris Murray, *Emancipation and the Freed in American Sculpture: A Study in Interpretation* (1916; reprint, Freeport, N.Y.: Books for Libraries Press, 1972).

52. *Catalogue of Finished Pictures, Studies, and Drawings by the Late Eastman Johnson, N.A.* (see n. 45 above), no. 128, 22 by 25½ inches. There

is no indication of a signature or date on the painting. Another related painting of the site, *Dinnertime*, no. 85 (location unknown), and measuring 14 by 9½ inches, is described: "A portly Negro woman stands back to the spectator, apparently near the doorway of her cabin, blowing upon a dinner horn. A strong flood of sunshine falls upon the flower garden and landscape, against which the figure, together with an overhanging vine and a few wooden boxes, is in high relief." Interestingly, Homer painted *At the Cabin Door*, dated 1865 and 1866 (The Newark Museum, Newark, New Jersey), showing a black woman standing in a doorway as Union troops pass by. See also the essay by Sarah Burns in this volume.

53. See Boime, *The Art of Exclusion*, pp. 152–219.

54. See Hills, *The Genre Painting of Eastman Johnson*, p. 81.

55. The Nast illustration was accompanied by an essay reminding readers of the inhumanity of slave auctions.

56. In fact, Lincoln, like many antislavery northerners, felt that slavery was morally wrong, although he intended the Emancipation Proclamation as a war measure only; he wanted, as the historian Kenneth Stampp reminds us, a "gradual, compensated emancipation" that need only be completed before 1900, a strategy unacceptable to the demands of the abolitionist movement that sought immediate emancipation with no compensation to slaveholders; see Stampp, *The Era of Reconstruction: 1865–1877* (New York: Vintage, 1965), p. 44. See also LaWanda Cox, *Lincoln and Black Freedom: A Study in Presidential Leadership* (Columbia: University of South Carolina Press, 1981).

57. Johnston's collection, which included Frederic Church's *Niagara* and Turner's *Slave Ship*, as well as *The Chimney Corner*, is listed in Tuckerman, *Book of the Artists*. In February 1864 Johnston loaned Johnson's "*Old Joe*," doubtless the same painting, to an exhibition in Albany; see Yarnall and Gerdts, *Index to American Art Exhibition Catalogues*, entry 49589. Hence, the image had wide exposure.

58. Horace Greeley was known for advocating the education of emancipated slaves. Regarding Greeley's reputation for this among African Americans, see Terry Dopp Aamodt, "Righteous Armies, Holy Cause: Apocalyptic Imagery and the Civil War," Ph.D. dissertation, Boston University, 1986, pp. 158, 257–58.

59. Contemporary viewers would again think of Uncle Tom. Later, in 1866, Johnson would exhibit *Sunday Morning* (No. 34), depicting a family of white people, with a similar mood of piety. Other pictures by Johnson of African Americans will be included in the author's forthcoming catalogue raisonné.

60. For the United States Sanitary Commission, see George M. Fredrickson, *The Inner Civil War: Northern Intellectuals and the Crisis of the Union* (New York: Harper and Row, 1965).

That the owner of *Old Kentucky Home* is unlisted adds to the conundrum of whether or not it was indeed The New-York Historical Society's painting, still owned by William P. Wright, or whether it is the High Museum painting; see n. 17 above.

61. In fact, of the 153 works submitted to the Fair that were not for sale, Johnson was perhaps the *only* artist who had a work referring to contemporary wartime events—either the battles or homefront activities. Of the 207 works included for sale at the Fair, only 9 have titles suggestive of Civil War themes. One of the other two works that Johnson submitted was *The Postboy*, then owned by Marshall O. Roberts. Listed for sale was a third work, *The Young Sweep*. There is some confusion about this last work; the April 9, 1864, edition of the *New-York Daily Tribune*, p. 12, states: "Mr. Belmont, we see with regret, has hung Johnson's 'Savoyard' miscalled in the catalogue, 'The Chimney Sweep,' [*sic*] at the very top of the wall, where only good eyes can see it." *The Savoyard*, one of the works Johnson painted at The Hague during the time that August Belmont was U.S. ambassador, was still in Belmont's collection in 1867, when Henry Tuckerman published his *Book of the Artists* (see p. 470). It was perhaps the case that Belmont's *Savoyard* was added to the exhibition after the catalogue was printed. In any case, *The Young Sweep* was clearly a different picture since it sold at auction along with some 200 other paintings and sculptures at the conclusion of the Fair; the sale price of $275 was noted in the April 20, 1864, issue of the *New York Herald*. I am grateful to Charlotte Emans Moore for reminding me of Johnson's heavy commitment to Fair committee work and also for bringing the *Herald* notice to my attention. A painting called *The Young Sweep* was noted in Tuckerman's *Book of the Artists*, p. 630, as belonging to the Philadelphia collector Joseph H. Harrison, Jr.

62. See Reginald G. Haggar, *A Dictionary of Art Terms* (New York: Hawthorne, 1962), p. 131: "a term invented by Sir Joshua Reynolds (1788) to describe Gainsborough's pictures of 'little ordinary beggar-children.'"

63. The black author Frances Ellen Watkins Harper, in her novel of the years of Reconstruction, *Iola Leroy; or, Shadows Uplifted* (Philadelphia: Garrigues Brothers, 1892), speaks of the keen interest that slaves took in news of the war, often communicating in visual and verbal codes to avoid the displeasure of their masters.

64. See Charlotte Emans Moore, "'These Noble Offerings': The Art Gallery of the Metropolitan Sanitary Fair, New York City, 1864," forthcoming Ph.D. dissertation, Boston University.

65. "National Academy of Design: Fifth Article," *Watson's Weekly Art Journal* 3, no. 8 (June 17, 1865), p. 115.

66. Quoted in David H. Wallace, *John Rogers, the People's Sculptor: His Life and His Work*

(Middletown, Conn.: Wesleyan University Press, 1967), p. 212. In 1865 Child published *The Freedmen's Book*, an anthology of writings by herself and other abolitionists as well as black authors, which was aimed at the recently freed slaves, with any and all profits to go to the Freedmen's Aid Association.

A similar sentiment was expressed by the critic Anne Brewster and Emanuel Leutze about the Irish woman and African American man depicted in Leutze's Capitol mural, *Westward the Course of Empire*, completed in 1862; see Patricia Hills, "Picturing Progress in the Era of Westward Expansion," in William H. Truettner, *The West as America*, exh. cat. (Washington, D.C.: Smithsonian Institution Press, 1991), p. 119.

67. Quoted in the *New York Leader*, August 19, 1865, p. 4. I am grateful to Lucretia Giese for mentioning the "black broth" quotation in her dissertation, "Winslow Homer: Painter of the Civil War," Ph.D. dissertation, Harvard University, 1985, which led me to the full quotation. I have not been able to find Cook's original article or the source from which the *New York Leader* was quoting. A famous hoax at the time was the anonymous pamphlet *Miscegenation: The Theory of the Blending of the Races, Applied to the American White Man and Negro*, purportedly written by Radical Republicans, but later discovered to have been written by two southern Democrats, David Goodman Croly and George Wakeman. The press fell for the hoax and generally condemned the advocacy of miscegenation, although Horace Greeley's *Tribune* and the *National Anti-Slavery Standard* gave it "cautious endorsement," according to Fredrickson, *Black Image* (see n. 26 above), p. 172. Fredrickson concludes: "The controversy is significant, not because of its political impact—which was negligible—but because it further reveals the extent to which northerners approached Reconstruction with their basic racial prejudices largely intact. The Negro was appreciated as an amiable being with some good qualities, whose innate submissiveness had served—and might continue to serve—northern purposes. But he was expected to remain in his 'place'" (p. 174).

68. Ibid., p. 37.

69. Others were Senators Henry Wilson of Massachusetts, Benjamin Wade of Ohio, and Zacharia Chandler of Michigan, and Representatives Thaddeus Stevens, William Kelley, and John Broomall of Pennsylvania, George S. Boutwell of Massachusetts, James M. Ashley of Ohio, George W. Julian of Indiana, and James F. Wilson of Iowa.

70. Stampp, *The Era of Reconstruction*, p. 36.

71. Eric Foner, *Politics and Ideology in the Age of the Civil War* (New York: Oxford University Press, 1981), p. 104.

72. See Stampp, *The Era of Reconstruction*, p. 110.

73. The veto and Johnson's later rationalizations for it puzzled both his advocates and his detractors. The Freedmen's Bureau had been set up by the

federal government as a war measure to operate for one year beyond the armistice. Since the one-year anniversary was quickly approaching, debates circulated about its necessity. Editors of *Harper's Weekly* (March 3, 1866, p. 130) reacted by asking how freedom could be maintained for the ex-slaves in view of the Black Codes of South Carolina and Mississippi. In the next week, *Harper's Weekly* (March 10, 1866, p. 146) noted the support of President Johnson's position from William Cullen Bryant's *Evening Post* (New York) and Henry Ward Beecher. *Harper's* commented that both the *Post* and Beecher "did not understand the President to be opposed to any bill, but only to the present one," because he felt that presidential power would be exceeded if he created a welfare state for ex-slaves.

74. Stampp, *The Era of Reconstruction*, p. 130.

75. Ibid., pp. 142–44.

76. Ibid., p. 135.

77. Ibid., p. 95.

78. Optimism about cotton production runs as a leitmotif throughout *Harper's Weekly* in the postwar years. In the very issue (March 3, 1866) in which the editors puzzled over President Johnson's February 1866 veto of the Freedmen's Bureau, they were optimistic about the projected cotton crop for 1866, which they saw as a by-product of free labor. The editors boasted that *only* cotton, not food, would be planted for 1866, and that the projected crop for 1867 would be more than five million bales. A year later, in the March 16, 1867, issue, the editors admitted that the actual cotton crop for 1866 had been fewer than two million bales, and that the United States had fallen behind India. In fact, because only cotton had been planted and because of the general disarray of agriculture and shortage of cash owing to the cotton crop failure, much of the South experienced severe food shortages, with the federal government having to step in finally in 1867. See Woolfolk, *Cotton Regency*, chapter 3, "The Famine Year and After," pp. 76–93.

79. See Patrick W. Riddleberger, "The Radicals' Abandonment of the Negro during Reconstruction," *Journal of Negro History* 2 (April 1960), pp. 88–102. Riddleberger cautions: "It is now recognized that the Radicals, even during the war, were far from unified. Although classification is difficult, at least two distinct groupings are recognizable: those who continued to support President Grant during and after 1872 (the Stalwart Radicals) and those who joined the Liberal Republican Movement and opposed him (the Liberal Radicals)" (p. 88). Riddleberger concludes that the Liberal Radicals (which would include Sumner and Greeley) "failed to think through to the full consequences of the antislavery movement. . . .[W]hen confronted with the harsh results of their work with respect to the Negro, it is apparent that some of them suffered a loss of nerve" (p. 101).

80. The New-York Historical Society's copy is

reproduced in Wallace, *John Rogers* (see n. 66 above), p. 216, who states: ". . . 'Uncle Ned's School' was immediately hailed as a powerful commentary on the freed Negro's determination to educate himself and improve his lot by his own efforts."

81. [Clarence Cook], "National Academy of Design," *New-York Daily Tribune*, July 4, 1866, p. 5. Édouard Frère was an established genre painter in Écouen, France, who painted small pictures of boys and girls. *Fiddling His Way* is also discussed in Guy C. McElroy, *Facing History: The Black Image in American Art, 1710–1940* (San Francisco: Bedford Arts, 1990), p. 56. For Cook, see Jo Ann W. Weiss, "Clarence Cook: His Critical Writings," Ph.D. dissertation, The Johns Hopkins University, 1977, and Saul E. Zalesch, "Competition and Conflict in the New York Art World, 1874–1879," *Winterthur Portfolio* 29, no. 2–3 (Summer/Autumn 1994), pp. 103–20.

82. "National Academy of Design," *Evening Post* (New York), May 2, 1867, p. 1. African American slaves liberated by Union troops were called "contraband," which refers to their status as property. The fact that *The Veteran* in Wood's set of three pictures is crippled complicates any easy interpretation of the picture. Wood's image was reproduced in *Harper's Weekly* (May 4, 1867). Other Academy pictures in 1867 included Vincent Colyer's *A Soldier's Return from the War* and Louis Schultze's *And the Colored Troops Fought Nobly* (both location unknown).

83. Toni Morrison drew on this event for her novel *Beloved* (1987). See Leslie Furth, "'The Modern Medea' and Race Matters: Thomas Satterwhite Noble's *Margaret Garner*," *American Art* 12, no. 2 (Summer 1998), pp. 36–57.

84. See Eric Foner, *Reconstruction: America's Unfinished Revolution, 1863–1877* (New York: Harper and Row, 1988), ill. opp. p. 386. *Harper's* praised "the good sense and discretion, and above all the modesty" of the freedmen in the engraving, noting that they approach the ballot box "not with expressions of exultation or of defiance of their old masters and present opponents . . . , but looking serious and solemn and determined," and concluded, "The picture is one which should interest every colored loyalist in the country" (p. 722).

Other paintings from the year 1867 that were not included in the Academy's show but that essayed these themes were John Whetten Ehninger's *Fife and Drum* (location unknown); Theodore Kaufmann's *On to Liberty* (The Metropolitan Museum of Art, New York); and Thomas Noble's *John Brown's Blessing* (The New-York Historical Society), based on Whittier's poem "Brown of Ossawatomie."

85. See Carol Troyen, "Innocents Abroad: American Painters at the 1867 Exposition Universelle, Paris," *American Art Journal* 16, no. 4 (Autumn 1984), pp. 2–30. Troyen does not give the same analysis as I do here.

86. For a discussion of this painting, see Patricia

Hills, "Eastman Johnson's *The Field Hospital*: The U.S. Sanitary Commission and Women in the Civil War," *Minneapolis Institute of Arts Bulletin* 65 (1981–82; published 1986), pp. 66–81.

87. There are several versions of *Boyhood of Lincoln*, the most widely known being the chromolithograph published by Prang; see n. 46 above.

88. See Albert Boime, "Burgoo and Bourgeois: Thomas Noble's Images of Black People," in *Thomas Satterwhite Noble, 1835–1907* (Lexington: University of Kentucky Art Museum, 1988), pp. 52–53.

89. See David Tatum, "Thomas Hicks at Trenton Falls," *American Art Journal* 15, no. 4 (Autumn 1983), pp. 4–20.

90. See Patricia Hills, *The Painters' America: Rural and Urban Life, 1810–1910* (New York: Praeger Publishers and the Whitney Museum of American Art, 1974), p. 5.

91. H. W. Beecher to Andrew Johnson, October 23, 1865, Johnson Papers, Library of Congress, quoted in Clifford E. Clark, Jr., *Henry Ward Beecher, Spokesman for a Middle-Class America* (Urbana: University of Illinois Press, 1978), p. 171. On Greeley's attitudes, see Fredrickson, *Black Image*, p. 182.

92. *Evening Post* (New York), February 16, 1865, p. 1.

93. *Catalogue of Finished Pictures, Studies, and Drawings by the Late Eastman Johnson, N.A.* (see n. 45 above), no. 126.

94. There are other instances when Johnson did two racial versions of a picture.

95. I am grateful to Betsy Fahlman for sending me photocopies of the many newspaper clippings that Weir collected of his *The Gun Foundry* and the painting he completed two years later, *Forging the Shaft* (destroyed; 1874 replica at The Metropolitan Museum of Art, New York). See Betsy Fahlman, "John Ferguson Weir: Painter of Romantic and Industrial Icons," *Archives of American Art Journal* 20, no. 2 (1980), pp. 2–9.

96. All following quotations from, and correspondence with, Mount are from Alfred Frankenstein, *William Sidney Mount* (New York: Abrams, 1975), pp. 440–41, 444–47.

97. Mount's figure is ambiguously both "dead" and "needs rest." Since the time when Mount's *Farmers Nooning*, 1836 (Suffolk Museum and Carriage House, Stony Brook, New York), was distributed to thousands of members of the American Art-Union in 1843, the image was well established in visual culture. See Hills, *The Painters' America*, pp. 21, 22, for a discussion of the motif in Mount's *Farmers Nooning*. See also Boime, *The Art of Exclusion*, pp. 93–95; and Johns, *American Genre Painting* (see n. 16 above), pp. 33–38, 107–8.

98. In his journal of May 17, he praised the Republican senators who voted not to impeach Johnson, adding that they "will be remembered with honor."

99. Mount refers to Belmont's having inquired about the price at "the Club House." The "Club" to which he refers is unclear—perhaps the headquarters of the Democratic party. Belmont belonged to The Century Association, but Mount did not.

100. See letter to Johnson, dated April 6, 1868, quoted in Frankenstein, *William Sidney Mount*, p. 452. *The Dawn of Day* remained unsold during Mount's lifetime; nor was it sold at the estate sale held in April 1871; see Frankenstein, *William Sidney Mount*, p. 462.

101. Nast had been trained in New York and had begun illustrating for *Frank Leslie's Illustrated Newspaper* in the mid-1850s. After a three-year stint with the *New York Illustrated News*, he moved to *Harper's Weekly* in 1862.

102. The September 5 issue of *Harper's Weekly* carried two editorials, "The Platform of Civil War" and "Political Terrorism," which discussed the platform and the coercion of the southern freedmen to vote Democratic through threats by plantation owners that they would lose their jobs. Nast was capable of making very racist caricatures of the Irish in his cartoons, as we see here, and later of some of the African American legislators in the southern states who had been seated in Congress. Nast's imagery conforms to the changing concerns of the Republican party and deserves more care to unravel than space allows in this essay.

103. The Ku Klux Klan, founded in 1866 in President Johnson's home state, Tennessee, was in 1868 spreading its terror of nighttime arson, murder, lynchings, and intimidation at the polls throughout the Piedmont counties of South Carolina and into Georgia and Louisiana. See Foner, *Reconstruction* (see n. 84 above), pp. 342–45.

104. The Currier and Ives image may have come either directly or indirectly from Mount. In a diary entry of April 1857, Mount describes one of his own pictures (location unknown), done for the print publisher William Schaus, of "Negro asleep in a barn—a boy tickling the darkies ear while another urchin is tickling his foot." Frankenstein, *William Sidney Mount*, p. 169.

Another Currier and Ives print that itself reflected and contributed to cultural racism is Thomas Worth's "The Freedman's Bureau," 1868 (*Harper's Weekly*, July 25, 1868), which viciously satirized the whole enterprise by equating the Bureau with a piece of furniture—a bureau with a broken mirror, before which a black man preens himself, with his fiddle and a picture of Lincoln on the wall. For Worth, see Karen C. C. Dalton, "Currier & Ives's Darktown Comics: Ridicule and Race," paper delivered at *Democratic Vistas: The Prints of Currier & Ives, A Symposium*, Museum of the City of New York, May 2, 1992.

105. In *Watson's Weekly Art Journal* 3, no. 8 (June 17, 1865), p. 116, the reviewer of the 1865 Academy exhibition deplored the fact that the National Academy of Design welcomed images of blacks, but not African Americans themselves:

"An association that to this day has the meanness to exclude negroes from their exhibitions, is not likely to be animated by any noble impulse, by any responses to the spirit of the times." Lucretia Giese first brought this quotation to my attention.

106. *Union League Club of New York: Report of Executive Committee, Constitution, By-Laws and Roll of Members*, January, 1864; reprinted July 1864, Archives of the Union League Club.

107. Will Irwin, Earl Chapin May, and Joseph Hotchkiss, *A History of the Union League Club of New York City* (New York: Dodd, Mead, 1952), pp. 7–25. The club secured a headquarters on Union Square, which included a meeting room, committee rooms, a lounge, two billiard rooms, and a bar.

108. Ibid., pp. 31–36. The first event was covered by *Leslie's Illustrated News* in its March 20, 1864, issue; later, in 1868, E. L. Henry painted the "Distribution of the Colors," for the club. The club later organized the Twenty-sixth Colored Infantry, and subsequently recruited 600 black soldiers to merge with a Connecticut group to form the Thirty-sixth Colored Infantry. See also Iver Bernstein, *The New York City Draft Riots: Their Significance for American Society and Politics in the Age of the Civil War* (New York: Oxford University Press, 1990).

109. Irwin, May, and Hotchkiss, *A History of the Union League Club*, pp. 40–41.

110. *Union League Club of New York, Report of Special Committee on the Passage by the House of Representatives of the Constitutional Amendment for the Abolition of Slavery*, January 31, 1865, p. 4, Archives of the Union League Club.

111. Irwin, May, and Hotchkiss, *A History of the Union League Club*, p. 50.

112. The Report of the Executive Committee of January 10, 1867, recorded that a resolution had passed thanking congressional members who voted for the civil rights bill, but noted, "Pledged from its commencement to the establishment of equal government, and an early and self-appointed guardian of the rights of the negro, [the Club] has no occasion to make a further advance in its principles."

113. Irwin, May, and Hotchkiss, *A History of the Union League Club*, p. 51.

114. All three were leading players in the American Art-Union (1839–52); see Patricia Hills, "The American Art-Union" (see n. 21 above). Marshall O. Roberts, another Art-Union benefactor, James Gordon Bennett of the *New-York Herald*, and Henry J. Raymond, publisher of the *New York Times*, who then represented New York in the Congress, were also present. See "Proceedings," in *Mass Meeting of the Citizens of New-York, Held at the Cooper Institute, February 22d, 1866, to Approve the Principles Announced in the Messages of Andrew Johnson, President of the United States* (New York: George F. Nesbitt & Co., 1866).

115. See Irwin, May, and Hotchkiss, *A History of the Union League Club*, p. 52. Greeley felt it was unjust to hold Davis in prison without a trial. He was joined by the abolitionist Gerrit Smith. See Henry Luther, *Horace Greeley: Printer, Editor, Crusader* (New York: Putnam, 1946), p. 235. The meeting to censure Greeley at the Union League Club was held on May 17, 1867. Although Greeley did not attend, he issued a statement to the club: "I do not recognize you as capable of judging or even fully apprehending me. You evidently regard me as a weak sentimentalist, misled by a maudlin philosophy. I arraign you as narrow-minded blockheads who would like to be useful in a great cause but don't know how." Quoted in Luther, *Horace Greeley*, p. 237.

116. See Irwin, May, and Hotchkiss, *A History of the Union League Club*, p. 93. William J. Hoppin, the first treasurer of the club, and later one of its presidents, had been active in the American Art-Union. Johnson was to become the official painter of the club, painting its presidents and many distinguished members. The first recorded general exhibition, opening on February 14, 1867, included Thomas Waterman Wood's *The Contraband*, *The Recruit*, and *The Veteran*.

117. Johnson was among a distinguished group of men from the Union League Club, as well as from The Century Association, who in the late 1860s became active in the founding of The Metropolitan Museum of Art, a project first proposed by William J. Hoppin in October 1868. See Irwin, May, and Hotchkiss, *A History of the Union League Club*, pp. 86–90.

118. Both paintings are initialed "E.J."—typical of paintings sent to the estate sale. At the time of the 1940 Brooklyn Museum exhibition, the conservator Sheldon Keck examined these initials and concluded that many of them were added long after the painting had been completed—perhaps by Johnson's widow. See Sheldon Keck, "The Technical Examination of Paintings," *Brooklyn Museum Journal* 2 (1942), pp. 71–82.

119. Tubman escaped from slavery in Maryland in 1849 and reputedly made more than nineteen trips back to the South to escort some three hundred slaves to freedom along the Underground Railroad.

120. At the 1907 Johnson estate sale, *Head of a Black Man* was incorrectly called *Uncle Remus*, after the character in the Joel Chandler Harris stories written in the 1880s.

121. *Brooklyn Daily Eagle*, January 23, 1873, p. 3. It was not the first time that a black doll appeared in a Johnson painting. Suzaan Boettger has pointed out that the toys that the children play with in the Blodgett family portrait (No. 31) include a black stick puppet, manipulated by the young son of Blodgett; see Boettger, "Eastman Johnson's *Blodgett Family* and Domestic Values during the Civil War Era," *American Art* 6, no. 4 (Fall 1992), pp. 51–67. See also second essay by Teresa A. Carbone in this volume.

122. I touch on this shift in "The Formation of a Style and Sensibility," in Patricia Hills, *John Singer Sargent* (New York: Abrams, 1986), and also in "Afterword/Afterwards: Eastman Johnson's Transition to Portrait Painting in the Early 1880s," in Marc Simpson, Sally Mills, and Patricia Hills, *Eastman Johnson: The Cranberry Harvest, Island of Nantucket*, exh. cat. (San Diego: Timken Art Gallery, 1990), pp. 86–87; 90–91, nn. 54, 55.

123. See Zalesch, "Competition and Conflict in the New York Art World, 1874–1879" (see n. 81 above).

124. [Clarence Cook], "Fine Arts: National Academy of Design," *New-York Daily Tribune*, April 9, 1875, p. 7.

125. "National Academy of Design," *New-York Tribune*, April 29, 1876, p. 2. In his review of April 22, 1876 (p. 7), Cook commented on both Johnson's *The New Bonnet* (No. 45) and his *Husking Bee, Island of Nantucket* (No. 44). He praised *The New Bonnet* but felt it old-fashioned, with its "careful, neat Dusseldorfish manner" painted "to please the world as it goes" (p. 7). He clearly preferred *Husking Bee*, which he saw as being done "to please artists and connoisseurs," and he pushed Johnson to make the shift toward a more spontaneous style.

126. Quoted in Foner, *Reconstruction*, p. 527. In 1866 Henry Ward Beecher argued for the justness of Andrew Johnson's decision to allow the southern states to determine when and how the freedmen should exercise the vote; for this, he received sharp criticism even from his brother Edward Beecher. However, his sister Harriet Beecher Stowe was satisfied when African Americans merely achieved their freedom; the question of suffrage could be postponed to another day. See Clark, *Henry Ward Beecher*, pp. 165–80, and Gossett, *Uncle Tom's Cabin*, pp. 324–25. Forrest G. Wood remarks of the liberals: "That these former supporters of emancipation and impartial suffrage could change so quickly underscored the insidiousness of white racism in America." Wood, *The Era of Reconstruction, 1863–1877* (New York: Crowell, 1975), p. 85.

127. Winslow Homer made a brief foray into the subject of the lives of African Americans in the late 1870s, but he too abandoned the subject. See essay by Sarah Burns in this volume.

128. A continuity of nonstereotypical visual representations of African Americans was, however, effected by African American artists such as Henry O. Tanner and Edmonia Lewis in the late nineteenth century and Meta Warwick Fuller in the early twentieth century.

NO. 81
Mother and Child, 1869
Oil on paper board, 14⅞ x 12¼ in.
Collection of Howard and Melinda Godel

166

Home-Loving Sentiments: Domestic Contexts for Eastman Johnson's Paintings

JANE WEISS

FIG. 70.
Frederick Dielman
"As Soon as She Was Set Free Ellen Brought
Her Bible"
From Susan Warner, *The Wide, Wide World*
(Philadelphia: J. B. Lippincott Company, 1888),
vol. 1

Grandmother and granddaughter sit together, their backs to a log fire in a wide, deep fireplace. Both are dressed plainly; large, practical aprons cover their skirts. The old woman leans over her knitting, gazing fondly at the child, who reads aloud from the Bible. In the foreground, the clean wood floor is bare. Three flatirons sit in the niche above the fireplace, warmed by the chimney. Gourds, a bucket, and a homemade whisk broom hang from the rafters. It is a moment of quiet intimacy in a hardworking rural household (fig. 70).

The image by Frederick Dielman (1847–1935) described above illustrated Susan Warner's *The Wide, Wide World*, a domestic novel that sold 40,000 copies within a year of its publication in 1850 and remained continuously in print for the next seventy years.[1] *The Wide, Wide World* typified the nascent genre of domestic literature. Like genre painting, domestic literature eschewed the dramatic settings and incidents of Romanticism, and instead interpreted kitchens, farms, parlors, shops, and other ordinary settings of daily life. The experience of the American home inspired both writers of ephemera—magazines, housekeeping manuals, gift books, and religious tracts—and respected novelists, poets, and journalists. Although women writers dominated the various domestic genres, the American household engaged writers and readers of both sexes.[2] Nathaniel Hawthorne complained bitterly about the "damned mob of scribbling women" with whom he competed for sales, and twentieth-century critics have assumed that Hawthorne's rivals appealed only to simplistic, saccharine tastes.[3] Nineteenth-century literary critics, however, praised the "naturalness" and "lack of pretension" of domestic fiction. In 1852 a reviewer commented that the best-selling novels of Susan Warner seemed uncommercial, lacking "the showy and impassioned" style that popular audiences craved:

> *Still less is the secret of their success to be found in any condescension to popular taste. . . . The country is painted sincerely—not dressed up for effect. The writer is content with the fields and woods, the streams and fountains, the hills and plains, in their natural costume, without seeking to disguise them by meretricious adornments. . . . The homesteads, where her personages first draw their breath, are such as every farmer and every farmer's wife in the country is perfectly familiar with.*[4]

Twentieth-century critics have labeled both domestic literature and genre painting "sentimental," but nineteenth-century reviewers defined the term differently. In 1851 a reviewer of *The Wide, Wide World*, which depicted the religious education of an orphan girl, said that the novel contained "not even a paragraph of sentimentalism" and that the heroine was "worth myriads of such sentimental, false and unnatural creations of George Sand."[5] Similarly, a reviewer of Eastman Johnson's *The Field Hospital*, 1867 (No. 82), asserted that "there is plenty of sentiment in this picture, strong and true; but not an ounce of sentimentality."[6] By the 1950s the term "sentimentality" connoted femininity rather than sensationalism. Modernist critics, seeking to establish a forward-looking and impressively masculine identity for the canon of American literature, labeled works depicting domestic life or familial relationships or, often, religion "sentimental."[7] In the nineteenth-century view, a work was sentimental if its content was unlikely or exaggerated, or if the emotions registered seemed overwrought or insincere. Pictures like Dielman's etching, or the passage in *The Wide, Wide World* that it illustrated, would not have seemed sentimental to typical nineteenth-century audiences because such scenes, as part of the fabric of everyday life, merited special consideration and appreciation.[8]

An associative link between the paintings of Eastman Johnson and the literature of domesticity would have come naturally to Johnson's nineteenth-century audience. A reviewer in 1871 compared Johnson to "the best modern novelists; he is natural, sometimes realistic, and always keeps close to the actual."[9] In the same year Harriet Beecher Stowe's most explicitly domestic novel, *Pink and White Tyranny*,

NO. 82
The Field Hospital, 1867
Charcoal on paper, 24 x 30 in.
The Minneapolis Institute of Arts, The Julia B.
Bigelow Fund, 74.17

described "those characteristic parlors which show that they have been arranged by a home-worshipper, and a mother. There were plants and birds and flowers, and little *genre* pictures of children, animals and household interiors, arranged with a loving eye and hand."[10] Johnson's *Sunday Morning*, 1866 (No. 34), or *Mother and Child*, 1869 (No. 81), would have been appropriate decorations in such a parlor, painted by a genuinely "home-worshipping" artist; his own involvement with domestic life allowed him to render familiar scenes honestly, with unaffected emotion.

The Hearth

"Home" seems elemental, but the connotations of the word for twentieth-century Americans are surprisingly recent. Before the mid-nineteenth century, the home was associated more with daily labor than with tender feelings. Unremitting work was necessary in order for most Americans to procure practically everything commonly used or consumed in daily life: clothing, food, shelter, medicine, even playthings. This work typically took place in the house, not in a factory or office; the interior of the home was not sealed off from the world outside. Even for privileged members of the upper-middle class, the household was at once an administrative headquarters and a collection of workshops under the same roof.[11]

The industrial revolution changed the practical function of the home for American families, especially in the densely populated northeastern states. As the nineteenth century went on, fewer upper-middle-class, middle-class, and urban working-class households manufactured their own necessities or produced commodities for sale. Rural working-class, pioneer, and farming families experienced less dislocation, but people living in the industrial cities on the East Coast saw the productive center of economic life shift from the house to the factory or counting room. Although daily life within the household still required grueling, almost unimaginable effort, the work now maintained the house itself rather than produced commodities or tools. New technologies or newly abundant manufactured products ameliorated some household labor. Clothing, for example, was still made at home throughout the century, but the cloth from which it was cut would now be purchased, except in the most isolated rural districts. In affluent households, Argand lamps and whale oil or mass-produced spermaceti candles replaced homemade tallow candles; metal implements, purchased from a tinsmith or shop, replaced homemade wooden and clay pots and utensils; coal-burning stoves replaced open wood-burning fireplaces. The walls of the house no longer enclosed a space in which implements such as roof shingles, rakes, and ropes were created for use by family members outside the house. Gradually, the time spent within the home became a complement or an alternative to the commercial world.[12]

Amid change, the open fireplace was a powerful signifier of old-fashioned family unity, celebrated by domestic novelists and featured prominently in Johnson's *The New England Kitchen*, circa 1863–66 (fig. 71), *Fiddling His Way*, 1866 (No. 78), and, in an outdoor variation, the maple-sugaring paintings. In actuality, by the 1850s an open fireplace was more a mark of poverty than of home-loving sentiment. Housekeepers who could afford potbellied or box stoves found them cleaner, thriftier of fuel, more efficient as heat sources, and simpler to cook with. Yet the shift to stoves changed family dynamics as profoundly as it changed housework, though less dramatically. Open fireplaces had enforced proximity. Because so much heat inevitably went up the chimney, the warmth of an open fire could be enjoyed only if everyone clustered around its flames. A box stove, which extended into the space that it heated and radiated warmth from all four of its sides, let family members disperse into the room's corners.[13]

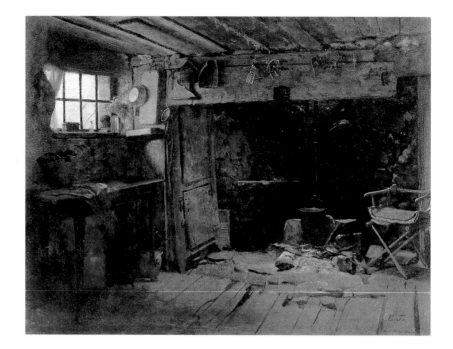

But few fictional interiors lacked flickering flames or merry blazes in open hearths, even if the authors used their royalties to buy efficient new stoves. The hearth in midcentury domestic literature was less a functional device for heating or cooking than a symbolic heart or a vestal altar of affection and intimacy. A housekeeping manual of 1889 carried the title *The Hearthstone* (fig. 72), and its author, Laura Holloway, explicitly linked the fireplace with creativity, arguing that "one cannot conceive a happy thought or genuine inspiration to have been suggested by, or derived from, the modern stove or heater." Her eulogy continued:

> *The centre of all that once was bright was the home fireside. What stories were told by its red glow and flickering flame! What books and magazines were read aloud beside it! How much sweet talk of absent ones! The wind that shrieked amid the leafless trees, or round the corners of the street, made us draw closer to it. Then the heroic story, the pathetic poem, the narrative of hairbreadth 'scapes, the ghost story or tale of highway robbery, would hold us spellbound. But neither waves nor winds, nor ghosts nor robbers scared us till we went to bed, for we felt safe from physical and spiritual harm so long as we could see live coals burning on the altar-hearth of Home.*[14]

Even the realist Susan Warner, who iconoclastically sang the praises of central heating, attributed to her favorite characters a penchant for open fireplaces. In her novel *My Desire* (1880), a lonely woman finds companionship at her fireside: "The fire snapped and flickered and blazed and glowed; its crackling and breathing were the

FIG. 73
Eastman Johnson
The Boy Lincoln, 1868
Oil on canvas, 46 x 37 in.
University of Michigan Museum of Art, Ann
Arbor, Bequest of Henry C. Lewis, 1895.90

only sounds to be heard in the utter stillness of the winter night. It was like a living presence with me; there was stimulus, and admonition, and comfort-giving in its company."[15] The famous opening of Louisa May Alcott's *Little Women* places the sisters in a firelit room:

> *[They] sat knitting away in the twilight, while the December snow fell quietly without, and the fire crackled cheerfully within. It was a comfortable old room, though the carpet was faded and the furniture very plain; for a good picture or two hung on the walls, books filled the recesses, chrysanthemums and Christmas roses bloomed in the windows, and a pleasant atmosphere of home-peace pervaded it.*[16]

Johnson himself, enjoying an extended stay at his Nantucket cottage in the autumn of 1879, commented that his house was made comfortable by "a little wood fire in the evening," and wrote enticingly to a friend a year later, "My wife and I sit here by our quiet cheerful wood fire. How I wish you could step in."[17]

Johnson's well-heeled urban patrons could simultaneously occupy town houses heated with furnaces and relish Johnson's paintings of old-fashioned wood fires. In *The Boy Lincoln*, 1868 (fig. 73), Johnson places the young Lincoln's virtuous study in the glow of an enormous fireplace, with the equipment of household labor—a flatiron, a hook for a stewpot or kettle—within the hearth itself; the firelight falls brightly on the pages and reflects onto the youth's face. The two focal points in the painting—the boy ardent with virtuous ambition and the charred logs, glowing embers, and rough stones of the chimney—reflect one another, visually connecting Lincoln's character to the nostalgia of the open fire.

The Kitchen

A huge fireplace dominates Johnson's *The New England Kitchen* (fig. 71); in fact, it takes up an entire end of the narrow room, and there is room for a chair within the fireplace itself. A large stockpot hangs over the fire from a chain. A variety of implements, including a ladle, a tin saucepan, and a few baking pans, hang on the walls or sit on the shelf under the window, ready for use. Bunches of herbs are drying above the fire. The stones of the hearth and the wooden boards of the floor are

worn, even broken, but scrupulously clean. The austerity of Johnson's treatment forbids us to indulge in nostalgia. Hearty provisions may have come from this hearth, but hard work has taken place here.

This "old-fashioned" kitchen connoted not only the intimacy, but also the productivity of colonial farmsteads. The romantic glow of the fireside and the conflation of self-sufficiency and familial affection were a new significance for the kitchen: colonial housekeepers seldom discussed kitchens in symbolic terms at all. A cookbook and household manual published in 1796, Amelia Simmons's *American Cookery*, emphasized the production rather than consumption of food. The section on "Butter" gave explicit instructions for selecting and storing good-quality product. Simmons's sections on vegetables told readers how to propagate the plants; instructions for preserving perishables dominate the recipe sections.[18]

In contrast, a popular cookbook written forty-five years later by Sarah Hale, *The Good Housekeeper* (1841), stressed correct sentiment, not mere mechanical production of comestibles. Hale, a novelist and the editor of the influential women's magazine *Godey's Lady's Book*, took pains to instruct her readers in gentle sensibilities, domestic affections, modern improvements, and appreciation of old-time traditions. Even poultry recipes could be an opportunity for a lesson in delicacy. In her entry on "Pigeons," Hale listed the poultry available at the market but enjoined her readers to avoid eating robins: "The robin is sometimes killed; but it is a sin against feeling to kill a singing bird—one, too, so innocent and gentle. Any one who kills a robin to eat, ought to have it hung round his neck as the albatross was around the 'Ancient Mariner.'"[19] One's eating habits reflected one's aesthetics and morality. Through her cookbook as well as *Godey's Lady's Book*, Hale promulgated the idea of refinement, striving to glorify work that would transform homes into refuges for their inhabitants and expressions of homemakers' personalities and talents.

The industrial revolution changed the nature of household work without diminishing the labor that homemaking demanded. New ideals of domestic refinement aroused new expectations of cleanliness and attractiveness.[20] Romantic authors and artists praised the effect of refinement while ignoring the labor that it entailed. In *The House of the Seven Gables* (1851), Nathaniel Hawthorne described the way in which a housewifely girl revitalizes a grim, decrepit house:

> *Little Phoebe was one of those persons who possess, as their exclusive patrimony, the gift of practical arrangement. It is a kind of natural magic that enables these favored ones to bring out the hidden capabilities of things around them; and particularly to give a look of comfort and habitableness to any place which, for however brief a time, may happen to be their home. . . . No less a portion of such homely witchcraft was requisite to reclaim, as it were, Phoebe's waste, cheerless, and dusky chamber. . . . What was precisely Phoebe's process we find it impossible to say. She appeared to have no preliminary design, but gave a touch here and another there; brought some articles of furniture to light and dragged others into the shadow; looped up or let down a window curtain; and, in the course of half an hour, had fully succeeded in throwing a kindly and hospitable smile over the apartment.[21]*

Through similar witchery, Phoebe manages to "manufacture yeast, both liquid and in cakes," "brew a certain kind of beer, nectareous to the palate, and of rare stomachic virtues," and "bake and exhibit for sale some little spice cakes." Although by the end of the novel, the brooding atmosphere of the old house threatens to dim even Phoebe's exuberance, the author evidently believes that the culprit is the house itself, not the housework. Phoebe's housekeeping is effortless, spontaneous, and charming:

> *She was very pretty: as graceful as a bird, and graceful in much the same way; as*

pleasant about the house as a gleam of sunshine falling on the floor through a
shadow of twinkling leaves, or as a ray of firelight that dances on the wall while
evening is drawing nigh. . . . It should be woman's office to move in the midst of
practical affairs, and to gild them all, the very homeliest—were it even the scour-
ing of pots and kettles—with an atmosphere of loveliness and joy.

Writers and artists in the vanguard of domestic realism did not romanticize housework in this manner. Familial intimacy involved conflict, and it was typically depicted as a crucible testing one's supply of patience, faith, or self-abnegation. As for housework, women writers and women readers knew that it was not "natural magic," but grinding labor, including tasks that one would not normally associate with twinkling leaves or singing birds. In 1869 the noted "domestic scientist" Catherine Beecher published an article in *Harper's Bazar* revealing "How to Make the Best Family Bread with the Least Time and Labor." The directions for "Hop and Potato Yeast" might well account for Phoebe's discouragement. Beecher tells housewives to prepare potatoes and hops, "which last tie in a muslin rag." After cooking the mixture, one must "mash fine or press the potatoes through a colander," and add the yeast "when the rest is blood-warm." Once prepared, the concoction "must be renewed when it ceases to look foamy, or becomes watery with sediment at the bottom."[22] In a comprehensive housekeeping manual, *The American Woman's Home* (1869), Beecher and her sister Harriet Beecher Stowe rhapsodized about the satisfactions of homemaking but also devoted long sections to plans for hygienic earth-closets and recipes for cockroach poison. The manual addressed middle-class women and included a chapter on "The Care of Servants," but the authors assumed that even readers with servants would do substantial amounts of housework, including sewing, cleaning, gardening, and care of farm animals, not to mention managing and beautifying their households. While the authors assured readers that such undertakings were within their abilities, the sheer length of the instructions demanded a certain commitment. After sternly informing readers that "[t]he care of the Kitchen, Cellar and Store-room is necessarily the foundation of all proper housekeeping," the authors provide directions for tending the sink that contrast with Hawthorne's portrait of Phoebe, daintily rinsing teacups:

A sink should be scalded out every day, and occasionally with hot lye. On nails,
over the sink, should be hung three good dish-cloths, hemmed, and furnished with
loops; one for dishes not greasy, one for greasy dishes, and one for washing greasy
pots and kettles. These should be put in the wash every week. . . . Under the sink
should be kept a slop-pail; and, on a shelf by it, a soap-dish and two water-pails. A
large boiler of warm soft water should always be kept over the fire, well-covered,
and a hearth-broom and bellows be hung near the fire.[23]

In her novel *Queechy* (1852), Susan Warner described the arduous labor required to keep a farm household functional, let alone pretty and refined. One of many domestic novels depicting reversals of fortune, *Queechy* told of Fleda Ringgan, who is taken into a wealthy family but must make use of the farmhouse skills of her childhood when her adoptive family is reduced to poverty. The heroine's scrambles to get food for the family fill some three hundred pages of dense prose, recording the work of hired hands, aunts and cousins, and the heroine in exhaustive detail. Warner described tasks familiar to most American women, from cooking omelettes, picking watercress, making soap, and darning gloves, to haymaking, preparing chicken feed, and tapping maple trees for sugar.[24]

Wealth did not necessarily free women from boring, exacting housework. As a child growing up in New York City in the 1830s, Warner herself devoted pages of her journal to records of her housekeeping duties in her father's luxurious town houses: she "rubbed two of the back parlour chairs, with a waxed cloth," "swept

the two lower piazza's, and dusted the blinds," "rubbed the knobs of my worktable, with whiting," and "washed all the set of white china, & Aunty wiped it; it took us about 4 hours."[25] In one of her last novels, *The Letter of Credit* (1882), Warner described the excruciating job of patching linen, a kind of "plain work" done by all but the very wealthiest women:

> *The rest of the history of that afternoon is the history of a patch. How easy it is, to an unskilled hand, to put on a linen patch by a thread, let anyone who doubts convince herself by trying. Rotha basted it on, and took it off, basted it on again and took it off again; it would not lie smooth, or it would not lie straight; and when she thought it would do, and shewed it to her aunt, Mrs. Busby would point out that what straightness there was belonged only to one side, or that there was a pucker somewhere.[26]*

Later in the novel, Rotha faces the genuinely horrifying prospect of doing laundry. After quailing at the task, Rotha resolves to do her duty, but not before Warner has communicated the girl's dismay:

> *It suddenly flashed upon Rotha that she must have some clothes washed. That she should ask Mrs. Purcell to do it, was out of the question. That she should hire somebody else to do it, was equally out of the question. There remained—her own two hands.*
>
> *Her hands. Must she put them into the wash tub? Must they be roughened and reddened by hard work in hot and cold water?*
>
> *. . . She went through a hard struggle and a painful one, before she could take meekly what was put upon her.[27]*

It is easy now to misread Rotha's aversion to laundry as affectation or hyperbole, because we easily forget what painful labor laundry, mending, and cooking actually required. Such forthright descriptions of the "feminine sphere" reminded readers that no matter how honorable homemaking might be, it was still *work* meriting recognition.

Johnson's *Mother and Child* (No. 81) is a reminder of the demands as well as the satisfactions of domesticity. A woman sits in a rocker before her kitchen stove. The open doors of the stove reveal the glowing fire; the mother gazes tenderly at her sleeping child. The baby fits a little awkwardly into her lap, looking a little heavy, and the mother's face is weary as well as loving; her skirt looks dusty and she rests a foot on the stove ledge. The tidy kitchen, decorated with a pretty wreath, is filled with the accoutrements of housework, buckets and mixing bowls and pans. The diffuse light reflects off the large, sturdy water-boiler sitting ready on the stove top, presumably filled with soft water as Beecher and Stowe recommended, ready for work as soon as this moment of fireside rest is over.

The Parlor

If the kitchen was the heart of the home, the parlor mediated between the home and the outside world. Anticipating the terminology of cultural historians, *The Christian Home* (1868), a household manual published the year before *The American Woman's Home*, analyzed the "home-parlor":

> *In it we have a view of the relations of home to society beyond it. The parlor is set apart for social communion with the world. Much of momentous interest is involved in this relation. The choice of companions, the forming of attachments and matrimonial alliances, the establishment of social position and influence in life beyond the family,—these are all involved in the home-parlor.[28]*

In the parlor, the family's taste was on display; but for domestic writers, in marked contrast to advocates of the Aesthetic Movement, taste was inseparable from ethics. A "homelike" parlor combined modern convenience with old-fashioned intimacy

and industry; thrift and homemade contrivances were more beautiful, because more meaningful, than stylish furniture. Dramatizing her domestic principles in the novel *Pink and White Tyranny*, Harriet Beecher Stowe savaged a frivolous decision to update a parlor. In its original decor, the parlor is the setting for hospitality, study, and charity, a natural extension of the old-fashioned sincerity of the family who live there:

> It was a parlor of the past, and not of to-day, yet exquisitely neat and well-kept. The Turkey carpet was faded: it had been part of the wedding furnishing of Grace's mother, years ago. The great, wide, motherly, chintz-covered sofa, which filled a recess commanding the window, was as different as possible from any smart modern article of the name. The heavy, claw-footed, mahogany chairs; the tall clock that ticked in one corner; the footstools and ottomans in faded embroidery,—all spoke of days past. So did the portraits on the wall. One was of a fair, rosy young girl, in a white gown, with powdered hair dressed high over a cushion. It was the portrait of Grace's mother. Another was that of a minister in gown and bands, with black-silk gloved hands holding up conspicuously a large Bible. This was the remote ancestor, the minister. Then there was the picture of John's father, placed lovingly where the eyes seemed always to be following the slight, white-robed figure of the young wife. The walls were papered with an old-fashioned paper of a peculiar pattern, bought in France seventy-five years before. The vases of India-china that adorned the mantels, the framed engravings of architecture and pictures in Rome, all were memorials of the taste of those long passed away. Yet the room had a fresh, sweet, sociable air. The roses and honeysuckles looked in at the windows; the table covered with books and magazines, and the familiar work-basket, with its work, gave a sort of impression of modern family life.[29]

When a worldly woman marries into the family and refurbishes the house following the dictates of a decorator, her husband paces the redecorated rooms uneasily, affording Stowe the opportunity to lecture the reader in the semiotics of decor:

> Rooms have their atmosphere, their necessities, their artistic properties. Apartments à la Louis Quatorze represent the ideas and the sympathies of a period when the rich lived by themselves in luxury, and the poor were trodden down in the gutter; when there was only aristocratic contempt and domination on one side, and servility and smothered curses on the other. With the change of the apartments to the style of that past era, seemed to come its maxims and morals, as artistically indicated for its completeness. . . . [John] never felt like lolling at ease on any of those elegant sofas, as of old he used to cast himself into the motherly arms of the great chintz one that filled the recess.[30]

A set of associations as deep-rooted and powerful as the domestic ideal could, of course, be commodified. Domestic imagery could be appropriated to sell virtually anything. The models of taste proposed by the British aesthete Charles L. Eastlake and popularized by department stores and mass-marketing ventures demanded the expenditure of considerable amounts of money. In contrast, many domestic writers urged women to substitute elbow grease and ingenuity for pretentious purchases. A chapter in *The American Woman's Home* on "Home Decoration" explained how to construct a homemade sofa, a process that Stowe described earlier in a letter to her sister-in-law: "Good Mrs. Mitchell and myself made two sofas, or lounges, a barrel chair, divers bedspreads, pillow cases, pillows, bolsters, mattresses; we painted rooms; we revarnished furniture; we—what *didn't* we do?"[31]

Having hammered together and upholstered the furniture for her parlor, the housewife could not yet rest from her labors. Careful attention was called for daily to keep the room nice. A chapter titled "The Care of Rooms" commands women to tend their furniture carefully, dusting it with silk rags and homemade polish:

"Some persons rub in linseed-oil; others mix bees-wax with a little spirits of turpentine and rosin, making it so that it can be put on with a sponge, and wiped off with a soft rag."[32] The actions of cleansing and dusting were more essential than the purchased materials.

The domestic paradigm could be adapted to wealth or near-poverty, but the ideal synthesized the productivity of the farmhouse with the refinement and comfort of the town house. Richer or poorer homes, or those more urban or more rural than the golden mean, won approval for the extent to which they approximated this irresistible combination. In *Queechy*, Susan Warner described her heroine's delight in a homely old farmhouse, with low ceilings, whitewashed walls, and "chocolate color" woodwork; in *My Desire*, the more sophisticated town house of a wealthy gentleman was nonetheless praised for its air of old-fashioned welcome:

> *Every nook and corner of it is pleasant to my eyes, from the wide hall and the easy, gentle staircase, to the drawing-room with its dark old spindle-legged and inlaid tables and soft, thick Persian carpet. There are pictures, old china, antique bronzes, quaint old-fashioned lamps, wide fireplaces, and blazing wood fires. Nothing is brilliant or showy or in the fashion of to-day; everything is comfortable, quiet to the eye, easy to the hand and foot.*[33]

The drawing-room in *My Desire* resembles the setting of Johnson's *The Hatch Family*, 1871 (No. 83). Although the painting does not include a fireplace, the warm reds and auburns of the drapes, sofa, and rug evoke the colors of the hearth. Despite the expensive and fashionable Renaissance Revival drapes and carved mahogany furniture, the parlor has an old-fashioned air of intimacy and business. The entire family, including three generations and eleven children, is encompassed by the space, and both work (sewing and writing) and productive play (sketching, reading periodicals, putting together a puzzle) are taking place there. A large painting and several sculptures are visible. The rich, beautiful carpet is scattered with children's toys, including an undressed doll tossed in a corner; a teenage boy rests his foot on the arm of a magnificent tufted chair; and the gas light that hangs from the ceiling illuminates grandfather's newspaper, grandmother's work, and the children's careful play with the baby. Nothing in the room is merely for show.

The parlor indicated its occupants' educations, whether formal, self-taught, or aspirational. Domestic novelists did not subscribe to the Romantic belief that book learning was antithetical to spontaneous feeling and especially inappropriate for women. On the contrary, they insisted that scholarship enriched a woman even as educational materials—books, maps, travel souvenirs, stereoscopes, even the plaster statuettes mass-produced by John Rogers—enhanced the home atmosphere. Domestic novels recorded female characters' studies in meticulous detail. In *Queechy*, Warner presented a list of some twenty-three books that the precocious heroine has read over the course of a year, ranging from Lacretelle's *Histoire de France* and Paley's *Natural Theology* through *Paolo e Virginia* and *The Faerie Queene*; the list was based on her own readings as an adolescent. Nor does Fleda's belles-lettres education hinder her when she is called on to scrub, mend, cook, and manage a farm.[34] Even Martha Finley's insipid Elsie Dinsmore, heroine of a heavily didactic series of children's books, is described studying mathematics and Latin.[35]

In sitting rooms the presence of books, writing materials, and decorations, however improvised or scant, testified to the occupants' participation in intellectual experiences that transcended decorative purchases. *The American Woman's Home* urged women to economize on carpeting to reserve funds for chromolithographs, listing Johnson's *The Barefoot Boy*, 1867 (fig. 53), among the "really admirable pictures of some of our best American artists." "Besides the chromos," Beecher and Stowe continued, "which, when well-selected and of the best class, give the charm

FIG. 74
Anna Warner
"Hanging Basket of Cocoa-Nut Shell, with Kenilworth Ivy"
From Anna Warner, *Gardening by Myself* (New York: Randolph, 1872)

of color which belongs to expensive paintings," thrifty housekeepers might choose engravings, or "a few statuettes," which would give "a really elegant finish to your rooms." But elegance alone was not the point. Art in the home would encourage creative imagination:

> Surrounded by such suggestions of the beautiful, and such reminders of history and art, children are constantly trained to correctness of taste and refinement of thought, and stimulated—sometimes to efforts at artistic imitation, always to the eager and intelligent inquiry about the scenes, the places, the incidents represented.[36]

A few authors indulged in the use of intellectual motifs to the point of self-parody, inviting ridicule from reviewers. Augusta Evans Wilson, for example, decorated a gentleman's sitting room in her novel *St. Elmo* in this extraordinary fashion: "The walls were painted in Saracenic style, and here and there hung specimens of Oriental armor—Turcoman cimeters, Damascus swords, Bedouin lances, and crimson silk flag, with heavy gold fringe, surmounted by a crescent. . . . A huge plaster Trimurti stood close to the wall, on a triangular pedestal of black rock, and the Siva-face and the writhing cobra confronted all who entered."[37] The heroine of *St. Elmo* masters not just Greek and Latin, but Hebrew, Chaldean, and Egyptian hieroglyphics. Reviewers snickered at Wilson's excesses, but the message was that education was crucial in a democratic society, a public duty as well as a private amenity. At the end of *Uncle Tom's Cabin*, Stowe described the sitting room of George and Eliza Harris, former slaves who have escaped to Canada:

> The scene now changes to a small, neat tenement, in the outskirts of Montreal; the time, evening. A cheerful fire blazes on the hearth; a tea-table, covered with a snowy cloth, stands prepared for the evening meal. In one corner of the room was a table covered with a green cloth, where was an open writing-desk, pens, paper, and over it a shelf of well-selected books.[38]

The sketchy description telegraphed to nineteenth-century readers the genuinely admirable values and hopes of the Harris family, who realize some of their dreams through extraordinary courage. The books and desk are emblematic of the desire for intellectuality, rather than simple upward mobility; the snowy cloth, emblem of refinement, testifies to hours of bleaching, wringing, and ironing.

Conversely, in *The Letter of Credit*, Susan Warner provides a cautionary example of a room bereft of the domestic spirit:

> It was so full of luxury. The soft plush carpet, the thick rug on which she was crouching; how they glowed warm and rich in the red shine of the fiery gate; how beautiful the crimson ground was, and how dainty the drab tints of the flowers running over it. How stately the curtains fell to the floor with their bands of drab and crimson; and the long mirror between them, redoubling all the riches reflected in it. . . . [T]he rest of the room was bare of everything but furniture. The furniture was elegant; but the chairs stood round the sides of the room with pitiless regularity and seemed waiting for somebody that would never come. Empty riches! Nothing else.[39]

Their intense focus on material objects notwithstanding, domestic writers distanced themselves from commercial versions of domesticity, insisting that artistic decor did not demand discretionary income. "If you live in the country, or can get into the country, and have your eyes opened and your wits about you, your house need not be condemned to an absolute bareness," the authors of *The American Woman's Home* wrote sternly.[40] Anna Warner's handbook *Gardening by Myself* (1872) suggested that readers make a "hanging-basket of cocoa-nut shell," filled "with Kenilworth ivy" (fig. 74).[41] *Godey's Lady's Book* and *Harper's Bazar* provided instructions and patterns for homemade decorative objects. While some of the suggestions in magazines and manuals seem ill-advised, "fancy work," or homemade

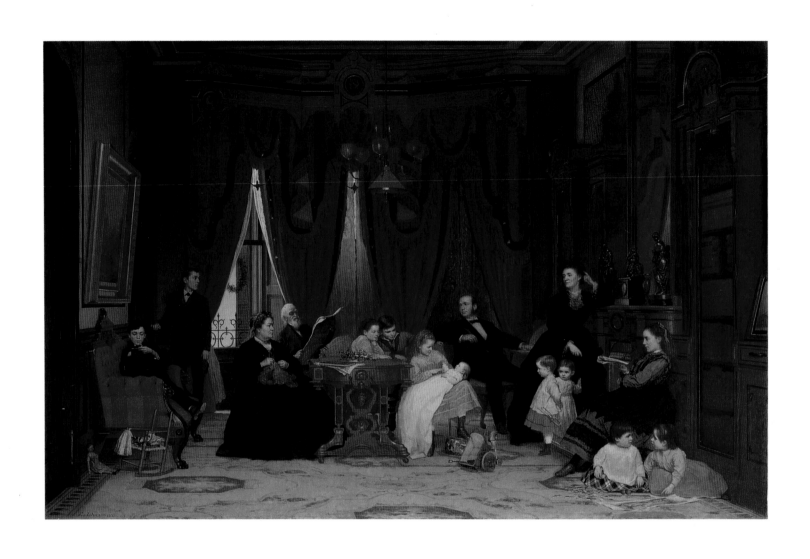

NO. 83
The Hatch Family, 1871
Oil on canvas, 48 x 73⅜ in.
The Metropolitan Museum of Art, New York,
Gift of Frederic H. Hatch, 1926 (26.97)

NO. 84
Study for "The Hatch Family," Mrs. Ruggles, 1871
Graphite and charcoal heightened with white on
paper, 9⅞ x 7¾ in.
Collection of Mr. and Mrs. Stuart P. Feld

NO. 85
Study for "The Hatch Family," Mrs. Hatch, 1871
Graphite and charcoal on paper, 8⅝ x 9 in.
Collection of Mr. and Mrs. Stuart P. Feld

FIG. 75
"Toothpick or Match Safe"
From *Godey's Lady's Book and Magazine*
(May 1867)

art objects designed by the creator, was a kind of expressive decor that could be improvised from even the most unlikely materials. One might wonder about the "Toothpick or Match Safe" that *Godey's Lady's Book* suggested readers construct from "portions of lobster shell and pieces of bright-colored velvets or silks," but it displayed undeniable originality, and demonstrated vividly the remarkable potential lurking in what might easily be dismissed as rubbish (fig. 75).[42] Sarah Orne Jewett's depiction of an isolated island cottage in *The Country of the Pointed Firs* (1896) evokes both the pathos and the strength of a house beautified by flotsam and jetsam. In rural dialect, a character describes the sitting room:

> *"Joanna had done one thing very pretty. There was a little piece o' swamp on the island where good rushes grew plenty, and she'd gathered 'em, and braided some beautiful mats for the floor and a thick cushion for the long bunk. She'd showed a good deal of invention; you see there was a nice chance to pick up pieces o' wood and boards that drove ashore, and she'd made good use o' what she found. There wasn't no clock, but she had a few dishes on a shelf, and flowers set about in shells fixed to the walls, so it did look sort of homelike, though so lonely and poor."*[43]

Johnson provides many of the simple farmhouses in his paintings with similar tokens of imagination: the family in *Fiddling His Way* (No. 78) listens rapturously to an itinerant musician, and one frequently spots a geranium on a windowsill or some pretty china on a shelf even in the humblest interiors.

Twentieth-century critics have been embarrassed by the effusive language and clichéd images of nineteenth-century domesticity, and have turned away from them with the dismissive, automatic label "sentimental."[44] In fact, the creators of domestic culture knew the work of the home and depicted it accurately. Although the primacy of the home and household work have become ideologically charged issues, appropriated by advertisers and antifeminists, distortions of domesticity do not lessen the validity of seeing the home as a place in which aesthetics, comfort, and ethics ought to converge. Both genre painters and domestic novelists saw what is resolutely ordinary, what is closest to home, as the most important subject at hand for men and women alike. For Eastman Johnson, even kitchen floors deserved appreciation; in letters to Jervis McEntee, Johnson told his friend, "[I]f the blues beset you decend to your new kitchen floor & contemplate its clean, well jointed, and fresh expanse, & think how long it will last, how white it will be kept, what cold it will keep out, what loads of comfort & hospitality it will send up from day to day" and reproached him, "[T]he truth is you *dont know what you are walking on.*"[45] Johnson's paintings, Joanna's lonely cabin, and even those bizarre lobster-shell creations celebrate the ability to cherish what otherwise might be discarded, overlooked, or taken for granted.

Eastman Johnson believed that small subjects and small events fully deserved the respect of artists and audiences. Johnson's *The Tea Party*, 1874 (fig. 76), depicts a small girl playing with her dolls. She is sitting on the kneeler of a prie-dieu; the sacred furniture frames her small shape. This tea party may have ritual elements, but the little girl is not a delicate angel. She is a sturdy, dumpy toddler. She sits squarely, knees wide apart, feet planted firmly on the carpet. Her expression is one of ferocious concentration as she tries to give a favorite doll some tea as it lies supine across her lap. Scaled to the child's perception, the prie-dieu towers over her head; an armchair to her left seems enormous, but the carpet on which the toy pitcher and saucer sit is vividly detailed with bright figures, a jubilant reminder of what we "are walking on." At once particular and familiar, this scene is domestic realism at its most joyous, urging us to treasure commonplace moments that we might easily overlook.

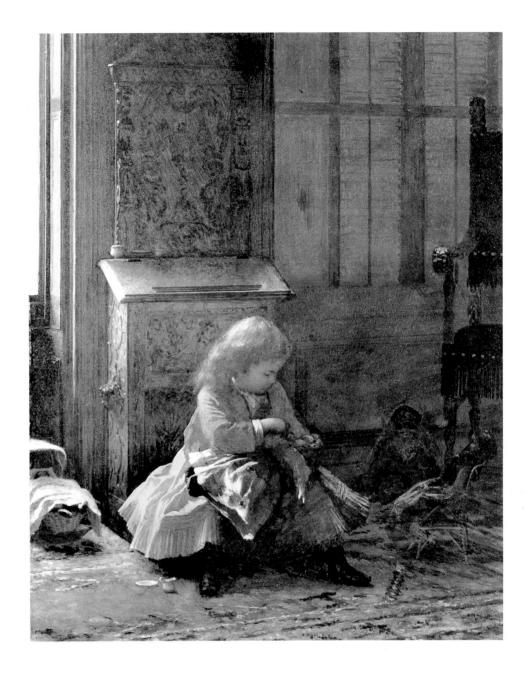

Notes

1. Illustration by Frederick Dielman in Susan Warner, *The Wide, Wide World* (1850; reprint, Philadelphia: Lippincott, 1888), p. 297. Information on sales of *The Wide, Wide World* appears in Frank Luther Mott, *Golden Multitudes: The Story of Best Sellers in the United States* (New York: Macmillan, 1947), p. 124.

2. Through an examination of borrowing patterns at the New York Society Library, Ronald J. Zboray demonstrates the similarities between male and female readers' tastes in *A Fictive People: Antebellum Economic Development and the American Reading Public* (New York: Oxford University Press, 1993), chapter 11, "Gender and Boundlessness in Reading Patterns" (pp. 156–79). Well-received domestic writers included Caroline Kirkland and Susan Warner, journalists Fanny Fern and Grace Greenwood, reformers Harriet Beecher Stowe and Caroline Chesebro', and Gothic fantasists Augusta Evans Wilson and E. D. E. N. Southworth. Several male writers dabbled in the genre, and one, E. P. Roe, made a career in domestic fiction.

3. Nathaniel Hawthorne, *Letters of Hawthorne to William D. Ticknor* (Newark, N.J.: Carteret Book Club, 1910), vol. 1, p. 75. Hawthorne asked Ticknor, "What is the mystery of these innumerable editions of the Lamplighter, and other books neither better nor worse?—worse they could not be, and better they need not be, when they sell by the 10,000." He then jokingly suggested that Grace Greenwood has "stabbed a man" and is in "the State prison."

4. Anonymous review, *New-York Daily Tribune*, clipping [circa 1852], Warner Diary, Constitution Island Association Archives, West Point, New York.

5. Anonymous review, *Newark Advertiser*, clipping, Warner Diary, Constitution Island Association Archives, West Point, New York.

6. "National Academy of Design," *New-York Daily Tribune*, June 18, 1868, p. 2.

7. Alexander Cowie's *The Rise of the American Novel* (New York: American Book Co., 1948) dismissed the domestic novel as "an extended prose tale composed chiefly of commonplace household incidents and episodes casually worked into a trite plot involving the fortunes of characters who exist less as individuals than as carriers of moral or religious sentiment" (p. 413); most Americanists of the 1950s and 1960s ignored the genre altogether. Ann Douglas's *The Feminization of American Culture* (New York: Knopf, 1977) was among the first extended analyses of domestic literature, although Douglas concluded that the domestic writers were limited, antiintellectual moralists against whom the canonical authors revolted. David S. Reynolds's *Beneath the American Renaissance: The Subversive Imagination in the Age of Hawthorne and Emerson* (New York: Knopf, 1988) reiterates Douglas's thesis.

8. Judith Fetterley points out that in their appreciation of the quotidian rather than the exceptional, "American women writers were realists well before the Civil War," in *Provisions: A Reader from Nineteenth-Century American Women* (Bloomington: Indiana University Press, 1985), p. 10, and David Shi connects domestic writers with later American realists in *Facing Facts: Realism in American Thought and Culture, 1850–1920* (New York: Oxford University Press, 1995), pp. 34–36. Jane Tompkins argues that domestic novelists made coherent and powerful political and theological arguments through their fiction in *Sensational Designs: The Cultural Work of American Fiction, 1790–1860* (New York: Oxford University Press, 1985). Two extremely useful overviews of domestic fiction by women are Nina Baym, *Women's Fiction: A Guide to Novels by and about Women in America, 1820–1870* (Ithaca, N.Y.: Cornell University Press, 1978), and Susan K. Harris, *19th-Century American Women's Novels: Interpretive Strategies* (Cambridge: Cambridge University Press, 1990).

9. "Fine Arts. National Academy of Design," *New-York Daily Tribune*, June 18, 1868, p. 2.

10. Harriet Beecher Stowe, *Pink and White Tyranny* (Boston: Roberts Brothers, 1871), p. 231.

11. For extensive discussion of preindustrial America, see Stephanie Grauman Wolf, *As Various as Their Land* (New York: HarperCollins, 1993), pp. 139–210, and Jane Nylander, *Our Own Snug Fireside* (New York: Oxford University Press, 1993), pp. 165–82.

12. The impact of industrialization is vividly described in Susan Strasser, *Never Done: A History of American Housework* (New York: Pantheon, 1982), pp. 180–201, and Jack Larkin, *The Reshaping of Everyday Life, 1790–1840* (New York: HarperCollins, 1988), pp. 2–61.

13. Nylander, *Our Own Snug Fireside*, discusses the advantages of stoves and misgivings that New Englanders felt at relinquishing their open fires (pp. 96–102). Strasser, *Never Done*, describes the transition to stoves on pp. 50–66.

14. Laura C. Holloway, *The Hearthstone; or, Life at Home* (Chicago: L. P. Miller, 1889), pp. 34–35.

15. Susan Warner, *My Desire* (1880; reprint, London: Nisbet, n.d.), p. 227.

16. Louisa May Alcott, *Little Women* (1868; reprint, Boston: Little, Brown, 1902), p. 10.

17. Eastman Johnson to Jervis McEntee, November 17, 1879, frame 457, reel D30, and December 2, 1880, frame 469, reel D30, Charles E. Feinberg Collection of Artists' Letters, Archives of American Art, Smithsonian Institution, Washington, D.C. Also see Appendix.

18. Amelia Simmons, *The First American Cookbook: A Facsimile of "American Cookery, 1796"* (New York: Dover, 1984), p. 9. Simmons instructs cooks to "go into the centre of balls or rolls to prove and judge it; if in firkin, the middle is to be preferred, as the sides are frequently distasted by the wood of the firkin," and to store the commodity "in the coldest part of your cellar, or in the ice house."

19. Sarah Josepha Hale, *Early American Cookery: "The Good Housekeeper," 1841* (1841; reprint, New York: Dover, 1996), p. 53.

20. Richard L. Bushman, in *The Refinement of America: Persons, Houses, Cities* (New York: Vintage, 1993), discusses the dialectic of fashion and domesticity; Nancy F. Cott, in *The Bonds of Womanhood: "Woman's Sphere" in New England, 1780–1835*, 2d ed. (New Haven: Yale University Press, 1997), examines the development of the "cult of true womanhood."

21. Nathaniel Hawthorne, *The House of the Seven Gables* (1851; reprint, New York: Bantam, 1993), pp. 68–69. Subsequent references are to the Bantam edition, p. 75.

22. Catharine [*sic*] Beecher, "Gastronomy: How to Make the Best Family Bread with the Least Time and Labor," *Harper's Bazar* (August 14, 1869), p. 522. Susan Strasser discusses the limitations of Beecher's attempts to dignify housework and the contradictions of the ideology of "separate spheres" in *Never Done*, pp. 185–201.

23. Catherine Beecher and Harriet Beecher Stowe, *The American Woman's Home* (1869; reprint, Hartford, Conn.: Harriet Beecher Stowe Foundation, 1996), p. 372.

24. Susan Warner, *Queechy* (1852; reprint, London: Routledge, 1853).

25. Jane Weiss, "'Many Things Take My Time': The Journals of Susan Warner," Ph.D. dissertation, City University of New York, 1995, pp. 62, 77, 82, 200.

26. Susan Warner, *The Letter of Credit* (New York: Robert Carter & Brothers, 1882), p. 426.

27. Ibid., pp. 574–75.

28. A. M. Phillips, *The Christian Home* (Springfield, Mass.: Gurdon Bill, 1868), pp. 256–58.

29. Stowe, *Pink and White Tyranny*, pp. 21–22.

30. Ibid., p. 138.

31. Annie Fields, ed., *Life and Letters of Harriet Beecher Stowe* (Boston: Houghton Mifflin, 1868), p. 128.

32. Beecher and Stowe, *The American Woman's Home*, pp. 137–38.

33. Warner, *My Desire*, pp. 260–61.

34. Warner, *Queechy*, pp. 142–45.

35. One typical discussion of education appears in Martha Finley's *Elsie's Widowhood* (New York: Dodd, Mead and Company, 1880), pp. 96–100. Schoolroom and study scenes appear in many of the twenty-seven volumes in the series.

36. Beecher and Stowe, *The American Woman's Home*, pp. 93–94.

37. Augusta Evans Wilson, *St. Elmo* (1866; reprint, New York: Grosset and Dunlap, 1896), p. 57.

38. Harriet Beecher Stowe, *Uncle Tom's Cabin* (1852; reprint, New York: Penguin, 1981), p. 604.

39. Warner, *The Letter of Credit*, pp. 411–12.

40. Beecher and Stowe, *The American Woman's Home*, p. 94.

41. Anna Warner, *Gardening by Myself* (1872; reprint, West Point, N.Y.: Constitution Island Association, 1972), p. 1.

42. *Godey's Lady's Book* (May 1867), pp. 406–7. Beverly Gordon calls attention to this unique example in "Victorian Fancywork in the American Home: Fantasy and Accommodation," in *Making the American Home: Middle-Class Women and Domestic Material Culture, 1840–1940*, ed. Marilyn Ferris Motz and Pat Browne (Bowling Green, Ohio: Bowling Green State University Popular Press, 1988), pp. 48–68.

43. Sarah Orne Jewett, *The Country of the Pointed Firs* (1896; reprint, New York: Dover, 1996), p. 55.

44. Jane Tompkins dates this reaction to the turn of the twentieth century, describing the western novel as part of a backlash against the feminist overtones of domesticity. Westerns depicted the home as a repressive enclosure, filled with feminine affectations and furbelows that men should escape. See Jane Tompkins, *West of Everything: The Inner Life of Westerns* (New York: Oxford University Press, 1992), pp. 28–45. Nineteenth-century reviewers frequently used terms such as "tender," "delicate," and "sweet" to praise male as well as female artists and writers; twentieth-century reviewers have as a rule disdained such qualities, especially in works by men.

45. Eastman Johnson to Jervis McEntee, June 12, 1866, frame 132, reel 4707, and July 25, 1862, frame 509, reel D30, Charles E. Feinberg Collection of Artists' Letters. For July 25 letter, also see Appendix.

FIG. 77
Carte de visite of Eastman Johnson, circa 1865
Brooklyn Museum of Art Library Collection,
Schweitzer Gallery Files

FIG. 78
Napoleon Sarony
Portrait of Winslow Homer, circa 1880
Photograph
Bowdoin College Museum of Art, Brunswick,
Maine, Gift of the Homer Family, 1964.69.179.4

In Whose Shadow?
Eastman Johnson
and Winslow
Homer in the
Postwar Decades

SARAH BURNS

Now one of the canonized masters of American art, Winslow Homer (1836–1910) has loomed so large as a towering force in recent years—indeed, for much of the twentieth century—that his example continues to skew our perspectives on art life and practice in the Gilded Age. This is still the case, despite a prodigious expansion and refinement of American art-historical scholarship on nineteenth-century visual and material culture. Most tellingly, the huge Homer retrospective mounted in 1995 by the National Gallery of Art in Washington, D.C., almost entirely neglected to mention any of Homer's art-world peers in New York and Boston, linking him instead with such transatlantic giants as Edgar Degas and James McNeill Whistler.[1]

Such distorted views do little to adjust our understanding of the decades when Homer—then a very long way from great masterhood—was one of the pack, competing for business and recognition in the culturally turbulent American climate of the 1860s and 1870s. At the time, the name most frequently linked with Homer's was that of Eastman Johnson, Homer's senior by a weighty twelve years. Then playing at the very top of his form as *the* foremost celebrant of American life and character, Johnson was the towering figure who cast a long shadow over those who, like Homer, aspired to similar success in the field.

With the exception of spadework done by Patricia Hills and John Wilmerding, scholarship on the relationship between the two artists remains thin.[2] It is true that beyond a couple of significant documentary scraps, there is almost nothing to go on, save for what can be deduced from records of the two painters' social and professional movements during the 1860s and 1870s, when both were bent on establishing and securing their reputations in New York City. The principal evidence of whatever bound or separated them lies in the works themselves and, secondarily, in how viewers responded to them at the time.

Despite such handicaps, further investigation of their connections gives access to a richer and more complex understanding of the time when Johnson, not Homer, was supreme among his peers—yet never averse to watching Homer and occasionally appropriating his tricks. Throughout the sixties and seventies, Homer's reputation was uneven, though he was almost always a painter worth watching, if not liking. About 1870, almost no one (except, perhaps, Homer himself, in fantasy) could have foreseen that the eccentric, contrary commercial-illustrator-turned-painter would ever eclipse the older, professionally trained, infinitely smoother practitioner of genre.

Critics of the day routinely accorded Johnson the status of America's premier painter of scenes from everyday life. In 1867 the critic Henry T. Tuckerman published *Book of the Artists*, a detailed and comprehensive critical geography of the art world, its major and minor players, and its greater and lesser works. The author devoted a good five pages to Johnson, including lengthy extracts from journals and newspapers, praising Johnson's truthfulness, tender feeling, and affecting pictorial narratives. "In all his works," wrote Tuckerman, "we find vital expression, sometimes *naive*, at others earnest, and invariably characteristic; trained in the technicalities of his art, keen in his observation, and natural in his feeling, we have a *genre* painter in Eastman Johnson who has elevated and widened its naturalistic scope and its national significance. His pictures are in constant demand and purchased before they leave the easel." By contrast, Homer received all of two sentences, in which Tuckerman remarked on the success of Homer's only hit to date, *Prisoners from the Front*, 1866 (The Metropolitan Museum of Art, New York), which, despite "some inadequacy of color," had "won more praise than any *genre* picture by a native hand that has appeared of late years."[3]

Soon after, Homer's own good friend, the painter and critic Eugene Benson (1839–1908), ranked Johnson as "unquestionably the first name" among contempo-

raries specializing in genre scenes. Writers sometimes paired Homer's name with
Johnson's in holding them up as stalwart celebrants of pure American values, stand-
ing firm against the tide of French fashion threatening to overwhelm the native
spirit in painting. More often, however, Homer failed to measure up to Johnsonian
standards. At the Philadelphia Centennial Exhibition, for example, Johnson's *The
Old Stage Coach*, 1871 (No. 86), and Homer's *Snap the Whip*, 1872 (fig. 79), attracted
one critic's attention as products of a genuine "American school" of genre, which
featured an "exuberant sense of sunshine, and of sympathy with nature." Like
Johnson, Homer was "entirely free from foreign influences"; he had the same sensi-
bility and the same feeling for nature. Nevertheless, he did not have "the same
force" as the older man (an observation that is ironic, in light of the fact that
Homer's forcefulness in the later seascapes earned him wildly enthusiastic admira-
tion). In contemporary eyes, Homer's career subsequent to the stunning success of
Prisoners from the Front constituted a perverse and irritating deviation. Periodically,
throughout the seventies, critics measured Homer's current work well short of his
own past mark in *Prisoners*, leading the painter at one point to snap that he was
"sick of hearing about that picture." He earned the highest approval when his work
in subject and sentiment approached Johnson's.[4]

The two painters, both Yankees, had circulated in the same territory from early
on. At the age of sixteen, Johnson apprenticed for about two years in the shop of a
Boston lithographer—as did Homer when he entered Bufford's as an apprentice in
1854. In 1846 Johnson was back in Boston, summoned by the poet Henry Wadsworth
Longfellow to execute a group of crayon portraits (see Nos. 3–5, 70); he continued
on there until embarking for Düsseldorf in 1849. During that time Homer was a
teenager in Cambridge, where Longfellow, famously, resided. Johnson's early success
in portraiture and Homer's commercial training foreshadowed the means by which
each made his living while pursuing genre subjects: Johnson as portrait painter to
New York's elite; Homer as prolific and successful illustrator for popular magazines,
most notably *Harper's Weekly*, to which he contributed from 1859 until 1875, when
watercolor supplanted graphic art as his bread-and-butter medium.

Johnson returned from Europe in October 1855 and moved to New York to take
a studio in the University Building on Washington Square in April 1858. Marrying
in 1869, he remained there until 1872 and then shifted both his social and profes-
sional activities uptown. Homer moved to New York from Boston in the fall of 1859.
In 1862 he rented studio space in the University Building, which served as his base
of operations until 1871, when he moved to the Tenth Street Studio Building.

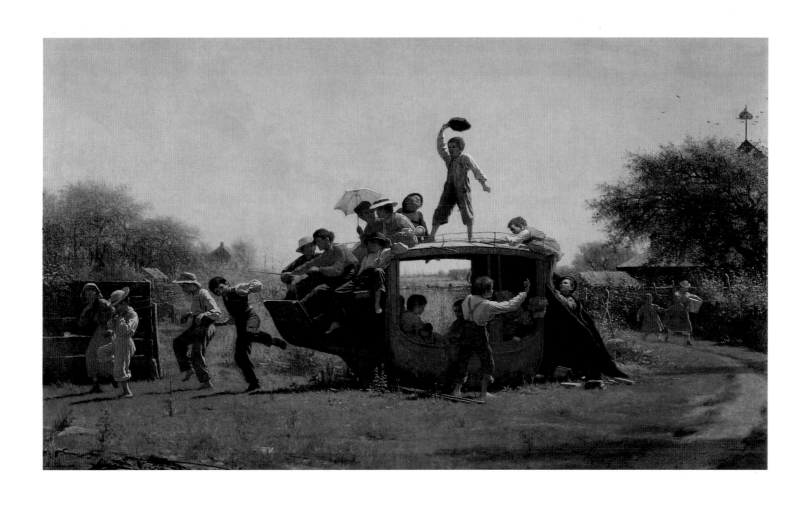

NO. 86
The Old Stage Coach, 1871
Oil on canvas, 36¼ x 60⅛ in.
Milwaukee Art Museum, Layton Art Collection,
Gift of Frederick Layton (L1888.22)

For the better part of a decade, Johnson and Homer were cohabitants in the University Building. In addition, both were National Academicians: Johnson gained full membership in 1860, Homer in 1865. In 1862 Johnson was admitted to membership in the elite Century Association. On November 30, 1865, Homer, nominated by Eastman Johnson and the portrait painter William Oliver Stone (1830–1875), also won election to the Century—a prime venue for making contacts with potential patrons. Until the end of the seventies, Homer exhibited and often attended meetings there; Johnson remained an active member all his life.

Their patterns of work and travel were strikingly congruent as well. As artist-civilians, they toured Union army encampments and even witnessed action in the course of the Civil War. For both, these experiences proved a rich source of imagery and, in at least one instance, of direct iconographic transmission: John Wilmerding and Patricia Hills have suggested that Homer's 1863 lithograph *The Letter for Home* from the portfolio *Campaign Sketches* was a likely source for Johnson's oil painting, *The Field Hospital*, 1867 (No. 82)—an early example of Johnson's tendency to watch Homer, almost as much as Homer watched him.[5]

In the mid-sixties Johnson made annual pilgrimages to his native state of Maine, where he studiously planned his panoramic though never-completed celebration of good times in a Down East maple-sugar camp. By 1870 he had "discovered" the island of Nantucket, the subject and setting of his most celebrated rustic genre pictures: *The Old Stage Coach*; *Husking Bee, Island of Nantucket*, 1876, and *The Cranberry Harvest, Island of Nantucket*, 1880 (Nos. 86, 44, and 60). In the later seventies, once more in Maine, he produced a cluster of barn interiors, in which his daughter and her little friends modeled for scenes of happy, rustic play. Meanwhile, Homer too roamed the countryside to stake out his own artistic territory, painting up-to-date young women at croquet in Belmont; beachgoers in Manchester, Massachusetts, and Long Branch, New Jersey; children in the picturesque seaport of Gloucester, Massachusetts; campers in the Adirondacks; and farm girls in rural New York State.

Most genre painters of the period traced similar patterns of activity: country travels in search of the picturesque and city winters spent networking, exhibiting, and marketing the results of the summer's labors. On his rambles Homer sometimes enjoyed the company of painter friends such as Thomas Waterman Wood (1823–1903; also Johnson's chum) or Enoch Wood Perry (1831–1915), who produced a large number of works close in subject and spirit to Homer's own (and, equally, to Johnson's). In the 1870s Homer frequently visited the summer retreat of his friend and patron Lawson Valentine and his family, at first in Walden, New York, and later at Houghton Farm in Mountainville. Johnson, for his part, hosted visiting family and friends at his summer house and studio on the Cliff in Nantucket and devoted a great deal of time and energy to the planning of much-anticipated (though not always accomplished) annual camping trips in the wilds of Maine with his painter friend Jervis McEntee (1828–1891).[6]

A thorough diagram of similarities, exchanges, and appropriations between Johnson and Homer, over the two decades when their work traced much of the same ground, would look like a dense web of crisscrossing lines, some running one way, others in both directions. The appearance of country boys and girls in their work, for example, takes on a kind of fugue-like pattern. Johnson stated the theme as early as 1860, when he produced his all-American *The Barefoot Boy* (Private collection; see fig. 53). In 1864 both he and Homer produced paintings of country children at work—Johnson's *Nest Hunting* (Private collection), Homer's *Haymaking* (Columbus Art Museum, Columbus, Ohio), and others. After the Civil War, Homer drew illustrations of children romping and gathering berries for *Our Young Folks*

and other publications. Johnson scored a major success with the *The Old Stage Coach* in 1871, and Homer followed with *Snap the Whip* (fig. 79) the very next year. Johnson's sunstruck arrangement of figures in the oil sketch *Five Boys on a Wall*, circa 1871 (No. 87), strikingly recalls Homer's treatments of the subject, such as his 1874 watercolor, *Children on a Fence* (Williams College Museum of Art, Williamstown, Massachusetts). In the mid-seventies, Homer's Gloucester children, wading, fishing, and boating, reconfigured the theme of childhood play once again, as did Johnson's barn interiors at the end of the decade, with boys and girls frolicking or daydreaming in hay-filled lofts. Many of their contemporaries, such as John George Brown and Seymour Joseph Guy (1824–1910), also dipped into that same thematic reservoir—a rich and almost bottomless one, given bourgeois culture's turn to youth, hope, and nostalgia during a time of acute anxiety for present and future prospects of life in America.[7]

Beyond demonstrating the currency of the subject as well as obvious correspondences between the older and the younger painter, what more does this exercise tell us about the particular relation of Homer to Johnson, Johnson to Homer? A look at *The Old Stage Coach* and its antecedents can serve as a case study for further examination of these connections. Exhibited to fervent acclaim at the Union League Club, the Brooklyn Art Association, and the National Academy of Design in 1871, the painting inspired torrents of heated praise. It was in many ways the epitome of all the virtues that made Johnson the foremost practitioner of American genre. It was natural and bucolic, intricately designed yet legible, abrim with life and feeling. Above all, it exuberantly extolled the joys of childhood. When it appeared at the Brooklyn show, the *Post* hailed it as a "tour de force." By the time it reached the National Academy, a mere four weeks later, it had already become the "famous *Old Stage Coach*."[8]

Johnson's "tour de force"—his greatest popular success since *Negro Life at the South* (No. 67) had so resoundingly launched his New York career in 1859—was a work of utter artifice. According to his early biographer William Walton, Johnson had come across the derelict vehicle while hiking in the Catskills and had made a sketch of it. Back on Nantucket, he built a platform and, recruiting local children as models, designed an elaborate arrangement of skillfully posed and charmingly characterized players, from the cap-waver at the top of the compositional pyramid to the passengers miming grown-up attitudes and the team (led by a black girl and a white boy) capering in harness.[9] While the work invites interpretation as an allegory of sorts, drawing together America's Puritan if well-worn past (the coach *Mayflower*) and its hoped-for future (healthy children revitalizing the old, empty hulk), viewers in 1871 responded overwhelmingly with nostalgic self-indulgence. "Does not as much glee, so much pure spirit, communicate itself to our own jaded or inert being so that life springs anew, and we drink again from the pure sources of existence—childhood and summer in the country!" raved the *Evening Post* in a typical effusion. The painting was all the more effective because of its seemingly artless naturalism: "We think less of Mr. Johnson's work as a *picture* simply because it means so much as *life*." The brighter palette and vivid effects of light and air contributed to the painting's transparency, though its crisp highlights and sharp shadows seem to owe as much to Jules Breton's (1827–1906) *Le Départ pour les champs*, 1857 (Private collection), which Johnson copied in about 1865 (No. 88), as to plein-air observation.[10]

Johnson's success could hardly have failed to pique Homer, whose own recent offerings—*Eagle Head, Manchester, Massachusetts (High Tide)*, 1870 (The Metropolitan Museum of Art, New York), and *The Bridle Path, White Mountains*, 1868 (Sterling and Francine Clark Art Institute, Williamstown, Massachusetts)—had

NO. 87
Five Boys on a Wall, circa 1871
Oil on paper board, 12¾ x 21¾ in.
Dallas Museum of Art, Foundation for the Arts
Collection, Gift of Roland S. Bond, Mrs. Alfred
L. Bromberg, and Margaret J. and George V.
Charlton, 1978.8.FA

drawn sharply mixed reactions at the previous year's National Academy show (words such as "perverse," "crude," and "grotesque" flowed readily from the critics' pens). Johnson was popular; Johnson's paintings inspired warm praise and affection; he was known and loved particularly as America's supreme painter of childhood. It is not so surprising that the very next year, Homer produced *Snap the Whip* as a response and perhaps challenge to Johnson as the leader of the field. Homer had treated childhood themes himself in illustrations and paintings. Nothing previous had been so ambitious, however.[11]

By that time, both artists had moved away from the University Building, where presumably they had had many opportunities to fraternize and to look over each other's work. Johnson was now married; Homer had relocated to the Tenth Street Studio Building. Of course other occasions for socializing presented themselves. Both attended functions at the Century as well as openings and private viewings. Well aware of Johnson's triumph, Homer, ambitious to move beyond illustration and claim a place for himself in the front ranks of the art world, endeavored in *Snap the Whip* to do a "Johnson"—only better.

Clues to the nature of their rivalry can be gleaned from a look at Johnson's rising star in the 1860s, when the creator of *Negro Life at the South* turned increasingly to rustic, domestic Yankee subjects. In his often tender, intimate treatment of maternal affection or childish innocence, he impressed many an admirer as the American answer to the popular art of Édouard Frère (1819–1886), whose warmhearted depictions of humble French cottage life commanded high prices and excited praise as fulsome as that which would greet *The Old Stage Coach* in 1871. "Mr. Johnson," wrote one reviewer in 1864, "is climbing by no slow steps to the very front rank of our painters and bids fair at no distant day to rival Edouard Frère, though in a totally different field. He is one of the most natural, unaffected, and sweetly serious of our artists, and one of our best painters too." Eugene Benson, for his part, declared that as a painter of children, Johnson was equal to Frère—though "far more vigorous and varied in his work."[12]

It may well be that Johnson, as the American answer to Frère, became Homer's chief target. Very early in his career, Homer had singled out Frère as the painter he most wanted to surpass. Joseph E. Baker, Homer's co-worker at Bufford's, reported that once in a Boston picture gallery the apprentices were looking at a genre picture by Frère, a kitchen interior with figures. "Homer remarked, 'I am going to paint.' Asked what kind of work he intended to do, he pointed to the Frère and replied, 'Something like that, only a damned sight better.'" This story may be apocryphal, though it has a certain plausibility. How appropriate, in this light, that several years later, at the Brooklyn and Long Island Fair in 1864, a reviewer glowingly extolled the sweetness of Frère's *The Little Cook (La Petite Cuisinière)*, 1858 (fig. 80), with its young peasant girl holding a ladle and watching a pot in a rustic interior. In the very next sentence, the writer made much of the striking truthfulness of Homer's *The Sharpshooter on Picket Duty*, 1863 (fig. 81), in the same show. Considering Homer's reported declaration, it is not difficult to imagine his sharpshooter drawing a bead on Frère's all-too-earnest little kitchen helper. Not long after, however, it was Johnson, the American Frère, that Homer pinpointed in his sights.[13]

Though smaller (about two-thirds the size of *The Old Stage Coach*), *Snap the Whip* in other respects seems to make calculated references to the earlier work. In both, the time is after school, and the schoolhouse partially visible at the right in *The Old Stage Coach* has its counterpart in the red schoolhouse building behind the chain of boys in *Snap the Whip*. In both, the appearance of spontaneous play is the result of painstaking design; both conjure effects of fresh, outdoor brightness. Of course there are obvious differences: the racial and gender mix in Johnson's paint-

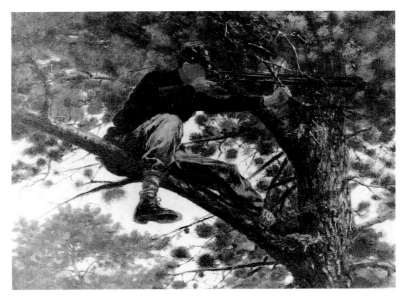

ing gives way to the all-boy cohort dominating Homer's, and Johnson's artfully contrived "let's pretend" scenario explodes into embodied dynamism as whiplash energy pitches the outermost boys to the ground. This action in itself, though, yields a further hint as to Homer's own game. In *Snap the Whip* had he not set out to "whip" Johnson—the American Frère—by rendering Johnson's most celebrated subject "a damned sight better"?[14]

The venture paid off. When Homer showed a preliminary version of *Snap the Whip* (now in The Metropolitan Museum of Art, New York) at the Union League Club in December 1872, the *New York Times* rated it "a great improvement on some of his later works. . . . [It is] good in composition, drawing, and expression, and pleasing, in spite of its crudities and apparent carelessness of execution." The second, and definitive, version of the painting was exhibited (along with *The Old Stage Coach*) in the American paintings section of the Centennial Exhibition in Philadelphia, and the next year it went to the Exposition Universelle in Paris. Homer's pictures of boys having fun received very good press in the 1870s—consistently better and less ambivalent than responses tended to be for most of his other subjects. *Breezing Up* (National Gallery of Art, Washington, D.C.) at the National Academy in 1876 inspired the *Nation*'s critic to enthusiasm: "Mr. Homer gives us this spring the most admirable sketch he has made since the period of his war-time pictures. The exulting freedom with which his brush ripples over the canvas . . . while his little boys drink in the health and breeze of the young day, is for Mr. Homer a revelation. He has never told a story so well, nor has his pithy economy of expression ever become him more."[15]

If Homer's *Snap the Whip* was his most Johnsonian effort, Johnson's *Woman Reading*, circa 1874 (No. 89), was surely his most Homeric. In this painting, a young woman strolls along a grassy shore. Clean, white light falls on her fashionable walking dress with its pale overskirt and black accents. Shading her face is a steeply tilted coal-scuttle straw hat edged in red. She is holding what seems to be a letter, which absorbs her attention completely. On the ocean floats a two-masted sailboat, its reflection shimmering. Pink mist suffuses water and sky alike, erasing the horizon. The paint handling is summary, describing figure and ground in sketchy swathes and stipplings.

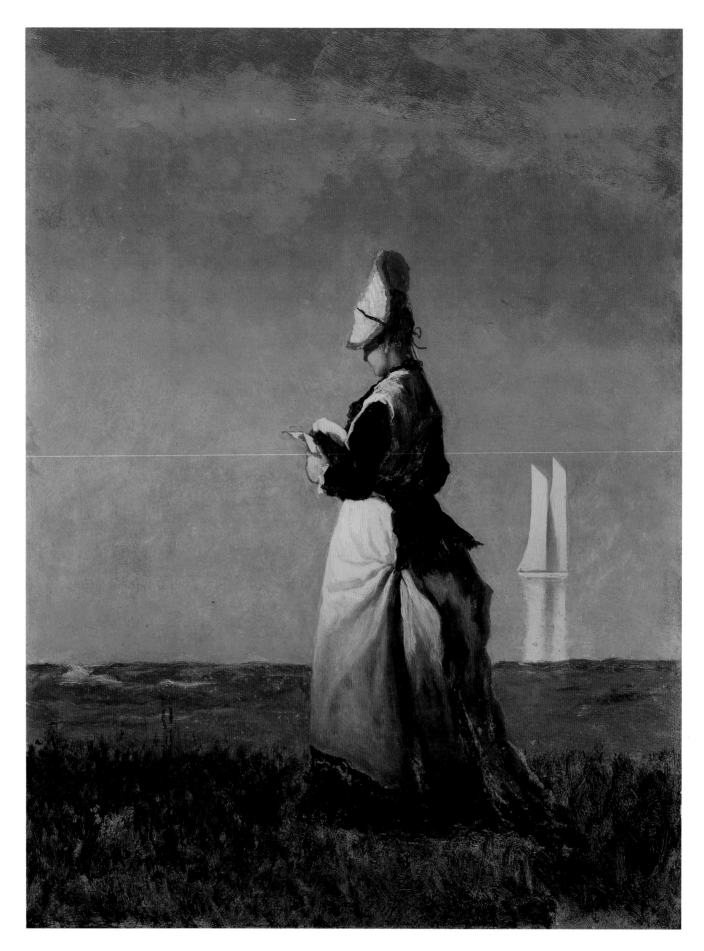

NO. 89
Woman Reading, circa 1874
Oil on paper board, 25⅛ x 18⅝ in.
San Diego Museum of Art, Gift of the Inez
Grant Parker Foundation, 1977.9

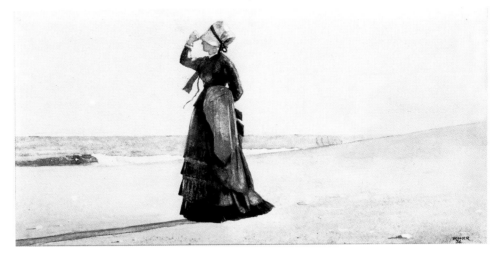

In a general way, Johnson's picture could fit quite plausibly within the compass of Homer's oeuvre in the late sixties and through the seventies, when he ran variations, in painting and illustration, on the theme of women playing, bathing, and parading on the shores of New Jersey, Massachusetts, and Long Island.[16] Homer's *Long Branch, New Jersey*, 1869 (The Metropolitan Museum of Art, New York), for example, depicts two young women overlooking the beach at this popular seaside resort. Tricked out in rakish, sloping hats, huge chignons, and elaborately draped bustles, they embody the height of fashion and artifice in abrupt juxtaposition with the elemental—sea, sky, and sand. The effects of breezy freshness and sparkling light suggest that, in accordance with Homer's usual practice at this time, the work was painted in the open air (though not necessarily on site).

Long Branch is a lively, cluttered, touristic scene, different in kind and mood from Johnson's tranquil image. In subject and design, Homer's watercolor *On the Beach, Marshfield*, 1874 (fig. 82), however, is virtually interchangeable with *Woman Reading* and was painted at about the same time. In her trailing, bustled skirt, a kerchief bound around her heaped-up coiffure, Homer's woman pacing the sand cuts a nearly identical profile, though here she shades her eyes and gazes out to sea. Later Homer repeated the motif in the ambitious oil *Promenade on the Beach*, 1880 (Museum of Fine Arts, Springfield, Massachusetts), where two women, arm in arm and stylishly adorned, saunter alongshore and look out to sea at twilight, as a sailboat cuts through the dark blue waters behind them.

What more is there to make of these morphological crossovers? It should not be forgotten that Homer and Johnson were among a circle of painters—including George C. Lambdin (1830–1896), William John Hennessey (1839–1917), and John George Brown—who explored many of the same themes. At this time the decorative female figure emerged into prominence, at least partly in response to the commercial success of works in this vein produced by European artists such as Alfred Stevens (1823–1906) and Auguste Toulmouche (1829–1890). Their paintings were on view in the New York galleries of Goupil and Knoedler, among others, and reproductions after their work appeared in the illustrated magazines.[17]

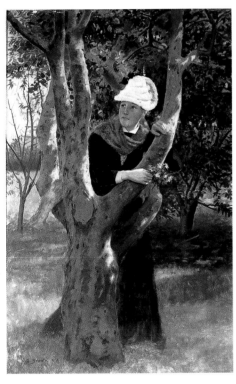

Many images featuring such subjects (on the shore, in the woods, or in boudoirs, equally) linked them to romance through such devices as reverie, letter reading, or expectant attitudes. John George Brown, Homer's neighbor in the Tenth Street Studio Building, produced representative work in this vein. Brown's *Among the Trees*, circa 1875 (fig. 83), for example, offers a young woman in yet another tilted hat (high fashion in the early seventies), peering out between framing branches, with a bouquet of daisies in one hand. Her anxious expression, and her flowers—commonly associated with the petal-counting ritual, "He loves me, he loves me not"—function as unambiguous signifiers of the circumstances.[18]

FIG. 84
Alfred Lumley
"Prepared for the Campaign—A Reverie of
the Coming Summer"
From *Harper's Weekly* (July 5, 1873)
Brooklyn Museum of Art Library Collection

FIG. 85
Winslow Homer
Butterfly Girl, 1878
Oil on paper board, 37½ x 23½ in.
New Britain Museum of American Art, New
Britain, Connecticut, Friends of William F.
Brooks, 1950.3

FIG. 86
Winslow Homer
At the Window, 1872
Oil on canvas, 22⅝ x 15¾ in.
The Art Museum, Princeton University,
Princeton, New Jersey, Gift of Francis Bosak,
Class of 1931, and Mrs. Bosak

NO. 90
Catching the Bee, 1872
Oil on canvas, 22⅞ x 13¾ in.
The Newark Museum, Newark, New Jersey, Purchase
1958 Wallace M. Scudder Bequest Fund, 58.1

Brown's painting may be glaringly obvious, but it functions as an efficient key to understanding the conventions and the implications of such imagery. Despite renewed feminist activism and attempts at reform dating from the years immediately following the Civil War, there was as yet little to shake the consensual view that women were born to be wives and mothers. To put it crudely, the business of girls was to perfect the arts of attracting, pleasing, and catching suitable mates. Humorists and fashion-magazine columnists, among others, seldom challenged this construction, and the popular magazines did not lack for stories and pictures to reinforce it. Alfred Lumley's cartoon "Prepared for the Campaign—A Reverie of the Coming Summer," of 1873 in *Harper's Weekly* (fig. 84), allows us a peek inside the maiden's mind, where visions of courtship by land and by sea predominate to the exclusion of all else. Other caricaturists made sport of the woman as huntress in the mold of the goddess Diana, shooting, trapping, or netting her hapless masculine victim.[19]

Female figures by Homer and Johnson during these years conform to the same pattern, suitably refined for a more elite medium. Even though the model was his own young wife, Johnson's *Catching the Bee*, 1872 (No. 90), is not without its delicate allusions to conquest, nor is Homer's *Butterfly Girl*, 1878 (fig. 85), with its subject's look of single-minded attention on her fluttering quarry. Homer's watercolor *Summer*, 1874 (Sterling and Francine Clark Art Institute, Williamstown, Massachusetts), with its young woman tending a hanging pot of flowers in a lush garden, clearly echoes *Catching the Bee*. Both artists also produced interiors featuring a woman at the window, gazing pensively out: Johnson's *A Day Dream*, 1877 (No. 91), and Homer's *Reverie* (Private collection) and *At the Window* (fig. 86), both of 1872.

More than any ballroom, garden, or boudoir, however, the seashore—a liminal zone where relaxation was the rule—figured as a supremely modern playing field for flirtation and romance. With the rise of middle-class leisure and the development of popular resorts, illustrated magazines such as *Harper's Bazar*, *Harper's Weekly*, and others made much of the romantic seaside in the years after the Civil War, when maturing girls began to thrust themselves aggressively into public as never before. The illustration "On the Look-Out," 1869 (fig. 87), published in *Harper's Bazar*, is a beach scene featuring a troupe of six maidens, all turned out in elaborately layered dresses and saucy hats. Three of them, two with binoculars, spy coyly in the direction of several lounging, presumably wary young gentlemen. In the following week's issue, the sequel, "In Tow," showed the young women in triumphant procession, leading their captivated, and captive, admirers along the sands.

Homer's "Beach at Long Branch," published in *Appleton's Journal* (August 21, 1869), plays on the same theme, showing one lone, top-hatted flaneur, completely hemmed in by young, ripe females. As Homer slyly frames it, this gentleman's stroll down the beach is tantamount to running the gauntlet. One of the girls has

FIG. 87
"On the Look-Out"
From *Harper's Bazar* (October 2, 1869)
Brooklyn Museum of Art Library Collection

FIG. 88
Winslow Homer
"On the Beach—Two Are Company, Three Are None"
From *Harper's Weekly* (August 17, 1872)
Brooklyn Museum of Art Library Collection

NO. 91
A Day Dream, 1877
Oil on paper board, 24 x 12 in.
Fine Arts Museums of San Francisco, Gift of
Mr. and Mrs. John D. Rockefeller 3rd, 1993.35.20

inscribed the artist's own initials in the sand with the tip of her parasol—as if marking a conquest. In a more serious vein, "On the Beach—Two Are Company, Three Are None," 1872 (fig. 88), suggests the longing, envy, and emptiness of the young woman who walks away through spiky dune grass while looking back at an amorous couple in a beached rowboat.

Connections between the idea of lost or absent love and seaside meditation were conventional. A gloomy poem about the autumn sea, published in *Appleton's Journal* (1870) has an unsigned illustration showing a young woman in full fashionable regalia, bowed down in thought on a deserted strand. Audiences, it seems, made such connections readily, with or without narrative cues. What else could girls at water's edge be thinking of? Certainly the *Springfield Republican* writer who reviewed Homer's *Promenade on the Beach* did not hesitate to assume that the two young women gazing out across the waves had romantic thoughts in their heads.[20]

It was not until the 1870s that Johnson turned to such themes in earnest. Recently married, the middle-aged painter (who had remained a bachelor well into his forties) was understandably preoccupied with love, and his wife made an appealing model. Notwithstanding the triumph of *The Old Stage Coach*, it is also likely that Johnson, having abandoned blacks and maple-sugar camps, was in search of new subjects, as suggested by his turn to history painting in *Milton Dictating to His Daughters*, 1875 (location unknown; an 1876 version is in Blanden Memorial Art Museum, Fort Dodge, Iowa). How indifferently he succeeded is suggested by a review in the *New-York Daily Tribune* that queried, "What shall we say of Mr. Eastman Johnson's 'Milton and His Daughters,' except that the artist must himself wonder what set him at such an alien task?" Henry James considered *Milton* a "very decided error." More to the present point, James was equally unimpressed by Johnson's *The Toilet*, 1873 (No. 39). "Mr. Johnson will never be an elegant painter— or at least a painter of elegance," wrote James. "He is essentially homely." Johnson scored consistent triumphs only when he returned to the rustic anecdote for which he was best known. Oddly, the American Frère was regarded, by the mid-seventies, as one of the last lines of defense against the tides of Frenchness (and German-ness) engulfing the native spirit. Nonetheless, his decorative young women— reading letters by the seaside, wandering lonely as clouds, catching bees, staring wistfully out windows—are clear indications of Johnson's interest in retooling himself along more contemporary lines.[21]

Certain technical developments may also reflect Johnson's response to contemporary trends. In the late sixties and into the seventies, his lighter palette and sketchier technique recall the open-air naturalism of Homer's work about the same time. As an artist-reporter, Homer had by necessity relied on the ability to sketch rapidly outdoors, and as early as 1864 he was reported to be painting in the sun on the roof of his studio in New York. As some have pointed out, the croquet scenes that he painted in 1866 bear a striking resemblance to the open-air work that young French Impressionists—notably Claude Monet—were pursuing around the same time. Henry Adams, however, has made a convincing case for the example of Eugène Boudin (1824–1898), whose bright, breezy beach scenes were on display in 1866 in the New York show of some one hundred modern French paintings from the collection of the Paris firm Cadart and Luget.[22]

To what extent Johnson was indebted to Homer may be impossible to gauge with any certainty, since there is little to go on except visual evidence. Observers did note the changes in his palette. When *Catching the Bee* made its appearance in the National Academy show in 1873, the *Tribune*'s reporter was struck by "how much brighter a chord of color Mr. Johnson is working in than he used to employ." Yet Johnson's "impressionist" style could owe as much to the realism of his Parisian

FIG. 89
Winslow Homer
Fresh Air, 1878
Watercolor with opaque white highlights over charcoal on paper, 20⅛ x 14 in.
Brooklyn Museum of Art, Dick S. Ramsay Fund, 41.1087

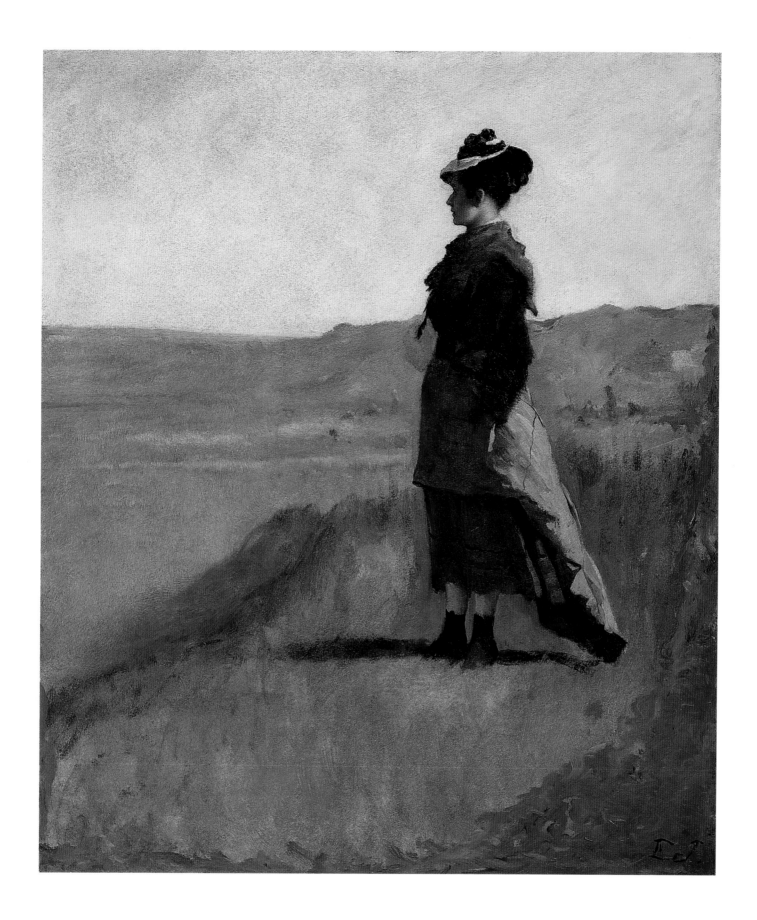

NO. 92
Woman on a Hill, circa 1875–80
Oil on paper board, 26 x 21½ in.
Addison Gallery of American Art, Phillips
Academy, Andover, Massachusetts, Museum
Purchase, 1938.5

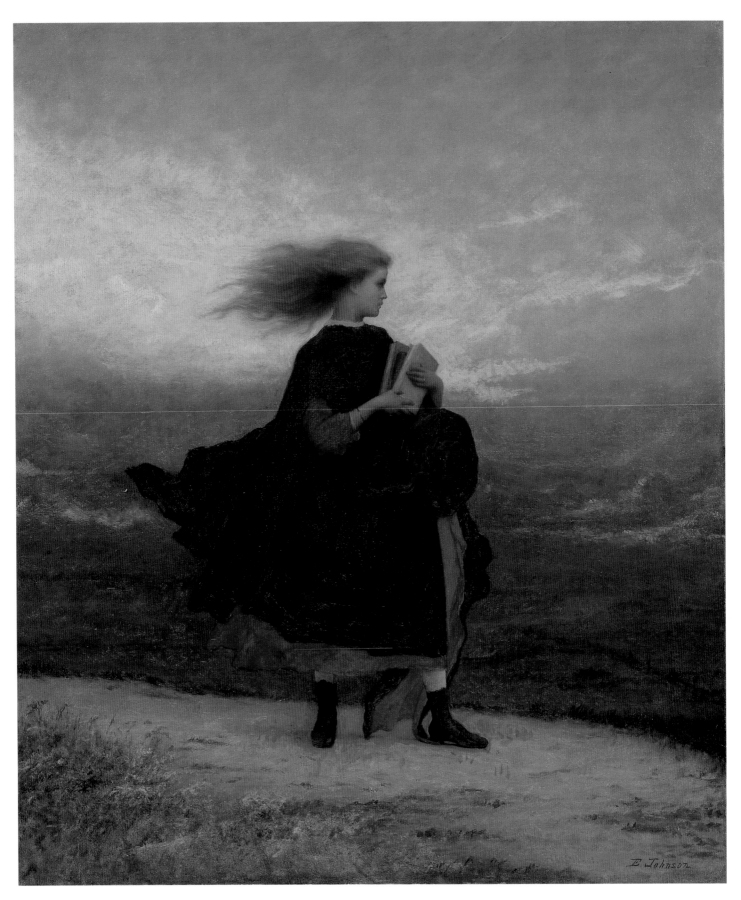

NO. 93
The Girl I Left behind Me, circa 1875
Oil on canvas, 42 x 34⅞ in.
National Museum of American Art, Smithsonian
Institution, Washington, D.C., Museum Purchase
made possible in part by Mrs. Alexander Hamilton
Rice in memory of her husband and by Ralph
Cross Johnson, 1986.79

teacher Thomas Couture (1815–1879), wielder of a vigorous, broad brush, as to Homer. Even more, as suggested above, Johnson was attentive to Jules Breton's technique of representing figures in full sun with brilliant slivers and bands of light, deep shadows, and vivid touches of color against a field of earth tones—as in Johnson's plein-air sketches for *The Cranberry Harvest*, as well as in the finished studio product. For a brief period during and after his trip to France, Homer also utilized the same technique.[23]

What really distinguished Johnson from Homer was, as Hills has written, the former's adherence to the standard of the more finished studio painting as an "exhibitable" work of art. Although he enjoyed his preliminary sketches and kept many in his studio for reference, or as mementos, he did not present and probably did not even think of them as sufficient unto themselves. Contrast this with Homer, whose reception throughout the 1870s was clouded time and again by critics' complaints about his lack of finish. If only he would bring his work to a higher state of completion, they nagged, he would surely stand in the first rank of our artists. Even the most positive reviewers at times could not resist tossing in one final fillip. At the 1875 exhibition of the American Society of Painters in Water Colors, for example, one writer concluded: "Mr. Homer's style is wonderfully vigorous and original; with a few dashes of the brush, he suggests a picture, but a mere suggestion only, and it is a mistaken eccentricity which prevents its finish." Working in watercolor, of course, encouraged the production of such shorthand "impressionistic" effects.[24]

Finally, in the technical department, there is the question of the modular figure. In John Wilmerding's view, Johnson's *Woman on a Hill*, circa 1875–80 (No. 92), is almost an "exact copy" of the central figure in Homer's *Long Branch, New Jersey*, 1869 (Museum of Fine Arts, Boston). If so, the same figure boomeranged back to Homer's work, appearing as the rococo shepherdess in his watercolor *Fresh Air*, 1878 (fig. 89). However, Johnson had his own earlier woman on a hill, as well: the windswept damsel in *The Girl I Left behind Me*, circa 1875 (No. 93). Were the two painters playing a game of pictorial one-upmanship, or were they both drawing on motifs from a common iconographic pool?[25]

More suggestive of Johnson's appropriation of Homer's tricks was his occasional exploitation of a repertoire of interchangeable parts. Homer regularly put figures from his illustrations into his paintings and vice versa, or moved the same figures or even groups from one picture to another, combining two separate compositions to make a new third. The most striking instance of this practice in Johnson's work appears in *Hollyhocks*, 1874–76 (No. 94), where a walled garden encloses eight young women, among them the figure from *Catching the Bee*, transported bodily from one canvas to the next. Johnson also recycled the figure of the ancient sea captain in several Nantucket paintings, and he often used the same accessories in his old-fashioned kitchen scenes.[26]

In sorting out the relation between Johnson and Homer, the question remains: Was Johnson a failed Homer or was Homer a struggling and not always successful contender for the territory in which Johnson reigned supreme for two decades? Given Johnson's seniority, and the admiration that so easily came his way, to see him as an also-ran behind Homer is untenable. Homer comes down to us, historically, shrouded in the myth of his uncompromising individualism. This in turn obscures the extent to which he was involved in contemporary art practices, markets, and institutions—which meant playing according to some fundamental rules of audience appeal in choice and treatment of subject. How often he missed the mark is abundantly evident in the ambivalent responses of his critics. Whether he was consciously "perverse" or simply inept in the way that he spoke the language of genre may not be possible to determine. To consider him as a failed Johnson, however, can

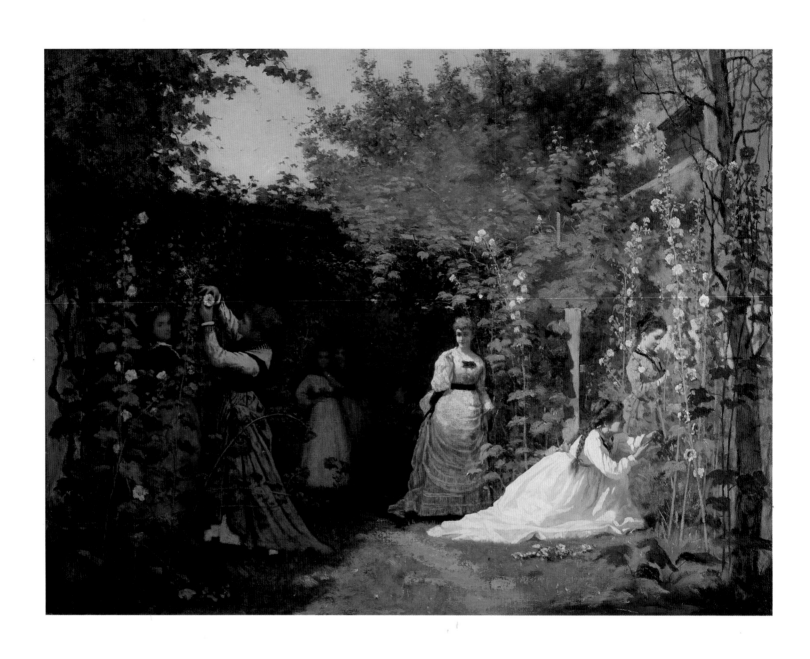

NO. 94
Hollyhocks, 1874–76
Oil on canvas, 25 x 31 in.
New Britain Museum of American Art, New
Britain, Connecticut, Harriet Russell Stanley
Fund, 1946.7

lead us a little closer to the heart of what connected, and disconnected, these two paradigmatic painters of the Gilded Age.

First, the two were strikingly different personalities. The extent to which the art maker can be detected in the work—how much of him or her is *in* the art—is always a thorny question. Layers of mediating factors such as aesthetic conventions in play at the time and imperatives of the market can obscure, distort, or even obliterate traces of the person and personality behind the brush. Still, the contrasts between the expansive Johnson and the sphinxlike Homer are worth considering.

By all accounts, Eastman Johnson was a warm, cheerful, loquacious man, strongly sociable and at the same time cozily domestic. Convivial from first to last, he painted himself popping the cork of a champagne bottle in 1863 (No. 27) and later, near the end of his career, posed for another self-portrait (fig. 108) in the fancy-dress costume he wore to a "Twelfth Night" party at The Century Association. An acquaintance who knew him in later years recalled him as a "very short, *rotund* little man who used to make us children laugh by telling us there was only one piece of clothing he could buy ready made and that was a pocket handkerchief." Will H. Low (1853–1932), one of the young, cosmopolitan painters, visited Johnson on Nantucket and found him to be "an ideal host in his pleasant house," who presided over "merry gatherings around the dinner table." Sometimes Johnson described his own life as if it were one of his paintings. In an 1880 letter to his longtime friend Jervis McEntee (1828–1891), he wrote, "My wife and I sit here by our quiet cheerful wood fire. How I wish you could step in." So domestic was Johnson that even when planning wilderness excursions with McEntee, he was never far from home. "My wife," he reported, "has knitted me a Tam O'Shanter cap so becoming that I wanted to travel through Maine with it, and one for you, all done and ready. I thought we should look so fine. And they are such admirable nightcaps, in camp."[27]

Something of Johnson entered into his works, however calculated and artfully designed they may have been. Writing to his patron John F. Coyle, the painter described an upcoming visit to "the wilds of the State of Maine" to study life in the maple-sugaring camp. The subject, explained Johnson, was "a picturesque & in one way interesting one, partly perhaps on account of its being associated with my pleasantest early recollections." Many of the genial artist's genre paintings had the knack, as Patricia Hills has argued, of "appeasing" divided factions, whether pro- or anti-abolitionists in the case of *Negro Life at the South* (No. 67), or tradition-keepers and modernists, as in the late double portrait *The Funding Bill—Portrait of Two Men*, 1881 (No. 97). Most of his successful works, in fact, were celebrations of seamless community, whether frolicking children or hardworking cornhuskers.[28]

Homer, on the other hand, was thin, small, tense, and laconic. A vivid description by James Edward Kelly, a young staffer at *Harper's*, paints just such a portrait. Visiting Homer's Tenth Street studio in the early 1870s, Kelly reported the artist to be erect, slim, and "military looking." His hair was close-cropped and his features clean-cut. He was dressed to such perfection that his "black cutaway coat and steel-gray trousers had the set and precision of a uniform." His studio was in "perfect order, spic-and-span looking, like himself. . . . During the intervals of his talk, if anything was out of order, he would shift it into its place; a thread, or a piece of paper on the floor, would bring him to a standstill until he could pick it up." According to Homer's biographer Lloyd Goodrich, a "young lady who used to see [Homer] on picnics" reported that "'he was a quiet little fellow, but he liked to be in the thick of things.'" Later in the 1870s, during the time of his involvement with the jolly Tile Club artists' group, Homer's code name was the Obtuse Bard, a play on his surname combined with an allusion to his miserly way with words. Like his body,

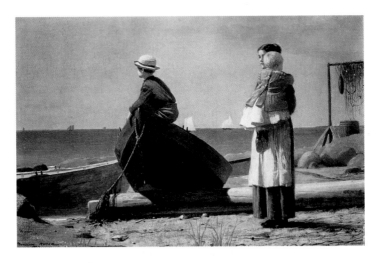

his humor was dry and thin, as his friend Augustus Stonehouse noted in 1886.[29]

Self-contained and obsessed with control over himself and his environment, Homer had little if any of the expansive geniality that characterized Johnson. Even his paintings were tart. The critic Susan N. Carter (director of the Cooper Union) detected in Homer's color "a little of the flavour to the mental palate of the pickle, or perhaps of olives," a taste not for everyone but "heartily enjoyed" if one learned over time to relish it. Reporting on *Answering the Horn*, 1877 (Muskegon Museum of Art, Muskegon, Michigan), the *Evening Post* observed that the artist was so abhorrent of "clap-trap" that occasionally "he seems purposely to have thrown oil of vitriol upon the faces he has painted, lest haply we might find in them too much sentiment and soul."[30]

A lifelong bachelor, Homer left New York for good in 1884 to live near his immediate family (particularly his widowed father and his favorite brother, Charles). While he was never the crusty hermit that his biographers made him out to be, he guarded his privacy from outsiders and let leak almost nothing of his inner thoughts and feelings. His letters, in contrast to Johnson's rambling, confiding outpourings, are almost aggressively terse. On several occasions, when buyers asked what his paintings meant, he responded with corrosive sarcasm. When queried about the girls gazing out to sea in *Promenade on the Beach*, for example, Homer penned this prickly reply: "They are looking at anything you wish to have them look at, but it must be something at sea & a very proper object for Girls to be interested in."[31]

Though his home base was the family compound at Prout's Neck, Maine, Homer—ever the unencumbered bachelor—was a relentless traveler. His life was a curious amalgam of tough asceticism and regular indulgence in good whiskey and gourmet treats. Unlike Johnson, he reveled in danger and drama in nature. When

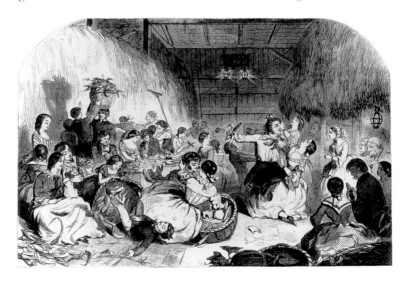

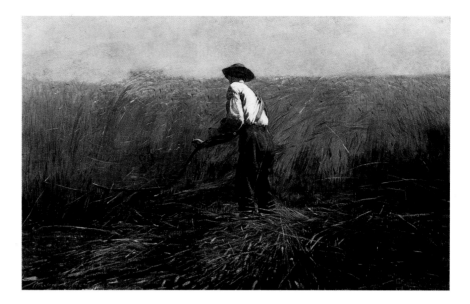

violent storms swept Prout's Neck, he would rush out to the cliffs overlooking the sea in a "fever of excitement" to experience the tempest. By contrast, when a massive hurricane nearly flattened the island of Nantucket in 1878, Johnson anxiously waited it out by his fireside, getting up to nail down billowing rugs and tuck the blankets around his sleeping wife and daughter.[32]

Signs of these temperamental differences are not difficult to read in the work. The two painters' representations of motherhood, for example, are telling. In Johnson's typically cozy interior, *Mother and Child*, 1869 (No. 81), a pensive woman gently rocks by a warm stove and cuddles her baby, who sleeps peacefully on her bosom, secure in the circle of her arms. Although Homer seldom depicted family life, the few mothers in his illustrations and paintings of the sixties and seventies are most unlike Johnson's. Only compare the relaxed physical and emotional intimacy of Johnson's figures with the rigid stiffness of the mother holding her young child in Homer's *Dad's Coming!*, 1873 (fig. 90). Despite the physical connection, their emotional relation seems remote, as the mother, upright and unyielding, looks stonily ahead while the baby, who clings to her rather precariously, faces back over her shoulder. Equally detached, the older boy sits atop a beached dory and gazes out to sea. The optimistic title belies the mood of the painting, which is tense and grim, despite the calm sea and bright skies.

Grim the mood may be in *Dad's Coming!*, but the pickles and olives of Homer's humor lend a sharp edge to other works. The illustration "Husking the Corn in New England," 1858 (fig. 91), is frankly bawdy. A young swain, having uncovered the folkloric red ear that conferred free kissing privileges at huskings, lunges at his reluctant target, while another couple, embracing, tumbles to the floor. Several other men proudly display their stiff, red ears to admiring feminine eyes, as the scene threatens to degenerate into some sort of Yankee bacchanal. Good-humored Johnson certainly was; satirically humorous he could never be. His *Corn Husking* (No. 25) of 1860 is solemn and sedate, its refined compositional harmonies reinforcing the sense of familial harmony that pervades the scene. Everyone, from the little daughter (patriotically decked out in red, white, and blue) to the courting couple, the sturdy yeoman, and the old grandfather, works in a spirit of peaceful cooperation. It is inconceivable that Johnson's ears of corn might suddenly metamorphose into phallic trophies like Homer's. Even in the later *Husking Bee, Island of Nantucket*, 1876 (No. 44), the single red ear flourished by a young man does nothing to rupture the peace and decorum of the scene. As the *New-York Tribune* put it, Johnson saw true poetry and delicacies of sentiment underlying even the "coarsest life."[33]

FIG. 93
Winslow Homer
A Visit from the Old Mistress, 1876
Oil on canvas, 18 x 24⅛ in.
National Museum of American Art,
Smithsonian Institution, Washington, D.C.,
Gift of William T. Evans, 1909.7.28

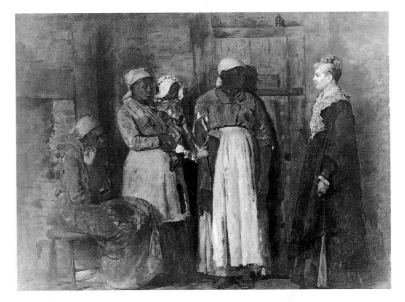

The expression of community so often present in Johnson's rural scenes, such as *Husking Bee, Island of Nantucket*, is more often strikingly absent in Homer's work. His *The Veteran in a New Field*, 1865 (fig. 92), toils all alone, whereas Johnson's *The Pension Claim Agent*, 1867 (No. 35), is all about the collective experience of being a veteran. Even when Homer shows situations where people work together, they tend stubbornly to remain individuals. Of course there are exceptions. At the very outset of his career, Homer studied and depicted army life, and his later shipwreck and fishing scenes highlight the critical importance of teamwork for survival amid the most dire circumstances. Both of these "communities" are predicated on struggle, danger, and death in the face of hostile circumstances, however, in contrast to the organic unity among generations, genders, and nature itself that undergirds Johnson's celebrations of rustic labor. As a man and an artist, Johnson never strayed far from hearth and home, while Homer increasingly sought the excitement of nature's wild side.

Up to about the middle of the 1870s, Johnson and Homer were like skaters on a pond, each intersecting the tracks of the other as they inscribed their figures on the ice. Frequently one or the other might loop away, only to converge again at another point. After that, however, they began (at first gradually) to diverge, and it was during this period that Homer undertook an ironic reworking of the painting that had established Johnson's reputation in New York. There is no foolproof way to determine if this occurred by happenstance or design, but the clues, once again, are persuasive.

That key work of Johnson's was, of course, *Negro Life at the South*, renowned from the time of its debut in New York in 1859. Ecstatically hailed by critics and widely circulated in reproductions, the painting itself came before the public several times over the next two decades. Among other venues, it went in 1867 to the Exposition Universelle in Paris and in 1876 was one of four paintings by Johnson in the American paintings exhibit at the Philadelphia Centennial.

John Davis has argued recently that the politics of painter and painting at the time of *Negro Life at the South*'s production were more subtle and more polemical than previously recognized, especially in the way that the composition encodes interracial tensions. Davis points to the white mistress's entry on the scene, for example, as a device hinting at the resentment felt when whites intruded upon the slaves' leisure time to take part in their music and dance. Subsequently, Davis argues, the specific, topical meaning of the imagery blurred, and it became "symbolic" in a more general way as an evocation of the vanished old South, with its picturesque slaves and crumbling institutional structures.[34] Still, whatever racial tensions Johnson may have tried to incorporate into the encounter of mistress and slaves,

the interest is dominated by what seems to be a comprehensive catalogue of black stereotypes, stage-managed with a suave grace that does a great deal to smooth over any rough political edges. Because of Johnson's meticulously descriptive style, it was easy for contemporaries to accept the painting's fictions as "truth," and (whether for or against abolition) to buy into its naturalization of social and racial hierarchies.[35]

Homer's *A Visit from the Old Mistress*, 1876 (fig. 93), was very likely a calculated postscript to Johnson's masterpiece. He painted it in the same year as the Centennial and exhibited the work several times: at the Century in 1877, at the Boston Art Club in 1879, and at both the Union League Club and the National Academy in 1880. The result of Homer's recent travels in Virginia, the picture recapitulated the encounter between a white woman (now the *old* mistress in every sense) and her former chattels. Given the long-standing visibility of *Negro Life at the South*, and its apotheosis at the Centennial, it is difficult to imagine that Homer did not have that painting in mind when he composed his own.

What distinguishes *A Visit from the Old Mistress* from Johnson's earlier effort is its resolute and perfectly characteristic denial of sentiment. Homer set out to strip away the grace notes and the beguiling evocation of harmony among the slaves that sweetened Johnson's representation of their bondage. Incapable of such sweetness, Homer produced a scene charged with ambiguity, a visual seesaw in which three sturdy African American women and a baby are poised in the balance against one aging white female. Their body language conveys not the smallest sign of deference to their visitor as they confront her with level, unwelcoming gazes. The old mistress, with her lace, wedding ring, and fan, clearly occupies a more privileged social place. The erstwhile slaves, despite their putative freedom, are still at the bottom of the social order. Their ragged garments and the meanness of their dwelling signal this, but even more, their sheer bulk—even brawn—mark them off decisively from the standard of refined (and leisured) delicacy associated with higher-class Anglo-American women. Homer's painting refutes the equivocations that soften the political and social thrust of Johnson's message. Whereas Johnson infused even his most provocative tableau with the warmth of his expansive nature, Homer drained that warmth away, to replace it with the cool dryness of his own rigorously self-contained personality.[36]

I have attempted to trace here the overarching patterns of exchange and convergence in the art of Johnson and Homer during the two decades when they were

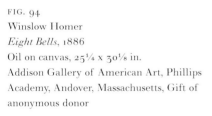

FIG. 94
Winslow Homer
Eight Bells, 1886
Oil on canvas, 25¼ x 30⅛ in.
Addison Gallery of American Art, Phillips Academy, Andover, Massachusetts, Gift of anonymous donor

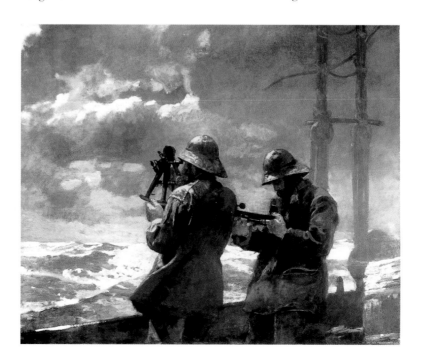

New York–based specialists in the rustic genre line. It remains to account for the sharp, clean break that took place about 1880. From that time, Johnson turned almost exclusively to the lucrative business of portrait painting and, with one or two exceptions, would never again produce scenes of daily life in rural America. In the summer of 1880, Homer lived and painted alone on Ten Pound Island in the harbor of Gloucester, Massachusetts. Early the following spring, he sailed to England and spent the next eighteen months in the fishing village of Cullercoats, where he studied the hard fortunes of the local population and turned to the solemn and often tragic subjects that were to occupy the second half of his career.

A look at Johnson and Homer in the mid-1880s dramatically illustrates the shift in their power relations. Johnson's *The Nantucket School of Philosophy*, 1887 (No. 104), presents a group of old sea captains and islanders, smoking and chatting around the stove in the local cobbler's shop. Like battered schooners whose seagoing days are over, these ancient mariners have dropped anchor for good. Johnson, crowded by the young cosmopolitans, identified more and more with his old captains, living relics of vanished times. In part, at least, a "portrait" of Johnson's state of mind, *The Nantucket School of Philosophy* is a manifesto of the aging painter's intention to stay in port. Homer's career, by contrast, was figuratively and in a sense quite literally on the high seas: in the mid-eighties he was painting imperiled fishermen, terrible shipwrecks, and women saved from drowning by courageous lifeguards. The sailors in *Eight Bells*, 1886 (fig. 94), for example, are the very opposite of Johnson's comfortable, paunchy old salts. Surrounded by heaving waves and far from any cozy stove, they gauge their ship's position—an act on which their welfare and ultimate survival directly depend.[37]

The reasons for Homer's seemingly abrupt shift in subject—which spilled over into style—have been much debated. There has been the suspicion of some romantic disappointment, and speculation that Homer went through a midlife crisis that prompted the decision to expand his horizons and take on bigger, weightier themes. Although he was younger than Johnson, it is not unlikely that he too felt some pressure from the cohort of "new men" trained in Europe and shared Johnson's sense that support for native, rural genre painting was on the wane. At the National Academy exhibition in 1877, for example, the critic for the *New York World* dismissed genre painting as old hat. Over and over and over, there were the same kitchens and spinning wheels, the same comic incidents, the same old women reading the Scriptures on Sunday morning, the same arrivals of the same country stages. Johnson's own long-planned, monumental *The Cranberry Harvest, Island of Nantucket*, 1880 (No. 60), while well received, did not inspire the greatest excitement; the *Nation*, for example, found it "inoffensive."[38]

Identified with the archaism of Nantucket, the place that he celebrated in paint, Johnson, like other members of his generation, became passé. Whereas once he enjoyed the advantage of twelve years' seniority over Homer, by 1880 the tables were turning. Johnson's career arc as a genre painter had peaked and was about to enter the path of descent. Homer, still in young middle age, could rechart his course, which he did with outstanding success. The starkly powerful paintings of the stormy Atlantic coast, which he began to exhibit to great acclaim in 1890, rapidly propelled him to the top rank of American masters. By the time of his death in 1910, he was widely recognized as one of the greatest modern painters the nation had produced. By the second decade of the twentieth century, the name of Johnson, dead in 1906, was all but forgotten.[39]

Homer's currency at the end of the twentieth century has remained high, and scholars have scrutinized every phase of his career, with special studies of his Civil War paintings, his images of African Americans, and other subjects. In late

twentieth-century eyes, his beach beauties, gamboling schoolboys, and poor Virginia blacks are rich in interest and in problems. We tend to forget that at the beginning of the century, his early work received scant attention from critics, who tended to focus almost exclusively on the late seascapes and wilderness adventure scenes. His acclaim was tightly bound up with these works. His canonization, however, shed its luster back through the decades to gild the paintings that a majority of viewers at the time could not see as anything but crude and eccentric, no matter how interesting. With his rising fame, Homer's eccentricity metamorphosed into the uncompromising, all-American individualism that undergirded his lofty reputation.[40]

It might fairly be claimed, in fact, that Homer's "greatness" has depended to some degree on the foil so conveniently provided by Johnson (and what he represents) and, further, on maintaining a space between the two. In this view, Johnson has come to stand for everything Victorian: cloying sentiment, bourgeois moralism, and quasi-literary storytelling, while Homer exemplifies proto-modernist values in his irony, refusal of narrative, progress toward abstraction, and ultimate, alienated immersion in universal, elemental themes. Modern bibliographies bear this out: skinny Homer's is expansive, while roly-poly Johnson's has remained slender.

Had the historical curtain rung down in 1880, however, the roles would have been reversed, with Johnson playing the part of first-rate Victorian painter whose works, legible and accessible, had popular appeal. Homer, by contrast, would have failed to approach the level of Johnson's success—or to have received even a fraction of the love that Johnson so easily won. Time, of course, moved on, and the picture changed. To look back at those earlier years, though, is to recognize that it was not yet so easy to separate the Victorian from the modern, and that for some considerable span of time, Homer was only an upstart shoot struggling to reach his own patch of sun beyond Johnson's far-reaching shadow.

Notes

1. Nicolai Cikovsky, Jr., and Franklin Kelly, *Winslow Homer*, exh. cat. (New Haven: Yale University Press, published in association with the National Gallery of Art, Washington, D.C., 1995).

2. For discussion of Johnson and Homer, see Patricia Hills, *Eastman Johnson*, exh. cat. (New York: Clarkson Potter, in association with the Whitney Museum of American Art, 1972), pp. 79–82; Patricia Hills, *The Genre Painting of Eastman Johnson: The Sources and Development of His Style and Themes* (New York: Garland, 1977), pp. 98–101, 137–39; John Wilmerding, *Winslow Homer* (New York: Praeger, 1972), pp. 63, 86–87. There has been one exhibition of works by Homer and Johnson presented side by side, although without cross-comparison: *Winslow Homer 1836–1910; Eastman Johnson 1824–1906* (Oklahoma City: Oklahoma Art Center, circa 1948). I thank Teresa A. Carbone for bringing this catalogue to my attention.

3. Henry T. Tuckerman, *Book of the Artists* (New York: G. P. Putnam & Son, 1867), pp. 466–71, 491. The difference in space allotted to Johnson and Homer has been noted by Hills, *The Genre Painting of Eastman Johnson*, p. 99.

4. Eugene Benson, "Eastman Johnson," *Galaxy* 6, no. 1 (July 1868), p. 111; "The National Academy of Design," *New-York Daily Tribune*, May 4, 1868, p. 2; "The Art of America," *New York Times*, June 11, 1876, p. 1. Lloyd Goodrich reports Homer's exasperation at critics' persistence in viewing *Prisoners from the Front* as the high-water mark of his achievement in *The Life and Works of Winslow Homer* (New York: Macmillan, 1944), p. 51.

5. Hills and Wilmerding have both pointed out the likely connection between the two letter-writing scenes; see Hills, *The Genre Painting of Eastman Johnson*, pp. 82–83, and Wilmerding, *Winslow Homer*, p. 63.

6. Chronologies of the careers of Johnson and Homer are included in Hills, *Eastman Johnson*, pp. 121–22, and Cikovsky and Kelly, *Winslow Homer*, pp. 391–406; on Johnson in Nantucket, see Marc Simpson, Sally Mills, and Patricia Hills, *Eastman Johnson: The Cranberry Harvest, Island of Nantucket*, exh. cat. (San Diego: Timken Art Gallery, 1990); on Homer's travels in the 1870s, see D. Scott Atkinson and Jochen Wierich, *Winslow Homer in Gloucester*, exh. cat. (Chicago: Terra Museum of American Art, 1990), and John Wilmerding and Linda Ayres, *Winslow Homer in the 1870s: Selections from the Valentine-*

Pulsifer Collection, exh. cat. (Princeton: The Art Museum, Princeton University, 1990). For an interesting but polemical analysis and interpretation of Gilded Age painters of daily life in their social and institutional relations, see Leslie Carol Wright, "Men Making Meaning in Nineteenth-Century American Genre Painting, 1860–1900," Ph.D. dissertation, Stanford University, 1993.

7. For a discussion of rural childhood in Gilded Age painting, see Sarah Burns, *Pastoral Inventions: Rural Life in Nineteenth-Century American Art and Culture* (Philadelphia: Temple University Press, 1989), pp. 297–334. Johnson, Homer, Wood, Perry, and others in their circle also played variations on the theme of the American yeoman farmer. A useful survey of this iconography and its meanings is found in Patricia Hills, "Images of Rural America in the Works of Eastman Johnson, Winslow Homer, and Their Contemporaries," in *The Rural Vision: France and America in the Late Nineteenth Century*, ed. Hollister Sturges (Omaha, Nebr.: Joslyn Art Museum, 1987), pp. 63–81.

8. "The Brooklyn Art Association," *Evening Post* (New York), March 13, 1871, p. 4; "National Academy of Design," *Evening Post* (New York), April 13, 1871, p. 2.

9. William Walton, "Eastman Johnson, Painter," *Scribner's Magazine* 40, no. 3 (September 1906), p. 272.

10. "Eastman Johnson's Last Picture, The Old Stage Coach," *Evening Post* (New York), March 10, 1874, p. 2. On Johnson and Breton, see Sally Mills, "'Right Feeling and Sound Technique': French Art and the Development of Eastman Johnson's Outdoor Genre Paintings," in Simpson, Mills, and Hills, *Eastman Johnson: The Cranberry Harvest*, pp. 65–68. Mills discusses Breton's popularity among collectors in the United States. For more on the latter subject, see Madeleine Fidell-Beaufort, "Jules Breton in America: Collecting in the Nineteenth Century," in Hollister Sturges, *Jules Breton and the French Rural Tradition*, exh. cat. (Omaha, Nebr.: Joslyn Art Museum, 1982), pp. 51–61.

11. See, for example, "National Academy of Design," *New York World*, April 24, 1870, p. 3, in which the critic ambivalently notes the "crude, perverse originality" of *The Bridle Path*. Porte-Plume thought the bathers in *Eagle Head* "grotesque." "More about Pictures and Painters," *Citizen and Round Table* 6 (May 14, 1870), p. 854.

12. "Second Artists' Reception at Dodsworth's Building," *New-York Daily Tribune*, February 27, 1864, p. 10; Benson, "Eastman Johnson," p. 112. On Frère's reputation in the United States, see John Davis, catalogue entry on Johnson's *The Early Scholar*, in Franklin Kelly et al., *American Paintings of the Nineteenth Century*, part 1 (Washington, D.C.: National Gallery

of Art, 1996), pp. 373–76. Hills notes that in the critical literature, Johnson was continually compared with Frère as well as with his German contemporary and friend Ludwig Knaus, another highly respected genre painter; see Hills, *The Genre Painting of Eastman Johnson*, p. 97.

13. Goodrich, *The Life and Works of Winslow Homer* (see n. 4 above), p. 6; "Artists' Reception for the Benefit of the Brooklyn and Long Island Fair," *New-York Daily Tribune*, February 19, 1864, p. 2.

14. Hills and Wilmerding have briefly discussed the relation between *The Old Stage Coach* and *Snap the Whip*. Wilmerding sees Johnson's painting as a possible inspiration for the happy, running boys and the lateral organization of Homer's composition. Hills contrasts Johnson's sweetness with Homer's energy in their representations of the children. See Hills, *The Genre Painting of Eastman Johnson*, p. 129, and Wilmerding, *Winslow Homer*, p. 87.

15. "Fine Arts—Reception at the Union League Club—New Pictures," *New York Times*, December 16, 1872, p. 2; "Fine Arts: The National Academy Exhibition," *Nation* 22 (April 20, 1876), p. 268.

16. The provenance of Johnson's *Woman Reading* is complicated by the fact that it once bore Homer's signature and was published as his work. The painting went on the market in the mid-1970s. A cleaning at that time "easily removed the apocryphal Homer 'signature'. . . and uncovered Eastman Johnson's characteristic initialed signature EJ in the lower left." See Hirschl & Adler Galleries, *The American Experience* (New York: Hirschl & Adler, October–November, 1976), no. 40. *Woman Reading* is clearly related to another painting done about the same time, Johnson's *Lambs, Nantucket*, 1874 (Mellon Collection), in which the model (Johnson's wife with her pet lamb) wears the same hat, though a different walking dress. My sincere thanks to Abigail Booth Gerdts and Patricia Hills for their generous help in providing information on the history of *Woman Reading*.

17. Concerning the influence of contemporary European painting on the emergence of the "solitary reflective contemporary woman" as a theme in American painting after the Civil War, see Edward J. Nygren, "American Genre: Its Changing Form and Content," in Edward J. Nygren and Peter C. Marzio, *Of Time and Place: American Figurative Art from the Corcoran Gallery*, exh. cat. (Washington, D.C.: Smithsonian Institution Traveling Exhibition Service, published in association with The Corcoran Gallery of Art, 1981), pp. 11–14.

18. On Brown, see Martha J. Hoppin, *Country Paths and City Sidewalks: The Art of J. G. Brown*, exh. cat. (Springfield, Mass.: George Walter Vincent Smith Art Museum, 1989). An

informative study of the single female figure in Homer's work about 1865 is Lucretia Giese's "Winslow Homer's Civil War Painting *The Initials*: A Little-Known Drawing and Related Works," *American Art Journal* 18, no. 3 (1986), pp. 4–19. Giese points out the relation of Homer's drawings and paintings to contemporary work along the same lines, by friends and colleagues such as Eugene Benson and William John Hennessey.

19. I follow the interpretation of *Catching the Bee* proposed by Lauren Keach, "Eastman Johnson's Domestic Interiors of the 1870s," Master's thesis, Indiana University, Bloomington, 1996, pp. 10–11. Studies of feminism and its opponents during the period include William Leach, *True Love and Perfect Union: The Feminist Reform of Sex and Society* (New York: Basic Books, 1980), and Carroll Smith-Rosenberg, *Disorderly Conduct: Visions of Gender in Victorian America* (New York: Knopf, 1985).

20. Paul H. Hayne, "By the Autumn Sea," *Appleton's Journal* 4, no. 84 (November 5, 1870), p. 537; "Mr. Gill's Exhibition," *Springfield Daily Republican*, February 17, 1880, cited in Cikovsky and Kelly, *Winslow Homer*, p. 196, n. 2. For interpretations of images featuring women on shore, see Gregory M. Pfitzer, "Women at the Water's Edge: The Body Language of Winslow Homer's Seascape Women," *American Transcendental Quarterly* n.s. 8, no. 4 (December 1994), pp. 257–86; Christopher Reed, "The Artist and the Other: The Work of Winslow Homer," *Yale University Art Gallery Bulletin* 40, no. 3 (Spring 1989), pp. 69–80. Also see Russell Lynes, William H. Gerdts, and Donald B. Kuspit, *At the Water's Edge: Nineteenth- and Twentieth-Century Beach Scenes*, exh. cat. (Tampa, Fla.: The Tampa Museum of Art, 1989).

21. "Fine Arts. The National Academy of Design," *New-York Daily Tribune*, April 29, 1875, p. 7; Henry James, "On Some Pictures Lately Exhibited," *Galaxy* 20 (July 1875), p. 93. Johnson painted *Gathering Lilies* (No. 33) in 1865, but it was several more years before he devoted sustained attention to the single female figure.

22. Henry Adams, "Winslow Homer's 'Impressionism' and Its Relation to His Trip to France," in *Winslow Homer: A Symposium*, ed. Nicolai Cikovsky, Jr., *Studies in the History of Art* 26 (Washington, D.C.: National Gallery of Art, 1990), pp. 71–73. Cikovsky and Kelly, *Winslow Homer*, p. 393, quote the *New York Leader*, April 30, 1864, on Homer's practice of studying figures in the sunlight on his studio rooftop.

23. "Fine Arts: The National Academy of Design," *New-York Daily Tribune*, April 15, 1873, p. 4. On the question of Johnson's palette and his "impressionism," see Hills, *The Genre Painting of Eastman Johnson*, pp. 127–39, and Mills, "'Right Feeling and Sound Technique,'" pp. 53–75. Mills notes (p. 66) that the year

Johnson studied in Paris, Breton's *Gleaners*, 1854 (National Gallery of Ireland, Dublin), was the most highly acclaimed of the three paintings for which Breton won a third-place medal at the Exposition Universelle. Marc Simpson observes that in *The Cranberry Harvest*, the impression of a freshly observed outdoor scene might support the notion that Johnson shared with Homer a belief in the rightness of painting *en plein air*; see Simpson, "Taken with a Cranberry Fit: Eastman Johnson on Nantucket," in Simpson, Hills, and Mills, *Eastman Johnson: The Cranberry Harvest*, p. 33.

24. "The American Society of Painters in Water-Colours," *Art Journal* n.s. 1 (1875), p. 92.

25. Wilmerding, *Winslow Homer*, p. 86.

26. Cikovsky has suggested an analogy between Homer's practice of recycling figures and the industrial manufacturing system of interchangeable parts invented by Eli Whitney; see "Modern and National," in Cikovsky and Kelly, *Winslow Homer*, pp. 66–68. Hills discusses Johnson's repetitions of the sea captains and rustic accessories; see *The Genre Painting of Eastman Johnson*, pp. 155–64. Wright singles out frequent repetition as one of the salient characteristics of genre painting during this period; see Wright, "Men Making Meaning in Nineteenth-Century Genre Painting," p. 14.

27. Hills, *Eastman Johnson*, p. 116, on Johnson's costume in the self-portrait of 1899; letter to John I. H. Baur from Miss Euphemia Whittredge, quoted in Baur, *An American Genre Painter: Eastman Johnson, 1824–1906*, exh. cat. (Brooklyn: Institute of Arts and Sciences, 1940), p. 26; Will H. Low, *A Chronicle of Friendships* (New York: Charles Scribner's Sons, 1908), pp. 266–68; Eastman Johnson to Jervis McEntee, December 2, 1880, and September 13, 1882, frames 469 and 479, reel D30, Charles E. Feinberg Collection of Artists' Letters, Archives of American Art, Smithsonian Institution, Washington, D.C. Also see Appendix.

28. Eastman Johnson to John F. Coyle, March 13, 1864, Artists' Correspondence, frame 1372, reel D10, Archives of American Art, Smithsonian Institution, Washington, D.C. (also see Appendix); Patricia Hills, "Afterword/Afterwards: Eastman Johnson's Transition to Portrait Painting in the Early 1880s," in Simpson, Mills, and Hills, *Eastman Johnson: The Cranberry Harvest*, p. 84.

29. Quoted in Goodrich, *The Life and Works of Winslow Homer*, pp. 47–48, 24; on Homer at the Tile Club, see W. MacKay Laffan, "The Tile Club at Work," *Scribner's Monthly Magazine* 17 (January 1879), pp. 401–9; Augustus Stonehouse, "Winslow Homer," *Art Review* (February 1886), p. 84.

30. S. N. Carter, "The Water-Colour Exhibition," *Art Journal* 5 (1879), p. 94; "The Academy of Design," *Evening Post* (New York), May 12, 1877, p. 1.

31. Winslow Homer to George Walter Vincent Smith, March 3, 1880, curatorial files, Museum of Fine Arts, Springfield, Massachusetts.

32. John Beatty, "Recollections of an Intimate Friendship," in Goodrich, *The Life and Works of Winslow Homer*, pp. 213–14; Eastman Johnson to Jervis McEntee, October 15, 1878, frames 511–15, reel D30, Charles E. Feinberg Collection of Artists' Letters. Also see Appendix.

33. "National Academy Exhibition," *New-York Daily Tribune*, March 27, 1861, p. 8; Hills observes that Johnson's farm scenes from early on "represent the cooperative aspects of farm life" in *Eastman Johnson*, p. 49.

34. John Davis, "Eastman Johnson's *Negro Life at the South* and Urban Slavery in Washington, D.C.," *Art Bulletin* 80, no. 1 (March 1998), pp. 67–92.

35. Wright discusses the way in which the "language of dominance" encoded in paintings such as *Negro Life at the South* was effectively delivered as "truth" through the medium of Johnson's meticulous descriptive skills; see Wright, "Men Making Meaning in Nineteenth-Century Genre Painting," pp. 74–75.

36. On Homer in the South, see Peter H. Wood and Karen C. C. Dalton, *Winslow Homer's Images of Blacks: The Civil War and Reconstruction Years*, exh. cat. (Austin: University of Texas Press, published in association with The Menil Collection, Houston, 1988); Michael Quick, "Homer in Virginia," *Los Angeles County Museum of Art Bulletin* 24 (1978), pp. 60–81; and Mary Ann Calo, "Winslow Homer's Visit to Virginia during Reconstruction," *American Art Journal* 12, no. 1 (1980), pp. 4–27. In "Eastman

Johnson's *Negro Life at the South*" (p. 81), Davis argues that American painting would not see "such a forceful visual evocation of the strained relationship between master and slave until the blunt confrontation of Winslow Homer's *Visit from the Old Mistress*." Elizabeth O'Leary points out that *Old Kentucky Home* can be seen as a predecessor to *A Visit from the Old Mistress*; see O'Leary, *At Beck and Call: The Representation of Domestic Servants in Nineteenth-Century American Painting* (Washington, D.C.: Smithsonian Institution Press, 1996), p. 287, n. 144. But the idea of Homer's painting as a direct comment on and challenge to Johnson's has not been fully explored.

37. Hills suggests that as he became older, Johnson may have identified himself with the old sea captains whom he depicted staring sadly into the embers on the hearth (see No. 65); see Hills, *The Genre Painting of Eastman Johnson*, p. 164.

38. "The Academy Exhibition, IV," *New York World*, April 23, 1877, pp. 4, 5; "Fine Arts," *Nation* 30 (April 15, 1880), p. 296. Hills interprets Johnson's *The Reprimand*, 1880 (Private collection), as carrier of metaphoric content bearing on the new generation of European cosmopolitans (such as William Merritt Chase) rebelliously reacting against the "old-guard academicians"; see Hills, "Afterword/Afterwards," p. 80. In *The Reprimand*, a haughty young woman in a short, flounced dress turns her back on a glowering old sea captain with top hat and cane.

39. On Homer's reputation in the 1890s and after, see Bruce Robertson, *Reckoning with Winslow Homer: His Late Paintings and Their Influence*, exh. cat. (Bloomington: Indiana University Press, published in association with The Cleveland Museum of Art, 1990), and Sarah Burns, *Inventing the Modern Artist: Art and Culture in Gilded Age America* (New Haven: Yale University Press, 1996), pp. 187–217. Hills considers the change in Johnson's reputation in "Eastman Johnson," pp. 167–78.

40. On the tendency to gloss over the earlier work, see, for example, Frederick W. Morton, "The Art of Winslow Homer," *Brush and Pencil* (April 1902), pp. 47–48.

NO. 95
Sunday Morning (formerly "The Evening Newspaper"), 1863
Oil on paper board, 17 x 14½ in.
Mead Art Museum, Amherst, Massachusetts,
Gift of Herbert W. Plimpton: The Hollis W.
Plimpton (Class of 1915) Memorial Collection

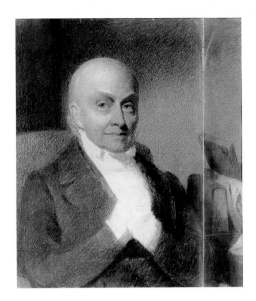

sketched the city's famous, including John Quincy Adams and Dolley Madison. Because celebrating national heroes as moral exemplars was a mainstay of the period's civic culture, he must have known the portraits would be noticed. "Every government degenerates when trusted to the rulers," Thomas Jefferson had written in the 1780s; "the people themselves therefore are its only safe depositories" and "their minds must be improved to a certain degree."[7] Jefferson prescribed education to build characters capable of freedom. Soon Americans enlisted pageantry and symbols as well. On numerous public occasions—the Fourth of July, election days, Lafayette's triumphal return to the United States in the 1820s, Mount Vernon's restoration in the 1850s—citizens were swept up in dramas of reverence for democracy's leaders. The social harmony of *Sugaring Off* would not survive, most assumed, without didacticism. Civic heroes, as models of virtue, would instill responsibility in the populace at large.[8]

The drawings of Dolley Madison and John Quincy Adams (figs. 2, 97) reflect this mind-set. Both subjects, near eighty when they sat for Johnson in 1846, were venerable Washington residents with family ties to the Revolutionary generation. As an old man, Adams gained notoriety for fearlessly presenting antislavery petitions to Congress. Madison, legendary for saving state papers when the British burned the city in 1814, was a favorite hostess, still receiving admirers.[9] Johnson rendered them respectfully. Each faces outward with a direct gaze; sharp lines convey firm dignity. The artist must have understood that he was competing with the camera, the new rage of the 1840s called "miraculous" by some.[10] When Mathew Brady published his *Gallery of Illustrious Americans* (1850), twelve lithographs made from his daguerreotypes, more than half were politicians, including the elder statesmen Calhoun and Clay (figs. 98, 99). Brady need not have been especially mercenary to see that the illustrations would sell to people fascinated by democracy's saints. Many believed that photographs penetrated the sitter's spirit better than art. Louis Daguerre, inventor of the glass-plate method, said "art cannot imitate their accuracy." Edgar Allan Poe concurred that the camera was "*infinitely* more accurate in its representation than any painting by human hands." But not everyone favored photographers. They were "all failed painters," countered Charles Baudelaire, the French poet, expressing a sentiment with which Johnson, persisting in his vocation, perhaps agreed.[11] Even then, the debate was solely about means. Honor distinguished republican heroes, and illustrators in both media were eager to make their merits known.

Although Americans' faith in moral suasion was tested by the Civil War and its aftermath, Johnson continued to paint public figures. Disunion and violence

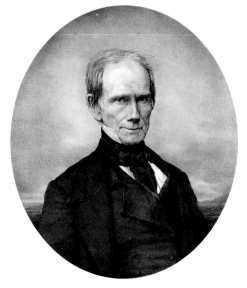

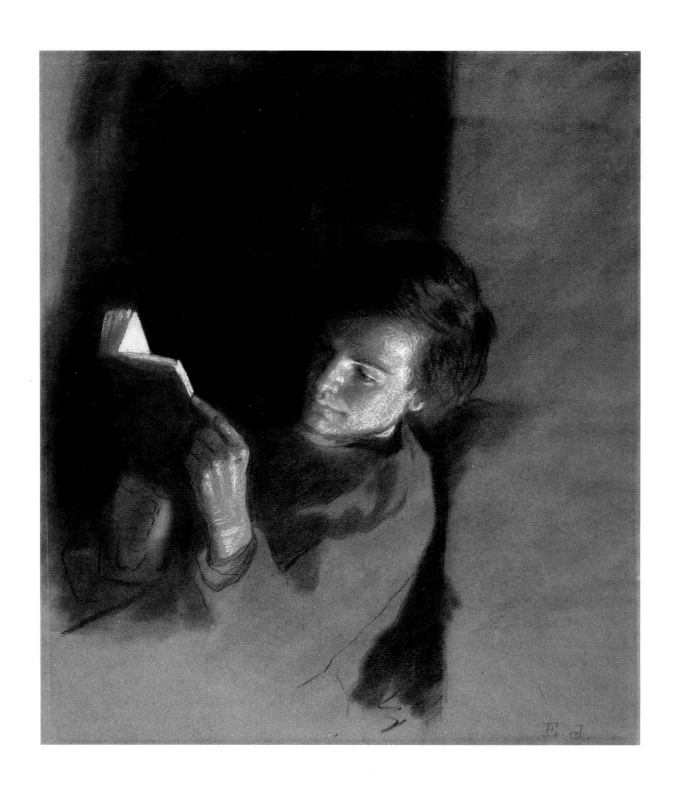

NO. 96*
Study for "The Boy Lincoln," 1868
Charcoal, white chalk, and gouache on paper,
14⅞ x 12¾ in.
The Detroit Institute of Arts, Gift of John S.
Newberry
*not in exhibition

culminated in the first assassination of a president. Like others, the artist must have wondered about the efficacy of patriotic culture. His *Study for "The Boy Lincoln,"* 1868 (No. 96; see fig. 73), paid homage not only to the martyr, however, but to the ideal of nurturing character. "And what shall the pictures be that I hang on the walls, / To adorn the burial-house of him I love?" Walt Whitman asked in "When Lilacs Last in the Dooryard Bloom'd," his elegy of Lincoln. Whitman imagined that American scenes—"Pictures of growing spring and farms and homes"— should cover Lincoln's tomb, as surely as portraits of the hero would be displayed in every loyal household. In this didactic climate, Johnson's study was a memorial that matched Whitman's estimate of the hero as "gentle, plain, just and resolute."[12] By painting Lincoln as a boy, he in effect replaced the dead president with the hoped-for legacy: a new generation of independent young men, bent on self-improvement and poised for action. Leaning toward the light, the Lincoln of the picture seems focused on the future. Viewers, too, must look ahead, the composition urges, and reconstruct the nation along well-tried lines.

Not even rising suspicions of government corruption dislodged Johnson's confidence in a politics of honorable intentions and good examples. Was officeholding a mere screen for self-seeking, Americans asked in the age of robber barons, a tool for consolidating private power? Mrs. Lightfoot Lee of Henry Adams's novel *Democracy* (1880) came to Washington "to touch with her own hand the massive machinery of society." She left disillusioned at its "moral paralysis."[13] In *The Funding Bill— Portrait of Two Men*, 1881 (No. 97), Johnson cautiously took up the theme. He called a preliminary study, conceived as a double portrait, *Two Men* (1880; location unknown). The final title evoked thoughts of behind-the-scenes political dealing: well-dressed men in fine surroundings leisurely pull strings. They remain, however, two men, neither resembling a "moral lunatic," Mrs. Lee's words for one political boss, betraying freedom.[14] The light cast on their faces and hands gives an impression of honest openness. Unidentifiable to the average observer, the men would not inspire reverence. But they seem trustworthy, deserving esteem and imitation. Holding up leaders to citizens as exemplars was republicanism's first premise.

Johnson remained so interested in political subjects that he possibly saw these works as instruments to transmit civic values. Access to art was far less common in his society, however, than acquaintance with books. Americans expected education to support social order, and Johnson's frequent portrayal of reading and writing suggests his appreciation of literacy's role. The commonwealth, Horace Mann declared in 1846, must educate "all its youth, up to such a point as will save them from poverty and vice, and prepare them for the adequate performance of their social and civil duties."[15] In this formula, state, school, and individual enter a partnership to sustain peace by voluntary compliance. Johnson himself, ironically, "got a rather doubtful amount of schooling," according to one historian.[16] This was not unusual at a time when public schools were a new idea. Perhaps he identified with the young future president in *The Boy Lincoln*. Destined for greatness, the boy reads alone, without prodding from teachers. The image repeats the period's core message about learning: Knowledge builds character and strengthens the polity.

Painting after painting depicts readers. A man turns his back on the boiling syrup in *Sugaring Off* to study the newspaper. Another man, tilted back in his chair smoking a pipe, looks up in *Sunday Morning (formerly "The Evening Newspaper")*, 1863 (No. 95). The papers introduce elements of tension. Picturing leisure, both works were produced during wartime, and the men must be reading war news. Why able-bodied men are at home is a question; but at least they recognize their democratic obligation to keep informed. Mother and child read together in *The Little Convalescent*, circa 1872–80 (No. 98). In a society that could imagine no better teacher

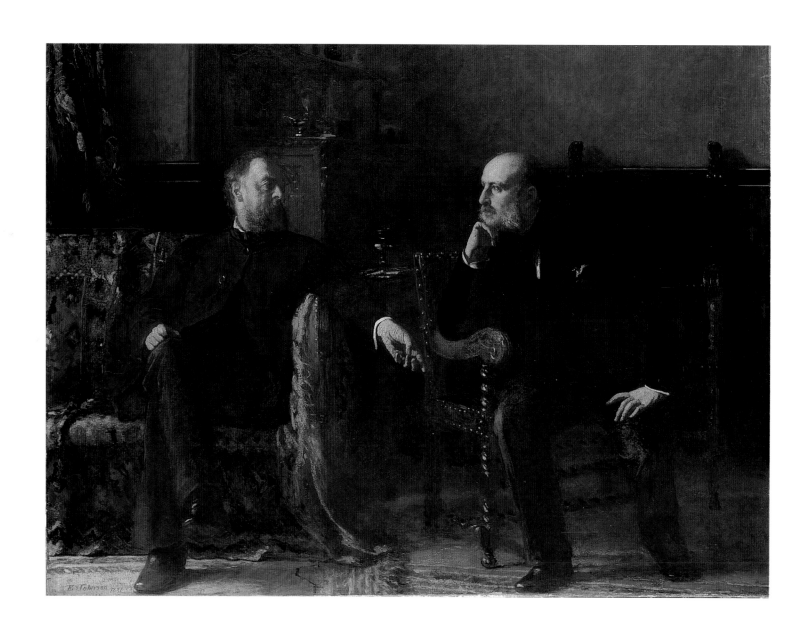

NO. 97*
The Funding Bill—Portrait of Two Men, 1881
Oil on canvas, 60½ x 78¼ in.
The Metropolitan Museum of Art, New York,
Gift of Robert Gordon, 1898 (98.14)
*not in exhibition

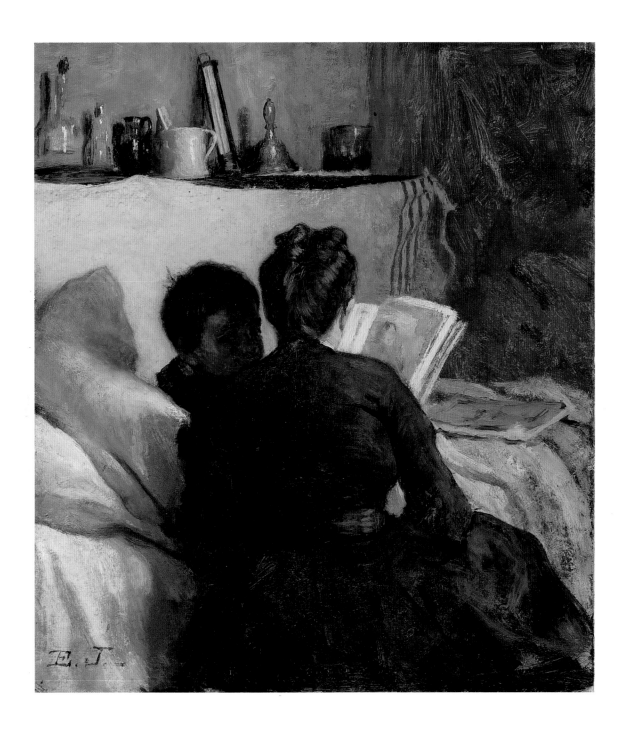

NO. 98
The Little Convalescent, circa 1872–80
Oil on paper board, 12¾ x 11 in.
Museum of Fine Arts, Boston, Frederick Brown
Fund, 40.90

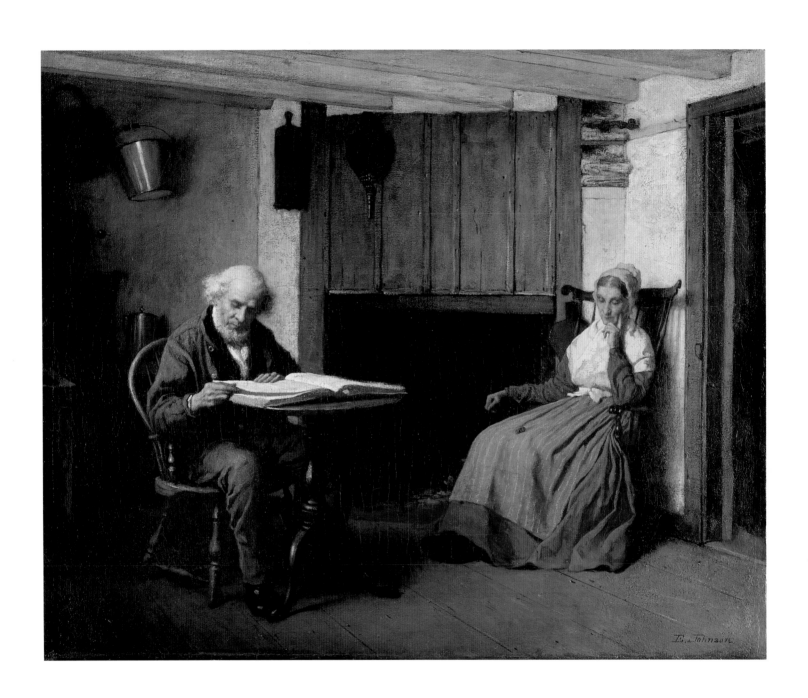

than mother, cozy scenes of domestic reading were a happy portent of enlightened adults. While the sick boy's attention strays to the artist, his mother concentrates on the book. Her care for his mind as well as his health was more than a model of nurturing; indeed, it was a public trust. Old men read the Bible to kin in *Sunday Morning*, 1866 (No. 34), and *Thy Word Is a Lamp unto My Feet and a Light unto My Path*, circa 1880–81 (No. 99). The Scriptures anchored society, nearly all Americans believed. Reading itself was a moral activity; communicating sacred words at home would seem, to most, especially promising of good. True, showing Bible reading as a pastime of old people might hint at its marginality in modern times. Johnson left little evidence of personal religious interest or faith. Late in life he belonged to an Episcopal church; but he still wrote, following the death of a friend's wife in 1879, that "I look with some dismay at the lack of philosophy with which I am equipped" for such an event.[17] Nonetheless, the paintings may equally associate the Bible with the wisdom of age. If so, reading, the centerpiece of each, binds households and, in *Sunday Morning*, unites generations under grandfather's authority.

A society with such high expectations for knowledge was naturally prey to fears of its abuse. Women, considered from time immemorial the weaker sex, might be duped by "tales of fancy" to slight the "real vision" of their duty for "affectation, show and falsity." This typical warning appeared in Sarah J. Hale's *Ladies' Magazine* in 1829.[18] Decades later, Johnson measured changing moods in paintings of women reading. Women's attention to texts now seems a healthy sign of their independence. *Woman Reading*, circa 1874 (No. 89), places the figure in an almost empty, dreamlike landscape. Solitary and absorbed in a letter, she claims her individuality by this act of imaginative escape. Why, too, has the girl of *Interesting News*, 1872 (fig. 100), hung her sewing scissors and thread on the wall, and picked up the paper? Her relaxed posture and back to the window suggest that her inquisitiveness reflects no radical ambitions. Even so, the girl's reading is an index of transformation in women's lives. Literacy, no longer a simple guarantee of order, might challenge tradition. Johnson himself was married for the first time at age forty-four in 1869. His only child, a daughter, was born the next year. Perhaps family life complicated his impression of women, inspiring both the candid glimpse of mother and son in *The Little Convalescent* and the views of women alone with their thoughts.[19] Women read to children at one moment, in private the next. A male eyewitness in the household, Johnson painted as a chronicler of women more than as a moralist.

For most Americans, women were not the only ones to raise questions about the reliability of learning as the cornerstone of order. The boundaries of the political

FIG. 101
J. T. Zealy
Jack (driver), Guinea. Plantation of B. F. Taylor, Esq., Columbia, S.C.
Mounted daguerreotype
Peabody Museum, Harvard University, Cambridge, Massachusetts

FIG. 102
Eastman Johnson
My Jew Boy, 1852
Graphite, crayon, and chalk on paper, 14 1/16 x 12 7/16 in.
Carnegie Museum of Art, Pittsburgh, Andrew Carnegie Fund, 06.11

nation—citizens with a vote and voice in government—were repeatedly scaled and redrawn during Johnson's career. Women's-rights advocates first put suffrage on their platform in the "Declaration of Sentiments" at Seneca Falls, New York, in 1848. The Fifteenth Amendment to the Constitution in 1868 gave black men the vote. Resistance accompanied each step toward social inclusiveness. In the 1850s the Know-Nothing party, driven by anti-Catholicism, stumped for a twenty-one-year probationary period to precede the naturalization of immigrants. Under pressure from the abolitionists to free the slaves, slavery's defenders defined blacks as sub-human. Josiah Nott, a physician, became the first American to argue that the races were separate species, telling a Mobile audience in 1844 "that there is a genus, Man, comprising two or more species—that physical causes cannot change a White man into a Negro."[20] Photographs made the point visually. In 1850 Louis Agassiz, the esteemed Harvard naturalist, commissioned J. T. Zealy of Columbia, South Carolina, to take daguerreotypes of local slaves (fig. 101). All, including women, stripped to the waist, they appear as specimens, a sad parody of Mathew Brady's *Gallery of Illustrious Americans.*[21] Johnson's *The Lord Is My Shepherd,* circa 1863 (No. 76), makes a brave counterstatement in this setting. Here is a black man of quiet intensity—indeed, a man reading. His absorption in his Bible is a declaration of Johnson's faith in African Americans as future citizens.

Painted in 1863, the year of the Emancipation Proclamation, *The Lord Is My Shepherd* shows the artist's keen sense of political timing. He could not have missed the currency of its message about the capability of black men. Johnson's interest in social outsiders, however, was long-standing. *My Jew Boy,* 1852 (fig. 102), pictured one of Europe's proscribed class. Johnson sketched the figure, apparently his servant, halfway through his six-year residence in Düsseldorf, The Hague, and Paris to study art. Without being disrespectful, the image leans toward realism. The boy is unkempt, swarthy, and coarse-featured, nearly a stereotypical Jew if Johnson's careful lines had not preserved his individuality.[22] It was not until 1853 that the artist met August Belmont, the newly appointed U.S. ambassador to The Hague who became his patron. A German-born Jew, Belmont arrived with his Episcopalian wife, a daughter of Commodore Matthew C. Perry, and children. Johnson painted Caroline Perry Belmont and sketched her son and their friends, making the children "overly pretty and sweet," in the words of one scholar, "perhaps in response to the expectations of the patrons and contemporary convention."[23] How Johnson's friendliness with a cultured and powerful Jew forced revision of his perception of Jews can in large measure only be guessed. He did one drawing of Belmont and, in 1857, an oil painting of Louisiana's Senator Judah Benjamin but pictured no more anonymous Jewish subjects. While it was once easy to render *My Jew Boy* as a curious type, how to approach Jews artistically was perhaps less simple after one Jew became an acquaintance.

If ethnic stereotypes complicated Johnson's work, the dilemma pursued him in America. Jewish immigrants, one group among the Irish, Italians, and other ethnic peoples who came to the United States, pushed the number of the nation's Jews from 15,000 in 1840 to 1.7 million in 1905, the year before Johnson's death.[24] Many settled in New York, where he lived after 1858. Returning from Europe three years earlier, Johnson bypassed urban crowds, however, to paint Indians. He saw intelligence and gentleness in the faces of the Anishinabe (Ojibwe) he sketched near the Great Lakes in *Kenne waw be mint* (No. 100) and *Kay be sen day way We Win* (No. 101), both 1857. Indians possessed natural virtue, in the eyes of the eighteenth-century Enlightenment.[25] After 1800 frontier warfare and racial theories eroded respect for the Indians. But the artist George Catlin (1796–1872) still depicted majestic Indian figures "amenable to no laws except the laws of God and honor"

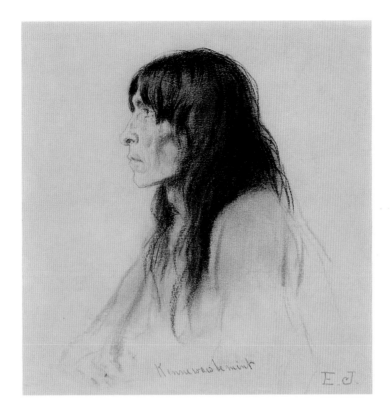

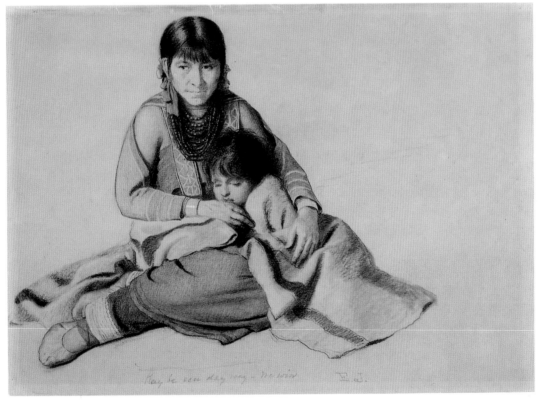

NO. 100

Kenne waw be mint, 1857

Charcoal and crayon on paper, 8 x 7½ in.

From the Permanent Collection of the St. Louis County

Historical Society, Duluth, Minnesota, 62.181.29

NO. 101

Kay be sen day way We Win, 1857

Charcoal and crayon on paper, 10¾ x 14 in.

From the Permanent Collection of the St. Louis County

Historical Society, Duluth, Minnesota, 62.181.27

during five years in the Far West in the 1830s. "I have flown to their rescue," he wrote, recording "their looks and their modes" in art.[26] Johnson did not work with Catlin's Romantic temper. His subjects belonged to everyday life: what in this era could suggest simple virtues better than his modest mother and child?

Something new also marked the canvases of the Anishinabe (Ojibwe) that Johnson produced in the Minnesota Territory, however: numerous small figures shared the landscape with natural features and man-made structures. Indians in *Camp Scene at Grand Portage*, 1857 (No. 102), occupy the foreground, but their faces are indistinct compared to the buildings in the distance. Human beings simply do not dominate the visual field.

Panoramas are not surprising at this moment in history, but they posed vexing questions. Johnson did not have to read Charles Darwin's *Origin of Species* (1859) to suspect that man was not God's purpose in creation, but a byproduct of history. *Principles of Geology* (1830–32) by Charles Lyell opened the prospect that the geological record, demonstrating slow changes in flora and fauna, might offer a truer view of the past than the Book of Genesis. Nor could a thinking person in the age of *The Communist Manifesto* (1848) facilely dismiss Marx and Engels's contention that dialectical materialism, not human will, drove events. "Things are in the saddle, / And ride mankind," Emerson mused closer to home in 1847.[27] The republican doctrine of character formation gained its force from the Bible. Good intentions most reliably anchor society if people are conceived as moral agents, not pawns of nature or the means of production. Yet as Johnson moved beyond portraits to paint natural settings in the 1850s and 1860s, he sensed that we do not act alone. Even *Sugaring Off*, on second glance, may reveal less a town holiday than workers intermixed with the rural industry's equipment, all dwarfed by the forest. Although the tone is cheerful and the community intact, material forces coexist with the human initiatives.

Johnson took few steps, though, down the road to philosophical Naturalism. In this he kept company with his countrymen. "In Europe," one historian writes, "evolutionary thought slipped more easily into a dark vision of a blind and purposeless universe." Americans "tempered the naturalistic creed with a supreme confidence in their own destiny."[28] The national habit of reading change as progress and machines as servants shaped Johnson's *The Old Stage Coach*, 1871 (No. 86). Nostalgia enters the picture mainly by what is not shown: fast, noisy, dirty railroads now linking villages. Even with the trains offstage, the boys pretending to be horses suggest that people, ignorantly will-less as animals, may be technology's slaves. But Johnson resisted unhappy thoughts. The pile of figures on the stagecoach, crowned by the triumphant boy, says instead that the new generation will dominate invention. What today is make-believe in a backwater holds future promise, particularly because girls, too, are swept up in the fun. In 1900 Henry Adams felt awed and confused by the dynamo at the Paris Exposition: nearly "anarchical" and "parricidal," the machine summoned an instinct "to pray to it," idol of "a new universe which had no common scale of measurement with the old."[29] Johnson's technology, by contrast, remained on a human scale. This helps explain his optimism about its utility.

No event during Johnson's lifetime shook Americans' confidence more than the Civil War. Patriotic displays, solid schooling, and well-intended citizens had not kept the Union from dissolution. Photographs circulated showing corpses strewn across battlefields. *A Harvest of Death, Gettysburg, Pennsylvania*, July 1863 (fig. 103), pictured the aftermath of combat where Robert E. Lee alone lost 20,000 men. It was a stark landscape, where minuscule figures on the featureless field survey the dead. Realism, in the sense of commitment to record unembellished, often grim facts, did not, however, dominate the arts of the era. Perhaps human nature resists too much

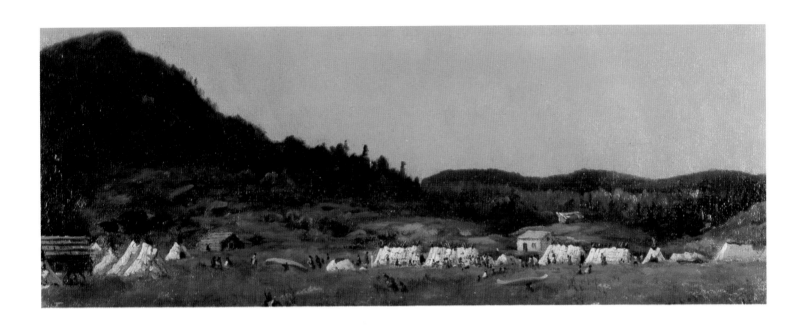

NO. 102
Camp Scene at Grand Portage, 1857
Oil on canvas, 4¾ x 13 in.
From the Permanent Collection of the St. Louis
County Historical Society, Duluth, Minnesota,
62.181.1

FIG. 103
Timothy O'Sullivan
A Harvest of Death, Gettysburg, Pennsylvania,
July 1863
Photograph
From A. Gardner's *Sketch-Book of the War*
(1865–66), plate 36
Rare Books Division, The New York Public
Library, Astor, Lenox and Tilden Foundations

FIG. 104
Mathew B. Brady
Sherman and His Generals, May 1865
Albumen silver print
Chicago Historical Society, ICHi-12473

FIG. 105
Winslow Homer
"The War for the Union, 1862—A Cavalry
Charge"
From *Harper's Weekly* (July 5, 1862)
Brooklyn Museum of Art Library Collection

pessimism, and Americans especially had a limited taste for lurid scenes. Mathew Brady, who invested more than $100,000 in crews to photograph battles, declared bankruptcy in 1873. Buyers were tired of war. Even during the fighting, heroic styles competed with morose views. Nearly every famous Union general sat for Brady. This expanded his "gallery of illustrious Americans" and gave it a military flavor. Group portraits of officers and their staffs were a popular variant. The stump of the arm of the standing officer in *Sherman and His Generals,* May 1865 (fig. 104), hidden by the sleeve of his dress uniform, is a symbol of self-sacrifice, not a reminder of horror.[30] On the battlefield, artists sketched the excitement for magazine readers. Winslow Homer's "The War for the Union, 1862—A Cavalry Charge" (fig. 105), printed in *Harper's,* showed the troops' rush forward, sabers drawn, instead of the charge's tragic consequences.[31] Americans could not ignore the war's sorrow. Everyone knew someone away fighting, or worse, maimed or dead. But sturdy habits of focusing on traits worthy of emulation—devotion, camaraderie, bravery—produced images at once stirring and consoling. Here was republicanism's faith in character.

Johnson's canvas of *The Wounded Drummer Boy,* 1871 (fig. 106), displayed this hardy temper. The artist pictured suffering: the boy's bandaged leg, his strained expression, the man staring blankly ahead. But spirited resistance is the dominant mood. Bodies and weapons are not spread haphazardly about. The tough little drummer, raised high, centers the composition. He is the moral exemplar, surrounded by touches of hopefulness: a wounded man being cared for and vegetation miraculously not trampled down. Completed six years after the war's end, the painting may have helped viewers frame sad memories in invigorating thoughts. Akin to his recent *The Boy Lincoln,* this painting, too, speaks of the courage of youth. In

both, Johnson seems to have felt comfortable as a public artist. Facing tragedies—the assassination that called to mind many other deaths—he drew on his culture's most elemental notions of virtue and order to suggest routes to a better future.

The war also made Johnson reflect on community in ways that had little to do with battle. His numerous studies of rural maple sugaring (1861–66) were less an evasion of painful truths than a revisiting of social ideals. *Sugaring Off* asks a question: What amiability keeps these neighbors together, at the same time that good will like theirs fails the nation? Though the painting cannot answer directly, there are assurances that civility will prevail. Storytelling, whittling, fiddling, and dancing—unglamorous yet sociable pastimes—link acquaintances. Common labor, interrupted by private moments such as depicted in *At the Camp, Spinning Yarns and Whittling*, circa 1864–66 (No. 103), reinforces bonds. Johnson's contemporaries would not have missed the resemblance between the sugaring camp and army encampments, Union and Confederate, scattered in the countryside. Soldiers, too, amused each other with cards, tales, and songs. Men's domesticity, embarrassing in peacetime, gained currency as a symbol of normalcy. Mathew Brady or an assistant took a picture of Pine Cottage (fig. 107), a shacklike cabin serving all too typically as winter quarters for troops. Its inhabitants gather outside to talk, read, even sweep. Except for the absence of women, they duplicate the casual society of Johnson's Maine woods. In wartime, reminders of peace promised its return.[32] Soldiers' quarters provoked thoughts of hometowns and what made them work.

Even Lincoln, burdened by tragedy, returned to first principles. "Four score and seven years ago," he began in 1863 at the dedication of the cemetery at Gettysburg, "our fathers brought forth on this continent a new nation, conceived in Liberty, and dedicated to the proposition that all men are created equal."[33] The Civil War did not alter American thinking all at once. New systems—Social Darwinism, forms of socialism, philosophical Pragmatism—emerged gradually. When Johnson painted in the postwar years much as he had before, his loyalty to time-honored habits was not unusual. He did portraits of politicians, genre scenes of women, and landscapes of rural labor. Honest leadership, loving homes, and hard work were parts of a tested formula.

Johnson had a sense of humor about aging, however, and the aging of ideas. In 1887 his title for *The Nantucket School of Philosophy* (No. 104) brought irony to the scene. What sort of philosophy could these old men be spinning, gathered around their stove? Painted during the years of the Concord School of Philosophy (1879–88), the picture calls to mind the Nantucketers' famous peers: Bronson Alcott, who resembled Johnson's man on the left, and Emerson, remarkably similar to the next one in line. Inspired by nostalgia, the school convened each

FIG. 106
Eastman Johnson
The Wounded Drummer Boy, 1871
Oil on canvas, 47¾ x 38½ in.
Union League Club, New York

FIG. 107
Mathew B. Brady
Pine Cottage, Soldier's Winter Quarters, undated
Photograph
National Archives, Washington, D.C.,
photo no. 111-B-265 (Brady Collection)

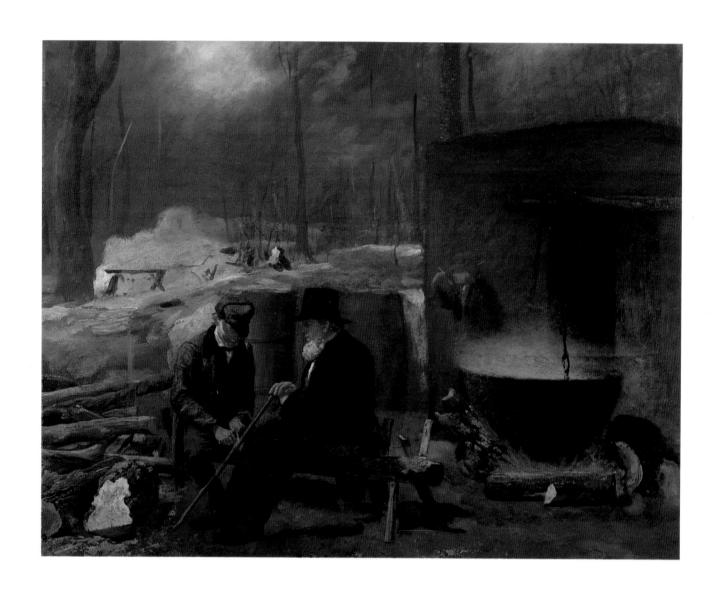

NO. 103
At the Camp, Spinning Yarns and Whittling,
circa 1864–66
Oil on paper board, 19 x 23 in.
Kennedy Galleries, New York

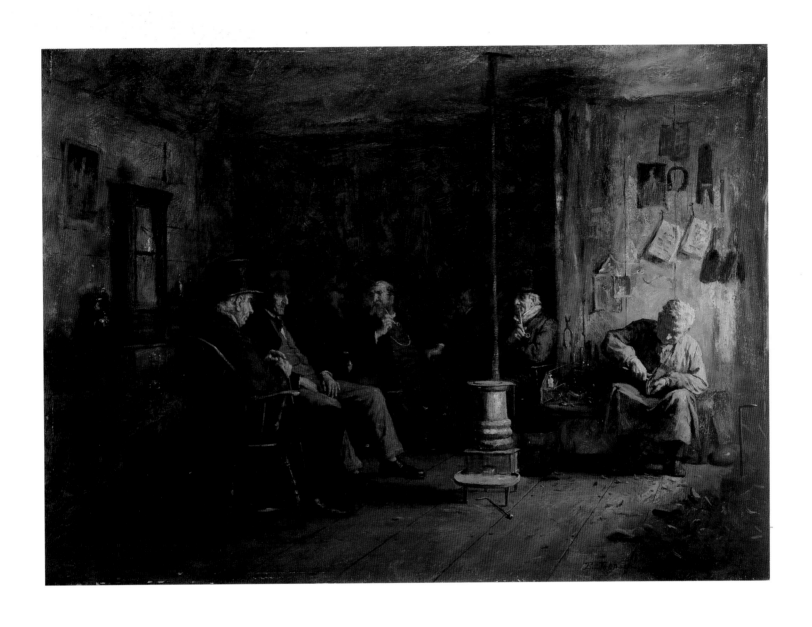

NO. 104
The Nantucket School of Philosophy, 1887
Oil on panel, 23¼ x 31¾ in.
The Walters Art Gallery, Baltimore, 37.311

231 EASTMAN JOHNSON AND THE CULTURE OF AMERICAN INDIVIDUALISM

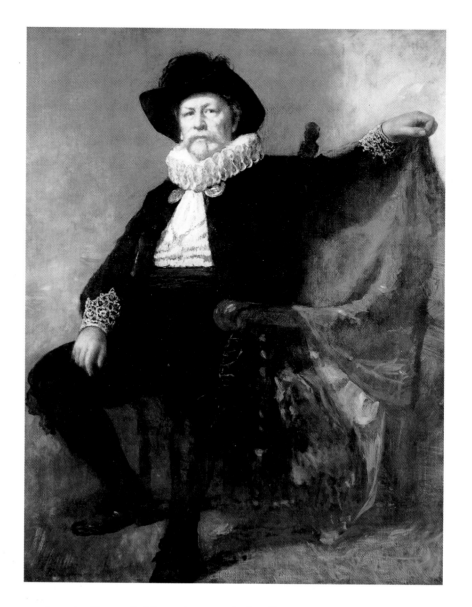

summer in Concord, Massachusetts. Aging Transcendentalists and their followers were its teachers. It was, one historian observes, "like visiting a museum of antiquities."[34] Emerson died in 1882. Alcott had a stroke the same year. Doddering and always so esoteric that they seemed a bit foolish to their countrymen, the Transcendentalists had nonetheless become American icons. No one counseled selfhood more boldly. Johnson had sketched Emerson in 1846. But on the whole, he saw individualism less abstractly than the Concord seer. His *Nantucket School* championed plain virtues. The man in the corner soling shoes, standard piecework in New England households during long winters, stamped his neighbors' philosophizing as the thoughts of ordinary folk. Their opinions were old but durable, presumably like those of the artist himself.

Johnson's humor was one expression of his critical cast of mind. He pictured American life in light of his confidence in character, without forgetting that his premises, shared with his contemporaries, raised questions as well as gave answers. These crosscurrents in the man and his work appear in a late self-portrait of 1899 (fig. 108). Johnson was still intrigued by faces. The republic depended, Americans believed, on who people were, and features were windows on the soul. Johnson played in the portrait, however, with how he dressed. He showed himself in the Elizabethan clothes that he wore to a party at The Century Association in New York. A member since 1862, he socialized with the city's important men, and his art repeated a message they approved: An educated citizenry promised orderly progress. Just the same, the ruff around his neck, embroidered sleeves, and black stockings

identify his clothing as a costume. Here is the artist who sees beyond surfaces and thinks discerningly about what he observes. Johnson combined an uncomplicated embrace of republican values with shrewd insight into their ambiguities. Seeking social harmony, he did not expect everyone to be the same. He imagined cooperation without conformity and consensus without dogmatism. In this, he appealed to his peers, and does to us, as an American artist.

Notes

For generous assistance with sources and critical suggestions, I am grateful to Teresa A. Carbone, Amy Golahny, Patricia Hills, Sally McMurry, William Petersen, and Carol Reardon. I wish especially to thank Teresa A. Carbone for her kind encouragement and expert advice.

1. "Self-Reliance" (1841), in *Selections from Ralph Waldo Emerson: An Organic Anthology*, ed. Stephen E. Whicher (Boston: Houghton Mifflin, 1957), pp. 148, 149.

2. "The Artist of the Beautiful" (1844), in *The Complete Novels and Selected Tales of Nathaniel Hawthorne* (New York: Modern Library, 1965), p. 1143.

3. Emerson, "Self-Reliance," p. 162.

4. On changes in maple sugar production and marketing, see Mark D. Ware, "Spotza, Keelers and Stirred Sugar: The Maple Sugar Industry of Southwestern Pennsylvania," in *Proceedings of the 20th Anniversary Annual Meeting, June 17–24, 1990, The Association for Living Historical Farms and Agricultural Museums* 13, ed. Debra Reid and Ken Yellis (Santa Fe: The Association for Living Historical Farms and Agricultural Museums, 1993), pp. 48–58.

5. On the Maine Law of 1851, as well as the state's antebellum transportation system and economy, see, respectively, Richard R. Wescott and Edward O. Schriver, "Reform Movements and Party Reformation, 1820–1861," and Joyce Butler, "Family and Community Life in Maine, 1783–1861," in *Maine: The Pine Tree State from Prehistory to the Present*, ed. Richard W. Judd, Edwin A. Churchill, and Joel W. Eastman (Orono: University of Maine Press, 1995), pp. 203, 227–28. On the Fryeburg Academy, see John Stuart Barrows, *Fryeburg: An Historical Sketch* (Fryeburg, Maine: Pequawket Press, 1938), chapter 12. The Maine of Johnson's youth had only recently separated itself from Massachusetts and gained statehood in 1820 as part of the Missouri Compromise. This was mainly the work of democratically minded inhabitants in Maine's interior, most likely men similar to Johnson's father, as Alan Taylor explains, in *Liberty Men and Great Proprietors: The Revolutionary Settlement on the Maine Frontier, 1760–1820* (Chapel Hill: University of North Carolina Press, 1990).

6. Biographical information on Johnson and his family may be found in two works by Patricia Hills, *Eastman Johnson*, exh. cat. (New York: Clarkson Potter in association with the Whitney Museum of American Art, 1972), and *The Genre Painting of Eastman Johnson: The Sources and Development of His Style and Themes* (New York: Garland, 1977). Before Philip Johnson entered politics, he operated a tavern, as noted in Barrows, *Fryeburg*, p. 176. Although Eastman Johnson came to sympathize with the Republicans on issues of race and national unity after the party's formation in the mid-1850s, Maine was a Democratic state during his childhood and his father a Democratic politician. In the mid-1840s, President Polk appointed Philip Johnson chief clerk in the Bureau of Construction, Equipment, and Repair of the Navy Department, a position that he held until his death. See John Davis, "Eastman Johnson's *Negro Life at the South* and Urban Slavery in Washington, D.C.," *Art Bulletin* 80, no. 1 (March 1998), p. 68. Sectionalism and slavery brought turmoil to the American party system in the 1850s. Competition between Democrats and Whigs, the norm for two decades, was replaced by contests between Democrats and Republicans. Public reorganization was matched by private soul-searching and realignment. Many northerners, Democrats and Whigs, were disturbed by the established parties' equivocation on the slave system. See Anne C. Rose, *Victorian America and the Civil War* (Cambridge: Cambridge University Press, 1992), pp. 214–18. In this setting, the state of Maine shifted from a Democratic to a Republican majority, as explained in Wescott and Schriver, "Reform Movements," pp. 214–25. On the Republican outlook, see Eric Foner, *Free Soil, Free Labor, Free Men: The Ideology of the Republican Party before the Civil War* (London: Oxford University Press, 1970).

7. Query XIV, "Laws," *Notes on the State of Virginia* (1787), in *The Portable Thomas Jefferson*, ed. Merrill D. Peterson (New York: Viking, 1975), p. 198.

8. On Lafayette's tour (1824–25), see Fred Somkin, *Unquiet Eagle: Memory and Desire in the Idea of American Freedom, 1815–1860* (Ithaca, N.Y.: Cornell University Press, 1967), chapter 4; on the restoration of Mount Vernon, see George B. Forgie, *Patricide in the House Divided: A Psychological Interpretation of Lincoln and His Age* (New York: Norton, 1979), pp. 168–72; and on this political spirit more generally, see Anne C. Rose, *Voices of the Marketplace: American Thought and Culture, 1830–1860*

(New York: Twayne Publishers, 1995), chapter 2. Johnson himself did several paintings of Mount Vernon, including *The Old Mount Vernon* (No. 68), and *Kitchen at Mount Vernon* (No. 69), both 1857. Artists, it was commonly said in the early republic, had a civic obligation to employ themes and styles conducive to public well-being, as Neil Harris explains in *The Artist in American Society: The Formative Years, 1790–1860* (1966; reprint, New York: Simon and Schuster, 1970), especially chapter 2. Sarah Burns shows, by contrast, that by the late nineteenth century much debate centered on the artist's social role, in *Inventing the Modern Artist: Art and Culture in Gilded Age America* (New Haven: Yale University Press, 1996).

9. Johnson probably sketched Adams (1767–1848) at the artist's studio in the Capitol. Dolley Madison (1768–1849) spent her last years in the household of her nephew, James Madison Cutts, Second Comptroller of the Treasury, a Democratic bureaucrat like Johnson's father. Philip Johnson may have helped his son meet Madison. Cutts's daughter Adele became the second wife of Stephen A. Douglas in 1856, despite the fact that Adele, following her mother's religion, was a Catholic. It was said that her great-aunt Dolley schooled Adele in the social graces. See Marie Perpetua Hayes, "Adele Cutts, Second Wife of Stephen A. Douglas," *Catholic Historical Review* 30, no. 2 (July 1945), p. 181.

10. Oliver Wendell Holmes, "The Stereoscope and the Stereograph" (1859), in *Classic Essays on Photography*, ed. Alan Trachtenberg (New Haven: Leete's Island Books, 1980), p. 73.

11. Daguerre, "Daguerreotype" (n.d.); Poe, "The Daguerreotype" (1840); Baudelaire, "The Modern Public and Photography" (1862), in *Classic Essays on Photography*, pp. 12, 38, 87. Italics in this and subsequent quotations appear in the original texts. On events leading up to the publication of Brady's *Gallery*, see Alan Trachtenberg, *Reading American Photographs: Images as History, Mathew Brady to Walker Evans* (New York: Hill and Wang, 1989), pp. 33–52. For an excellent discussion of Brady's political subjects in both artistic and cultural contexts, see Mary Panzer, *Mathew Brady and the Image of History* (Washington, D.C.: Smithsonian Institution Press, 1997), chapter 5.

12. The first two phrases come from "When Lilacs," the second from "The Dust Was Once the Man," both part of the larger poem titled "Memories of President Lincoln," in *Walt Whitman: Complete Poetry and Selected Prose*, ed. James E. Miller, Jr. (Boston: Houghton Mifflin, 1959), pp. 235, 240.

13. Henry Adams, *Democracy: An American Novel* (1880; reprint, New York: New American Library, 1961), pp. 17, 181. I have argued that suspicions of government corruption were as much a function of growing professionalism and impersonality in politics as of actual wrongdoing: see Rose, *Victorian America and the Civil War*, pp. 208–14.

14. Adams, *Democracy*, p. 182.

15. *Tenth Annual Report of the Secretary of the Board of Education* [of Massachusetts], excerpted in *Antebellum American Culture: An Interpretive Anthology*, ed. David Brion Davis (1979; reprint, University Park: Pennsylvania State University Press, 1997), p. 42. On the rise of public schooling, see Carl F. Kaestle, *Pillars of the Republic: Common Schools and American Society, 1780–1860* (New York: Hill and Wang, 1983).

16. John I. H. Baur, *An American Genre Painter: Eastman Johnson, 1824–1906* (Brooklyn: Institute of Arts and Sciences, 1940), p. 5.

17. Eastman Johnson to Jervis McEntee, November 17, [18]79, frames 458, 456, reel D30, Charles E. Feinberg Collection of Artists' Letters, Archives of American Art, Smithsonian Institution, Washington, D.C. For November 17 letter, also see Appendix. Baur notes that Johnson's funeral was held at St. George's Episcopal Church in New York (*An American Genre Painter*, p. 27). Even with this apparent coolness toward religion, Johnson produced a number of paintings with titles taken from biblical passages. *Thy Word Is a Lamp unto My Feet and a Light unto My Path*, for example, is a quotation from Psalms 119.105. Similarly, he produced three paintings of women whose names had significance in light of a Bible story: *Ruth*, circa 1880–85 (No. 63), *Hannah amidst the Vines*, 1859 (No. 73), and *Dinah, Portrait of a Negress*, late 1860s (No. 79), all undated. Ruth in the picture, sitting by her stove, calls to mind the loyalty to household of her namesake in the Book of Ruth. Hannah in Johnson's portrait relates less directly to Hannah of the Bible, remembered for her piety (1 Samuel 1–2.11). Both biblical women were familiar and respected figures to nineteenth-century audiences, however, and an artist could be sure viewers would respond warmly to their names. The rape of Dinah, daughter of Jacob and Leah, leads to the slaying of her seducer and his kin by her brothers; her story has clear meaning for the history of American black women (see Genesis 34). Johnson's choice of these subjects and titles indicates his acquaintance with the Bible. It was not unusual in this era to find religious knowledge, acquired in childhood, coupled with doubt and lax practice in adulthood; see Rose, *Victorian America and the Civil War*, chapter 1.

18. W. R., "The Dangers that Beset the Female Sex," *Ladies' Magazine* 2, no. 6 (June 1829), pp. 280, 281. Ancient notions about women's liability to temptation surfaced during this formative period of the "cult of domesticity." Although women were now praised for their spirituality and cast as moral exemplars, older fears of their capacity to stray contributed to a persistent undercurrent of ambivalence. On the rise of domestic ideals, see Nancy F. Cott, *The Bonds of Womanhood: "Woman's Sphere" in New England, 1780–1835*, 2d ed. (New Haven: Yale University Press, 1997).

19. More generally, Johnson's formal portraits of family groups, including *Christmas-Time (The Blodgett Family)*, 1864 (No. 31), *The Brown Family*, 1869 (No. 36), and *The Hatch Family*, 1871 (No. 83), were joined by informal genre studies of women, such as *Not at Home*, circa 1873 (No. 37), and *The Toilet*, 1873 (No. 39). On the family portraits, see Suzaan Boettger, "Eastman Johnson's *Blodgett Family* and Domestic Values during the Civil War Era," *American Art* 6, no. 3 (Fall 1992), pp. 51–67, and John Davis, "Children in the Parlor: Eastman Johnson's *Brown Family* and the Post–Civil War Luxury Interior," *American Art* 10, no. 2 (Summer 1996), pp. 51–77.

20. Josiah Nott, "Two Lectures on the Natural History of the Caucasian and Negro Races," quoted in William Stanton, *The Leopard's Spots: Scientific Attitudes toward Race in America, 1815–59* (Chicago: University of Chicago Press, 1960), p. 69. On the proposed probationary period for immigrants, see Ray Allen Billington, *The Protestant Crusade, 1800–1860: A Study of the Origins of American Nativism* (1938; reprint, Gloucester, Mass.: Peter Smith, 1963), p. 410.

21. The story of Zealy's daguerreotypes may be found in Trachtenberg, *Reading American Photographs*, pp. 52–60. The photographs were not published but stored at Harvard, where they were discovered in 1976. Despite the degrading poses, the faces of the subjects display their individuality and pride, in effect subverting the "scientific" purpose of the photographic record.

22. On stereotypical images of Jews, see Sander L. Gilman, *The Jew's Body* (New York: Routledge, 1991).

23. Hills, *Eastman Johnson* (n. 6 above), p. 17. I am grateful to Patricia Hills for a comprehensive list of the subjects of Johnson's portraits. On *My Jew Boy*, see K[enneth] N[eal], "Eastman Johnson," in *American Drawings and Watercolors in the Museum of Art, Carnegie Institute*, ed. Henry Adams (Pittsburgh: Museum of Art, Carnegie Institute, 1985), pp. 37–38. On Belmont, see Irving Katz, *August Belmont: A Political Biography* (New York: Columbia University Press, 1968). Belmont was a rising Democrat, and perhaps Johnson made his acquaintance through his father's political ties. Following his marriage in 1849, Belmont entered politics with the encouragement of his wife's uncle, the congressman and later senator John Slidell from Louisiana. Appointed by President Pierce to The Hague, he managed Stephen A. Douglas's 1860 presidential campaign and subsequently served as Democratic National Chairman until 1872. He had arrived in America in 1837 as an agent of the Rothschilds and made a fortune in banking. Although his wedding and

funeral were conducted at New York's Church of the Ascension, he never became a Christian.

24. Nathan Glazer, *American Judaism*, 2d rev. ed. (Chicago: University of Chicago Press, 1972), pp. 23, 193.

25. Thomas Jefferson reflected the Enlightenment view when he wrote in 1787 that the Indians' "reason and sentiment [are] strong, their imagination glowing and elevated," in contrast to blacks who show "want of fore-thought" and "in imagination" are "dull, tasteless, and anomalous." See Jefferson's Query XIV, "Laws," *Notes on the State of Virginia* (1787), in *The Portable Thomas Jefferson* (see n. 7 above), p. 188.

26. "Letter from the Mouth of the Yellowstone River" (1832), in *American Art, 1700–1960: Sources and Documents*, ed. John W. McCoubrey (Englewood Cliffs, N.J.: Prentice-Hall, 1965), pp. 94, 95. On the uneven survival of the myth of the "noble savage" after 1800, see Reginald Horsman, *Race and Manifest Destiny: The Origins of American Racial Anglo-Saxonism* (Cambridge, Mass.: Harvard University Press, 1981), pp. 189–92.

27. "Ode, Inscribed to W. H. Channing," in *Selections from Ralph Waldo Emerson*, p. 440. Much scholarship rightly emphasizes that science did not immediately dislodge religion; instead, Americans absorbed scientific theories in ways compatible with Judeo-Christian premises. Still, there were tensions between religious and scientific worldviews that at least sporadically gave rise to conflict, as Sydney E. Ahlstrom indicates in *A Religious History of the American People* (New Haven: Yale University Press, 1972), pp. 763–74.

28. John Higham, "The Reorientation of American Culture in the 1890s," in *The Origins of Modern Consciousness*, ed. John Weiss (Detroit: Wayne State University Press, 1965), p. 37.

29. Henry Adams, *The Education of Henry Adams: An Autobiography* (1918; reprint, Boston: Houghton Mifflin, 1961), pp. 380–81.

30. On Brady's varied wartime subjects, see Panzer, *Brady*, chapter 7; on his bankruptcy, see James D. Horan, *Mathew Brady: Historian with a Camera* (New York: Crown, 1955), pp. 40, 68.

31. Although the subjects of Homer's Civil War paintings were diverse, he depicted more battle scenes than Johnson. This is ironic, because Johnson studied in Europe in the 1850s with the American expatriate painter Emanuel Leutze, whose heroic historical subjects included *Washington Rallying the Troops at Monmouth*, 1854 (University Art Museum, Berkeley, California). On Homer's Civil War works, see the essays in Marc Simpson, ed., *Winslow Homer: Paintings of the Civil War*, exh. cat. (San Francisco: Fine Arts Museums of San Francisco, 1988), and Nicolai Cikovsky, Jr., *Winslow Homer* (New York: Abrams, 1990), chapter 2. Lucretia Hoover Giese concludes that neither American artists nor their audiences favored the war as a subject; see Giese, "'Harvesting' the Civil War: Art in Wartime New York," in *Redefining American History Painting*, ed. Patricia M. Burnham and Lucretia Hoover Giese (Cambridge: Cambridge University Press, 1995), chapter 4. This matches the assessment of literary critics who wonder why the war did not inspire more literature; see, for example, Daniel Aaron, *The Unwritten War: American Writers and the Civil War* (New York: Knopf, 1973). These judgments may correctly measure the response of highbrow culture to the war, but they seem to slight the numerous songs, engravings, short fiction, and other popular forms of expression circulating most often in the periodical press. Although Edmund Wilson did not focus on lowbrow works, he did take a broad view of what constituted valuable literature, examining diaries, travel narratives, and memoirs in *Patriotic Gore: Studies in the Literature of the American Civil War* (New York: Farrar, Straus and Giroux, 1962).

32. Bell Irvin Wiley details the amusements and living arrangments of Civil War soldiers in *The Life of Johnny Reb: The Common Soldier of the Confederacy* (Indianapolis: Bobbs-Merrill, 1943), chapters 4, 9, and his *The Life of Billy Yank: The Common Soldier of the Union* (Indianapolis: Bobbs-Merrill, 1951), chapters 7, 9. When Congress passed a draft law in 1863, Johnson was eligible as one of the first group called: all men ages twenty to thirty-five and all unmarried men ages thirty-five to forty-five. The second group, all remaining men, would only be called when the first was exhausted. Johnson was a thirty-eight-year-old bachelor when the law was enacted on March 3. The act allowed draftees to hire substitutes for $300. If Johnson was called, he may have chosen this option, like many others who could afford it. See Marvin A. Kreidberg and Merton G. Henry, *History of Military Mobilization in the United States Army, 1775–1945*, Department of the Army Pamphlet No. 20-212 (Washington, D.C.: Department of the Army, 1955), pp. 104–9.

33. "Gettysburg Address," in *The American Intellectual Tradition*, ed. David A. Hollinger and Charles Capper (New York: Oxford University Press, 1993), vol. 1, p. 429.

34. John McAleer, *Ralph Waldo Emerson: Days of Encounter* (Boston: Little, Brown, 1984), p. 641. McAleer discusses the Concord School of Philosophy in chapter 77.

A Selection of the Artist's Letters

Although only a limited number of Eastman Johnson's letters survive, it is clear that he was a prolific and effusive correspondent. The following selection was chosen to offer a fuller sense of the circle of colleagues within which Johnson worked and some of the personal and aesthetic concerns that preoccupied him over the course of half a century.

All of the letters were transcribed directly from the originals or from photocopies thereof, with errors and anomalies of spelling and punctuation left intact. Ellipsis points within brackets (i.e., [. . .]) show the place of an illegible or obliterated word (in certain cases the result of damage to the paper); a question mark within brackets (i.e., [?]) follows a tentative reading of a word that was not definitively legible.

The letters printed here are from the Archives of American Art (Charles E. Feinberg Collection of Artists' Letters, Reel D30; Miscellaneous Manuscripts, Reel 3483; Artists' Correspondence, Reel D10; Jervis McEntee Papers, Reel 4707; Weir Family Papers, Reel 530); Houghton Library, Harvard University; and The New-York Historical Society (Folsom Papers).

Archives of American Art
Misc. Mss.
Reel 3483
Frame 82

Dusseldorf, March 25, 1851.

My dear Charlotte,[1]

Yours of Nov. 17th 1849 is rec'd & I hasten to reply—I have also to acknowledge the receipt this day of another of Feb. 19, 1851 from you & Hannah. I find this all right, & as it should be, that you do as you would be done by, & that your resentful & revengeful feelings which you for a time nourished did not triumph but were at last overcome by a kindly and forgiving spirit—There is every reason why this should prevail, for I have been the suffering party—You complain, & feel your case a hard one, but think of *mine*, and consider what I must have undergone in comparison, in the consciousness of my obligation & ingratitude, in having failed for so long a time to reply to your letters—Let this not be your fault, for you have no conception of the remorse you can bring down upon yourself by so doing—I have felt it much in my time. I particularly in this instance in its fullest force. I have [. . .] as I could, (& I think I can endure as much in this way as another) till their reception today of yours & Hannah's of the 19 ult. rendered it insupportable, & I resolved to sweep away the weight on my conscience & which has bowed down my good name in the minds of those where I would fain it should still flourish as fresh & green as in the days of old—Speaking of days of old, what a vista opens upon my memory, half pleasant, half unpleasant, in those years of my life that were passed in Augusta (now a city, with its Mayor), but as vague almost as my dreams, with the exception of some few points of reality which are still as palpable to my mind's eye as mortality need be, such as the girls to whom I write & c. (& this I take it you will consider no reflection on your being also quite as *spiritual* as you need be) This may be owing to the five years that have elapsed since I last left there, & its present remoteness, with the difference of scene, life, circumstances, & c. in which I now find myself placed—But we will let that go for the present. You would probably prefer to know what the difference is—Let me however first thank you for your kind remembrance of me in my wanderings in far off & strange lands & for sending a second

Frame 83

letter in search of me after the first had met with such an *apparent* ill return & be assured how heartily I appreciate your constant regard & especially your continued confidence in mine which I trust you will have no occasion to diminish.

Pray write me soon again—It is a delightful thing to hear now & then from my old home direct, & have the names of acquaintances & companions freshly brot. up to me & an image of the little world as it still goes on there with its various

changes, some sad & others pleasant in all of which I feel much interest—Some are married—Very naturally—You girls however continue apparently obstinate, & dont give me to understand that there is anything of the sort going on there—I am prepared however any day for another story—

Chas. Lambard & the pretty Fanny Johnson I understand have sometime since consummated matters, & are probably now in the jogging pace of married life. What a distance ahead of me—when *I* shall come to this, is, I fancy as utterly a matter of conjecture as can possibly be, especially if I wait for such a pretty girl to fall in Love with me as Chas. has got—Perhaps you imagine it no impossibility that I should at last bring home a dutch girl. Not at all. I fall back upon *"down east"* in preference, which according to my experience is the place for saw-logs & pretty girls of all the places in the world—They would shine here like stars.

You no doubt expect in this a most interesting letter, coming awa-a-y from Germany, a land of fable, poetry, & song where every mountain & every castle has its story, & the rivers flow in murmurs that seem but voices of the lingering spirit of sainted warriors, sprites, heroes & maidens with which fancy & romance & the legends of a thousand years have peopled them, but Lord bless you my dear child, you have not yet learned that *commonplaceness* is the sum & substance of what one finds, go where one will, & that to see all these fine things, the Rhine with its rocks and ruins, its castles and its crags that have been sung & sung in a thousand metres, while I have found great pleasure in it, I have found also to a greater degree than I expected if not much variety, at least in the multitude of guides beggars & other nuisances a great deal of vexations of spirit—That is as being directly & inseparably connected with the pleasantest things—

Frame 84.

One must live amongst them for a time and learn to divest themselves of the multitude of annoyances that are mixed up with all sight seeing in these lands before they can enjoy the fine things to a reasonable extent—I have now been here a year & a half, but my time has been most entirely spent in this quiet town from whence I date, whose interesting & distinguishing points are very few, and are now to me as *hum-drum* as any of the peculiarities of our down-east villages.

The extent of my journeying is in having made the tour of the Rhine with an additional excursion to Heidelberg & into a portion of Bavaria ending the long list of ancient ruins, which are of course the cheifest & most interesting feature of this delightful trip, with the Castle of Trifels, where Richard Coeur de Leon was two years a prisoner on his return from Palestine, & where Blondell his minstrell sung beneath his walls & then discovered his place of long concealment—It is perched on the top of a rock projecting from the summit of a conical mountain, three sides of which rock are perpendicular & by any means of great difficulty of ascent— From a small area on this high point rises the solitary tower, the only remains of what was once a strong fortress & the prison of England's heroic & romantic kings. It contains however the dungeon where he was said to be confined—But the scenery which it overlooks is of extraordinary beauty, mountains receding one beyond another vallies & vineyards & all at this time clothed in the brown & beautiful colours of Autumn—Altho you may not be able to acct. for it, I assure you that while looking at this fine sight & enjoying the thots. which its history suggested I was seized with the idea & desire to make a sketch of the whole & address it with a note to you two girls—But it was already late in the season & at this elevation so frightfully cold that I was utterly unable to accomplish it, so after making but an imperfect drawing of the tower & ruin & plucking a quantity of leaves from the evergreen ivy that was clinging to the rocks & twisting its branches around its ancient & crumbling walls I was forced to descend very much benumbed & blue— Of these, I at least send you one, thinking you may probably have pleasure in such

a memorial of this interesting spot similar to my own. They were growing upon the outside of the dungeon wall just over the entrance. I mention this chiefly to show you that altho. I give perhaps but poor proof a proper remembrance in the way of writing letters I still think of the girls (over the way) a thousand times when they do not think of me—

Frame 85

And by the way, I will here thank you for the yellow leaf enclosed in your letter—It came to me safely its long way across the ocean & in its bright colour spoke to me of the glowing autumn forrests of America, of those rich landscapes whose million hues blent in such matchless beauty I have loved to gaze upon in my own home, before I knew that they were unrivaled by any other, & that the sad sweet charm that always rests upon them in all their gayness of attire is perhaps peculiarly their own.

This comes from the "ledge"—that old familiar name, "up on the ledge"— where we have strolled in summer & slid down hill in winter—Here the trees go gradually into the [sere] & yellow leaf & wither away into brownness without putting on the bright [. . .] that foretells their decay with us as they perish into winter—This is owing to the want of the sudden frost which we have that nips the leaves while they are full of sap—Altho. so much farther north the winters here are much milder, but very little snow & ice, the past, scarcely none. But the summers also much colder indeed the last one seemed to me no summer at all, tho. it was to be sure unusual for this region—It is suited however apparently for grapes & wine which flows most bountifully from all southern hill sides & sunny slopes & vallies—They were beginning the vintage while I was on my journey. The vineyards all about me were laden with the ripe fruit & without fences or hedges to prevent the freest access—

The peasantry were all at work, men & women, & it was my habit to give each party a call. Now & then a pretty girl would emerge from the vines with her tub of grapes on her head & I would help her to plunge them into the great cask that always stood by the roadside for the bruising of them, which was an excellent commencement to a nice little rustic flirtation, & then she would gather me some particularly nice bunches, & I would tell her what an odd thing it seemed to me, to see such a pretty girl working in the fields & how nice & lazy she could live where I come from in America, where all the girls do nothing but grow fat & get married & have black slaves to wait upon them, which she could scarcely believe, tho. she had heard America was a paradise—But the fair eyed lovely maids generally associated with vineyards in poetry, I am pretty well convinced is a fiction entirely, at least in Germany, for they are for the most part less fascinating than the cows yoked to their carts & ploughs. Constant labour in the field,

Frame 86

& bearing heavy burdens on the head must always have the effect, to render them stupid, ungraceful & unfeminine. In the cultivation of the grape especially the labour is often excessively hard—The finest grows on the banks of the Rhine where the course of the river for a great way admits on one side of a southern aspect, rising abruptly & often to a great height the favourable quality & position of the soil is too precious to be lost & every inch is tended & improved with the greatest care. Here the women & girls may be seen descending the steep & rocky declivity where it looks almost impossible to climb, with a brimming tub balanced on their heads, as severe a labour as could possibly be. Also great quantity of earth is carried up to add to the dearth of soils in some sunny crevice—You have read I dare say many tours upon the Rhine, & it is not at all worth while for me to give you a journal of mine—I saw all its castles & ruins, sketched many & enjoyed my rambles among these, ancient monuments of another time & another people to the very fullest degree—I spent five or six days at Heidelberg which is the most magnificent of

them all—While crouched at work on my sketching stool one day three Bostonians whom I had met at home accosted me, one, the son of Dana the poet,[2] the only Americans I met during my absence. We talked over America from one end to the other—Directly in the vicinity of Dusseldorf are none of the attractions in point of scenery, peculiar to the Rhine above here. On the opposite side of the river the country is entirely flat & uninteresting. On this side however, at an hour's walk, it rises into hills and forms some picturesque views—Here the people resort in great numbers every Sunday to stroll in the forrests eat & drink of the cheer that is afforded there & indulge their propensity of coming together, for they do not, like us, seek their walks in retired places & where fewest are to be met, but where they can see the greatest numbers—The germans are essentially *gregarious*, with none of the cold shyness of one another that with our people almost forbids the exchange of necessary civilities till doubts & suspicions are removed by the ceremony of a formal introduction—When they find themselves together their only natural impulse is to talk together, & to make themselves quite as comfortable & happy as the circumstances will admit whether they have never seen one another before in their whole lives or not—The men all belong to clubs & a great many to half a dozzen. Their word *Gesellschaft* designates germans as essentially a *roast beef* does Englishmen—Everyone of any standing has his Gesellschaft where he can chat away his evening over his wine or beer & pipe, & the lower orders their beer-houses—I limit myself to two—one of which is the painters club, & the smartest in town—The other, of quite an opposite character composed chiefly of the King's best friends & a great number of his military servants, & Lovers of their country *as it is*, where republicanism cant be mentioned above a whisper.

Frame 87

I belong to this because they have the only two good billiard tables in town & take an English newspaper—My acquaintance with Society generally is very slight. I divide my leisure time between the clubs, fumbling in german dictionaries, dominoes, riding horseback Galignani's Messenger, & a few other promiscuous exercises, rather hard pushed for amusement any how—They have an opera here but I go seldom—The women here are not handsome—Pretty girls are rare & I've not been in Love once for the year & a half—Up to the present time I've not felt a pang since I left America, & you may think this evidence of a great poverty of charms in the fair sex of Dusseldorf.

I've had to be sure no fair sitters to spend my hours with when they were trying to look lovely—I am painting away with men companions & very diligently, trying to get *the hang of it*, which I find I assure you no easy matter—I sent a couple of things to the Art Union sometime ago, & shall presently send them some more, & Italian girl, & a monk—very bad—I do nothing in my old way of crayons. I am delighted you find the portrait of your Mother so satisfactory, & assure you am doubly paid for my pains in the pleasure it gives you—I desire to be remembered in the kindest manner with best wishes for her health & happiness—Since the first of January I've been with Leutze[3]—Our studio is a large hall where six of us paint with convenience, & three on large pictures. The chief, is Leutze's of "Washington Crossing the Delaware" 20 feet by 16, figures size of life—It is already perhaps two thirds finished,

Frame 88

& I am making a copy on a reduced scale from which an engraving is to be made— It is sold to the owners of the International A. Union of N. York, & will be exhibited thro. the States in the fall—With six in a room, a cask of the best "Laurish Beer" always behind the great canvass & a disposition to be jolly you may be sure it does not want for animation—Leutze is an energetic and talkative fellow, generous and full of spirits—He is [. . .] artists here, & in an atelier a vast deal of company, as he paints, talks, sings & [. . .] altogether. To give a more decided tone to the place

three canon were recently brot. & a battery constructed with the stars & stripes waiving on one side & the black & white of Prussia on the other—Nothing could exceed the enjoyment produced by the sound of the entire battery, so that almost every one that enters is recd. with three guns, & accordingly up to the present time there has been a pretty uninterrupted cannonade—The fun has been increased by shooting with bullets also, & the walls are fearfully scarred with this continued bombardment—These people are very different from us—They amuse themselves in whatever innocent way that is possible, & altho. I have always thot. they were called heavy & phlegmatic, I have never seen so much of social spirit & animation as among the germans. With so much tumult you might suppose there could be very little work, but Leutze has painted the [. . .] of his immense picture in the last three months—[. . .] our six is a nobleman, a "Graff" (corresponding to an English earl) whose chief ambition is to paint landscapes [. . .] Am uncertain how long I shall remain here, probably leave [. . .] the summer for Italy, perhaps first to Paris—I am desirous to go somewhere where I can get something to eat, for german living has taken me down dreadfully, present appearances to the contrary notwithstanding—With my immense mustachios & all, I think you would scarcely know me—I have of course learned to talk german to some little extent, otherwise I should be miserably off. At scolding I am a tolerable hand. I am anxious for the fine weather to come to take a little scour about the "seven mountains" which you may be aware includes the Drachenfels, and is only two hours from here by railroad thro. Cologne, & almost the finest part of the Rhine—

Frame 89 I have made excursions there several times—We are now but three Americans in Dusseldorf. One lodges with me, is from Cincinnati, will probably be in America in a year from this time & go to Maine, on a sketching tour—I have promised him great delight in the pretty girls there—Remember me to all such that may be remaining as I know, or as have any interest in me, which at the present time must be precious few. My love to Margie, from whom a plaintive regret has reached me of my apparent forgetfulness, & also to Pauline who was a little thing as I left the shores of Kennebec—The only one spoken of personally is [. . .] Hartwell, whom Hannah mentions somewhat unfeelingly as she evidently considers her in the light of a former flame, and says she did not even inquire for me the last time she met her—I could have wished it otherwise, but nonetheless send my cordial regards & shall think very hard of Loisa if she dont write a note to be enclosed in your next letter. I hope Hannah will not feel slighted in my addressing this to you, which by rights I believe is your due, & whereby she will get the next—tho. I consider her bound at the same time to answer it as well as yourself, & that as soon as possible—Remember me to Jo Ellis who promised to write, or else I promised to write him, and if he is not yet married I should be delighted if he would fulfill it, also to Chas. Lambard, Hen [?] Selden & such other of the boys as are still there—Please tell me who is courting Hannah, & tell Hannah to please tell me who is courting you—If you dont find this letter as entertaining as you expected I cant possibly help it, tho. such a result will be quite what I expected—Write very soon & tell me all about it & believe me in the meantime, very sincerely yours,
Eastman Johnson

The New-York Historical Society
Folsom Papers
Page 1 Venice March 17, 1852

My dear Sir,[4]
The hurry & excitement of travelling have thus far made it quite impossible for me to write to you as [. . .] I intended, & according to your invitation—As far as Florence I came as fast as steam & slow diligences would bring me, both night & day, & leisure

moments were therefore few—I began a letter at Marseilles, where I was obliged to remain a day & one night, but was interrupted & unable to finish it before embarking—Bitter cold weather seemed to have set in just as I left Holland.

We were too late for the Paris train at Antwerp, & I stayed over night at Brussels, by which I lost the day at Paris, as we arrived there in the evening, & only in season for the night train to Lyons. I drove in at one end of the city & out at the other, catching but a rather tantalizing view of the metropolis—We left snow some fifty miles north of this place, & went into it again as far south of it, while the cold seemed to increase the farther we went—On the river from Chalon to Lyons it was almost impossible to remain on deck—The landscape was as wintry as a N. England december, the hills buried in snow, the river, which flows rapidly even skimmed over with ice, & the whole aspect of nature so bleak & dismal, that my anticipations of this sunny part of France were far from realized—It was however, as I learned, a severity of weather

Page 2 almost unknown—In the same proportion, you must have been pretty much frozen up in Holland. I encountered on the boat no less than five young Americans. Two of them were going to Florence to study as artists, & we journied very agreeably together the rest of the way—To our great vexation, we learned at Lyons, that the steamers had stopped running farther down on acct. of low water & that we must proceed by diligence to Avignon, a matter of thirty six hours in the present state of the roads—The number of travellers in the same predicament as ourselves rendered the inconvenience the greater, by crowding these vehicles to their utmost capacity—We were packed in like herrings, little children filling the interstices, & unpacked at Avignon, much damaged after thirty six hours of weary endurance—We encountered driving snow storms, & were pulled along sometimes by eight or ten mules & horses. I dont know whether you have been on this route—The scenery begins at Lyons, which is located where the banks approach, & rise in perpendicular rocks, the houses perched upon their sides, & rising one above another in a striking & picturesque manner, resembling very much the character of the Rhine, which it preserves in a considerable degree quite to the sea. In summer it must be a very charming route—As we neared Avignon, the snow began to disapear, till finally the country revealed itself in its naturally

Page 3 pleasing features, favourably presenting all its very beautiful varieties of scenery. Part of a day was agreeably spent in viewing the various interesting objects of this old city—Olive groves, evergreen & the almond in blossom, lined our way to Marseilles, & the bare mountains with their many hues & thousand forms closed my journey this far quite to my satisfaction & delight. Nothing in Marseilles to render it a stopping place, but its admirable location, & the various advantageous points to view its beautiful surrounding scenery—We had fine weather on the Mediteranean, stopped at Corsica, at the picturesque old town of Brescia, & landed in Leghorn just too late to enter the city, the boom being closed at sundown, & we were accordingly obliged to pass another night on board—Here begins to fuss & trouble with passports—The state of the country at the present time occasions much inconvenience to travellers—Arms are entirely prohibited—Being possessed of a *revolver*, & another gentleman (lately from the Mississippi) of a *bowie knife*, they were immediately taken possession of, & to get them again, we were obliged, on leaving, to be escorted by a guard to the gates—We stopped a few hours at Pisa. Its cathedral is one of the finest I have seen—My friends had been impatiently waiting for me some days—At the hotel in Florence, I was agreeably surprised to find my old friends Mr. & Mrs. Marsh. Two ladies, relatives, were also of their party. They left soon after for Athens—Mrs. M. is an invalid, & cannot walk, yet they have travelled thro. all the East, where she has been carried upon men's shoulders, over the desert of *Saharah*, & I know not where

Page 4 also thro. Greece & a considerable portion of Europe—She must even be lifted in & out of the carriage. He is waiting to be *turned out*, but will probably remain still sometime in this country—I am delighted with Italy—Florence is beautiful, tho. I

was somewhat disapointed in its pictures—The more I see of old pictures the more *humbug* I find in them, & I have had a surfeit these past few days—They obliged me to go back to Leghorn for the *Visé* of the *American Consul* before the Austrian Minister would attach his to my passport—I made the acquaintance of Powers[5] at Florence, a simple & pleasant man—We posted from thence to Mantua in two days, stopping at Bologna the first night. The scenery among the mountains was fine—They were bare of trees, but much covered with snow—On descending into the valley, the climate was warm & delightful. At the hotel in Mantua 400 francs were stolen from our Courier ("Albergo de la [. . .]) From there here in four hours by railroad—But *Venice* exceeds everything I have ever seen, in beauty & magnificence, the only city in Europe I have not been disapointed in. Its treasures of art, & wealth of palaces cannot be reckoned. We glide from one to another in our gondola as in a dream—From here we proceed to Trieste by steamboat, thence to Vienna, Dresden, Munich & down the Rhine, as quickly as possible—we were advised not to attempt to go to Milan—I write in a hurry, as we leave early in the morning. Should you have recd. any letters for me, I have to request that you will be so good as to retain them till I arrive, which will probably be in a fortnights' time—

With best regards to Mrs. Folsom & the children. I remain, very respectfully & truly yours.

Eastman Johnson

Page 5

P.S. As I wrote this the night before leaving Venice I was unable to mail it at that place. In fact, we came with the mail as far as here, being unable to attain post carriages at Trieste—We are at a little town within four hours of Vienna, where we arrived night before last, blocked up in snow—A storm set in immediately after we left Trieste, delaying our passage across the mountains considerably, & on reaching the railroad the snow had attained a depth of two feet. We reached this placed with the greatest difficulty, often interupted for two of three hours by the accumulation of snow, & requiring the force of two engines to overcome it—From here we were unable to proceed any farther, it being much drifted, & the wind still blowing violently—Thousands of soldiers, on their return from the frontiers of Turkey have filled all the houses, & we found ourselves fortunate to secure one room for us all, where we are waiting

Page 6

with such patience as we can summon to be liberated from a rather unpleasant imprisonment—A great portion of the passengers, including ladies, have been compelled to sit in the station house these two days & two nights—I fancy that with Yankee enterprise to encounter this snow storm, we should have been some time ago in Vienna—We have now, the pleasant inteligence however, by telegraph that at 3 o'clock a train will arrive to take us off—It has cleared away & the day is now warm & pleasant. We are in the midst of fine scenery but buried in snow.

Yours & c.

E. J.

Gloggnitz 22nd March

N. York Friday July 25/62

Dear Jervis[6]—

Hatty[7] will go up in the "Powell" on *Monday* next. She would have gone before but has not been well these two or three days—

I had a most pleasant call at West Point. Walked with Mr. Weir[8] down to Cozzens[9] (which however was not exactly the pleasant part of it, being in a smart rain) found Lang[10] in his studio, Leutze had left in the 12 o'clock boat for N.Y. I saw him here

yesterday. He expects to finish the picture in two or three months—Thompson[11] called in yesterday, had just returned. Wants me to go down to Mr. [. . .] with him tomorrow by invitation. Hardly think I shall

Frame 509

as I have been having such a good time for four or five days & ought to be willing to stay at home & desecrate the Sabbath by getting up my work, & content myself by occasionally an *imaginary* pull at the sweet morning air of your hills. You grumble some but let me say to you that on the whole I think you are pretty much blessed. You can weather a good deal of your snuggery up there, & I only wish I was as well off. The truth is you *dont know what you are walking on.* H—l's blazes, look about you and be easy. Best regard to Mrs. McEntee & Fanny.

Yours very truly

E. Johnson

Archives of American Art
Charles E. Feinberg Collection of
Artists' Letters
Reel D30
Frame 503

N. York Saturday June 28./62

Dear Jervis

I cannot return to the city [from Maine] without notifying you & your dear wife of the circumstance, & telling you how sensible I am of the great void your absence causes. I should have done it sooner but the week has slipped so quickly by. I don't suppose you are aware what a big hole your departure has made—the studio build-ing is a dismal waste, a body without a soul, tho. still of course retaining enough of normal life to be capable of being resusatated by your presence, tho. not otherwise. Thompson & Whittredge[12] just keep the breath of life in it. In the slow drag of my late exile I had counted with much pleasure

Frame 504

on sporting myself there early—now I must do the next thing, & so I send you both my hearty greeting. I was at Mrs. Vaux'[13] Sunday eve. with Newton & Whittredge. She with Thompson and May have given me accounts of you and your operations, the arduous duties you perform in overhauls, & the spirited and devoted constancy of Mrs. Gertrude[14] in taking upon her own round fair shoulders, the "heavy stand-ing round" [. . .], besides an occasional dash at the head of the stairs or some other weak point, at any sacrifice of fine linen & other material, & with a reckless expo-sure of person that we cannot too much admire. What a thing it is to have such a wife. And I wish I was possessed of a cottage perched up among the cool breezes, looking out at the

Frame 506

Highlands of the Hudson & a brisk cheerful wife to lift up her voice with the birds in the morning (only not too "early") & keep it up all day & with a pair of over-hauls & a house & garden to fix—oh dear—then blow ye winds & crack your cheeks—want to sell out?—When you have got anything to shine I should like to be requested to come and inspect the premises. I am generally slow to move, but with this hint I expect you would witness an alacrity not common in ponderous bodies. I like Roundout or, it is probably the friends there & the cottage which constitute my recollections & make them most pleasant, & it may be slightly sentimental—For the present, however, I thank the Lord that I am back again in N. York. (Possibly you thot I never thanked the lord for *anything*. It's a mistake)

Frame 507

I got terribly tired of the place I was in & the people, nor did I accomplish much for the time I was absent. You may be sure that *Pork* as a steady diet for three months is not favorable to art. I am lucky to be able to do more than grunt. The city appears delightful. Plug hats are soothing to the eyes. Napkins, butter knives, & salt spoons, bring a tear to the same organ. There is a rapture in beefsteaks and chops. The

rumbling of omnibuses on the stone pavement is an anthem to mine ear. Bill posters and lamp lighters I greet with a becoming smile, & upon the small rag-muffins as they swear at Hopscotch & other metropolitan games goes forth my benediction. The good rank gutters are fragrant and familiar, the daily papers sociable and *authentic*. Beggars are pleasant people. It is impossible to record the blessings that abound on every hand, that rise up to greet an observer. I turn my eye. Long may they wave—

Frame 504 — It would seem that the trials I have endured, owing to the peculiarities of diet & the somewhat limited social privileges for which that locality is truly remarkable & which are probably inevitably incidental to the pristine character & condition of the place & people of my native precincts have done me good service in qualifying the natural asperities of my disposition, & in having sent me home a wiser & a better man, & I take the liberty to believe that I am now about as amiable & benignant a member of Society as there is agoing. In proof of this I will state that last night there was the most infernal catawauling under my window ever executed in N. York. But it had the time & pitch of *city-cats*, a key altogether unattainable by country cats, showing cultivation, & not a brick-bat or a bottle was shied in their direction, whereas at any period previous to my late discipline

Frame 505 — not the faintest growl would have reached my apartment ere my battery (always in readiness) would have been unmasked & an 11 inch junk bottle dropped upon the flinty-rock in their midst would have distributed its death dealing fragments amongst them & sent the performers to the four winds. They had out their song and retired peaceably to their several abodes & let us hope, mutually edified & improved—I recommend that every citizen, be compelled to go to the country three months on pork, 30 miles from a railroad & no daily papers. The nett result in contentment & suppression of lawyers can't be estimated. My only apprehension is that, in my own case, the influence may be but temporary & that by the time you get back I shall be as sour as ever, with no more consideration for cats than a spring chicken has for June bugs. So don't be late—Some changes have taken place. Ehninger[15] to Europe. Gifford[16] to the War. What Ehninger has gone to Europe for I don't know, unless in search of a new sensation. Gifford will find less romance & more drudgery this time, but he is not the man to shirk either & if any credit falls in the way of his duty he is as likely to get it as the next man. Good luck to him, honor & a whole body when he returns—Your pictures in the exhibition are charming. They *stick out*—Mine, stick the other way, but I hope in the next each succeeding years to have something more than have of late—But I make no plans, only to work—What are yours? The same I trust.

Frame 506 — My sisters are well. They go occasionally to see Mrs. Vaux & talk of you often. I hope yours are. Let me be remembered most cordially to them & to all your family—To Mrs. McEntee I sent *unqualifiedly* my love, that being the only sentiment which I experience in particular towards her—It would be a pleasure to hear from you & I hope you will find a moment to let us know how you get on.

Yours sincerely, E. Johnson

N. York May 8, 1863
Mr. Longfellow[17]

Dear Sir,

I sent to you from Fryeburg by Express a keg of maple syrup which I hope reached you in good *order*. It left there with me on Monday, May 4th & should have been received on Tuesday, I suppose—

I was so busy during my short stay in Boston that I failed even to write to you but presumed it could not miss of going to you directly—

There were eight gallons for which I paid one dollar & a quarter per gallon & one dollar for the keg—

It is, I believe, of the best quality, & the people who made it suggest that if you have stone jugs at hand or anything of that kind perfectly fresh & sweet [?] it would be well to put it into them. It also keeps fresh longer when tightly bottled, although it will do very well as it is—If it ferments in the warm weather housekeepers will know how to treat it by simply "scalding"—You need not trouble yourself to remit the $11— to me, but may at your convenience hand it to a friend of mine Mr. Joseph May[18] who is at the Divinity School in Cambridge—

I should have sent it to you sooner but could not possibly obtain anything to put it into having sent & searched far & near, till finally the farmers gave me up their own cask.

Very respectfully & truly yours

E. Johnson

Archives of American Art
Artists' Correspondence
Reel D10
Frame 1371

N. York Mch 13 1864

My Dear Coyle[19]

I thank you for your kind letter & the notices subsequently recd. & it is of course gratifying to me to see anything I have done so well thought & spoken of. Hope you like it half as well in which case I should be very glad it is yours.

I am getting on well enough so far as commissions & plenty to do goes, but getting *wealth* is a hard matter, & will take bigger prices than I have been getting. But those I might have as well as not & in fact am gradually *raising on 'em* so that by & by if things keep agoing & the bottom don't drop out I may be able to get a little

Frame 1372

ahead of expenses. I hope in the next year to do something more considerable than I have yet done, to paint two or three larger & more *pretenscious* pictures, which are in fact all well under way. In furtherance of one of these I am about starting for the country to make studies for a month or six weeks. This will be my fourth annual trip for the same purpose to the wilds of the State of Maine—The scene is a Down-east *Sugaring*, a picturesque & in one way interesting one, partly perhaps on account of its being associated with my pleasantest early recollections. The operation takes place at a rustic camp in the woods, out of doors, in the early spring, while the snow is yet deep. There will be forty figures or more, the occasion an entirely social one, even jolly, & very well adapted as I think to exhibit character & picturesque combination of form color & c. At all events I am very much interested in the subject, have spent a good deal of time on it already & not yet begun the picture nor indeed got nearly all the materials. But this spring will do me, I hope, in that respect. The period of sugar making lasts only about a month, which is the reason I have had to go so many times. I shall hope to paint it next autumn & winter, I should very much like a copy of the photograph you

Frame 1373

mention when you can conveniently send it. Call & see me when you come on.

Very sincerely yours,

E. Johnson

N. York Aug. 8—67

My dear Jervis

I recd. your letter yesterday morning, & this is the first moment I could reply to it. I am rather tired & used up just now, but will send off a few lines as you desired an immediate answer. You will wonder perhaps at not getting it sooner, but I have been away & returned yesterday morning. On Friday evening last I went with Pinchot[20] up to Simsbury to his Father-in-law's. We left on the boat for N. Haven at 11 P.M., smoked and talked out on the open deck under the stars in a clear mild night till past midnight & were ready for an early breakfast in the

morning in N.H. But then it was raining. We did not mind however & took a carriage & drove through & about the city & saw it all & very pretty & agreeable it is— Besides that, I went & called on a young lady whose acquaintance I had made here. Miss Wolsey (a stunner) & had a charming call, only as it was already late it was painfully brief, but I was to stop to dine & tea & ride on my return which I fully intended to do. Cursed ill luck prevented and we went of course to see their picture exhibition. The rooms are quite fine or better than ours & the building all that could be desired.

The exhibition is pretty fair & reasonably successful—In the afternoon we went on to Simsbury reaching there at 5 P.M. Saturday & staid till Tuesday morning—I enjoyed my visit very much. They are cordial people & have a pleasant old home—Mr. & Mrs. Eno [?] are much younger people than I supposed with most of the good New England traits. I enjoyed talking with him or hearing him talk about his early life in that neighborhood where he was brought up under the strictest form of the Old Connecticut Blue Laws, pretty much all work & no play, with an infusion of that hard puritanical religious element through all their daily life which he seems to remember with

no great respect. But that same thing has very likely helped him immensely to what he *does* respect, & that is, a lot of money—not that he dont respect better things more. I think he does, & is altogether a good specimen of our thrifty, honest, energetic & successful New Englanders—We went from there in the morning to Hartford & spent the day. It is certainly the prettiest town I ever saw—I should think there were no poor people there. Everybody lived in a beautiful house with most pleasant grounds about it & lovely lawns shaded with trees hundreds of years old & evergreens of charming hue cut and trimmed like so many tops, & hedges bounding every man's premises trimed with the same precision. I judge

that most everybody keeps a carriage & that to live in Hartford is to be well off & I think of going there—I'm tired of this struggle & am thankful if I have discovered a place where people are spontaneously rich. We got a nice carriage & drove from one limit to the other, all over the town, passing Mrs. Colt's[21] place & thence over the dyke he built enclosing an immense track reclaimed from the water & added to the premises on which his house is built & which must have great value. We went into the *Willow Factory* & saw the operations there & then to the armory or pistol factory where we were very politely shown all it contained. A new weapon called the

"Gatling Battery" interested me very much. They are making a lot for the government. It is about as big as a twelve pounder, having six distinct barrels carrying an inch shot each (1/2 lb.) & by turning a crank will send 100 a minute. With astonishing urbanity they offered to fire it for us & did. It sounded like the volley from a regiment & the least we could do was to assure them of our hearty approbation. It seems they make other arms there besides Colts'—We met *Col Burdan* there (sharpshooter) who also has a new piece on hand. They are making it. It embraces also a plan for altering old muskets. After dinner we went to see a lady friend of

Frame 189	Pinchot who was a friend of Mrs. Colt & who was to go with us to see her & her pictures & pretty things. But she was sick abed so she gave us a note which procured us a cordial reception. She has a beautiful house & grounds about it in the best taste. Then you can imagine them stretching away embracing I don't know how many acres. As we came to see the pictures she recd. us in her pretty little gallery where she has a small lot of rather nice pictures—Churchs'[22] makes a good show. Mc.Entee and E.J. didn't loom up so particularly—I told Pinchot you said he got $15,000 for that. Was I right? She is a rather wholesome looking young widow & I think she would be likely to get picked up one of these days if she dont look out— Then as we passed out, in a big *show*
Frame 190	*case* amongst a lot of things was an assortment of gold & silver & precious stones quite bewildering. Rings, snuff boxes & other trifles too gorgeous to mention, but enough I should think to tempt the most respectable of burglars, presents from various crowned heads & potentates. She was very polite & very agreeable & I *may* call again—We took the cars to N. Haven & then the steamer again at 10 P.M., smoked & talked went to bed & here I am—This morning they dashed in my skylight, filled my room with dust & debris, & I am here tonight to watch any chance rainstorm that may come up before morning. They will have it tight if not finished tomorrow & I shall trust have more light—
Frame 192	I found letters here from Phill[23] dated *17th June* from *Madras*. The telegram of the wreck was *recd.* the 24th June, so they must have been wrecked between those two dates, & in any case we ought to get news of this event now any day—From what we learn from Washington Phill will probably come home & may for aught we know, now be near this coast. His promotion would make him ineligible for any position there, so far as we know, but we know nothing positively. I will with pleasure send you his letters when they come—I got to my rooms early in the morning having just taken a very early breakfast & took your letter with a pipe. It was'nt bad, & not much "long" I assure you.
Frame 191	I did'nt quite answer in that case to the "irascible old gentleman". If *I* were to look & dwell upon the gloomy side of the picture as you do there might be some sense or at least *excuse* in it, but for *you* with the wife you have, to behold aught but the most serene & cloudless future passes my comprehension. Now that's all there is about it—Talk of aches H—L "as Mrs. Stoddard[24] would say" Swap with me for 24 hours & then you will know what *aches* are. If I had a good loving wife such as I can imagine & even know—I wouldn't care a rush for all the rest, so make the most of it—I cant say when I will be up there, if at all. Nobody wants me so much as I want to go, but I cant do as I would. If I were you, I would stay late or as long as I could—The Autumn is glorious—I dont know how you can come away then— May be I will run up & take my chances for a few days—I want to take my sister Mary somewhere. It would be pleasant to go there if we could get in—I have not seen Gifford. He was here in my absence but left no note—Is at home I reckon. I never see Thompson—How I long for the things that surround you & the life you lead. I have never been here so late, & I feel as if it was lost, but I shall be off yet, & to me the season does not end till the last leaf has fallen—You describe very well *my* condition but not *yours*—
Frame 192	Postage will be high on this so I will stop, & go to my miserable *couch*—I thank Mrs. Mac for joining in your request & assure her I need no urging. Much love to her for the same. yours E. J.
 Thursday morning—It is raining like the Devil & coming down into my room in streams, a beautiful state of things if it keeps on, but letter safe— |

N. York June 21, 1870

Dear Jervis,

Do not think because your letter has been so many days unanswered that we are indifferent to the outrage of which you gave us such a harrowing account. I have never heard anything that made me more indignant, & I certainly consider it a merciful circumstance all round that you did not find that man when you sallied out, for nobody under the same conditions could hardly have withheld a death blow to the villain capable of such an act. It may be creditable to you to be able to find or imagine any state or stage of humanity that could palliate its brutality, but I confess in my eyes he would be a wretch whose life almost deserved to be trod out. Pinchot was just in here & I told him the story. He felt about the same way. This is no doubt a bad view of the case, & your

course was the wise one. I hope your father is mending, & will suffer no permanent injury. We are yet undetermined where to go, & the weather is already fearfully hot, tho. cooler today. We had a plan about Narragansett but it fell thro.—I have got the sea-air notion into my head partly because I know how well it is for my wife & because, feeling my own liberty somewhat restricted this season for the first time, the heat *tells* on me, & I think it would be favorable for work & so I dont like to give up the idea. I hear of furnished cottages to rent cheap at *Martha's Vineyard*, & if I can I may run down there & see what they are. I can have all Pinchot's quarters at Millford but fear they are hot. I think pleasantly of the Shokan & [. . .] region, but that too, is inland—I remember now the heat pours down with [. . .] the renovating vivifying salt sea breeze at Saco beach that I wrote you of while you were in Europe, & how it set one up & made me want to come right back with my tools & go to work there, & this heat is wilting me so I am afraid it will take all the life out of me. It will be sometime before I can leave anyway & I shall look round in the meantime— I appreciate all your kind suggestions. It is'nt perhaps worth while to think of what I wrote you in my last letter, because I cannot explain nor understand it myself. It is nothing that anybody can help me in any more than you can help an insane man, for what I refered to is nothing else than one form or degree of insanity I suppose, & is my own particular trouble. How great it is to me nobody knows, for I never alluded to it before to man or woman. I wanted to account to you if I could for what I fancied must seem to you an altered demeanor, but

which, if it is so, I am no more accountable for than for the color of my eyes or the change in my hair—I wish I could make out in one little statement my mental condition, but I cannot, for it is so uninteligible & unnatural to myself. I have no peace & no joy. That I *ought* to have, & that there is no known reason why I dont have is equally true—I feel myself so at odds with the world in which I live every moment of my life, such an unfinished incomplete product, whilst everybody else seems fitted for their place & to work into the grand plan. Great or small, good or bad, they are all at home in their sphere & perfectly comfortable. I cannot attain to that simple state of existence any more than if I had no right here. It is as if nature had an awful spite against me, as perhaps it has, tho. for what reason more than

against others who move along so joyously I cannot see. The rest of the world make the best of what they are, take themselves for better or worse, & think no more about it, do their work, enjoy each other & are happy. That is the right way of course, for what we happen to be is none of our business. But there is no sympathy between my body & soul, on the contrary, a bitter antipathy. My soul abhors my body, is always ashamed of it, & wants to get rid of it, & never can for any single instant of time. I am an incubus upon myself forever, while all the time I think of that blissful state where the body & soul go hand in hand—It is that possibility, an

animal condition, nothing more, except that it is also divine, that I brood over eternally. I think of nothing else, & as that goes on I believe I get worse & worse, for in the conflict

Frame 227

the body wins, is always on top & the soul writhes & withers—How well pleased all the rest of the world seem to be with themselves, which is right, & makes it go along so smoothly. By pleasing themselves they please & benefit others. The [. . .] are hateful, the dejected bores. We want cheerfulness & brightness which is our birthright. How I envy every man who is at peace with himself, the commonest fellow I meet. As I cannot see wherein my right in that respect should be curtailed I am unhappy, & I naturally look, as the only path out of all this trouble for some convulsion in my own being, some awful shock which shall tear me to pieces & set me up again with the parts in their true relation. I want to pluck out my soul root & branch & set it in the light. I am wearied to death of this imperfect life & it seems to me at times as if I could not support it. And yet the way seems so plain & easy, but something in me holds me away from it forever. I thought at one time my wife would die. If she had I think it would have done the business for me. It would have lifted me up out of this slough or killed me outright which would have been just as well. One would say that anybody with enough to eat, drink & wear, & in whose mind unclean thoughts do not harbor ought to be tolerably comfortable. But such need not necessarily be the case, believe me. There is a great deal of bosh written & talked about conscience. It seems to me conscience has often times nothing to do with happiness. You may think from all this that I am in an unusual state. Not at all. The same old state. But very likely I had better have said

Frame 226

nothing about it. It will puzzle you perhaps, especially as I cant give any inteligible account of the matter. Dont bother yourself about me. I shall poke along the same old road. The genial streak that is in me, which is the natural unencumbered spirit, constantly asserting itself fitfully in gleams & going out—& I shall get there at last, somewhere, even tho. I go all the way in the dark, as I expect I shall—I have heard of illuminations, wonderful ones, miraculous ones. Any preacher will tell us about them. I should like to see the light that can illuminate me—Dont show this to anybody. I should be very uncomfortable if I thought you did, & dont feel yourself bound to take any notice of it for it would likely be difficult to know what to say— I thank you suitably for your kind offer in the other case, of the sincerity of which I have not any doubt. Give my love to Mrs. Mac & [. . .] am your ever. E. J.

Archives of American Art
Charles E. Feinberg Collection of
Artists' Letters
Reel D30
Frame 510

Nantucket Oct. 15. 78

Dear Jervis

I was glad to get your letter last night and hope that your long trip in the woods and in camp was all that you had hoped for in its freedoms and enjoyment. It was hard however on coming home as full of the pleasant things you had to tell your wife to find her still more in need of your attentions as nurse than of your camp stories and adventures, although one will trust they will yet be effective in beguiling her sickness and in cheering her recovery—with such fortunate ministrations as your own pleasant home affords in physicians and nurses and a room that it would almost be a comfort to be sick in, we can surely look for speedy improvement—But you

Frame 511

I hope I shall hear from you again *very soon*, telling me what your Doctor says, and I shall look for a better report than what you apprehend—I can realize your anxiety by making it my own care, and one cannot in any other way, but I would fight off that idea as long as there is no *certainty* of its being realized—It will be the better

way on all accounts, and I cannot believe that it will not prove to have been a waste of your peace and of that cheerfulness which is now so needful—I forbear to say more—I thought I had better write as usual, and I hope I said nothing disquieting if she should happen to see it—

Frame 514

must nevertheless give her with our love our cordial sympathies and best wishes. Ever since we have been here, or soon after we came, we have been having our home mended and enlarged, and I hope improved, as was our plan before we came, and Bessie[25] was saying tonight as she has often before, that when we get settled again she wanted you and Mrs. McEntee to come down here for a visit. That is something we shall look forward to in the near future. At present she would be amused if she could look in upon the condition in which we are housed. My wife's remark that it was like a family in a small cabin in a ship at sea in a storm

Frame 511

conveys the best idea of the scene. We are turned out of our *garret*, Ethel[26] out of her room, and she obliged to be in bed with a sore throat. So there are two beds in the parlor and until today every door and window barricaded tight with rugs mats and blankets, for we have been having the *storm* part in very serious reality. The severest that has been known in Nantucket for Forty years. It was impossible to keep out all the wind so furiously did it pierce every crack and cranny. Then the house was of course in many places not fully closed up, places yet unshingled, doors and window only boarded up—It began on Friday night and lasted till Sunday morning and I thought sometimes

Frame 515

it would certainly land us, house and all in fragments over the fields—I sat in my chair those two nights, waiting for the roof at least to come off—Then there was staging up round three sides of the house. By night on Saturday all that on the most exposed side, which was towards the sea, had taken its leave, first the boards taking wing and sailing through the air, one after the other, then the uprights, joists, posts and supports coming with a crash to the ground. My fear was that they would smash through the house or windows, but fortunately they did not—But there was one tall two-story one at the end of the house towards the studio which stuck it out till dark, tho.

Frame 512

writhing and groaning and pounding all the time—I hoped it would hold till the storm broke for fear of the damage when it gave way, and took my seat by the fire to wait events. Altho. I had securely *anchored* the *new parts*, the house shook at times in the fury of the tempest, and I would look up to see beams or timbers crashing thro. the room, and then I thought of the poor fellows in vessels on the coast, many of whom, as it proves, were then struggling for life in the waves. But I poked the fire and stuck in another nail where the rugs bellied out and dozed till she heaved again with a fresh blast—To keep out the wind and the rain and the bedclothes on my two sleepers was work enough—such a howling and soaring and tearing I never heard, nor do I believe anybody away from a house

Frame 513

on the seashore can form an idea of what a storm is—It began to lull about daybreak and very soon thereafter my boss carpenter appeared to see after the state of things— Not a vestige of the tall staging was left—when it came down or where it went I never knew. The noise of its fall was lost in the general uproar—With one slight exception not a scratch did the house get. How it escaped I don't know, for many houses were unroofed in the town, barns leveled with the ground and twisted to pieces, cattle killed and drowned—Our poor Donkey was the only sufferer in the family. Just at dark a neighbor called to say that the roof of his stable or pen (which I had had made for him) was over in Mr. Folger's[27] yard, and poor Donkey turned out of house and home was cowering wet and cold and frightened out of his wits under the lea of the studio. We tried with might and main to get him into the shed, and then successively with three [. . .] stables of the different neighbors, but not a

foot would he set under any cover, till drenched and torn to pieces with the wind. I got him home again and set him adrift on the premises to weather it out as best he could—He was alive in the morning, but I imagine with all confidence in stables gone forever—We called on our neighbor for our roof next day and Jenkins has been busy ever since putting it and other fragments together, but I don't believe donkey will trust himself again within it—The sights in the town are curious, buildings without roofs, fences prostrate, chimneys gone and everybody hammering and tinkering at the ruins. One large barn

Frame 514

was piled up very neatly and squarely, side upon side, all on a level of not more than three feet from the ground—The wrecks on and near the Island are fearful, several with every soul lost, others with one or two saved—One man was brought in on the steamer tonight who had been thirty-six hours in the bottom of a vessel—The Captains wife, who was with him in the same situation, died before they were found— The rest all lost—I am doing very little work, cant, with this carpentering going on. It has taken much more time than I expected as is usually the case, and more money, alas—Tell your sister Sara that I sent for the *paper* and it is in the house, thanks to her—Also say to Mrs. McEntee that I got her card—With kindest regards to you all, Yours ever—EJ

Archives of American Art
Weir Family Papers (1809–1913)
Reel 530
Frame 264

65 W 55th St. June 15—79

My dear Weir[28]

Frame 264

I have been digesting my visit to New Haven and it is time for me to say how much I enjoyed it not only the social and family parts of it which was perfect and gave me the greatest pleasure, but the *Arts* part of it which was an equal pleasure and I may also say a surprise as well—It is perfectly true that I did not know before what you had done at New Haven, and I want to say that I think you have done a big work. I was

Frame 265

quite amazed to find there a school of art which seems to me so nearly complete in everything needed and so admirably and skillfully arranged to stimulate and make study attractive. You have certainly been active and energetic and I almost wonder at what you have accomplished. But giving you all the credit for work, let me say this that thing can't be done by any *dozzen* men nor by a corporation. It must be *one* man's work. You have had the advantage of being able to carry out a *single* plan without interference (at least so I presume). Too many cooks & c—You could work with a spirit and a personal pride in what you were doing, and personal responsibility for the result is always the best guarantee for success—That same force is what we want in the Academy—I don't wish to criticize the state of things there as it is as much my affair as anybodys, but I wish we could change its plan a little in the same direction. At least until we do I don't believe we can push any new blood into it—We need an *individual* director

Frame 266

whose whole time shall be at the service of the Academy and be *paid for*, and his credit and reputation consequently at stake—This of course the right man and the one who loves to work—
With all its present property and facilities [. . .] is lacking in that one [. . .] thing. I must say
[5 illegible lines]
You won't back that. Gifts and endowments ought to come in—I particularly [. . .]
[1 illegible line]

Frame 267

those incidental things as adjuncts to the general establishment, those beautiful wood carvings for example—It was very cute [?] of you to get hold of that treasure. Now

you can fill that room with objects of [...] all of which work directly to the right and the same end and in time what a storehouse of hints and ideas for artists you will have—Yes. You have been very wide awake and it is due you to say so, and let me add [...]

Frame 268 [...]

were all quite of one mind in that point—I am afraid I did not say much up there nor all I felt, and I can tell those folks that when they got you there
[1 illegible line]
Now begin with Mrs. French[29] and give my love to each one of the family separately and believe me faithfully yours, Eastman Johnson.

Archives of American Art
Charles E. Feinberg Collection of
Artists' Letters
Reel D30

Nantucket Nov 17—79

Dear Jervis,

Frame 455 You might reasonably perhaps have expected an earlier response to letter as full of trouble as your last but I beg you not to judge by this delay of my appreciation of the condition you describe or of my sympathy in the inevitable periods of extreme despondency which must come to you now and then and of my interest in all the incidents you recount which have given you lately such a freshened sense of that chapter which as you say is closed[30]—A part of this great hardship is I suppose that it must be borne alone

Frame 458 tho. I can imagine that the sufferer looks around and about him and reaches out wildly sometimes for that support which he feels he cannot do without. And yet he must bear it and does bear it till merciful nature brings some healing compensating balm, even without a lessening sense of loss—And whoever comes into contact with these events must feel them and realize if never otherwise that this experience in one shape or another must sooner or later be theirs, and they wonder how they will sustain it and who will or can comfort them—I confess it does seem to me that there is nothing in me to resist such a visitation and I look with some dismay at the lack of philosophy with

Frame 456 which I am equipped against such a [...]. I congratulate you as being made I believe of better stuff but we know not yet what we can encounter and stand up under. I have thought about you a good deal since this letter and while waiting to write you, and wish I could put into shape any of the thoughts and suggestions that pass vaguely thro. my mind, but I beg of you on one point, not to talk or think about having "done your work" or whether you will ever paint anymore. I am sure of one thing that precisely therein, in giving more serious and if possible more ardent attention to painting and to Art generally lies your best and safest refuge, and of this I have no doubt you too are sufficiently

Frame 459 conscious in your right moments, and with a full purpose in that direction, but one may too, suffer themselves to fall into a languor which even if temporary is not good and to whatever spurs or temptations in the opposite direction one can get by solicitation or otherwise should be availed of, and so I am glad you have gone to the expense of fitting up your home studio for I think it will be very much a stimulant to daily work and profitable diversion—It is dreadfully discouraging *to me* to hear you talk in that strain, and for my own part *if* I cannot fight off that idea for a good while yet I fear I shall make but a poor end. The change in your New York quarters was undoubtedly a wise one

Frame 456 and now that it is done you will feel yourself the better off for it—I can understand how reluctantly one proceeds to obliterate associations that seem sacred but our lives must go on and when we bury our dearest ones from our sight there is much else I suppose that we must bury with them—Time goes so fast now-adays that when I dare to think of it it seems as if there was but a little end left for me, something more for you maybe but there is no doubt reason why both of us should keep our courage up and for the sake of others feel as young as we can and be the last to own or see or feel a faltering step or a flagging interest or hand. To feel it is to court it and it will come

Frame 457 soon enough whether or no—I have not got over my disappointment in your failing to get here, and after I wrote to you about it it was a good while before I got anything further, but it proved you were as I finally thought, away from home and now I suppose you are in New York—You probably wonder what keeps me here. I am trying to get some work done—The harder I try the more I cant—Pulling up is a great interruption and for a considerable time and I dread it—The weather is lovely—We dont have fires all the time—a little wood fire in the evening—The house is comfortable and there is less bother than anywhere else and less occasion and need to spend money. But we must be moving now very soon. It is the middle of November. I would very well like to try it here a whole winter, but I daresay it would not be good for me. Oh no, we must keep in the whirl or be left behind, but I foresee a time coming when I shall be glad to be left behind—Did you get your bureau? I sent it the day I expected you, to be forwarded by steamer to Roundout as you directed—I see Stedman[31] has bought a house in our neighborhood and Mrs. Benson's daughter is to be married to a Lord—My wife is asleep or she would send some

Frame 458 message—Remember us to all your family an to the Giffords when you see them and I shall be glad to hear from you when you can write. What are the prospects for Art this winter? I see accounts of sales—Have you been to see Munkatcy's[32] picture?
Yours
E. J.

Archives of American Art
Charles E. Feinberg Collection of
Artists' Letters
Reel D30
Frame 467

Nantucket Dec. 2' —80

Dear Jervis

What I enclose is from the "World" [*New York World*], my new political light, which I get every day—I dont know that it is worth while to send it to you and make you mad, but I thought maybe you would get somebody to horsewhip him. Since this there is another notice of the Philadelphia Exhibition abusing the Academy for not giving the Americans abroad a fair chance at this exhibition, all of which is a succession of lies and nearly as beastly as this I enclose—What a pity there is nobody to meet such

Frame 468 scoundrels in a proper way. And yet it may be of small importance. Possibly it has met your eye before—Today is *Election.* Tomorrow we shall hear the first boom of the verdict, though it will probably be several days before we shall be able to know with any certainty how it has gone. But I hope that *certainty* is not to be long defered. The worst that can happen I believe, is a *disputed* election. It seems to me that we have not had an election since Lincoln's with so much at stake. But I cannot for the life of me believe that Garfield[33] will not be elected, and I think by such a majority as to leave all uncertainty out of the question—I trust it may be such a one as will settle that *Solid South* business for all time—If it is'nt, it will have to

come yet, for the battle has got to be fought over again with the ballot. It is the first political campaign in which I ever felt such an interest as seemed to impel me to contribute to it in *money*—.

I painted Mr. O'Conner's[34] portrait today—He has come back and taken a house to pass the winter here—We spent a good part of the day in the studio—He is a most reasonable democrat in every sense, favors the Chinese, is down on John Kelly,[35] and in fact I rather doubted whether he might not be a republican—I am sorry not to be in New York now—I had hoped to be there by next Saturday night

Frame 469

but shall not. I am going to get off though as soon as possible. But the weather here is lovely. Still I want to see N. York—When will you be there. You said you hoped to see me this winter often—now I hope you will, but you wont unless you come to see us—Can you tell me what the Century meeting decided about the memorial meeting to Gifford? I hope his wife will not see this beastly thing I send you. I would like to see the fellow that wrote it roasted—My papers have come—my wife and I sit here by our quiet cheerful wood fire. How I wish you could step in—She sends kindest regards and to all the family as I do—
Yours ever E. J.

Archives of American Art
Charles E. Feinberg Collection of
Artists' Letters
Reel D30
Frame 474

Nantucket Sept. 22—81

My dear Jervis

In reading your last letter over just now I see you ask me to write to you at Round-out so that you will get it before going to Boston, where you are due the 21st, yesterday—In the work I have had in hand that request has slipped my mind, and yesterday was the day you were to be in Boston. Did I know your address there I would not send this to Roundout, but lacking that, I have no other resource, and you will not get this till I get the little "damming" I suppose I deserve for not

Frame 475

being, as you are, prompt in these matters—Of course I shall not get to the Maine woods as I had planned, and shall make no use of all your directions. I could do nothing up to this time but work at the job I had in hand—I had to get through with that and it was of no use to plan and engage guides till I was rid of that. It is now off my hands—My subject left town day before yesterday, sitting to one till 5 o'clock the day before. The portrait is done, I suppose though I have still work to do with the accessories—It has engrossed me constantly for sometime and I have done no other work at all here

Frame 477

since I came, though I brought a number of unfinished things which I hoped and expected to work at—There was nothing to do but get through with it here—and it has been reasonably successful I believe. Now besides this, I have other work which I *must* do, so of course the Maine project grows dim and uncertain as to *time*—I swear I will go there, if it is midwinter and I go alone, or to some other place that will do as well. To have gone to the Maine woods with you or any wild where in the North would of course have been what I most desired, but I can be content with something much short of that and be delighted and thankful—The Adirondacks or the *Catskills* and the snow

Frame 478

flying will appease me to a very considerable extent, and something of this sort I am going to have—There is lots of time yet and the time too that is loveliest. All October, no time better, and even November, is as likely to be enjoyable as other wise—I have Mrs. Pullman's[36] portrait with me. She has just returned from England and is going back to stay a good while. She writes me that she wants this

254

portrait finished and hung up in her house and to know if I cant do it before she goes away in October—I think I can, and may come to New York before long about it, with the picture—I can come back by the way of Roundout, if you are there—I will let you know when I come—We could do a good deal of talking

Frame 475

up there in the course of a day, about Nevada, and possibly make some feasible plan for a pleasant little term in what remains of the pleasant weather this autumn. I am going to make the most of my time now, as I am doing, and get through if possible with what is pressing and then be free for anything—You have had your Western trip and seen so much. You will have found that the affair with the indians at Camp Apache was not so bad as at first reported, tho. serious enough, but it will, I suppose, have divested Lucy[37] and the Colonel of some of their companions, but I hope they will be restored or replaced, and that before the long winter months set in they will have their compliment again of officers and men. I want to see what you have done out

Frame 476

there, tho. with the excitement of such novelty in all the scenes and surroundings I should not wonder if, with the first visit, you had done very little—This is no longer such a good place to work in as formerly—This summer there has been a throng of people—A good many New Yorkers and there are various excitements, land speculations & C. They have a *railroad* across the island—My sister Mary is still here with Joe's[38] children. They go on Monday—A few others still linger but go next week—My portrait is full length, nearly life size—standing by the fire-side—four feet by six and a half—we expect Sarah Buckley[39] tomorrow. My sitter and her two children have been here much of the time till now. Altogether we have had rather a laborious summer—all seem alike oppressed with the Presidents'[40] death and we read only newspapers—My wife is asleep—I could not let go of the papers till she had gone to bed or she would send messages—It is now a very late hour, so good bye. I shall be rejoiced as I always am to get another letter from you. Yours ever
E. J.

Archives of American Art
Charles E. Feinberg Collection of
Artists' Letters
Reel D30
Frame 479

Nantucket Wednesday Sept 13. —82

Dear Jervis—
I have just got your dreadful letter telling me you would'nt go. I dont know whether I have been "enthusiastic" or not, but I know it is a great disappointment to find out that I am not to go into the woods with you this autumn. I have been making all the preparation I could. Today I ordered a little thin mattrass two feet wide and an inch and a half thick of good hair, to roll up. And I have had things made but was waiting till you got here for the final touches. My wife has knitted me a Tam O'Shanter cap

Frame 481

so becoming that I wanted to travel through Maine with it, and one for you, all done and ready—I thought we should look so fine. And they are such admirable night caps, in camp. I saw two little camp bedsteads today, just the things. I thought I would wait till you came before deciding to take them along. I have got a *saw* and brass wire in abundance, and I have found that india rubber coat for John Daicy [?]. Phil Wilson[41] sent it to me from New York. I have been hurrying with my work and counting the days. I have delayed for various reasons writing to you since receipt of your last but was just ready. Somebody here has been telling me of the country around the "Rangely Lakes" and offering special inducements to go there. He

Frame 480

thinks I would never go anywhere else if I once went there but he has not been up

the Nutamamkeag, I wanted to tell you about that. He belongs to a club that has a house there, where if we chose we could live in the greatest comfort. He offers to put me through, with letter & c. and make it easy, but as I prefered our camp life with our two guides I did not take up with it, tho. the offer remains open. Now why cant Vaux put in his time with us? And go to the Wilds of Maine. There would be somewhat more journey but none to hurt, and

Frame 482
after that it would be plain sailing—up the rapids in a canoe—with more of novelty and interest and fun, a hundred times, than he will get out of anything so near home. It would do him good. You could both of you come here, and that would be a new trifle to him for a day or two, and then all start well equipped from here. There is or would be an advantage in some respects in going to the Rangely lakes, even tho. you had countermanded your directions or changed your plans in writing to *Royal.* We can go there without any previous arrangements and most of the way by railroad, and this club have telegraphic and *telephonic* communication with

Frame 480
Portland and at the same time reach out by the best facilities to the most unfrequented Wilderness where there is all the game and fishing to be found anywhere. Those fellows Royal would however no doubt be ready at a moments' notice if we went there. I admit all the claims of the *barn,* but when you are ready to go with Vaux take him along and come this way. I will wait for you and we will give him a good time. I had determined anyhow to take an extra man and canoe and he will just do for him—Now I wont say any more. The Kingston creek wont do for me after having thought and counted all summer on the Wilderness. If you dont go maybe I will turn my thoughts and revisit Lake Superior or maybe I will

Frame 481
stay home and drudge. You have already had the refreshment of a long and interesting journey this season, and if the concerns at home want your attention you cant go. I know well you would like to. I must make shift to get through without you, or I may put off alone to *Parmachenee* Lake which is beyond the Rangely and where, Baxter[42] tells me, everything is to be had of the sort wanted that is to be had anywhere. I will make up my mind at leisure. You shall have your cap anyhow my wife says, and John Daicy [?] his Rubber coat. I'm as busy now on a *hen house* as you are on your barn. That is, I run out and see if things are *plumb*—
Yours E. J.

Archives of American Art
Jervis McEntee Papers
Reel 4707
Frame 254
65 West 55th St.
Aug. 13th 1883

Dear Jervis
I was'nt thinking of writing you tonight but I have just heard that "an incident force falling on an aggregate containing like and unlike units segregates the like and separates the unlike"—That is what some fellow states in so many words down there at that Concord School of Philosophy[43]—I did'nt know it before and I thought perhaps you did'nt and I would write you at once and let you do what you thought best and most prudent.

I suppose it is true, or it may be, and if it is, I wanted to ask you if you dont think Hell will be to pay? But

Frame 255
he cuts on even worse—He pretends to say that "on the one hand the homogeneous becomes the heterogeneous and the heterogeneous becomes *even more so*" (think of that) while on the other hand ["]integrations occur partially offsetting the former movements" (that would be encouraging only for what follows) "but not enough to prevent the constant increase of heterogeneity["]—So the dammed thing is on the

increase, unless he lies, which likely enough he does. But we know the cholera is, and if half he says is true of course there is no knowing what will happen next as the tadpole said when his tail dropped off, and I feel like moving into a safe place— If you and Whittredge have got well out into the country up there at Port Jervis under some trees you had better stay there. These things generally strike large cities first. I will keep a lookout here and if anything breaks, more than wind—will let you know—But the papers are full of horrors of every kind now, every day—Earthquakes, railroad smashups, suicides, strikes, breach of promises and the Devil knows what—I am glad I have got my house fixed so that I can very shortly flee [?] as for refuge to the bosom of my family—And if you happen to hear anything of that heterogeneity fellow you can inform me. Maybe it is a hoax, but if he is merely trying to get up a scare I hope the Devil will catch him—

Frame 254

All this time I have been watching plumbers and other workmen. Am now done and hope to get away by Thursday—I am going to York where Joe[44] has built him a house and then to Nantucket, stopping at Portsmouth, or near there to call on Stedman whom I met the other day and he showed me a sketch of the house he is building there—very pretty and odd I thought. I was in Nantucket last week for a few days—I got your last note from Roundout written just as you were about leaving— I hope you are doing well and full of work—Nothing would suit me better than to look in upon you two fellows, but there is a loud call from an island in the sea— Remember me cordially to Whittredge and believe me, Yours E J

Archives of American Art
Charles E. Feinberg Collection of
Artists' Letters
Reel D30
Frame 498

65 W. 55—Monday
Nov. 17–90

Dear Jervis

It is half past one A.M. and I have just returned from a dinner to Boughton[45] at the University Club, given by Mr. Joseph Harper[46] but before going to bed I must give you the briefest possible account of my effort to see Coleman,[47] as tomorrow I shall be very busy—I had a lot of errands to do, all over town, and I took in Coleman. As the Devil would have it he was of course *out*—I left a note for him and thought he might perhaps be up today to see me, but

Frame 499

he has not. He now understands however your invitation and will no doubt respond—I sent you a letter this morning and you will see how it is with me, and I told him, so the matter must be left for such arrangement as we can make—I did not get any talk with Boughton and your correspondence with him must inform you as to what he can do—The champagne and stuff, and the hour incline me to bed just now—It has rained in torrents and I had a beautiful tramp—The dinner was all right, 24—Harper, G. W. Curtis,[48] [. . .], Charleton Sears, Laffan,[49] Abner Harper, *Avery*,[50] G. W. Warren,[51] H. M. Alden[52] (Editor Harper's Weekly), J. W. Alexander,[53] Ch. S. Rhinehart, Henry Harper, *C. S. Smith*,[54] Parsons, Dr. Draper,[55] Ch. R. Miller[56] (Times) Godkin,[57] Ford, Lawrence Hutton,[58] E. J. I told Hutton about you and he expressed great interest—Now keep yourself in order and we will see what can be done—
Yours E. J.

Notes

1. Charlotte Child, a friend from Johnson's youth in Maine.

2. Richard Henry Dana, Jr. (1815–1882), lawyer and writer, author of *Two Years before the Mast*.

3. Emanuel Leutze (1816–1868), American history painter and an influential exponent of the mid-nineteenth-century Düsseldorf school.

4. George Folsom (1802–1869), Maine native, lawyer, historian, and the chargé d'affaires to the Court of the Netherlands in The Hague, 1850–54.

5. Hiram Powers (1805–1873), leading mid-nineteenth-century American Neoclassical sculptor, expatriate in Italy from 1837.

6. Jervis McEntee (1828–1891), American landscape painter and Johnson's closest friend.

7. Harriet Johnson (b. 1833), the fourth of Johnson's five sisters.

8. Robert Walter Weir (1803–1889), American history painter and an art instructor at the United States Military Academy, West Point, from 1834 to 1876.

9. Abraham M. Cozzens, an important New York patron of prominent New York artists including Thomas Cole, Frederic E. Church, John F. Kensett, Daniel Huntington, and Emanuel Leutze. Cozzens also was the owner of a hotel at West Point.

10. Louis Lang (1814–1893), American genre painter and miniaturist, based in New York from 1847.

11. Launt Thompson (1833–1894), American Neoclassical sculptor, active in New York from 1857.

12. Thomas Worthington Whittredge (1820–1910), American landscape painter and a close friend of Johnson's from their Düsseldorf years. For Thompson, see n. 11 above.

13. Mary McEntee Vaux, sister of Jervis McEntee and wife of the prominent landscape architect Calvert Vaux (1824–1895).

14. Gertrude McEntee (d. 1878), wife of the painter Jervis McEntee.

15. John Whetten Ehninger (1827–1889), American genre painter and an early student of Emanuel Leutze's in Düsseldorf.

16. Sanford Robinson Gifford (1823–1880), American landscape painter and a close friend of Johnson's.

17. Henry Wadsworth Longfellow (1807–1882), American poet, Maine native, and an early patron of Johnson's.

18. Joseph May, son of the ardent Unitarian reformer and antislavery activist Samuel Joseph May (1797–1871) and husband of Johnson's sister Harriet from 1865.

19. John F. Coyle, Johnson's friend and patron from his years in Washington, 1855–58.

20. James Wallace Pinchot (1831–1908), successful New York merchant and a patron of Johnson and his close colleagues.

21. Elizabeth Hart Colt (1826–1905), widow of the late Hartford arms manufacturer Colonel Sam Colt (1814–1862).

22. Frederic Edwin Church (1826–1900), leading midcentury exponent of the Hudson River School of American landscape painting.

23. Johnson's brother Philip Carrigan Johnson, Jr. (b. 1828), an officer in the United States Navy.

24. Elizabeth Drew Barstow Stoddard (1823–1902), poet, novelist, journalist, and the wife of the poet and editor Richard Henry Stoddard (1825–1903); both were among Johnson's close friends.

25. Elizabeth Johnson, wife of the artist.

26. Ethel Johnson, daughter of the artist.

27. Peter Folger (1812–1882), native of Nantucket, Commissioner of Wrecks and a Nantucket insurance underwriter, and Johnson's neighbor on the island.

28. John Ferguson Weir (1841–1926), American painter, known for his post–Civil War industrial subjects, and director of the Yale School of Fine Arts from 1869 to 1913.

29. The mother of Weir's wife, Mary French.

30. Johnson here refers to the death of McEntee's beloved wife, Gertrude, in 1878.

31. Edmund Clarence Stedman (1833–1908), poet, critic, anthologist, businessman, and a friend of Eastman Johnson's.

32. Mihaly Munkacsy (1844–1909), Hungarian figure painter whose *Blind Milton Dictating "Paradise Lost" to His Daughters* (location unknown) Johnson copied in 1878.

33. President-to-be James A. Garfield (1831–1881).

34. Charles O'Connor, a retiree on Nantucket and a portrait subject.

35. John Kelly (1822–1886), head of the re-formed Tammany lobby in the post-Tweed era and an active opponent of Governor Samuel Tilden in this period.

36. Hattie Sanger Pullman, wife of the Chicago railroad-car manufacturer George M. Pullman.

37. Lucy McEntee, sister of Jervis McEntee living at Fort Halleck, Nevada.

38. Joseph May, Johnson's brother-in-law, at this time a widower (see n. 18 above).

39. Sarah Buckley, sister of Johnson's wife, Elizabeth, and resident of Troy, New York.

40. President James A. Garfield, who had died on September 19, 1881, from a bullet wound inflicted by the lawyer and political office-seeker Charles J. Guiteau on July 2 of that year.

41. Philip J. Wilson (b. 1845), son of Johnson's sister Judith Johnson Jones Wilson, and resident at the Johnson home at 65 West Fifty-fifth Street, New York.

42. James Phinney Baxter (1831–1921), Maine businessman, historian, six-time mayor of Portland, and a Johnson patron from the 1880s.

43. The Concord Summer School of Philosophy and Literature (1879–88), a late effort in Transcendentalist education initiated by the aging Bronson Alcott (1799–1888) and joined by Ralph Waldo Emerson until Emerson's death in 1882.

44. Joseph May (see n. 38 above).

45. George Henry Boughton (1833–1905), American painter of historical genre subjects, expatriate in London from 1861.

46. Joseph Harper, Jr., son of the publisher Joseph Wesley Harper (1801–1870).

47. Charles Caryl Coleman (1840–1928), American figure painter, active in New York from 1863 to 1866, expatriate in Italy from 1866.

48. George William Curtis (1824–1892), author, Republican activist, and a *Harper's Weekly* editor from 1863.

49. William M. Laffan (1848–1909), writer for the *New York Sun* from 1877, publisher from 1884, and art collector.

50. Samuel P. Avery (1822–1904), collector, dealer, and a founder and trustee of The Metropolitan Museum of Art, New York.

51. George W. Warren, Democratic mayor of Troy, New York, and an early Johnson patron.

52. Henry Mills Alden (1836–1919), author, an editor of *Harper's Magazine* from 1869 to 1919.

53. John White Alexander (1856–1915), American figure painter and muralist, illustrator for Harper & Brothers in the early years of his career.

54. Charles S. Smith, merchant, founder of the Fifth Avenue Bank, president of the New York Chamber of Commerce, and a patron of Eastman Johnson.

55. William Henry Draper (1830–1901), prominent New York physician.

56. Charles Ransom Miller (1849–1922), editor in chief of the *New York Times* from 1883 to 1922.

57. Edwin Godkin (1831–1902), editor in chief of the *Nation* from its inception in 1865, and an editor of the *Evening Post* (New York) from 1881.

58. Lawrence Hutton (1843–1904), bibliophile, author, literary editor of *Harper's Magazine* from 1866 to 1898, and co-author with Clara Erskine Clement of *Artists of the Nineteenth Century* (1879).

Lifetime Exhibition History

COMPILED BY

JULIE M. DOUGLASS

The following list is a compilation of exhibitions in which Eastman Johnson participated during his lifetime, including also the memorial exhibition of 1907. The compiler relied heavily on published lists of annual exhibitions for institutions including the American Art-Union, The Art Institute of Chicago, Boston Art Club, Boston Athenaeum, Brooklyn Art Association, National Academy of Design, and Pennsylvania Academy of the Fine Arts. For both major and minor exhibitions prior to 1876, James L. Yarnall and William H. Gerdts's *National Museum of American Art's Index to American Art Exhibition Catalogues: From the Beginning through the 1876 Centennial Year* was used extensively. For subsequent exhibitions, the compiler systematically surveyed the major northeastern venues using exhibition catalogues housed at the Archives of American Art, Smithsonian Institution, and The Metropolitan Museum of Art, New York; catalogues for major national and international fairs were also reviewed. The compiler thanks David B. Dearinger, National Academy of Design, and Jonathan Harding, The Century Association, for invaluable assistance. Dates for the National Academy exhibitions were provided by David Dearinger, and brackets denote dates that are uncertain. Dates for New York's Artists' Fund Society citations pertain to the auctions held at the end of the exhibitions.

Listings here include year, city, venue, exhibition title (except for annual exhibitions), date of exhibition (when available), title of work, catalogue number, and owner. "E. J." indicates that the artist was identified as the owner of the work. Titles of works and names of owners retain the original spelling and punctuation as given in the source. Current titles are given in brackets for works that can be securely identified, and source of information is noted when it is not the exhibition catalogue. Unless otherwise noted, all works are oil.

1845

Boston. Boston Athenaeum. May. *Head of a Young Lady* (crayon), no. 6. E. T. Bridge.

1849

New York. American Art-Union. *Scene from the Honey-Moon* (crayon), no. 244. J. Grosvenor, New York.

1850

New York. American Art-Union. *The Sweepers* (crayon), no. 85. Edward McClellan, Skowhegan, Maine.

1852

Rotterdam. Tentoonstelling van Schilder-en Kunstwerken van Levende Meesters. March 3. *Twee Kaartspelers (Two Card Players)*, no. 151; *Die Vioolspeler (The Violinist)*, no. 152; *Poort van een Kastel bij winter (Doorway of a Castle in Winter)*, collaboration with Louis Rémy Mignot (figures by Johnson, landscape by Mignot), no. 224.

New York. American Art-Union. December 15–17. *The Junior Partner*, no. 19. G. Webster; *The Peas-ants of the Rhine*, no. 90. Hearn; *A Sleeping Monk*, no. 202. Haggerty; *Italian Girl Reading*, no. 242. Dean; *Italian Girl*, no. 264. Blodget. (A number of these works were originally received and given catalogue numbers in 1851 but not exhibited and sold until 1852.)

Amsterdam. Tentoonstelling van Schilder-en Anderer Werken van Levende Kunstenaars. *Een grijsaard, zijne kleindochter Christelijk onderwijs gevende (An Old Man Teaching his Grand-daughter a Christian Lesson)*, no. 225.

1853

The Hague. Tentoonstelling van Schilderijen, Enz. *Vader Tom en Evangeline, naar aanleiding van Uncle Tom's Cabin van Miss Beecher Stowe (Father Tom and Evangeline, after Uncle Tom's Cabin by Miss Beecher Stowe)*, no. 260.

1854

New York. New York Gallery of Fine Arts. May 1. *The Old Monk*, no. 130. O. Haggerty.

Rotterdam. Tentoonstelling door de Academie van Beeldende Kunsten en Technische Wetenschappen. *Een Savoijaard (A Savoyard)*, no. 137.

1856

New York. National Academy of Design. March 14–May 10. *The Card Players*, no. 60; *The Savoyard*, no. 194.

Boston. Boston Athenaeum. June. *The Savoyard*, no. 374; *The Card Players*, no. 375.

1857

New York. National Academy of Design. May 18–June 20. *Winter Scene in Holland* [*Doorway of a Castle in Winter*], collaboration with Louis Rémy Mignot (figures by Johnson, landscape by Mignot), no. 498. Geo. Folsom.

Baltimore. Maryland Institute. *The Monk and Child*, no. 97. John F. Coyle, Esq.; *Study from Life*, no. 104. John F. Coyle; *Jew Boy*, no. 112. J. F. Cogle [Coyle], Washington, D.C.; *The Monk and Child*, no. 112. J. F. Cogle [Coyle], Washington, D.C.

Washington, D.C. Washington Art Association. *Pestal* (crayon), no. 6. E. J., Washington, D.C.; *A Nun* (crayon), no. 7. E. J., Washington, D.C.; *Il Albanaise* (crayon), no. 8. E. J., Washington, D.C.; *Sketch* (crayon), no. 9. E. J., Washington, D.C.; *Childhood* (work on paper), no. 10. E. J., Washington, D.C.; *The Gamblers*, no. 46. E. J., Washington, D.C.; *The Pets*, no. 71. W. W. Corcoran, Esq.; *The Young Savoyard*, no. 78. G. W. Biggs [Riggs], Esq.; *Half-seas-Over*, no. 112. E. J., Washington, D.C.; *The Captive*, no. 113. E. J., Washington, D.C.

1859

New York. National Academy of Design. April 13–June 25. *The Nun* (crayon), no. 34. E. J.; *Roman Girl* (crayon), no. 133. E. J.; *Pastel* (crayon), no. 151. E. J.; *Negro Life at the South*, no. 321. E. J.; *The Pets*, no. 621. W. W. Corcoran; *The Sketch Book*, no. 713. E. J. *Street View in Guayaquil*, collaboration

with Louis Rémy Mignot (figures by Johnson, landscape by Mignot), no. 262. S. Gandy.

Boston. Boston Athenaeum. April. *Negro Life at the South*, no. 191.

Portland. Maine Mechanical Association. October 4. *Crayon*, no. 102. J. S. Little.

Washington, D.C. Washington Art Association. *The Fiddler*, no. 174. E. J.; *Pestal*, no. 40. J. F. Coyle.

1860

New York. National Academy of Design. April 14–June 16. *Washington's Kitchen at Mount Vernon*, no. 316. E. J.; *The Freedom Ring*, no. 449. E. J.; *Mating*, no. 465. E. J.; *Marguerite*, no. 530; *A Gentleman*, no. 610.

New York. Crayon Art Gallery. June. *The Barefoot Boy*. [*Evening Post* (New York), June 11, 1860, p. 2]

New York. Artists' Fund Society. December 22. *Prayer*, no. 128. J. A. Suydam; *Mating*, no. 146. W. Hatfield.

Boston. Boston Athenaeum. *The Barefooted Boy*, no. 209. W. Dwight; *Portraits*, no. 265½; *Margaret*, no. 278. W. Dwight.

New York. Dodworth's. February 4. *Girl Kneeling at her Orisons*. ["Domestic Art Gossip," *Crayon* (February 1860), p. 56]

Saint Louis. Western Academy of Art. *The Bottle*, no. 36. A. White; *Laughing*, no. 52. J. Snedicor.

Troy. Young Men's Association. *Old Kentucky Home* [*Negro Life at the South*], no. 125. W. P. Wright, New York.

1861

Troy. Young Men's Association. February 1. *Study from Life, "Down East,"* no. 1. Young Men's Association; *Musical Instinct*, no. 29. Irving Browne; *Corn Shucking "Down East,"* no. 50. Young Men's Association; *The Card Players*, no. 221. E. J.

Brooklyn. Brooklyn Art Association. February 19. *Gentleman at Ease in His Parlor; Barn Interior at Corn Husking Time.*

New York. National Academy of Design. March 20–April 25. *Husking*, no. 223; *The Papers—Portraits*, no. 259. E. J.; *The Marseillaise*, no. 269. Wilder Dwight; *The Post Boy*, no. 315; *A Foxy Morning*, no. 321; *The Culprit*, no. 374.

Buffalo. Young Men's Association. December 24. *Husking*, no. 153.

1862

Philadelphia. Pennsylvania Academy of the Fine Arts. Spring. *Corn Husking*, no. 44. E. J.

New York. National Academy of Design. April 14–June 23. *Warming Her Hands*, no. 281.

New York. Artists' Fund Society. December 23. *Before Breakfast*, no. 11; *Lighting his Pipe*, no. 47; *The Enraged Shoemaker*, no. 89. W. H. Webb; *Landscape with Figures*, collaboration with Jervis McEntee, no. 90.

Troy. Young Men's Association. *Down East*, no. 1. Young Men's Association; *Musical Instinct*, no. 7. Irving Browne; *Young America*, no. 13. Geo. B. Warren, Jr.; *Corn Shucking*, no. 15. J. B. Kellogg.

1863

Brooklyn. Brooklyn Art Association. March 3. *Portrait*, no. 186. J. McEntee.

Philadelphia. Pennsylvania Academy of the Fine Arts. Spring. *Warming Up*, no. 97. S. W. Dodge, Jr.

New York. Derby Gallery. May 7. *Roman Girl*, no. 53.

New York. Artists' Fund Society. December 21. *Village Blacksmith*, no. 52; *A Portrait*, no. 114. S. Gandy.

Weehawken, New Jersey. Weehawken Gallery. *Old Virginia Home* [*Negro Life at the South*], no. 87.

1864

Yonkers. Yonkers Sanitary Fair. February 15. *Girl with Flowers*, no. 16. E. C. Moore; *Card Players*, no. 18. H. N. Camp; *Portrait of the Artist*, no. 58. F. S. Cozzens.

Albany. Palmer's Sculpture. February 22. *Old Joe*, no. 88. J. T. Johnston; *The Blacksmith*, no. 101. P. Morgan; *Morning News*, no. 113. E. J.

Brooklyn. Art Exhibition of the Brooklyn and Long Island Fair in Aid of the United States Sanitary Commission. February 22. *Kentucky Home* [*Negro Life at the South*], no. 2; *Albano Girl*, no. 105, H. W. Beecher; *Albino Girl*, no. 167. H. W. Beecher.

New York. Dodworth's. February. *Repose*. [*Evening Post* (New York), February 26, 1864, p. 2]

Philadelphia. Pennsylvania Academy of the Fine Arts. Spring. *A Drop on the Sly*, no. 178. James L. Claghorn.

New York. Art Exhibition at the Metropolitan Fair in Aid of the U. S. Sanitary Commission. April 4–23. *The Postboy*, no. 84. M. O. Roberts; *Working for the Fair*, no. 138. Sheppard Gandy; *The Young Sweep*, no. 213.

Baltimore. Maryland State Fair. April 1864. *The Home Studio*, no. 105. J. McEntee; *Mating*, no. 66. Maj. Gen. Dix, New York (Manhattan); *Country Lad*, no. 112. J. A. Hoogewerff.

Brooklyn. Brooklyn Art Association. May 12–14. *Confidence and Admiration*, no. 115. Silas C. Evans.

Philadelphia. Great Central Fair for the Benefit of the U. S. Sanitary Commission. June. *Prayer*, no. 117. J. M. Burt, New York; *A Boy Reading*, no. 152. Chas. Day; *Shelling Corn*, no. 162. F. M. Butt [J. M. Burt], New York; *Writing His Lesson*, no. 178. Robt. Olyphant, New York; *A Drop on the Sly*, no. 197. James L. Claghorn; *Working for the Fair*, no. 328. Sheppard Gandy, New York; *The Culprit* (work on paper), no. 907. J. M. Burt; *The Prisoner* (work on paper), no. 1009. J. M. Burt.

New York. Artists' Fund Society. December 30. *Nest Hunting*, no. 62.

Philadelphia. United States Christian Commission. *A Drop on the Sly*, no. 178.

1865

Montreal. Montreal Art Association. February 27. *Card Players*, no. 43. H. Camp, New York.

Brooklyn. Brooklyn Art Association. March 22–25. *Galileo in Prison*, no. 10. O. G. Hillard.

New York. National Academy of Design. April 27–[July 1]. *Christmas-Time*, no. 376. Wm. T. Blodgett; *Corn-Sheller*, no. 501. Wm. T. Blodgett.

New York. Artists' Fund Society. December 29. *Not Enough for Two*, no. 49; *The Art Lover*, no. 23. National Academy of Design; *Country Home*, no. 128; *The Wood Chopper*, no. 146. M. O. Roberts.

Utica. Utica Mechanics' Association. *Getting Warm*, no. 143. W. E. Dodge, Jr.; *The Scythe Grinder*, no. 204. J. H. Prentiss.

1866

Brooklyn. Brooklyn Art Association. March 21–24. *Warming Up*, no. 192.

New York. National Academy of Design. April 17–[July 4]. *Comfort in Weariness*, no. 158; *Sunday Morning*, no. 247; *Fiddling His Way*, no. 251.

Chicago. Opera House Art Association. June. *Child Reading*, no. 254.

New York. Artists' Fund Society. December 21. *A Trade*, no. 29; *A Study*, no. 149. Robert Hoe.

Boston. Allston Club. *Cosette*, no. 24. E. W. Hooper; *Gathering Lilies*, no. 25. T. G. Appleton.

Brooklyn. Wellington Gallery. *Preparing Breakfast*, no. 71. Wellington Gallery, Brooklyn.

Utica. Utica Art Association. *The Innocent Cause of the War*, no. 273. L. M. Brown.

1867

Philadelphia. Artists' Fund Society. February. *Crossing the Brook*, no. 71. E. J.

Brooklyn. Brooklyn Art Association. March 27–30. (Title not given), no. 128; *Colraine*, no. 129.

Paris. Exposition Universelle de 1867. April–October. *Rustic Scene in Kentucky* [*Negro Life at the South*], no. 46. H. W. Derby; *Sweet Talk* [*Mating*], no. 47. John A. Dix; *The Violin Player* [*Fiddling His Way*], no. 48. R. L. Stuart; *Sunday Morning* [*Sunday Morning (formerly "The Evening Newspaper")*], no. 49. R. M. Hoe.

New York. National Academy of Design. April 16–July 4. *Portrait*, no. 397. J. W. Pinchot; *The Pension Claim Agent*, no. 452. E. J.

New York. National Academy of Design. First Winter Exhibition, including the First Annual Collection of the American Society of Painters in Water Colors, and the Works from the American Art Department of the Paris Universal Exposition. November 16, 1867–March 11, 1868. *Old*

Kentucky Home [*Negro Life at the South*], no. 644. H. W. Derby; *Fiddling His Way*, no. 651. R. L. Stuart; *Sabbath Morning* [*Sunday Morning (formerly "The Evening Newspaper")*], no. 685. Robert Hoe.

New Haven. Yale School of Fine Arts. *The Forbidden Game (Young Card Players)*, no. 204. Austin Dunham; *Pension Claim Agent*, no. 98. E. J.; *Portrait*, no. 101. J. W. Pinchot; *Village Blacksmith*, no. 197. J. W. Pinchot.

Utica. Utica Art Association. *Corn Huskers*, no. 36. P. V. Kellogg.

1868

New York. National Academy of Design. April 15–[June 20]. *The Field Hospital*, no. 250. Geo. H. Purser; *The Early Scholar*, no. 261; *The Boy Lincoln*, no. 366.

New York. Union League Club. Exhibition . . . in Honor of the Inauguration of the New Union League Club House. April 16. *Young America*, no. 12; *Reading the News*, no. 24; *The Kitchen*, no. 26.

Baltimore. Maryland Historical Society. *Papa's Portrait*, no. 88. E. J.; *New England Interior*, no. 98. J. F. Kensett.

1869

New York. National Academy of Design. April 14–[June 28]. *Portraits*, no. 196. J. C. Brown.

New York. The Century Association. December 4. *Mother Nursing a Child* (crayon).

1870

New York. The Century Association. January 10. *Boy in a Corner.*

New York. Union League Club. February 17. *Sulky Boy.* Dr. F. Otis.

New York. National Academy of Design. Summer. *Sewing for the Fair*, no. 532.

Baltimore. Jenkins Collection. *Peasant Girl of Brabant*, no. 11. J. Stricker Jenkins, Baltimore.

New Haven. Yale School of Fine Arts. *Our Father who art in Heaven*, no. 3. Aug. F. Smith; *Sunday Morning* [*Sunday Morning (formerly "The Evening Newspaper")*], no. 27. Robert Hoe; *Portraits*, no. 30; *Portraits*, no. 40. J. W. Pinchot.

1871

New York. Union League Club. January 26. *Grandmother.* J. W. Pinchot; *The Lullaby.* J. H. Hall; *Playing Soldier.* H. C. Fahnestock.

New York. The Century Association. February 4. *Stagecoach* [*The Old Stage Coach*], no. 22.

New York. Artists' Fund Society. February 6. *The Young Huntsman*, no. 58.

New York. Goupil's. March 10. *Old Stage Coach.* [*New York Times*, March 12, 1871, p. 5]

Brooklyn. Brooklyn Art Association. March 14–18. *Last Service of Old Stage Coach.* [*The Old Stage Coach*], no. 92. S. P. Avery.

New York. The Century Association. April 6. *Crossing the Stream*, no. 25; *Sulky Boy at School*, no. 22. H. G. Marquand.

New York. National Academy of Design. April 14–[?]. *The Old Stage Coach*, no. 274. George Whitney.

New York. The Century Association. May 6. *Sketch of a Baby, Mother, and Girl by Candlelight*, no. 13; *Girl with a Little Boy on Her Back. Crossing on a River*, no. 15.

New Haven. Yale School of Fine Arts. July 6. *Portraits*, no. 91. J. W. Pinchot.

New Haven. Yale School of Fine Arts. Exhibition of the Works of Art in the Permanent and Loaned Collections. Winter. *Portraits*, no. 74. J. W. Pinchot.

1872

New York. The Century Association. January 13. *Girl with Black Straw Hat Warming her Hands Before a Stove*, no. 7; *The Hatch Family*, no. 28.

New York. Artists' Fund Society. January 30. *Two Girls*, no. 70.

New York. The Century Association. February 3. *Girl Weaving on a Sofa*, no. 24; *The Drummer Boy* [*The Wounded Drummer Boy*], no. 27.

New York. National Academy of Design. April 12–July 4. *The Wounded Drummer Boy, an incident of the late war*, no. 205.

New Haven. Yale School of Fine Arts. 1872–73. *Portraits*, no. 43. J. W. Pinchot.

1873

New York. The Century Association. January. *Family Cares.* [*Evening Post* (New York), January 13, 1873, p. 1]

New York. Artists' Fund Society. January 28. *Family Cares*, no. 72.

Boston. Boston Art Club. January. *A Cold Day*, no. 111. G. H. Chickering.

New York. The Century Association. February 1. *What There is Left of the Whaling Interest in Nantucket*, no. 3.

New York. American Society of Painters in Water Colors. March 5. *The Mother*, no. 320.

New York. The Century Association. April 5. *Dropping Off*, no. 5; *A Portrait*, no. 26.

New York. National Academy of Design. April 15–June 7. *The Woodland Bath*, no. 157; *Catching the Bee*, no. 191; *The Sulky Boy*, no. 203.

New York. The Century Association. May. *Talking Politics*, no. 7; *The Pet Lamb*, no. 26; *The Prisoner*, no. 29.

New York. The Century Association. June 7. *Portrait of a Lady*, no. 1; *Cabinet Portrait of a Lady*, no. 17.

New York. The Century Association. December 6. *The Peddler*, no. 14.

Brooklyn. Brooklyn Art Association. December. *The Woodland Bath.* [*Brooklyn Daily Eagle*, December 18, 1873, p. 2]

Buffalo. Buffalo Fine Arts Academy. *Mother's Darling*, no. 121. H. A. Richmond.

Chicago. Chicago Inter-State Industrial Exposition. *Corn-Husking Down East*, no. 55. Kellogg.

Cincinnati. Cincinnati Industrial Exposition. *Feeding the Lamb*, no. 187.

1874

New York. The Century Association. January 10. *Lady Before a Mirror*, no. 3; *The Long Long Weary Day*, no. 25.

New York. Artists' Fund Society. January 27. *Bed-time*, no. 61.

New York. National Academy of Design. April 9–June 6. *A Prisoner of State*, no. 188; *The Tea Party*, no. 242. R. L. S. Hall; *Bo Peep*, no. 371.

New York. The Century Association. May 2. *Portrait of a Child*, no. 35.

New York. The Century Association. June 6. *Portraits of Children*, no. 4.

New York. The Metropolitan Museum of Art. Loan Exhibition of Paintings. September. *Old Man Smoking*, no. 52. Chas. S. Smith.

Chicago. Chicago Inter-State Industrial Exposition. *Feeding the Lamb*, no. 125. Williams and Everett, Boston.

Cincinnati. Cincinnati Industrial Exposition. *Cosette*, no. 5. Doll & Richards, Boston.

New Haven. Yale School of Fine Arts. *Portraits*, no. 9. J. W. Pinchot; *The Prisoner of State*, no. 50; *The Old Kentucky Home* [*Negro Life at the South*], no. 59. Robt. L. Stuart.

New York. Moore's Art Rooms, 9 Union Square, New York. *The Little Flower-Girl.* Moore's Art Rooms; *The Old Peddler.* Moore's Art Rooms.

1875

New York. The Century Association. January 9. *A Peasant Girl*, no. 8.

New York. The Century Association. February 6. *Portrait of a Lady*, no. 28.

New York. The Century Association. March 6. *A Portrait—Girl with Lamb*, no. 2; *Portrait of a Gentleman*, no. 17.

New York. National Academy of Design. April 8–May 29. *The Toilet*, no. 174. James Sloan; *Milton Dictating to His Daughter* [sic], no. 205; *The Peddler*, no. 268. James Roosevelt; *Portrait*, no. 452. H. M. Field.

Brooklyn. Brooklyn Art Association. November 29–December 11. *The Little Flower Girl*, no. 146. J. Y. Culyer; *A Naughty Boy*, no. 379. Jas. M. Burt.

New York. The Century Association. December 4. *The Conch Shell* [*What the Shell Says*], no. 15.

New York. National Academy of Design. Exhibition to Benefit the Fund for the Liquidation of the Mortgage Debt. *Old Captain.* [*New York Times*, December 16, 1875, p. 4]

Chicago. Chicago Inter-State Industrial Exposition. *Cosette*, no. 142; *The Old Stage Coach*, no.

208. George Whitney, Philadelphia; *Catching the Bee*, no. 209; *Sulks*, no. 210; *The Prisoner*, no. 211; *The Girl I Left Behind Me*, no. 212; *Milton Dictating to his Daughters*, no. 213; *After the Feast*, no. 214. Enoch Lewis, Philadelphia; *Family Cares*, no. 215; *Home Politics*, no. 437.

New Haven. Yale School of Fine Arts. *Portraits*, no. 25. J. W. Pinchot.

New York. Robert Hoe's Pictures. *The Artist*.

Rochester. Paintings in the Gallery of D. W. Powers, Rochester, NY. (1875–77). *The Reprimand*, no. 242.

1876

New York. Kurtz Gallery. Artists' Fund Society. *What the Shell Says*.

New York. The Century Association. January 8. *Interior*, no. 22.

New York. The Century Association. February 5. *Family Group of Portraits*, no. 5.

New York. National Academy of Design. March 28–May 31. *Husking Bee, Island of Nantucket*, no. 285; *The New Bonnet*, no. 289.

New York. The Century Association. April 1. *Consuelo*, no. 10.

Brooklyn. Brooklyn Art Association. April 24–May 6. *Pestal*, no. 196. James M. Burt; *The Girl I Left Behind Me*, no. 329; *The First Lesson*, no. 458.

New York. The Century Association. May 6. *Portrait*, no. 11; *Old Man with a Spy Glass*, no. 16; *Warming Hands*, no. 21.

New York. Young Women's Christian Association. May. *The Young Letter Writer*, no. 86. R. M. Olyphant.

New York. The Century Association. June 3. *Girls Picking Hollyhocks* [*Hollyhocks*], no. 5.

New York. The Belmont Gallery. New-York Centennial Loan Exhibition. June 19–22 and October 10–13. *The Pictures*, no. 25. August Belmont, 109 Fifth Ave., NY.

New York. New-York Centennial Loan Exhibition at the National Academy of Design and The Metropolitan Museum of Art. June 23–November 10. *Nest Hunting*, no. 330. Philip Van Volkenburgh; *Pension Agent* [*The Pension Claim Agent*], no. 85. Josiah M. Fiske; *The Chimney Corner*, no. 161. John Taylor Johnston, Esq.; *Warming Her Hands*, no. 243. R. M. Olyphant; *Young Letter Writer*, no. 245. R. M. Olyphant; *Sulks*, no. 278. Dr. F. N. Otis; *Warming Up*, no. 356. W. E. Dodge, Jr.

New York. Lotos Club. December 19. *Girls and Hollyhocks* [*Hollyhocks*].

New York. The Century Association. December. *City People and Country Quarters*, no. 7.

Chicago. Chicago Inter-State Industrial Exposition. *Corn Husking*, no. 266. P. V. Kellogg; *The Pet Lamb*, no. 411. Geo. M. Pullman.

Philadelphia. Centennial Exhibition. May 10–November. *Heel-Taps*, no. 48; *What the Sea Says*

[*What the Shell Says*], no. 72. B. Field; *Prisoner of State*, no. 96. E. J.; *The Old Kentucky Home* [*Negro Life at the South*], no. 118. R. L. Stuart; *Catching the Bee*, no. 143. Miss Jones; *The Wandering Fiddler* [*Fiddling His Way*], no. 185. J. T. Johnston; *The Old Stage-Coach*, no. 195. George Whitney; *Milton and His Daughters*, no. 259. E. J.; *Sabbath Morning* [*Sunday Morning (formerly "The Evening Newspaper")*], no. 423. R. L. Stuart; *Bo-Peep*, no. 462, H. Richmond.

1877

New York. The Century Association. January 13. *Girl and Turkey*; *Portrait*; *The Tramps* [*The Tramp*].

New York. Union League Club. Paintings Exhibited at the Ladies' Reception. January 25. *The Tramp*, no. 25. E. J.

New York. The Century Association. March 10. *Portrait of a Gentleman*; *Portrait of a Gentleman*; *Portrait Group*.

Philadelphia. Pennsylvania Academy of the Fine Arts. Spring. *The Woodland Bath*, no. 445.

New York. National Academy of Design. April 3–June 2. *Portrait of a Lady*, no. 324. G. F. Baker; *Portrait of a Gentleman*, no. 328; *Dropping Off*, no. 438. R. H. Stoddard; *City People in Country Quarters*, no. 463. E. J.; *The Tramp*, no. 491. E. J.

Boston. Boston Art Club. May 2–26. *The Prisoner of State*, no. 87.

New York. The Century Association. May 5. *R. B. Minturn*; *Self-Portrait*.

New York. The Century Association. June 2. *Female Head*.

New York. The Century Association. November 3. *Two Children on a Beam in a Barn*.

New York. The Century Association. December 1. *Child Asleep*; *Portrait of a Gentleman*; *Portrait of a Gentleman*; *Portrait of a Gentleman*.

1878

New York. Artists' Fund Society. January 22. *The Confab*, no. 58.

New York. The Century Association. February 2. *Portrait* (crayon).

New York. The Century Association. March 2. *Children on the Barn*.

New York. National Academy of Design. April 2–June 1. *Dr. Eliphalet N. Potter, President of Union College*, no. 467. E. N. Potter; *Chief Justice Daly*, no. 505. C. P. Daly; *Children Playing in a Barn* [*In the Hayloft*], no. 546.

New York. The Century Association. April 6. *Portrait of a Gentleman*.

New York. The Century Association. June 1. *Child with Rabbits*; *Portrait of a Gentleman*.

New York. National Academy of Design. Loan Exhibition 1878 in aid of the Society of Decorative Art. Fall. *Card Players*, no. 40. Hugh N. Camp.

Cleveland. The Cleveland Loan Exhibition for the Benefit of the Hospitals. November. *A Day*

Dream. [*New York Herald*, November 3, 1878, p. 6]

Brooklyn. Brooklyn Art Association. December 2–14. *About Right!*, no. 156.

Paris. Exposition Universelle de 1878. *Epis de blés* [*Husking Bee, Island of Nantucket*], no. 69. N. Sarony; *Ce que disent les coquillages* [*What the Shell Says*], no. 70. B. H. Field.

1879

New York. The Century Association. January 11. *Warming Up*; *Portrait of a Boy, Full-length*.

New York. Union League Club. January 23. *Heroine of an Unpublished Poem*, no. 65. E. J.

New York. The Century Association. February 1. *The Artist's Daughter*; *The Pedlar* [*sic*].

New York. The Century Association. March 1. *The Letter*.

New York. National Academy of Design. April 1–May 31. *The New England Pedler* [*sic*], no. 162. Thomas B. Clarke; *Portrait*, no. 179. Mrs. Geo. F. Baker.

New York. The Century Association. June 7. *Bayard Taylor, A Sketch*; *Winter*; *Portrait of a Child*.

New York. The Century Association. October 4. *Portrait of a Lady*.

New York. The Century Association. December 6. *Interior with Figure*.

Brooklyn. Brooklyn Art Association. December 8–20. *Girl with Sheep*, no. 141. W. A. White.

1880

New York. The Century Association. January 10. *A Glass with the Squire*.

New York. Union League Club. Art Exhibition at the Monthly Meeting. January. *Robert Ratliff*, no. 35. E. J.; *A Brown Study*, no. 53. E. J.

New York. The Century Association. February 7. *The Reprimand*.

New York. Artists' Fund Society. February 12–13. *The Old Squire* [*A Glass with the Squire*]. ["American Art News," *Art Interchange* 6, no. 4 (February 18, 1880), p. 31]

New York. Union League Club. Monthly Art Reception. February. *The Reprimand*. ["American Art News," *Art Interchange* 6, no. 4 (February 18, 1880), p. 31]

New York. The Century Association. March 6. *The Cranberry Harvest*.

New York. National Academy of Design. March 30–May 29. *The Reprimand*, no. 302; *The Cranberry Harvest, Island of Nantucket*, no. 382.

New York. Madison Garden. Hahnemann Hospital Fair. April. *The Pension Agent* [*The Pension Claim Agent*]. Josiah M. Fiske. ["A Disaster at the Fair," *World* (New York), April 22, 1880]

New York. The Century Association. April 3. *Portrait of a Child*.

New York. Art Students' League. Monthly Reception. Studies, Sketches, & Pictures by Eastman Johnson, and H. Humphrey Moore. April 6. [*Art Interchange* 4, no. 8 (April 14, 1880), p. 63]

New York. The Metropolitan Museum of Art. Loan Collection of Paintings. April–October. *The Corn Husking* [*Husking Bee, Island of Nantucket*], no. 44. N. Sarony; *Grandmother*, no. 98. J. W. Pinchot; *A Glass with the Squire*, no. 231. Geo. N. Curtis.

New York. The Century Association. May 1. *Portrait of a Gentleman.*

Brooklyn. Brooklyn Art Association. May 17–30. *Feather Duster Boy*, no. 138.

New York. The Century Association. June 5. *Boy, Full-length; Interior; Portrait of a Lady.*

New York. The Century Association. October 2. *Portrait Group.*

New York. The Metropolitan Museum of Art. Loan Collections of Paintings. October 1880–March 1881. *Grandmother*, no. 244. J. W. Pinchot.

New York. The Century Association. November 19. *Sanford R. Gifford.*

New York. The Century Association. December 4. *Portrait of a Gentleman.*

1881

New York. The Century Association. January 8. *C. O'Connor; Portrait, full-length.*

Boston. Boston Art Club. January 29–February 19. *Portrait*, no. 37. E. J.; *A Prisoner*, no. 131. E. J.

New York. Artists' Fund Society. February 7–8. *Thy word is a lamp unto my feet and a light unto my path*, no. 60.

New York. Society of American Artists. March 28–April 29. *A Portrait* [*Winter, Portrait of a Child*], no. 99.

New York. The Century Association. May 7. *Portrait.*

New York. The Metropolitan Museum of Art. Loan Collection of Paintings. May–October. *What is the Shell Saying?* [*What the Shell Says*], no. 116. Benjamin H. Field.

New York. The Century Association. June 4. *Portrait of a Lady.*

New York. The Century Association. November 5. *Portrait of a Lady.*

New York. The Metropolitan Museum of Art. Loan Collection of Paintings and Sculpture. November 1881–April 1882. *The Cranberry Harvest, Nantucket* [*The Cranberry Harvest, Island of Nantucket*], no. 10. Auguste Richard; *What is the Shell Saying?* [*What the Shell Says*], no. 41. Benjamin H. Field; *Grandmother*, no. 60, J. W. Pinchot.

Chicago. Inter-State Industrial Exposition. *The Funding Bill*, no. 337. E. J.; *I'se dot three*, no. 437. H. H. Porter, Chicago.

New York. National Academy of Design. *The Funding Bill—Portrait of Two Men*, no. 216; *A Portrait*, no. 401. H. H. Porter.

1882

New York. Artists' Fund Society. January 16–17. *The Fifer and his Son*, no. 33.

New York. Union League Club. Paintings Exhibited at the Annual Ladies' Reception. January 26. *The Anxious Mother*, no. 9. Geo. F. Baker.

New York. The Century Association. February 4. *Salem H. Wales.*

Boston. Boston Art Club. February 11–March 11. *The Funding Bill* [*The Funding Bill—Portrait of Two Men*], no. 112. E. J.

New York. The Century Association. March 4. *Full-length Portrait of a Lady.*

New York. National Academy of Design. March 27–May 13. *Portrait of a Lady*, no. 173. Geo. M. Pullman; *Portrait of a Gentleman*, no. 210.

New York. Society of American Artists. April 6–May 6. *Portrait*, no. 56. Mr. Einstein.

New York. The Century Association. May 6. *Pres. Porter, Yale College.*

New York. The Metropolitan Museum of Art. Loan Collection of Paintings and Sculpture. May–October. *What is the Shell Saying?* [*What the Shell Says*], no. 120. Benjamin H. Field, New York; *The Funding Bill* [*The Funding Bill—Portrait of Two Men*], no. 168. E. J.; *The Cranberry Harvest, Nantucket* [*The Cranberry Harvest, Island of Nantucket*], no. 174. Auguste Richard, New York.

New York. The Century Association. June 3. *Portrait of a Boy, Full-length; Portrait of a Gentleman.*

New York. The Metropolitan Museum of Art. Loan Collection of Paintings and Sculpture. November 1882–April 1883. *An Arrangement in Black and White*, no. 83. Schuyler Skaats, New York.

1883

New York. The Century Association. January 13. *Portrait of a Lady; Portrait of a Young Girl.*

New York. The Century Association. February 3. *What's That!; Dr. McCosh; Portrait of a Lady; Portrait.*

New York. American Art Association. Exhibition of Paintings by the Members of The Art Club of New York. February 12–28. *Children in the Woods*, no. 14; *Winter Sport*, no. 42; *A Moment of Rest*, no. 65.

New York. The Century Association. March 3. *Mr. Eno.*

New York. Union League Club. March 8. Exhibition of Pictures Belonging to the Union League Club. *Wounded Drummer Boy*, no. 10; *Salem H. Wales*, no. 50; *Jonathan Sturges*, no. 56.

New York. National Academy of Design. April 2–May 12. *Portrait of a Gentleman*, no. 287. Sir Edw. Archibald; *Portrait of a Child*, no. 348. David Einstein.

New York. The Century Association. April 7. *Dr. McCosh.*

New York. American Art Gallery. Works Selected to be Shown at International Art Exhibition in Munich. May 19–23. *The Corn Husking.* [*New York Herald*, May 19, 1883, p. 5]

Munich. International Art Exhibition. May. *The Corn Husking.* [*New York Herald*, May 19, 1883, p. 5]

New York. The Century Association. May 5. *Portrait; Portrait (E. J.).*

New York. The Metropolitan Museum of Art. Loan Collection of Paintings and Sculpture. May–October. *Puss in the Corner*, no. 59. William T. Evans, Jersey City.

New York. The Century Association. June 2. *Portrait of a Lady.*

Louisville, Ky. The Southern Exposition. August 1–November. *The Prisoner of State*, no. 323. George I. Seney, Brooklyn; *Children in the Wood*, collaboration with Jervis McEntee (figures by Johnson, landscape by McEntee), no. 364.

New York. The Century Association. November 3. *Portrait of a Lady.*

New York. American Art Galleries. The Private Collection of Paintings by Exclusively American Artists, Owned by Thomas B. Clarke. December 28, 1883–January 12, 1884. *New England Peddler*, no. 64; *In Kind Hands*, no. 65.

1884

New York. The Century Association. January 12. *Judge Folger.*

New York. The Century Association. February 2. *Portrait.*

New York. The Century Association. March. 100 studies.

New York. National Academy of Design. April 7–May 17. *Hon. Charles J. Folger*, no. 70; *Portrait of Dr. McCosh*, no. 259. Alex Maitland.

Boston. Boston Art Club. April 12–May 10. *Consuelo* (crayon), no. 194. I. T. Williams; *Cosette* (crayon), no. 195. Chas. E. O'Hara.

New York. The Century Association. April 19. 83 sketches and studies.

New York. The Century Association. May 3. *Edwin Booth; Portrait of a Lady; Portrait of a Gentleman.*

New York. The Metropolitan Museum of Art. Loan Collection of Paintings and Sculpture. May–October. *The Old Stage Coach*, no. 208. Geo. Whitney, Phila.

New York. Union League Club. November 13. *Portrait of Edwin Booth*, no. 42. E. J.; *Portrait of D. F. Appleton*, no. 43. D. F. Appleton.

New York. The Century Association. December 6. *Portrait.*

1885

New York. The Century Association. January 10. *M. Evarts; Portrait of a Gentleman.*

New York. The Century Association. February 7. *A. B. Chittenden; Pres. Woolsy.*

New York. The Century Association. March 7. *Portrait of a Gentleman*; *Portrait of a Gentleman*.

New York. National Academy of Design. April 6–May 16. *Portrait of Hon. Wm. M. Evarts*, no. 452.

New York. Union League Club. Exhibition of Oil Paintings at the Monthly Meeting. April 9. *A Glass with the Squire*, no. 53. Geo. M. Curtis.

New York. Union League Club. May 14. *Portrait*, no. 88. Daniel F. Appleton.

New York. The Century Association. June 6. *Grover Cleveland*.

New York. The Metropolitan Museum of Art. Loan Collection of Paintings and Sculpture. November 1885–April 1886. *Village Blacksmith*, no. 87. James W. Pinchot; *Portrait of a Lady*, no. 90. James W. Pinchot; *Grandmother and Child*, no. 95. James W. Pinchot.

1886

New York. The Century Association. March 6. *Dr. J. C. Dalton*.

New York. Union League Club. Exhibition of Paintings. March 11. *New England Peddler*, no. 69. Thos. B. Clarke.

New York. The Century Association. April 3. *Portrait of a Lady*.

New York. National Academy of Design. April 5–May 15. *Portrait of Dr. J. C. Dalton, President of College of Physicians and Surgeons*, no. 515. College of P. & S.

New York. The Century Association. May 1. *Portrait of a Child*.

New York. The Century Association. June 5. *Portrait of a Boy*; *Bishop H. A. Potter*; *Portrait of a Gentleman*.

New York. Union League Club. Exhibition . . . in Honor of the Representatives of the French Government, Attending the Inauguration of the Statue of Liberty. October 27. *The Culprit*, no. 35. J. F. Sutton.

New York. The Century Association. November 6. *President Barnard*; *Daniel Manning*; *Portrait of a Lady*.

New York. The Century Association. December 4. *Portrait*.

1887

New York. The Century Association. January 8. *J. S. Kennedy*.

New York. Artists' Fund Society. January 11–12. *Justice of the Peace*, no. 79.

New York. The Century Association. February 5. *Portrait, sketch*; *William H. Vanderbilt*.

New York. The Century Association. March 5. *Portrait*.

New York. Union League Club. March 10–12. *The Justice of the Peace*, no. 37. W. H. Payne.

New York. National Academy of Design. April 4–May 14. *Rt. Rev. H. C. Potter*, no. 164; *Old*

Whalers of Nantucket [*The Nantucket School of Philosophy*], no. 328; *Portrait of a Lady*, no. 363.

Brooklyn. Brooklyn Art Association. Exhibition of Mr. George I. Seney's Collection of Paintings. April 16–28. *The Culprit*, no. 112; *Sunday Morning*, collaboration with Worthington Whittredge (figures by Johnson, landscape by Whittredge), no. 152.

New York. The Century Association. May 7. *Portrait of a Boy*; *Portrait of a Man*.

Chicago. Inter-State Industrial Exposition. September 7–October 22. *The Culprit*, no. 240. George I. Seney.

New York. The Century Association. December 3. *Untitled*.

New York. Union League Club. December 8. *Portrait of Chester A. Arthur*, no. 40. Union League Club.

1888

New York. The Century Association. February 5. *Portrait*.

New York. The Century Association. March 3. *Alexander Hamilton*; *Portrait*; *Portrait*.

New York. National Academy of Design. April 2–May 12. *Portrait of Alexander Hamilton*, no. 156. Knickerbocker Club; *A Woman*, no. 292; *Portrait of a Lady*, no. 375. Jay C. Morse; *Portrait*, no. 456. Wm. D. Sloane.

Chicago. The Art Institute of Chicago. May 28–June 30. *Shelling Corn*, no. 101. James W. Ellsworth, Chicago.

1889

New York. The Century Association. February 2. *John W. Ehninger*.

New York. Union League Club. February 14–16. Collection of Oil Paintings and Antique Chinese Porcelains. *Portrait, C. R. Agnew*, no. 35. Union League Club.

New York. National Academy of Design. April 1–May 11. *Portrait of a Boy*, no. 246. E. Pope Sampson; *Portrait of Judge Monson*, no. 260. Knickerbocker Club.

New York. The Century Association. May 4. *Portrait*; *Portrait*.

Paris. Exposition Universelle de 1889. May 5–November 5. *Two Men* [*The Funding Bill—Portrait of Two Men*], no. 178.

Chicago. The Art Institute of Chicago. May 30–June 30. *Solitaire*, no. 101.

New York. Union League Club. Loan Collection. November 14–16. *Corn Husking* [*Husking Bee, Island of Nantucket*], no. 19. N. Sarony.

1890

New York. The Century Association. February 1. *Portrait*.

New York. Union League Club. Pictures by American Figure Painters. February 13–15. *The*

Cranberry Harvest [*The Cranberry Harvest, Island of Nantucket*], no. 17. Auguste Richard.

Chicago. The Art Institute of Chicago. Paintings Exhibited at the Opening of the New Galleries. February 24. *Corn Husking* [*Husking Bee, Island of Nantucket*], no. 245. Mr. Potter Palmer.

New York. The Century Association. May 3. *Gen. Miles*.

Chicago. The Art Institute of Chicago. Art Collections Loaned by James W. Ellsworth. May. *Shelling Corn*, no. 50.

Chicago. The Art Institute of Chicago. June 9–July 13. *Portrait of a Lady*, no. 102.

New York. The Metropolitan Museum of Art. Loan Collections. November 1890–April 1891. *The Big Bite*, no. 22. Frederick Loeser.

New York. National Academy of Design. *Portrait of a Child*, no. 442.

1891

New York. Union League Club. Loan Collection of Paintings in Landscape, Figure and Still Life by American Artists. January 8–10. *A Glass with the Squire*, no. 4. E. J.

New York. The Century Association. January 10. *William M. Evarts*.

New York. Union League Club. Paintings by Old Masters, and Modern and American Painters. February 12–14. *A Frosty Morning*, no. 41. H. L. Horton.

New York. The Century Association. March 2. *Portrait*.

New York. The Century Association. April 4. *Portrait*; *Portrait*.

New York. Society of American Artists. April 27–May 23. *Portrait*, no. 124.

New York. The Metropolitan Museum of Art. Loan Collections. May–November 1891. *The Big Bite*, no. 39. Frederick Loeser.

New York. The Century Association. June 6. *David Dows*.

New York. The Century Association. June 27. *Unknown Head, copy*.

New York. Union League Club. Exhibition of Oil Paintings. November 12–14. *The Late Jackson S. Schultz—Portrait*, no. 1. Union League Club.

New York. The Metropolitan Museum of Art. Loan Collections. November 1891–April 1892. *Portrait of Bayard Taylor*, no. 46. Mrs. Bayard Taylor.

1892

New York. Union League Club. Paintings by American Artists. January 14–16. *The Pension Agent* [*The Pension Claim Agent*], no. 34. Thomas B. Clark [Clarke].

New York. The Century Association. March 5. *Portrait*; *Portrait*.

New York. The Century Association. April 2. *Portrait*.

New York. National Academy of Design. April 4–May 14. *Full-Length Life-Size Portrait*, no. 264. Archibald Roger.

New York. National Academy of Design. Loan Exhibition for the New York Columbian Celebration. October. *Portrait*, no. 19. Frederic F. DePeyster, Esq.; *The New England Peddler*, no. 75. Thomas B. Clarke, Esq.

New York. The Century Association. November 5. *Portrait, Full-Length; Portrait, Bust.*

New York. The Century Association. December 3. 6 sketches, oil.

Cincinnati. Cincinnati Museum Association. Exhibition of Oil Paintings and Sculpture. *Portrait of Charles W. West*, 1882, no. 1.

1893

New York. Union League Club. January 12–14. *A Nantucket Symposium* [*The Nantucket School of Philosophy*], no. 27. Edward D. Adams.

New York. The Century Association. January 14. *Dr. Markoe.*

New York. The Century Association. February 4. *Frederick Layton.*

Philadelphia. Pennsylvania Academy of the Fine Arts. Spring. *The Nantucket School of Philosophy*, no. 157. Edward D. Adams.

New York. National Academy of Design. March 27–May 13. *Portrait of a Gentleman*, no. 125. Orson D. Munn, Esq.; *Portrait of a Lady*, no. 264. Mr. Carolan, San Francisco.

New York. The Century Association. April 1. *Portrait of a Lady.*

Chicago. World's Columbian Exposition. May 1–October 31. *Portrait of the Artist*, 1891, no. 438; *Portrait of a Girl* [*Florence Einstein*], 1883, no. 669. D. L. Einstein, New York; *Portrait of Dr. McCosh*, 1883, no. 784. Alexander Maitland; *Two Men* [*The Funding Bill—Portrait of Two Men*], 1881, no. 853; *Life Size Portrait* [*Colonel Archibald Rogers*], 1892, no. 921. Archibald Rogers, Hyde Park, New York; *The Cranberry Harvest, Nantucket Island, Mass.* [*The Cranberry Harvest, Island of Nantucket*], 1880, no. 954. Auguste Richard, New York; *The Nantucket School of Philosophy*, circa 1886, no. 983. E. D. Adams, New York.

New York. National Academy of Design. Loan Exhibition. Summer. *The Pictures*, no. 69. August Belmont.

New York. The Century Association. November 4. *Portraits, 1879.*

1894

Philadelphia. Pennsylvania Academy of the Fine Arts. Spring. *Portrait of Mrs. Eastman Johnson*, no. 178.

New York. The Century Association. June 2. *Portrait.*

Chicago. The Art Institute of Chicago. October 29–December 17. *Portrait of John D. Rockefeller*, no. 176. University of Chicago.

New York. National Academy of Design. Portraits of Women Loan Exhibition for the Benefit of St. John's Guild and the Orthopaedic Hospital. November 1–December 1. *A Portrait*, no. 161. E. J.; *Mrs. Frederic N. Goddard*, no. 162. Frederic N. Goddard, Esq.; *Grandmother and Child*, no. 163. J. W. Pinchot, Esq.

New York. The Metropolitan Museum of Art. Loan Collections. *Two Men* [*The Funding Bill—Portrait of Two Men*], no. 117. E. J.

1895

Chicago. The Art Institute of Chicago. Loan Exhibition of Portraits of Men, Women, and Children. January 2–15. *Eastman Johnson*, 1889, no. 188. Mrs. G. P. A. Healy; *George F. Porter*, 1886, no. 286. H. H. Porter, Chicago; *H. H. Porter, Jr*, 1880, no. 287. H. H. Porter, Chicago; *J. D. Rockefeller*, 1894, no. 304. University of Chicago.

New York. Union League Club. Loan Exhibition of Paintings. April 11–13. *The Wounded Drummer Boy*, no. 51. Union League Club.

New York. National Academy of Design. Loan Exhibition of Portraits for the Benefit of St. John's Guild and the Orthopaedic Hospital. October 13–December 7. *Mrs. Spencer Trask*, no. 175. Spencer Trask, Esq.; *Edwin Booth*, no. 176. Mrs. Edwina Booth Grossman; *Mary Devlin, First Wife of Edwin Booth*, no. 177. Mrs. Edwina Booth Grossman; *Portrait*, no. 178. Archibald Rogers, Esq.; *Mrs. Frank Lawrence and Lady Vernon*, no. 179. E. J.; *Mrs. Seligman*, no. 180. D. L. Einstein; *Master Sampson*, no. 181. Mrs. E. Pope Sampson.

New York. The Century Association. December 7. *Hugh Camp.*

New York. The Metropolitan Museum of Art. Loan Collections. *Two Men* [*The Funding Bill—Portrait of Two Men*], no. 117. E. J.

1896

New York. The Century Association. February 1. *A Recollection (Parke Godwin).*

New York. The Century Association. March 7. *1863; Mrs. Gerald Hoyt* (pastel).

New York. The Century Association. May 2. *Play Me a Tune; J. D. Rockefeller; Jackson S. Schultz.*

New York. The Metropolitan Museum of Art. Retrospective of American Paintings Loan Collection. May–November. *Two Men* [*The Funding Bill—Portrait of Two Men*], no. 410. E. J.

Cincinnati. Cincinnati Museum Association. A Group of Portraits. Summer. *Charles W. West*, no. 848.

New York. The Century Association. December 5. *Stephen B. Nash; Herbert B. Turner.*

1897

New York. Union League Club. Paintings by American Artists. January 14–16. *Play Me a Tune*, no. 17.

New York. The Century Association. January 14. *Portrait Group; Family Group; Frederick Augustus Porter Barnard.*

1898

New York. Lotos Club. March 26. *Embers*, no. 80; (no title given), no. 81.

New York. National Academy of Design. March 28–May 14. *Portrait*, no. 231.

Pittsburgh. Carnegie Institute. November 3, 1898–January 1, 1899. *Portrait of Miss Pullman*, no. 29.

New York. National Academy of Design. Loan Exhibition of Portraits for the Benefit of the Orthopaedic Hospital. December 14, 1898–January 14, 1899. *Mrs. Alfred R. Conkling*, no. 145. A. R. Conkling.

1899

Philadelphia. Pennsylvania Academy of the Fine Arts. Spring. *Hon. William M. Evarts*, no. 314; *Portrait of John Knox*, no. 315; *Bishop Potter*, no. 365.

New York. The Century Association. March 4. *Portrait.*

New York. Society of American Artists. March 25–April 29. *Portrait*, no. 264.

New York. The Century Association. April 1. *Amos Eno.*

New York. National Academy of Design. April 3–May 13. *Mrs. Frank Lawrence and Her Daughter, Lady Vernon*, no. 109; *Embers*, no. 118.

New York. The Century Association. June 3. *Portrait of a Gentleman.*

Pittsburgh. Carnegie Institute. November 2, 1899–January 1, 1900. *Play me a Tune*, no. 128.

New York. The Century Association. November 4. *General Thomas Davies.*

Chicago. The Art Institute of Chicago. *Embers*, no. 169; *Portrait*, no. 170.

1900

New York. National Academy of Design. January 1–27. *Portrait of Mr. Ed. Lyman*, no. 24; *Portrait Gen. Thomas Davies*, no. 34. Julian T. Davies, Esq.; *Portrait of Hon. Whitelaw Reid*, no. 91. New York Tribune.

Boston. Boston Art Club. January 6–February 3. *Twelfth Night at Century Club—Portrait of the Artist*, no. 54.

New York. Union League Club. American Paintings. January 11–13. *Attention*, no. 1; *Portrait of the Late Rev. Dr. McCosh, Pres. Princeton College*, no. 2; *The Cranberry Pickers*, no. 3; *Portrait of the Late Rev. Dr. Porter, Pres. of Yale University*, no. 4; *A Youth*, no. 5; *Mother and Daughter*, no. 6; *Portrait of the Late Charles O'Connor*, no. 7; *A Maple Sugar Camp in Maine*, no. 8; *Portrait of the Late Peter Folger*, no. 9; *Games in the Barn*, no. 10; *Warming the Hands*, no. 11; *Portrait of the*

Late Edwin Booth, no. 12; *The Corn Huskers*, no. 13; *Portrait of the Late Sanford R. Gifford*, no. 14; *Between Friends*, no. 15.

New York. The Century Association. January 13. *Female Figure*; *Portrait of a Lady*.

New York. Union League Club. Exhibition of Pictures by American Figure Painters and Persian & Indian Works of Art. February 13–15. *The Cranberry Harvest* [*The Cranberry Harvest, Island of Nantucket*], no. 17. August Richard.

New York. Lotos Club. February 24, 26, 27. *Portrait of Hon. Whitelaw Reid*, no. 17.

Philadelphia. Pennsylvania Academy of the Fine Arts. Spring. *Mrs. Francis C. Lawrence and Daughter Lady Vernon*, no. 207; *Play Me a Tune*, no. 245.

New York. The Century Association. March 3. *Embers*.

New York. Society of American Artists. March 24–April 28. *Child and Rabbit*, no. 297; *Portrait of Boy with Violin*, no. 326.

New York. The Century Association. April 7. *Dean van Amringe*.

Paris. Exposition Universelle de 1900. *Prisoner of State*, no. 110. Homer Lee, Esq.

1901

Boston. Boston Art Club. January 5–February 2. *Embers*, no. 32; *Play Me a Tune*, no. 41.

New York. Lotos Club. February 23, 25, 26. *Embers*, no. 20.

Philadelphia. Pennsylvania Academy of the Fine Arts. Spring. *Girl and Rabbit*, no. 330.

New York. The Century Association. March 2. *William M. Evarts*; *Dr. N. Cosh*; *Portrait of a Man*.

New York. Society of American Artists. March 13–May 4. *Portrait of Parke Godwin, Esq.*, no. 216; *Portrait of Wm. M. Evarts, Esq.*, no. 325.

New York. The Century Association. May 4. 44 oil paintings; *Self-Portrait, Full-Length*.

Buffalo. Pan-American Exposition. Summer. *Embers*, no. 730; *Twelfth Night at the Century Club (Portrait of the Artist)*, no. 731.

Pittsburgh. Carnegie Institute. November 7, 1901–January 1, 1902. *Mr. John D. Rockefeller*. no. 119.

Chicago. The Art Institute of Chicago. *Portrait of William M. Evarts*, no. 178; *Portrait of Mrs. George M. Pullman, of Chicago*, no. 179.

1902

Philadelphia. Pennsylvania Academy of the Fine Arts. Spring. *Portrait of John D. Rockefeller*, no. 143.

New York. The Century Association. March 1. *Portrait of a Man*.

New York. Union League Club. Portraits of Americans. March 13–15. *Portrait of John D. Rockefeller, Esq.*, no. 14. E. J.

New York. The Century Association. June 7. *J. D. Rockefeller*.

1903

Boston. Boston Art Club. January 3–31. *A Corn Husking*, no. 119.

New York. The Century Association. January 10. *Parke Godwin*.

New York. Union League Club. Portraits of Americans. February 12–14. *Portrait of Bishop Henry C. Potter*, no. 17. E. J.

1904

New York. The Century Association. January 9. *Parke Godwin*; *I'm the Tallest*.

New York. Lotos Club. February 27. *I'm Tallest*, no. 28.

New York. Union League Club. An Exhibition of Portraits. March 10–12. *Twelfth Night at the Century Club, being a Portrait of the Artist*, no. 23. E. J.; *William M. Evarts, Esq.*, no. 24. E. J.

New York. The Century Association. March 12. *Priscilla*; *Holland Peasant*.

New York. Union League Club. American Figure Painters. April 14–16. *Milton Dictating to His Daughters*, no. 15. Phillips Phoenix, Esq.; *Hollyhocks*, no. 16. Phillips Phoenix, Esq.; *Play me a Tune*, no. 17. E. J.

Saint Louis. Louisiana Purchase Exposition. *Portrait of Mrs. John D. Rockefeller*, no. 400; *Corn Husking*, no. 401.

1905

Chicago. The Art Institute of Chicago. Loan Exhibition of Portraits. January 2–22. *John D. Rockefeller*, no. 60. E. J.

New York. Lotos Club. January 28. *Embers*, no. 22; *Play Me Something*, no. 23.

New York. The Century Association. March 4. *Untitled*.

New York. Society of American Artists. March 25–April 13. *Child and Doll*, no. 23. Mrs. Charles Chickering.

1906

New York. The Century Association. January 6. *Not at Home*; *His Shad Over*.

New York. Union League Club. Modern Paintings. January 11–13. *A Drink with the Squire*, no. 14.

New York. Union League Club. Portraits by Contemporary Artists. March 8–10. *O. D. M., Esq.*, no. 14. Orson D. Munn, Esq.

1907

New York. The Century Association. Memorial Exhibition of Eastman Johnson. February 9–13. *Oswald Achenbach*, 1851 (crayon); *Adelaide*; *The Angora Kitten and His Pet Girl*; *Lady Audry*; *Back from the Orchard*; *The Baley by Candle Light*; *Baron Fresca Tuning His Violin*; *Blacksmith's Shop*; *The Blue Jay*; *Edwin Booth*; *Boy in Contemplation in the Maine Woods*; *The Card Players*; *Mrs. Frances Carolan* (pastel); *Catskill Dell*; *Child and Rabbit*; *City People in Country Quarters*; *Captain Coleman*; *Jim Wrecker Collins*; *The Corn Husking*; *The Counterfiters*; *The Cranberry Harvest*; *Day Dreams*; *Dinner Time in Old Virginia*; *The Down East Wooing*; *Dropping Off*; *Dutch Interior, Where I Got My Studio Cabinet*; *Early Lovers*; *Embers*; *Miss Eusden*, 1855 (crayon); *The Exterior of Mt. Vernon*; *Fiddling His Way*; *Flying a Kite*; *Caleb Frye*; *Fugitive Slaves, A Ride for Liberty*; *Gambler at the Hague* (sketch); *Girl and Rabbits*; *Girl and Sled*; *Girl and Turkey* (pastel); *The Girl I Left Behind Me*; *Giving Baby a Taste*; *Going to the Camp*; *Grand Portage*; *Gypsy Queen*; *Alexander Hamilton, Late President of the Knickerbocker Club* (pastel); *Mrs. Alexander Hamilton*, 1846 (crayon); *The Hermit*; *Holland Peasant Girl*; *The Hollander*; *I'm the Tallest*; *In the Barn*; *In the Land of Nod, Sleeping Child*; *Indian Girl* (sketch); *The Interior of Kitchen of Mt. Vernon with Four Figures*; *Interior of the Artist's House*; *Nathaniel Jenkins*; *Jumping in the Barn*; *Louis Knaus*, 1850 (crayon); *Otto Knille*, 1850 (crayon); *Lady in Gray*; *Lady Playing Harp*; *Little Brown Boy*; *Luncheon in the Camp*; *Dolly Madison*, 1846 (crayon); *Captain Manter, an Old Whaler*; *Kathleen Marvouren*; *Measurements and Contemplation in the Camp*; *Memory of a Lady in Art Gallery in Washington*, 1848 (pastel); *Head of Milton*; *The Moorish Girl*; *Morning News at the Camp*; *Mother and Child*; *Mother and Child, Child Nursing* (sketch); *Mt. Vernon in 1857*; *Benjamin Pollieux de Mudisen, a Distinguished French Refugee at the Hague*, 1851; *Mumblepeg*; *New England Kitchen*; *Nora*; *The Old Squaw*; *The Old Stage Coach*; *Peaceful Village*; *Play Me a Tune*; *Prince Rupert*; *Princess Marie of Holland*, 1855 (crayon); *Priscilla*; *Prisoner of State*; *A Quiet Hour*; *The Red Hot Stove*; *Rock-a-bye Baby, in the Tree Top*; *John D. Rockefeller*; *Rosaline*; *S. W. Rowse*, 1848 (crayon); *The Sap Gatherers*; *Savoyard*; *Self-Portrait, "Just as I Am"*; *Self-Portrait*, 1848 (crayon); *The Shy Musician*; *The Sly Drink at the Camp*; *Spinning Yarns and Whittling*; *The Story Teller of the Camp*; *Study for Corn Husking*; *Study for the Glass with the Squire*; *Study of an Artist's Wife*; *Sugaring Off*; *Sugaring Off*; *Sugaring Off, Card Playing*; *Sunlight and Shadow*; *Susan Ray's Kitchen*; *Susan Ray Coming into her Kitchen*; *Teaching Caesar*; *Three Heads of One of the Counterfiters*; *Through the Snow*; *The Tomb of Washington at Mt. Vernon*; *The Truants*; *Uncle Remus*; *The Vacant Chair*; *William H. Vanderbilt*; *Daniel Webster*, 1845 (crayon); *What the Shell Says*; *When Woods were Green*; *Wigwams*; *The Wildflower*; *Winnowing Grain*; *The Wounded Drummer Boy*; *Young Girl*, 1856 (pastel).

New York. The Century Association. April 6. *Self-Portrait*.

New York. The Century Association. May 4. *George W. Maynard*.

Selected Bibliography of Monographic Sources

American Art Galleries. *Catalogue of Finished Pictures, Studies, and Drawings by the Late Eastman Johnson, N.A., to be Sold at Unrestricted Public Sale by Order of Mrs. Eastman Johnson at the American Art Galleries.* New York: American Art Galleries, 1907.

American Paintings in the Detroit Institute of Arts, vol. 2. Eastman Johnson catalogue entries, nos. 53–56 by Patricia Hills. New York: Hudson Hills Press in association with The Detroit Institute of Arts Founders Society, 1997.

Ames, Kenneth. "Eastman Johnson: The Failure of a Successful Artist." *Art Journal* 39, no. 2 (Winter 1969–70), pp. 174–83.

Barry, William David. "The Rembrandt of Sugaring Off." *Down East* 38 (April 1992), pp. 34–37.

Baur, John I. H. *An American Genre Painter: Eastman Johnson, 1824–1906.* Exh. cat. Brooklyn: Institute of Arts and Sciences, 1940. Reprinted in *Three Nineteenth-Century Painters: John Quidor—Eastman Johnson—Theodore Robinson.* New York: Arno Press, 1969.

Benjamin, S. G. W. "A Representative American." *Magazine of Art* 5 (November 1882), pp. 485–90.

Benson, Eugene. "Eastman Johnson." *Galaxy* 6, no. 1 (July 1868), pp. 111–12.

Boettger, Suzaan. "Eastman Johnson's *Blodgett Family* and Domestic Values during the Civil War Era." *American Art* 6, no. 4 (Fall 1992), pp. 51–67.

Coffin, William A. "Eastman Johnson: The Century's American Art Series." *Century Magazine* 48, no. 6 (October 1894), p. 958.

Crosby, Everett U. *Eastman Johnson at Nantucket. His Paintings and Sketches of Nantucket People and Scenes.* Nantucket, Mass.: privately printed, 1944.

Cummings, Hildegard. "Eastman Johnson and 'Horatio Bridge.'" *Bulletin of the William Benton Museum of Art* 1, no. 4 (1975–76), pp. 17–32.

Davis, John. "Children in the Parlor: Eastman Johnson's *Brown Family* and the Post–Civil War Luxury Interior." *American Art* 10, no. 2 (Summer 1996), pp. 50–77.

————. "Eastman Johnson's *Negro Life at the South* and Urban Slavery in Washington, D.C." *Art Bulletin* 80, no. 1 (March 1998), pp. 67–92.

French, Edgar. "An American Portrait Painter of Three Historical Epochs." *World's Work* 13, no. 2 (December 1906), pp. 8307–23.

Grant, John B., Jr. "An Analysis of the Paintings and Drawings by Eastman Johnson at the St. Louis County Historical Society." Master's thesis, University of Minnesota, 1960.

Hartman, Sadakichi. "Eastman Johnson: American Genre Painter." *International Studio* 34 (1908), pp. 106–11.

Heilbron, Bertha. "A Pioneer Artist on Lake Superior." *Minnesota History* 21 (June 1940), pp. 148–57.

Hills, Patricia. *Eastman Johnson.* Exh. cat. New York: Clarkson N. Potter in association with the Whitney Museum of American Art, 1972.

————. "Eastman Johnson on Nantucket." In *Picturing Nantucket*, ed. Michael A. Jehle. Nantucket, Mass.: Nantucket Historical Association, forthcoming.

————. "Eastman Johnson's *The Field Hospital*: The U.S. Sanitary Commission and Women in the Civil War." *Minneapolis Institute of Arts Bulletin* 65 (1981–82), pp. 66–81.

————. *The Genre Painting of Eastman Johnson: The Sources and Development of His Style and Themes.* New York: Garland Publishing, 1977.

Hirschl, Norman. "Exhibition of Eastman Johnson—Forerunner of Homer and Eakins." Press release for an exhibition held at Frederic Frazier Gallery, New York, 1937.

Johnston, Patricia Condon. *Eastman Johnson's Lake Superior Indians.* Afton, Minn.: Johnston Publishing, 1983.

Kaskell, Joan Mary. "Eastman Johnson, Lithographer." *Imprint* 22, no. 1 (Spring 1997), pp. 11–15.

Keach, Lauren. "Eastman Johnson's Domestic Interiors of the 1870's." Master's thesis, Indiana University, Bloomington, 1995.

Keck, Sheldon. "A Use of Infra-Red Photography in the Study of Technique." *Technical Studies* 9 (1941), pp. 145–52.

Kelly, Franklin, et al. *American Paintings of the Nineteenth Century.* Part 1. Eastman Johnson catalogue entries, pp. 372–84, by John Davis. Washington D.C., New York, and Oxford: National Gallery of Art and Oxford University Press, 1996.

Kennedy & Company. *Exhibition of Charcoal Drawings by Eastman Johnson.* New York, 1920.

King, Edward. "The Value of Nationalism in Art." *Monthly Illustrator* 4, no. 14 (June 1895), pp. 265–68.

Low, Will H., Caroll Beckwith, Samuel Isham, and Frank Fowler. "The Field of Art: Eastman Johnson—His Life and Works." *Scribner's Magazine* 40 (1906), pp. 253–56.

Marks, Arthur S. "Eastman Johnson's Portrait of James Cochran Dobbin." *SEAC Review* 10, no. 3 (1983), pp. 138–43.

Selby, Mark. "An American Painter: Eastman Johnson." *Putnam's Monthly* 2, no. 5 (August 1907), pp. 533–42.

Simpson, Marc, Sally Mills, and Patricia Hills. *Eastman Johnson: The Cranberry Harvest, Island of Nantucket.* Exh. cat. San Diego: Timken Art Gallery, 1990.

Spassky, Natalie. *American Paintings in the Metropolitan Museum of Art.* Vol. 2, pp. 220–39. New York: The Metropolitan Museum of Art, 1985.

Tuckerman, Henry T. *Book of the Artists.* New York: G. P. Putnam & Sons, 1867. Reprint, New York: James F. Carr, 1967.

————. "Our American Artists. No. VI. Eastman Johnson." *Hours at Home* 4 (December 1866), p. 173.

Walton, William. "Eastman Johnson, Painter." *Scribner's Magazine* 40, no. 3 (September 1906), pp. 263–74.

Index

NOTE:
Italicized page numbers indicate illustrations.